TRUMBO

Dalton Trumbo was the central figure of the infamous "Hollywood Ten," the screenwriters who, during the McCarthy era, were charged by the House Committee on Un-American Activities for their associations with the Communist Party. Due to their refusal to cooperate during the investigation, Trumbo and his fellow screenwriters were declared in contempt of Congress and were ultimately blacklisted from Hollywood and some were even jailed. Although Trumbo was one of several hundred writers, directors, producers, and actors who were deprived of the opportunity to work in the motion picture industry from 1947 to 1960, he won an Oscar under the pseudonym Robert Rich for *The Brave One* in 1956, and he was the first to see his name on the big screen again in 1960 with *Exodus*, one of the year's biggest movies.

All his life Trumbo was a radical of the homegrown, independent variety. From his early days in Colorado, where his grandfather was a county sheriff, to his time in Los Angeles, where he organized a bakery strike and was even a bootlegger, to his time as an author when he wrote the powerful pacifist novel *Johnny Got His Gun*, to his heyday as a top-paid (yet frequently broke) Hollywood screenwriter—where his credits include *Roman Holiday, Spartacus, Papillon, Lonely Are the Brave, Thirty Seconds Over Tokyo, The Brave One,* and *Kitty Foyle*—his life rivaled anything he had created.

Written with Dalton Trumbo's full cooperation, at a moment when he himself did not know how much time he had left, TRUMBO is a candid tale of a colorful figure who was at the epicenter of a tumultuous period in recent American history.

PRAISE FOR TRUMBO
(Original Edition)

"What a relief...to read Bruce Cook's TRUMBO, a book of clarity, probing intelligence, and considerable grace. Trumbo was a true original. His life has the chronicler it merits."

—Nat Hentoff

"A gossipy, anecdotal narrative that is fascinating reading."

—*Publisher's Weekly*

"He wrote a brilliant novel and a number of very good movies, and he demolished the Hollywood blacklist almost single-handed, but his greatest achievement was just being the incomparable Trumbo. Bruce Cook has captured the wit, intelligence, and unpredictability that made him one of the truly original people of our time."

—Ring Lardner, Jr.

"As a study of life under the blacklist the book is superb....Essential reading for anyone interested in either the cinema or recent American history."

—Library Journal

BOOKS BY BRUCE COOK

NON-FICTION

The Beat Generation (Scribners, 1971; Morrow, 1994)
Listen to the Blues (Scribners, 1973; Da Capo, 1995)
Dalton Trumbo (Scribners, 1977)
Brecht in Exile (Holt, Rinehart & Winston, 1983)
The Town that Country Built (Avon, 1993)

FICTION

Sex Life (Evans, 1979; Dell, 1980)
Mexican Standoff (Watts, 1988)
Rough Cut (St. Martin's, 1990)
Death as a Career Move (St. Martin's, 1992)
The Sidewalk Hilton (St. Martin's, 1994)
The Judgement, by William Coughlin (uncredited by publisher)
(St. Martin's, 1997)
Young Will: The Confessions of William Shakespeare
(Truman Talley Books / St. Martin's, 2004; Griffin, 2005)

BY BRUCE ALEXANDER (PSEUDONYM)

Blind Justice (Putnam, 1994; Berkley, 1995, 2009)
Murder in Grub Street (Putnam, 1995; Berkley, 1996, 2010)
Watery Grave (Putnam, 1996; Berkley, 1996)
Person or Persons Unknown (Putnam, 1997; Berkley 1998)
Jack, Knave and Fool (Putnam, 1998; Berkley, 1999)
Death of a Colonial (Putnam, 1999; Berkley, 2000)
The Color of Death (Putnam, 2000; Berkley, 2001)
Smuggler's Moon (Putnam, 2001; Berkley, 2002)
An Experiment in Treason (Putnam, 2002; Berkley, 2003)
The Price of Murder (Putnam, 2003; Berkley, 2004)
Rules of Engagement (Putnam, 2005; Berkley, 2006)

TRUMBO

BRUCE COOK

GRAND CENTRAL
PUBLISHING

NEW YORK BOSTON

With gratitude to Mitzi Trumbo for her kind assistance.

Grand Central Publishing
Hachette Book Group
1290 Avenue of the Americas
New York, NY 10104

www.HachetteBookGroup.com

Printed in the United States of America

RRD-C

Originally published in hardcover as *Dalton Trumbo* by Charles Scribner's Sons, 1977

First Grand Central Edition: September 2015
10 9 8 7 6 5 4 3 2 1

Grand Central Publishing is a division of Hachette Book Group, Inc. The Grand Central Publishing name and logo is a trademark of Hachette Book Group, Inc.

The Hachette Speakers Bureau provides a wide range of authors for speaking events. To find out more, go to www.hachettespeakersbureau.com or call (866) 376-6591.

The publisher is not responsible for websites (or their content) that are not owned by the publisher.

ISBN: 978-1-4555-6498-9
LCCN: 2015946133

CONTENTS

TRUMBO

THE LION IN WINTER

The production chronicle of *Papillon* was such a saga of bad luck, dissension, and difficulty that it seems remarkable that a motion picture came out of it at all—much less the reasonably successful one it turned out to be. There were financial problems right from the start. One company started the project only to drop out when the budget began to get out of hand. That was when Allied Artists took it over. And when that happened, it was decided that the picture needed the sort of box-office insurance that two stars could provide—make it a kind of *Butch Cassidy and the Sundance Kid on Devil's Island* was the idea. Steve McQueen in the title role was good, but Steve McQueen plus Dustin Hoffman as his prison pal would be that much better. Hoffman, it turned out, was willing, and the deal was consummated only a short time before they were committed to begin production.

The trouble was, the screenplay they had in hand, by Lorenzo Semple, Jr., though otherwise quite satisfactory, had no part in it for Dustin Hoffman. A star needs a starring role. One would have to be written for him—and it would have to be done almost simultaneously with production.

In a situation like that, there was one writer—and just about one alone—to turn to: "I may not be the best screenwriter in Hollywood," Dalton Trumbo once said, "but I am incomparably the fastest."

There were many who considered him the best, too—among them, Franklin Schaffner, the director of *Papillon*, who put the problem before Trumbo and explained that it would mean coming along on

location to rewrite the script as it was being shot. Trumbo took the job for a good price; he was still trying to write himself out of the financial hole he had been put in by the failure of his own production of *Johnny Got His Gun.* There was very little he could do in the way of preparation and research, for there simply wasn't time for that. He read *Papillon,* of course—"a pretty damned dull book, if you ask me," he later commented. He sketched out a structure to accommodate Dega, the counterfeiter, the character to be played by Dustin Hoffman, a basic outline structure that satisfied everybody, more or less.

As for building the role of Dega, there wasn't much to go on in the book by Henri Charrière; he was only a minor character—in the story and quickly out of it. For the film, of course, he would have to stay in. What sort of man would he be? Trumbo and Hoffman got together during the few weeks that remained before shooting began and talked at length about the problem. And the longer they talked the better Hoffman got to know Trumbo, and the more certain he was that Dega should be in some important ways like Trumbo himself. "He's a real feisty man," Hoffman later told an interviewer, "and he's got a combination of toughness and sophistication and integrity that I felt were right for Dega....So I said, why didn't he write the character off himself, so to speak?" And that was what Trumbo did, traveling off to Spain with only sixty pages completed of a very long script, and then to Jamaica, writing never more than twenty pages ahead of them, as the film was being shot. It is not, to say the least, an easy way to work; but Trumbo was equal to the job, and if there were delays in the production of *Papillon* (and there were plenty), they were not attributable to him, as long as he was on the picture.

The shooting in Spain went well and quickly enough. This was the part of the film that was supposed to take place in France: the prisoners bound for the penal colony herded like animals through the streets by soldiers and into a dusty, sun-baked prison yard. There they are made to strip and listen as the warden of the prison informs them that few of them will live out their prison terms and that none will return home again—that for France they no longer exist. It is a cruel speech, certainly, but important and even necessary in that it perfectly sets the tone of the film, preparing the audience for the saga of inhumanity that is to follow. In the picture, it is delivered by the man who wrote it, Dalton Trumbo.

Franklin Schaffner, who chose him for the part, insisted that there was no special story here, and that there was certainly no irony intended (the warden played by a jailbird). When he said that he interviewed a couple of English actors for the part but that one morning he awakened, sat up in bed, and said to himself that it had to be Trumbo— well, what he was telling us, I think, is that he had by then suddenly come to recognize the intensely theatrical quality of the man, the sense of drama that Trumbo projected almost casually but never, certainly, unconsciously. Dalton Trumbo was a natural actor.

It was when the production moved to Jamaica, however, that problems on *Papillon* mounted, trouble came, and financial disaster struck. There were difficulties that may seem only petty in retrospect but at the time seemed almost insurmountable. Dustin Hoffman, for example, had been led to understand that he and Steve McQueen were not only to be given equal billing but were to be paid the same for their work in *Papillon*. In fact, Hoffman was getting $1.25 million to McQueen's $2 million. When he discovered that, he was for some days afterward aggrieved, indignant, and angry. Finally, he settled back down to work.

The *ganja* was, as always, plentiful there in Jamaica, and it was readily available to the company. Some were not content to smoke the stuff, however; they boiled a batch of it up and mixed it secretly into the drinks at a party. Everybody got high but a few got sick as well—among them, Franklin Schaffner, and so a day of shooting was lost. Other days were lost more prosaically to the weather. And there was a period of about three weeks when the money ran out and nobody got paid; it looked then as though the production would shut down altogether.

There was trouble with the local population. One morning on the way to the location, Dustin Hoffman's driver hit a pedestrian and caused serious injury. Because of that, not the driver, but Dustin Hoffman, received threats against his life. Threats only—no attempts. Larceny, however, was something else again. They not only attempted there, but succeeded on the grand scale. Theft and pilferage were constantly a problem, but when the production ended, and before properties could be packed and shipped, the island people began raiding methodically and simply stripped the set. Costumes went—six hundred pairs of shoes were stolen from wardrobe—machinery, even handy pieces of lumber: in all, a thirty-thousand-dollar loss.

But now I'm getting ahead of my story because just before shooting

on *Papillon* was completed, the production suffered its most serious setback—Dalton Trumbo was forced to leave the company before the script was quite completed. What happened was this: Weeks before, just prior to leaving for Spain, he had taken a medical examination for another insurance policy. They heard nothing about it. The examining physician had done his job, all right; he had called attention in his report to a worrisome shadow in the area of Trumbo's left lung. But the insurance agent had simply sat on the report, out of either ignorance or misdirected consideration. At last, however, he passed it on to Trumbo's wife, Cleo. She telephoned him immediately in Jamaica.

"Sure, I remember that call. It was a Sunday. We weren't shooting. There was a meeting right there in the Bay Rock Hotel, where we were staying. Dalton and myself and McQueen and Hoffman were all present, and Dalton was called out of the room to take this call from his wife. He was told it was important. Well, he came back, and didn't say anything. Finally McQueen and Hoffman left, and Dalton stayed and told me what he had just heard. It was very unsettling."

Franklin Schaffner. I talked to him at the old Goldwyn Studios in the heart of Hollywood. He was there cutting *Papillon*, under pressure to have it ready for simultaneous Christmas openings in New York, Paris, and Tokyo. So many millions were riding on the project that the holiday opening was essential. Never mind that at this point—late fall—it looked like just about an impossible task. With enough hours in the editing room (what was it outside? day or night?), with enough cigars smoked, and enough aspirin to see him through the ordeal, he just managed to make their deadline.

So this was how it was when we talked. That Franklin Schaffner would see me at all under such circumstances seemed remarkable enough and an indication of the sort of respect he had for Trumbo: if he could help, he wanted to. Schaffner seemed to look at it as the least he could do, for Trumbo had given him about as much as any man could down there at Ocho Rios.

"He didn't want to go back until the picture was finished, and he was still a good chunk from the end. But he made a concession and went to a doctor there on the island and had an X-ray made. The local doctor told him there was something there, all right, but that he thought that

his doctor back in Beverly Hills ought to see the X-rays and Dalton could work out with him what needed to be done. Well, that's what they did, and in a few days' time his own doctor is telling him to come back there so they can check it out.

"Now, the important thing to remember is that all through this business of getting X-rays and sending them off and waiting to hear from the doctor in California, Dalton kept right on working on the script. That's the kind of professional he is."

Franklin Schaffner was a tall, handsome man with an almost soldierly manner. You looked at him, and you realized why *Patton* was the kind of film it was. Tough, direct, and commanding, he was a man who looked right with a long, dark cigar in his mouth. When Schaffner talked about someone as a "professional," you got the feeling that this was about the highest praise he could give anyone.

"And the way we were working back then," he continued, "well, a lot of writers would have found it just impossible. I would get up at four A.M. and attack the day's work. This meant, among other things, sitting down with Dalton for an hour around five-thirty or six and giving a last look with him at the pages to be shot that day. Then when shooting was finished, I'd go back to the hotel and sometime that evening go over what Dalton had written during the day. Depending on how many things there were to be dealt with, it might be pretty late at night before the meeting could actually take place. I must say he was good about that. He would never protest what time we met. And of course we put in considerable time every Sunday. It was a script conference we were having the Sunday he got the call."

I asked Franklin Schaffner if there was a lot of give-and-take at these conferences. "Was the screenplay shot pretty much the way Trumbo wrote it?"

Schaffner looked at me as if I were nuts or naïve or both, but he spared me his personal reaction and gave me a direct answer: "That was another mark of his professionalism. He's not a man given to being egotistical on a motion picture script. We worked extraordinarily closely on it, and he took every kind of positive and negative criticism. He can certainly be ruthlessly critical of his own work—objective, and not a Salvationist of his own dialogue. But it's a two-way street. He demands professionalism on both sides. You know, there are a lot of unprofessional directors who throw good dialogue and good

writing out the window because of a lack of experience or a kind of ego gratification."

He paused, frowning, and took a couple of puffs on his cigar, as if asking himself where to pick up the thread of narrative he had dropped a few moments before. "At any rate," he resumed, "this was the way he continued to work until it became clear that it was absolutely necessary for him to return to California to have this checked out. There were, as he presented them, three options: It might be nothing, in which case he would turn right around and come back. Or if surgery were required, and it wasn't too serious, he would come back ten days afterward and do a little on-the-job recuperation. Failing that, if the news were really bad, he'd find somebody to replace him because there remained a minimum of thirty pages to be written before the script was completed. Well, he went home then and got the news from the doctor there, and it was bad, all right."

Dalton Trumbo was found to have lung cancer. Tests also showed that there were cancer cells present in his lymph nodes. Radical surgery was called for, but even at that the prognosis could only be termed hopeful—not, certainly, optimistic. A writer would have to be found to take his place. The situation, however, was complicated by the fact that there was a writers' strike on at the time, one directed against television but affecting motion picture production as well. To get a new writer cleared for just the last thirty pages of *Papillon* might be a rather complicated proposition, under the circumstances. And so Trumbo suggested to the producer of the picture, Ted Richmond, that an easier bargain might be struck with the Writers Guild if they were to hire his son, Christopher Trumbo, to do the job. He was betting that the Guild would find the sense of human drama and the symmetry of a son taking over from a father quite irresistible. And quite right. There were no objections to Christopher Trumbo replacing his father to finish up the *Papillon* project. And none from Richmond or Schaffner, for by this time Christopher had credits in both television and films and was quite capable of completing what his father had begun. The production company signed with the Guild. He left for Jamaica after Trumbo's surgery.

The lung and the lymph nodes were removed. Tests that followed

showed that the cancer in his lymph system was not as far advanced as they had feared; so there was some cause to feel relief at that. It was bad, in other words, but could have been worse—or could it? For as is fairly common when a lung is removed, the strain put on his heart in adjusting proved too much: less than a week after surgery, there in the hospital, he had a coronary attack. With that, a lesser man might have succumbed—but not Trumbo.

Not even the brutal cobalt treatments to which he was introduced following his release from the hospital succeeded in laying him low, though they came closer, certainly, than either surgery or his heart attack had done. They proved a shock to his entire system, disorienting him physiologically, upsetting any possibility at the time of achieving metabolic equilibrium. The enormous physical impact of the cobalt upon his already weakened body was such that during the course of this treatment, he had little strength for anything except simply being with his family, traveling to and from the hospital where he was bombarded three times a week with radioactive rays, and sitting down with me in his study, where he would talk for a few hours each day into my tape recorder.

For this is where I come in. I intrude myself into this account as something less than the magistrate of my own court and something more than mere reporter of the proceedings. Prosecutor? Definitely not. Advocate? Perhaps. I had come specifically intending to write a book about him and in that extended act there is implied, as we both well knew, a reserve of sympathy for the subject, any subject—if not always a perfect understanding of it. I would not have been there then, nor would I be writing this now, if I didn't think that Dalton Trumbo were a man whose life—and to a slightly lesser degree, whose work—mattered enough to us all to be talked about in detail. He knew that. He knew the tiny microphone I had propped up before him was, in fact, a sympathetic ear. But I think he must have known, too, (or suspected) that no matter what was *implied,* he would be taking his chances in consigning himself to me—or, for that matter, to any other writer. When you give yourself up to a biographer, the question is, finally, whether you yourself give sanction to your own life. He did. And the feeling I had as I listened to him through those summer days in 1973—when all anybody else was talking about was Watergate—was that Trumbo was speaking for the record. It accounts, I think, for the valedictory tone of much he

had to say; not that all of it was pleasant, and generous, and forgiving, though that is how a lot of people suppose men speak at such times in their lives. No, what he was interested in doing was setting the record straight; maybe, in a few instances, closing out some old accounts, debit or credit.

One way or another, he surprised a lot of people that summer.

On one of the few afternoons he had escaped the cobalt torture, Trumbo had gone to the doctor in Beverly Hills who had prescribed it and was mildly curious whether the treatment was doing any good. There were some tests that might tell.

Just getting around—in and out of cars, up elevators, and through the waiting rooms—was a problem for him then. His legs were weak, and breathing was hard for him, but he wouldn't ride in the wheelchair which everybody said would have made it easier. His wife, Cleo, served as his chauffeur, driving him to and from wherever he needed to go in her Jaguar sedan. He was dependent upon her physically for the first time, though he had been so in every other way for as long as they had been married.

It hadn't taken long in the doctor's office. It was just the trouble of getting there and now the same strain in getting back home. Trumbo was waiting in a parking garage in the basement of a Wilshire office building for Cleo to bring around the car. A couple emerged from the elevator and came toward him, a woman and an older man. Only the man was not nearly as old as he looked. Trumbo looked at them closely, immediately recognized Betty Garrett, and realized that the white-haired, white-bearded man leaning on her arm must be her husband, Larry Parks.

Larry Parks died in 1975, having lived a sentence in purgatory of over twenty years' duration. None of those called before the House Committee on Un-American Activities was more cruelly used than the actor with the sunny smile who used to play Al Jolson. In 1951, under great pressure, he cooperated with the Committee, giving a few names of Hollywood Communists—but only of those already well known as Party members. He tried, in other words, to say as little as possible and quite literally begged not to be compelled to give them even that:

I think to force me to do something like this is not benefitting this Committee. I don't think the Committee would benefit from it, and I don't think this is American justice to make me choose one or the other or be in contempt of this Committee, which is a Committee of my Government, or crawl through the mud for no purpose. Because you know who these people are. This is what I beg you not to do.

No, he didn't give the name of Dalton Trumbo, but he gave names of Trumbo's friends, one of whom was then in jail serving time with him for contempt of Congress.

Larry Parks emerged from the Committee room a pariah to both right and left. His career was ended. He dropped out of sight. And now, at close range, though he was less than sixty, he looked to be an old man. Trumbo had not set eyes on him in all those years, and he was shocked to see him now. If ever there were one who was only a victim of the Committee and the blacklist, it was certainly Larry Parks.

"Hello, Larry." He put out his hand.

Larry Parks took it and, looking grateful, shook it slowly. "Hello, Dalton. I'm glad to see you. You look the same, only older."

"We're both a lot older now."

They stood apart for a moment, not knowing what more to say. Then Cleo pulled up in the car and, with a nod goodbye, Trumbo got into the front seat beside her. They drove away.

"I could no more have turned my back on Larry Parks," Trumbo told me later, "than I could on some of the men I went to prison with."

Just such encounters as that one—embarrassed, apologetic, sometimes furtive—were taking place ever since the blacklist ended. Hostesses, in all innocence, gaily introducing the betrayed to his betrayer; agents pairing the wrong people in pictures; and of course innumerable chance meetings on street corners, in post offices, and—who knows?—perhaps even in the lines to register for unemployment compensation.

I had wondered about this. I asked myself how a man who had weathered the blacklist, remaining in Hollywood all those years of the McCarthy period, eking out a kind of shadow life on the movie black

market—how such a man might feel today, as he looked back on it all. Was he bitter? Would he take vengeance if he could? Did he keep a list? Such questions led me, inevitably, to Dalton Trumbo. In the course of researching an article on the blacklist and its aftermath, I had first met him a few years before. To say that I fell under his spell at that time seems excessive, though it is true enough in a way. Worse, it might undermine your faith in my ability to deal objectively with the material that follows. But let it stand because it communicates something essential about Trumbo. There was something larger than life about the man. Not physically—he would have had to stand on his tiptoes to hit five feet eight—but *personally,* according to his very nature. (The truest remark ever said of him was made by a journalist who once interviewed him, a woman. "He has," she said, "a very seductive personality." She didn't mean that in a sexual way.) There is a certain charismatic quality that I think would have been perceived even by one who didn't know who Trumbo was or what he had done.

But who was he? What had he done? He was a writer, of course. Yet one of the difficulties in giving any sort of serious literary consideration to Dalton Trumbo is trying to decide just what sort of writer he was. A novelist? He wrote four novels (and left one unfinished that was published posthumously), and one of them—*Johnny Got His Gun*—is one of the finest by an American in the thirties. Of the remaining three complete novels, two are of negligible quality and the other has never even been published in this country. A playwright? The only play he had produced, *The Biggest Thief in Town,* was good enough to have a run in London, though not really the sort of work with which one would advance serious claims for him as a dramatist. As a screenwriter then? Here, of course, he was enormously successful. Trumbo had what I reckon to be the longest continuous career of any writer in American films. Early in his career he got an Academy Award nomination for his adaptation of Christopher Morley's *Kitty Foyle.* When he was blacklisted in 1947, he was the highest-paid screenwriter in Hollywood. Even during the blacklist period he continued to work in the so-called black market, writing screenplays at cut-rate prices. But he never gave cut-rate quality: in fact, one of those black-market scripts, *The Brave One,* which he wrote under a pseudonym, won the Academy Award for Best Motion Picture Story. He was the man who broke the blacklist. He was the first of a couple of hundred writers, directors, producers, and actors,

who had been deprived of the opportunity to work in the motion picture industry from 1947 to 1960, to see his name back up on the screen. When that happened, it was for his work on *Exodus,* one of that year's biggest movies. And after that he worked almost exclusively on the biggest productions (though not always the most artistically distinguished ones), and he received fees to match.

But is a screenwriter a writer like any other? All the best of them can do is to provide the director with a good, comprehensive plan for a film. Even Trumbo considered his screenwriting craftsman's work. So we are left, as you can see, with the problem of evaluating an immensely talented writer, a very able and prolific writer, who has demonstrated tellingly on a number of occasions that he was capable of real art; yet at the same time one who has not much more than a single novel and a handful of screenplays to point to as the artistic achievement of his lifetime.

Trumbo didn't plan it that way. He started out, as young writers did in the twenties and thirties, to be a novelist. He backed into screenwriting thinking of it as temporary. Would he even have found his way into the motion picture industry if it were not for the fact that he was right there on the spot in Los Angeles? Probably not. But at a time in his life when he might have given up writing for films and concentrated on fiction, history intervened. Whether he wished it or not, Dalton Trumbo became deeply involved in politics. I suspect, frankly, that he did wish it—that being a political figure was almost as attractive to him as being known as a novelist. For once on stage he played his role with such relish and style that it is clear that the man did have a talent for politics. Dig into his background, and you see that he showed it as early as high school. He was by nature combative and thrived on controversy. Had he undertaken a political career in the usual way, under the conventional labels—Republican, Democrat, liberal, conservative—he would probably have been immensely successful.

But he was a radical and had been more or less consistent in that since he had found out, as a young man, what it was like to be poor. He came out of Colorado in the twenties a vague sort of populist. His outlook was altered by personal experience. As the Depression deepened, he broke into movies and his personal fortunes took a turn for the better. But he did not cultivate that peculiar functional myopia that made it possible for so many there to ignore the awful poverty that lay

just outside the studio gates. He indulged himself, "went Hollywood" as they say, but he never forgot who he was or what he had been. The looming prospect of war disturbed him profoundly. And when war came, he saw his choices limited, and became a Communist.

There was a whole generation of them in Hollywood—writers, directors, actors, and even a few producers, who, like Trumbo, followed their commitment as far left as it would lead them. They were, of course, infamously well off—"swimming pool Communists," they would later be called—but this was so because the group included some of the best and most talented people in motion pictures and the only real recognition Hollywood can give excellence is expressed in dollar signs, numbers, commas, and decimals. What is remarkable is not that so many were radical but that the overwhelming majority of them, the hundreds who were subsequently blacklisted, were willing to give up those swimming pools rather than inform on the rest. It would have been easy for them to keep what they had; a few names was all the House Committee on Un-American Activities was asking, a gesture to the Committee of good will, of cooperation. But only a few of them did cooperate, and to be fair, not all of those did so out of some base desire to keep what they had. There were as many reasons for giving names to the Committee as there were men who gave them. But for those who refused, who had everything to lose and only their self-respect to retain, there was only one justification and that was a moral one.

I drove up the coast to talk to one who had refused, Michael Wilson. He was one of the most accomplished writers in motion pictures, a winner of Academy Awards, a writer for the big projects, a savior of lost screenplays, one of the few they talked about in the same breath with Trumbo. On September 20, 1951, he appeared before the House Committee on Un-American Activities as an "unfriendly" witness, and when asked if he were then or ever had been a member of the Communist Party, he took the Fifth Amendment, refusing to answer on the grounds that to do so might incriminate him. In the years that followed he survived—even thrived—working on the black market, just as Trumbo did. And he had the pleasure, as Trumbo also had, of seeing one of the films he had written under another name during the blacklist

win an Academy Award for Best Screenplay.* Wilson was tough, a survivor, one who had the strength and intelligence that enabled him to take a moral stance, back it up, and hold it to the end.

Michael Wilson is living in Ojai at the time of our interview, a kind of artsy-craftsy spot about midway between Los Angeles and Santa Barbara and in the hills twenty miles or so from the coast. "When we moved to this country from Europe," he told me later, "we wanted to live someplace that was kind of out of the way but still close enough to that big money tit down in Hollywood so we could suck when we got hungry. This turned out to be just about ideal for us." And it looks ideal, too, as you drive through it, the sort of small-town atmosphere—it's not a suburb of any place—that is fairly rare in California. Following Wilson's directions, you turn off the highway and down a winding road, almost dark in mid-afternoon because it is so thickly shaded along the way with oak and pepper trees. Turn in the driveway then, and you see a modest enough ranch house with a separate building in front, Wilson's office, almost hidden in a grove of trees. It is from there he emerges and waves me over. I notice that he moves with some difficulty, lame from an auto accident in 1970. When he speaks, there is a slight thickness to his speech—the result, I later hear, of an operation of a couple of years back for cancer of the tongue.

"I guess I've actually known Dalton Trumbo since 1940. I was trying to break into the film business then but hadn't yet gotten my first job. We had mutual friends—Ring and Ian and Hugo—so it was sort of inevitable. But it wasn't until about the time of the Hollywood Ten that I got to know him well."

"There are certain similarities in your background, aren't there?" I put in. "I mean, yours and Trumbo's."

"How do you mean?"

"Well, for instance, you're both from the West, aren't you?"

"Yeah, I guess so. I was born in Oklahoma, and he was born... where?"

"In Colorado," I prompt him.

"In Colorado," he agrees. "But I was raised right here in California.

*That was *The Bridge on the River Kwai* (1957).

And you want to remember, too, that we're very different, personally different, in many ways. You must have seen how pert and frisky he still is—you've noticed that, I'm sure. When he's not working he's a very sociable and gregarious guy. But I am not, to put it simply. I tend to be reclusive and not social. Trumbo has had a way of bringing me out and getting me to socialize more than I was wont to do."

"You've worked together, though, haven't you?" I ask. "You actually collaborated on *The Sandpiper*—and didn't just share credit."

"Well, yes, but that was a pretty unusual sort of collaboration. I was in Paris and he was in Rome. We just sent the stuff back and forth in the mail, and we didn't really see each other until we got back to America the following year.

"We knew we could work that way," he continues, "because we did some scripts together during the blacklist. We decided we couldn't work together in the same room. Not many can. And it had to be done very fast, so we decided that we'd rely on what we called the 'pony express' method. I did an extended treatment which I sent off to him a few pages at a time. When he had knocked out about twenty or thirty pages of screenplay from those pages of treatment he would mail them to me, so that we were mailing stuff back and forth every day. We did three westerns that way in a matter of a few weeks, all for very little money, about three thousand dollars a script, which we had to split, of course. But that was the black market back then. That was how it worked."

"What were the titles, anyway?" I ask. (You never can tell who *really* wrote your favorite movies from the 1950s. Perhaps I had seen one of the three.)

"Oh, I don't think any of them were ever produced. Well, maybe one of them was. We wrote it as *The Target,* and then some Germans bought it. I told Trumbo that the title had been changed to *Crotch on der Saddle Horn.*"

Of all the screenwriters who continued to work on the movie black market during the blacklist period, Trumbo and Michael Wilson were by far the most successful. Without ever seeing their names up on the screen, they managed, by their industry, to earn more than many well-known screenwriters who had *not* been blacklisted; their success drove the Writers Guild crazy. Not only that, but along with a lot of routine hack work (such as those three westerns they wrote together)

both of them did work they could be proud of during that time. Why? Why had they succeeded when other very good writers had not done nearly so well?

Michael Wilson considers a moment, then shrugs. "Well, the fact that we were both so well established certainly had a lot to do with it. I know it was a factor in my case." The year Wilson was blacklisted he received the Academy Award for the screenplay he did for *A Place in the Sun*.

"I don't think, though, you can conclude from any of this that we two are birds of a feather." He adds this after a long moment's hesitation, and that said, he pushes on: "Trumbo was a more cunning and aggressive fellow in his hardship than I would have been. I didn't go to jail, of course. I took the Fifth. But Trumbo when he got out showed a truly remarkable tenacity and aggressiveness in fighting for jobs that helped see him through. I don't know that I'm as tough as he.

"And there's another difference between us. Trumbo almost to this day never turned down a job. Certainly never during the blacklist. He would always take on more work than he could do. That would really bother me. I couldn't do it. I would get psychologically overwhelmed, or something, if I took on two jobs at once. It would be mentally impossible for me to work from one to the other that way."

"Why do you think that is?" I ask him. "Why is it Trumbo can't say no?"

"He remembers the hungry days," Wilson replies. "And I don't mean just the time on the blacklist. It goes further back than that for him. In that sense I had an easier boyhood and young manhood than he did. And in that sense, too, I think I had less drive and had more...oh, creative indolence, I guess you'd call it. This has had a profound effect on his writing. He's got a novel going, you know."

"Yes," I say, "I know that."

"He sent me over a hundred pages of it a few months ago—it was February, as I remember—and asked me what I thought. Well, what I thought was it was very good, and it seemed to me that this habit of his of taking every damned screenwriting job he could find was getting in the way of finishing it, and that was a great pity. And so I wrote him, addressing him as we always address one another, 'Dear Old Boy,' and what I did was suggest that he give up screenwriting for Lent. It was the season, you see. That way he would have six uninterrupted weeks in

which to work on that novel, and the way he works that would finish it up. Well, you can imagine how much good that did."

"Yes," I tell him, "I can imagine."

He pauses, thinking, pondering, ruminating, and looks up at last: "What can I tell you? I really love the man, and I think he loves me."

It seems like the end of the interview, and so I flip my notebook shut and stand up, intending to take my leave. But Michael Wilson has other ideas: "There's somebody here I think you ought to talk to," he tells me.

"Oh? Who's that?"

"John Berry, the director. He's a house guest. He's known Trumbo nearly as long as I have."

"They even worked together, more or less, on a picture, didn't they?"

"That's right. More or less was it, all right, because it was during the blacklist, and Trumbo couldn't show his face on the set at all. But come on back to the house and meet him. He knows you're here."

Michael Wilson leads me out of his office and toward what he calls the "main house." On the way, it occurs to me that since this meeting was unplanned, it is fortunate that I have seen *Claudine*, Berry's recent film, and liked it. And not only did I like it, I wrote a very favorable review of the picture. I know, from experience, how it works. A favorable review of a director's film cannot assure a good interview, but an unfavorable review guarantees a bad one. Just before going inside the house, we are hailed and joined at the door by John Berry.

Inside, we sit down across from one another, and Michael Wilson trudges off to find something to do in another part of the house. We sit there, not knowing quite where to begin. Finally, I ask him about the movie he and Trumbo worked on together during the blacklist.

"Yes, that was *He Ran All the Way*, John Garfield's last film. It was actually released after Garfield's death. Dalton did the first draft of the screenplay, and he didn't even get credit on it because the blacklist was just beginning then. It was made, as I remember, while Dalton was in prison."

"Was that when you met?" I ask.

"Oh no. I've known Dalton a long time. And through the years I've continued to see him all the time. When he was in Europe—that was

when I was blacklisted—we used to visit back and forth quite a lot. I've always had this deep and abiding affection and admiration for the man. He's an enormous character. I spent the afternoon with them just the beginning of this week. It was one of the memorable days of my existence.

"I remember he described to me in detail his physical condition. At his age, he's got a good chance of beating the actuary charts even if he stays alive a matter of months. Then he quoted me the survival statistics on his operation, which aren't too favorable, as I'm sure you know. And then he said that he hoped it didn't embarrass me hearing him speaking about his own death. And about that time he stopped speaking for a moment, and he explained, 'I've got to wait to get my breath back so I can talk.' And then I said something like, 'Well, it's the first time I've ever known you to slow down.' Whatever it was—the kind of thing you'd say in a situation like that. And he said, panting, 'Wait. I'll talk. I'd rather hear my own voice than listen to your bullshit.' And then he started talking again."

We both laugh at that. It wasn't just a funny story, though. It said a lot about Trumbo—his rough humor, his toughness, and his scorn for the sort of easy expressions of concern we are all conditioned to give.

"What quality seems to characterize him?" I ask, neither expecting nor hoping for an answer in a single word.

Berry obliges: "Oh God, I don't know. Many, *many* qualities. He's a very complex man, after all. But there's something about him of the boulevardier—but of course he never goes out, so he's kind of a boulevardier of the living room. Great talker. But much stronger than that is the feeling that I get whenever I'm with him that I'm in the presence of aristocracy. There is a charm, a theatricality to the man that makes seeing him an event to which I always look forward. I don't understand how it is that a Bronx Jew and a Colorado Wasp hit it off so well, but we do. We do."

John Berry pauses. I have the feeling, though, that he isn't waiting for a question but is simply concentrating on what he wants to say about Trumbo.

"He's really a remarkable man," he resumes at last. "He has this determination and ability to commit his entire nature to the achievement of a goal he has set for himself. He's fierce, and not a sentimental man. Well, let's say that he has real sentiment but also has the ability to

grasp reality in terms of an existing situation that just eliminates any kind of self-deception or phoniness. And…well…what can I say? He's a mean fuckin' mother to have on the other side."

John Berry was blacklisted on the basis of testimony given by director Edward Dmytryk before the House Committee on Un-American Activities on April 25, 1951. (Dmytryk was, ironically, one of the original Hollywood Ten who went to jail for contempt of Congress along with Trumbo.) Berry, like a few other blacklisted directors, was lucky enough to get away to Europe and there squeeze out a living in films during the blacklist period. Only now, with movies like *Claudine,* was he beginning to take up his career where it had been broken off. One of the many.

Berry is Dalton Trumbo's junior by twelve years. Not just his story, but his attitude toward Trumbo, as well, seems fairly typical of those of his generation who were blacklisted. They kept in contact with him. Trumbo's voluminous correspondence from the blacklist period (boxes and boxes and boxes of it at the University of Wisconsin) contains innumerable letters back and forth, to and from Trumbo and others on the blacklist—in Europe, New York, Mexico, all over—who kept in contact with Hollywood through him. But he was more to them than the big brother who kept the home fires burning. He handed out practical advice when it was asked for, which was often; he encouraged, goaded, and inspired them not to despair; and in emergencies, he loaned them money when he himself could ill afford to do so. Breaking the blacklist became a kind of monomania with him. He saw to it that as much movie work as possible was directed to writers who were, like himself, working on the black market. Trumbo did an enormous amount of work during this period, but he passed nearly as much of it on to others. He was determined that so many scripts be written by those on the blacklist under pseudonyms, behind front names, or however, that the blacklist itself would become a kind of joke. And that, of course, was exactly what happened. It wasn't just because Trumbo's name was the first to appear on the screen again, thus ending the whole sorry affair, that he is widely known as the man who broke the blacklist. No, he actively led the fight against it, setting strategy, serving as unofficial spokesman for the entire group, writing articles and letters. It

didn't just happen. It was a campaign, brilliantly planned and daringly executed, and Trumbo was the general.

For this, he understandably became a figure of immense importance to those, like Berry, who suffered through the period. If he was a hero to them, it was not just because he was the man who broke the blacklist. He was admired for his personal qualities—his strength, his wit, his style, and not least certainly for his success.

That's right—success. None of his other fine qualities would have mattered a damn if he had not beaten the producers and studio executives at their own game, for they were, after all, the ones who were responsible for enforcing the blacklist. He proved to them that it was no longer in their interest to continue enforcing it, and he did this by addressing them eloquently and persuasively in the language they understood best, which was money. For one who could lay fair claim to thinking and acting like a radical for most of his adult life, Trumbo always maintained rather ambiguous relations toward money: he had a healthy liking for it; he was good at getting it; and the movies he wrote had better than average chances of earning it for other people. This last, of course, was what assured his ultimate triumph over the blacklist.

Money. If ever there was an instinctive capitalist, it was Dalton Trumbo. His competitive sense was so keenly developed that, at least in his younger days, there was hardly an activity he pursued that he did not feel driven to excel in. He was a believer in achievement, one imbued early with faith in the work ethic. ("I've never been without a job in my life," he told me, "even during the Depression, even during the blacklist.") And during the last years of his life, he seemed profoundly convinced that he could overcome any obstacle, any disadvantage, if he just tried a little harder. When he was put to the test during the blacklist period, he acted on this conviction and proved that it was so (at least for him). Because Trumbo worked in an industry in which achievement was measured in dollars and cents, he made a great deal of money.

But Dalton Trumbo was not merely a figure to the motion picture industry alone; he was remarkably well known to the nation at large, especially to that two-thirds of it under the age of thirty. He was known to them, first of all, as the author of *Johnny Got His Gun,* the novel that spoke more directly than any other to the Vietnam generation. He was known to a somewhat lesser but more deeply committed number of

that generation as one who took his role as radical seriously enough to go to jail for it, one who looked on his commitment as essentially a moral one. It was characteristic of him and goes a long way, I think, toward explaining his personal appeal to the young of that time that he always tended to see his conflicts, no matter how abstract their basis, in personal terms. It mattered to him greatly that he was a better man than any who persecuted him, than any who opposed him. And again and again, he felt called upon to demonstrate that to any who may have needed convincing.

He was the sort—one becoming all too rare in America and never as numerous as they told us in the high school history books—who thrived on competition, as though it were an added element required by his nature for continued survival. I hesitate to use the phrase "rugged individualist" to describe him, for it has been misused and overused to the point that it now seems to have only satirical value. Instead, I'll call Dalton Trumbo a "champion," with specific reference to Norman Mailer's dictum: "Champions are prodigies of the will."

Trumbo was that, certainly: a prodigy of the will. He hung in there—survived, prevailed, even triumphed on a couple of occasions. Ultimately, that is why he is worth our attention. Not primarily as a literary figure, nor because he ever really accomplished so very much politically (what, after all, do you prove by going to jail?), but rather because he was a man of moral stature. It may not even be too much to nominate him as an exemplar of a certain set of American virtues—toughness, independence, persistence—that are becoming fairly rare today.

He lives about halfway up a hill overlooking upper Sunset when I begin interviewing him. I have no idea who his neighbors are and never got around to asking, but it's a street of big houses that are, like his, deceptively small when viewed from street level. Enter through the Moorish gate and on past the door, and you find yourself in the top floor of three, well above part of Los Angeles and all of Beverly Hills. The woman at the door is Cleo Trumbo, Dalton's wife. In the days that follow, I will meet his three children on different occasions, as they trail in and out of the house on errands, more often on visits, just to find out

how he's doing. It's a quiet house, except for dogs that bark at every bell. The people in it are quiet. They speak in low voices, never raising them much above a murmur. This isn't Trumbo's style, but rather it is Cleo's. She is calm, still, contained—quite a beautiful woman, complete in herself, one who seems to feel little need to be emphatic. She makes her presence felt in subtler ways.

("The kind of relationship that that man has with that woman," John Berry had said to me, "it's just remarkable to see. To think that there is this kind of closeness between two people here in this...in this Babylon. Well, to see it in terms of this modern society, it's just a throwback to another era, and it's great.")

They have been married now closer to forty years than thirty. They have not grown in the least "like" one another, as people are said to who live together through long periods of time. They are different. And it is precisely their differences that seem to have sustained them in their marriage, adding dimension to the character of both. Trumbo, of course, is especially dependent upon her now, at this time and in his condition, and Cleo is watchful, guarding his time and strength, meting it out carefully to me and to others who come by simply to wish him a speedy recovery. It's agreed between us that I won't wear him out. Informally, we have set a time limit for this first day's session.

I wait in the den. It is a grand room, one whole wall of which is lined with books and the others crowded with pictures of all kinds—Cleo's photographs, drawings and cartoons by diverse hands, and a few paintings as well.

"I descend in my chariot!"

It is Trumbo, of course, seated upon the stair lift, wrapped in his robe, as he is conveyed slowly downward in my direction. The sound made by the machine, a sustained buzz, though not loud, seems to fill the room and preclude the possibility of discussion of any sort for the moment.

But I am standing now, ready to shake hands and greet him as soon as he dismounts. He does that well enough, steady on his feet, grasping my hand firmly, taking the place that I have arranged for him with the microphone and tape recorder ready and waiting. It is only then, when he is seated, that the exertion caused him by the trip downstairs becomes apparent.

He was having difficulty breathing. "I'd better get my breath back." He sat for a moment, speechless—alternately panting and wheezing. "The tricky business is learning to breathe on one lung," he said at last.

"It's physically different, then?"

"Quite different. But you see I'm going through the cobalt thing, which is about five or six minutes of cobalt every day. And you really can't adjust until you get through with it because it affects you in so many ways. It affects each person differently. Me, it's made—well, I once had to go back to the hospital. There was pain and I was breathing so shallowly that I couldn't get enough air in. Sometimes the appetite goes. Sometimes you become anemic because it destroys your red blood cells. And on and on and on. So as soon as the cobalt is over in two or three weeks, then these handicaps will vanish, I hope, and I'll begin to be able to live a normal life. And part of this will be learning to breathe with one lung. You see, I was lucky in that it was the right lung that was saved, which normally handles 55 percent of your breathing capacity—the other 45 percent for the left lung being accounted for by the presence of the heart on that side.

"The problem, of course, after an operation like this for cancer of the lung, is metastasis—whether it will spread. This had gone into one of the lymph glands." Trumbo pauses at this point and becomes suddenly very professorial: "The lymph glands, I discovered after research into the matter, are there for one purpose only, and that's for spreading cancer through the body." He delivers the line straight-faced, but he wheezes out a laugh at it himself in the right sort of spirit. "Happily," he proceeds, "the cells in the lymph glands were not nearly of the degree of malignancy as those in the lung. So . . . well, they took everything down there under the arm."

He gestures, pointing up into his armpit. I am familiar with the operation. A good friend of mine, many years Trumbo's junior, has just had the lymph glands and nodes removed from each side. I nod, mumbling my understanding, and Trumbo continues:

"If they succeeded and it was a clean operation, the chances are fairly good. If it wasn't, chances are in a year it will come back again—and that's the end, which doesn't greatly disturb me, to tell you the truth. I'd prefer that weren't the case, but, well, a curious thing: I was going through first the pneumectomy, then three days later the heart attack, well, you suddenly get to the point where you don't give a shit." He

laughs. It is really a chuckle. "It didn't matter one way or the other to me, which is rather a pleasant thing to know.

"And so I can discuss and consider quite rationally arranging the time ahead. If, for example, it seems that this operation is not a success, therefore my life shall be quite limited. Therefore, if somebody comes along and offers me a substantial sum for a screenplay, I will take that job, because it will provide more money for my wife and because that's the thing to do. If, on the other hand, the operation appears to be a success, I'm going to finish a novel for which I contracted. That will take six to eight months. I'll do that and *then* take a job. But you see how you calculate these things because I never saved much money, never been interested in that. There'll be enough for my wife. But having, for thirty-five years, lived with her in a certain state of comfort, I want there to be enough for her to continue in that state. Which there *barely* will be—and that's fine. But if it were just a matter of six more months—*bang!*—the man who comes here with a script has got himself a customer."

COLORADO

Trumbo settles into his chair. His attention flags, and he looks for a moment as though he were thinking of something else. Is he tired? He says he is not. Would he like me to call it quits for today and come back tomorrow? No.

"I'm just trying to decide where to begin this damned story," he explains.

"Tell me about your family."

"Well, all right. Now, this is information I got not firsthand but from a remote cousin. You see, when my name first appeared in *Who's Who*—I think it was in 1938 or '40—there was another Trumbo there. He wrote me at once. He was a banker in Oklahoma and had spent some money and had traced the Trumbo name to Switzerland. There's a waterfall there called Trummelbach, and the family apparently had taken its name from the falls, and they were van Trummelbachs. They then became Trumbach. They then apparently moved east into Alsace-Lorraine or around in there, and they became Trumbeau. They then went to England and became Trumbo. And in 1736 the first of them came into the United States, and they settled in Virginia. And when I was in jail in Kentucky, I took the *Louisville Courier-Journal*, whatever the newspaper is, and the local one, and I found both Trumbos and Tillerys—my mother's family name—much more common there. They spread through Virginia and West Virginia and Kentucky.

"My grandfather Tillery, I think, was born in Missouri. His father fought under Morgan's command for the South in the guerrilla raids.

And in a raid into Indiana or Ohio, he was wounded and left behind and died. That was my great-grandfather. But then my grandfather married my grandmother in Missouri and came to Colorado. He built a log cabin and became a populist and then a Bryan Democrat. I remember once at the county fair I was with my grandfather Tillery, and I saw a man I thought looked like President Taft, although Taft at that time I don't think was president. The man was making a speech. And I said to my grandfather, 'Is that President Taft?' My grandfather said, 'No, that's just some God-damned Republican trying to get himself elected to office.'"

His father, Orus Trumbo, was born in Albion, Indiana, not all that far from those Virginia and Kentucky Trumbos, in the year 1874. Orus was the son of James and Elizabeth Bonham Trumbo. James Trumbo was an angry man, given to awful fits of temper and bouts of excessive drinking—eventually he died of Bright's disease, though not before the better part of the relationship between father and son had been destroyed in the course of bitter arguments between them. Orus left home more or less at the first opportunity. He had completed a "normal school" education (two years of college and a teacher's certificate) and had done some teaching when he volunteered for army service in the Spanish-American War. The war ended when he was on the train on his way to camp. He had no special wish to continue teaching, and a friend persuaded him to come out West and take part in a venture in commercial beekeeping. That was how he happened to come to Colorado. Orus Trumbo's career as a beekeeper proved to be brief and unsuccessful, his failure in that line foreshadowing a pattern that continued all through his life. He worked subsequently as a farmhand, and then as a grocery clerk in Montrose, Colorado, a mountain town on the western slope of the Rockies. And that was where he met Maud Tillery, eight years his junior, who was the daughter of the sheriff of Montrose County.

Millard Tillery was a real six-gun-toting frontier sheriff, one whose life and exploits matched the most potent myths of the Old West. He had operated a cattle ranch since the mid-1880s in a place just east of Montrose called Cimarron. He continued to ranch during the terms he served as sheriff. Ranching alone kept him pretty busy, but when the law needed enforcing he was always ready to go out and do whatever

needed to be done. Sheriff Tillery earned a reputation as a good tracker, and he had to be that, for when men broke the law in Montrose County, they would invariably head out for the mountain wilderness that stood high around them on three sides. With Tillery in pursuit, the fugitives never got far—a hundred miles or so at the most—and he would bring them back alive, usually hitting his log-timbered ranch house just in time to overnight there before proceeding on to the jail in Montrose city. The lawbreaker might be a robber, a horse thief, or even a murderer, but he would be given the run of the house, unshackled and unchained, since it had already been demonstrated to him that there was no place in the surrounding territory for him to hide. A bluff? But it worked, all right—Sheriff Tillery lost no prisoners. His wife, however, objected strenuously to the practice. She felt that a house with murderers roaming around in it was no fit place to raise children.

Nevertheless, that was the way that Maud Tillery, Dalton's mother, grew up. Hers was an interesting mixture of qualities. She was tough and durable—as she would prove herself later on, when she raised her children on her own—but at the same time there was in this daughter of a profane, rough-and-ready frontier sheriff a great yearning for gentility. It must have been this that attracted her to that grocery clerk, Orus Trumbo. He was from the "East" (Indiana), had had a college education of sorts, but more important, he was an upright young man who read books and talked with her seriously about them. On the day of their marriage (December 4, 1904), in fact, he bought a set of Shakespeare, declaring that no home should be without Shakespeare and the Bible. Then the two moved into their room above the Montrose town library.

James Dalton Trumbo was born there December 5, 1905. There had already been a miscarriage early in the year, and Maud Trumbo, a small woman, had had a difficult pregnancy. The birth was a long and difficult one, too. As a result, Dalton Trumbo had forceps scars and an unevenly shaped head through his first year. He also carried a slight congenital defect that ran in the family—a drooping left eyelid that he had learned to disguise by arching his brow.

It was easy to get a sense of the sort of watchful, hopeful mother Maud Trumbo had been by looking at Dalton Trumbo's "Baby Book." It was, in a couple of ways, a remarkable document. For one thing, it told us far more about the mother who kept the record than it did about

the child. Except for the scars he bore from his birth, he seemed to have been a normal baby in every way—perhaps a little above average in size and in his response to the world around him. But Maud Trumbo's comments in the Baby Book made it clear she thought him superior in every way:

> First sentence was "See Mamma's baby." While walking in front of the mirror he saw himself in the glass, and after stopping and looking for several seconds he uttered his first sentence.
>
> At 2½ years. Remarks: While at his Grandfather's one day he couldn't understand why he was called papa. He said "Grandpa are you a papa," his answer was yes. Dalton said after studying a moment, "Well, my papa is not a grandpa." After being told to stop asking for fruit from the vegetable man he said all right and the next wagon with fruit which passed he said "Are you got any pears in your wagon?" When he came in with the pear, I asked him if he had begged it of the man, he said "no mama I just asked if he had any and he did give me one."

And on and on. A nice little boy, to be sure—although there was no hint in the record of the fierce, wailing, head-pounding temper he had. What came through most plainly in these entries was that James Dalton Trumbo was a child on whom the hopes, expectations, and even the ambitions of his parents had been pinned: he *had* to achieve great things. Why? Because he was their son. For their part, Orus and Maud Trumbo would do everything within their means to see that he be given every opportunity to succeed.

The tragedy was—and within the limits of his parents' lives it was a genuine tragedy—that their means to assure his success in life were sorely, almost pitifully, limited. Orus Trumbo tried hard. He worked at a succession of jobs, sometimes two at a time, both in Montrose and during the years that followed in Grand Junction, Colorado; but he was never able to do much more than scratch out a living for himself and his family. He was an intelligent and sensitive man, and an educated man who kept up with world events and had independent opinions, one who read widely for pleasure and to keep himself informed. Yet time after time, in venture after venture, his plans came to nothing. Dalton Trumbo remembered his father as "a very gentle man, a terribly

hardworking man, who was just born not to succeed—financially. One would say that my father was weak, but that is not an apt or a correct description. He simply was not modeled for competitive success. My mother was."

But success was the goal, and in pursuit of it they moved to Grand Junction, a city better than twice the size of Montrose, in 1908. There, Orus Trumbo worked for the Mesa County Credit Association. He also served as constable, running unopposed for several terms. Constable was a largely honorary position, one that paid nothing except for the fees he collected in performing his duties. This consisted of such thankless tasks as serving writs, judgments, attachments, and foreclosures. He was a poor credit collection man and an even poorer constable. Both jobs required a man of a flintier nature than Orus Trumbo possessed. Because of that, he eventually went to work as a clerk in Benge's Shoe Store in Grand Junction, a job that he held until just before he moved the family to Los Angeles in 1924.

When you fly over the Rocky Mountains from Denver to Grand Junction, it is worth taking a window seat just to watch the peaks and humps of the Continental Divide straining up to meet you. It is a fascinating sight—various and seemingly limitless—which may well hold you for the better part of the time it takes to make the flight. But then, toward the end of the journey, pay attention, for the mountains suddenly stop, falling away sharply to the flatter, arid-looking country that leads into the real desert of eastern Utah that lies just a little beyond. This is high plains country, the western slope of the Rocky Mountains. Grand Junction, with a population listed at 20,170 when I arrive there, is the only town of any size out here, a kind of regional capital.

Down on ground level it isn't as barren as it looks from above. There are farms and orchards in the surrounding countryside, and though the climate is harsh, heavy irrigation and a long growing season make it a fairly rich agricultural area. The town of Grand Junction itself seems curiously indistinct—one of a thousand, or even ten thousand, others like it in roadside America. It seems to exist only in the present. Driving through it, I wonder just what it might have looked like when Dalton Trumbo was here, but it is useless trying to imagine it so. Could any of

this have been here even as long ago as 1924? Grand Junction, like so many towns in the West, looks like a place utterly without history.

It has one, though. Mesa County and the rest of the region referred to as the Western Slope was the last part of Colorado to be settled. The Ute Indians were there until 1881, when they were driven westward, out into the desert. The lines were drawn for counties then. Grand Junction was founded that same year and incorporated the next. They settled on that name for the town because it was located at the junction of the Gunnison River and the Colorado River, which was then known as the Grand. The town prospered from the start, becoming a kind of sub-capital of the state—a railhead for the produce and cattle raised there in the beginning; a center for prospecting of one kind or another which culminated, just after the war, in a rich uranium strike in the country just to the south of the town; and when I visit, with petroleum growing scarce, it seems it might at last soon be economically profitable to process the vast deposits of oil shale in the area. The trend there is still up.

That's the way it looks downtown, too. Main Street has been bricked and landscaped into a mall area which permits auto traffic but gives the advantage to pedestrians. This, at least, lends some slight distinction to the physical aspect of the town. It is a pleasant enough area, and I am so busy taking it all in that I nearly overlook the particular store on Main Street that I have come hunting for. But there it is now—Benge's Shoe Store. It has been on Main Street for more than sixty years. George Benge, on whose head Dalton Trumbo places the blame for his father's death, died just a few years before at the age of ninety-eight. His son, Harry, runs the store now.

Harry Benge is a quick, nervous, black-haired man, exactly the sort I had pictured his father to be. When I tell him why I have come, he takes that in stride and remarks of Trumbo, "His father worked for my dad, you know."

"Yes, I know. I thought you might have some memories of him here."

"Well, yes, I suppose. We were kids, just kids, and Dalton was quite a bit older than me. He taught me how to hand wrassle, and I got pretty good at it, and I flipped him on that grillwork right over there." He points to a corner in the back of the store, as though to substantiate the claim. "I'll tell you, though," he continues, "I haven't seen Dalton

Trumbo in a lot of years. I remember when I was in the army during the war he wrote me two V-mail letters when I was in Belgium. I was glad to get them, even..."

"Even though what?"

"Well, you know, he had a couple of derogatory things to say about my mother in that book of his, that first one, *Eclipse*. I just figure that he—" He breaks off suddenly. "Oh, excuse me."

Harry Benge turns away from me as a customer enters and approaches. He is quite suddenly more at ease than he has been since I came in. This is a role he knows well: he is once again the friendly merchant, the man whose job it is to please. "Hi," he says pleasantly to the woman. "I've got a little gray shoe for you like you were asking about." He moves off swiftly to the rear of the store, finds the right shoebox, and is occupied for the next few minutes with the customer, gray-haired and in her fifties, and the sale of the shoes.

But he is soon back. Ready to conclude the business we have begun and clearly anxious to be done with it as quickly as possible.

"Well, I just want to say this about Dalton. He had some ornery things to say about people around here who helped him, who did things for him. I didn't have much personal animosity worked up toward him. I read that book myself. I was of an age where I read it and chuckled at some of the things in it because they were satirical, you know, and funny. But he caused some bad feeling around here, I'll tell you that."

"Well, do you—"

"No. That's about all I've got to say. There are a lot around this town who knew him a lot better than I did. You'd better talk to them."

He turned and walked away from me. That was all I was going to get that day, or any other, out of Harry Benge.

The Trumbos were a close-knit family, and the birth of his sister Catherine when Dalton was seven, and Elizabeth when he was ten, made them no less so. Maud Trumbo was perhaps a little overprotective of him (after all, she must have supposed, a boy with such prospects as his!), and when they moved to the little three-room, unpainted house at 1124 Gunnison in Grand Junction, she scrutinized his playmates very carefully to make sure they measured up. In the immediate

neighborhood only girls his age, and a much younger boy down the block, seemed to her gentle enough to play with Dalton.

Dalton was at the younger boy's house once and broke a toy belonging to him. These were the first keen feelings of guilt he experienced, Dalton said, and he was in torment—not just for having broken the toy but also for having lied about it afterward. In the end, though, he got away with it, and he felt it was probably not good that he did. He successfully evaded responsibility for a misdoing, and that set a pattern (he said) in his later life. He was emphatic: "My original habit of lying to avoid blame stuck with me all through my life. I can think of no incident wherein I lied if it would throw the blame on anyone else. But if it were simply a means that the criminal would remain anonymous I would always lie in order to protect myself." The virture of truth-telling was exemplified to him by his father, who refused to lie under any circumstances. Dalton, however, was inclined to look at it as a virtue of limited utility: Orus Trumbo's refusal to lie frequently brought him trouble—as it later did his son.

If Dalton's father wielded considerable influence within the family through his great moral force, his mother did perhaps even more to fix the spiritual side of their lives. About the time Dalton passed into fourth grade, she attended a Christian Science lecture and passionately embraced the religion. And although Orus Trumbo never actually joined the church, he attended services every Sunday with Maud and the children, and in general accepted its tenets. As for Dalton: "Christian Science, for me . . . was fact." He was never sick as a boy. Nobody in the family knew illness at that time. When the 1918 influenza epidemic came, and the bodies piled up in the Grand Junction mortuaries faster than they could be prepared for burial, the Trumbos spent all their time caring for their neighbors. Orus Trumbo nursed his employer, George Benge, and his employer's wife and child, back to health after all three had fallen ill at the same time. "I was never touched by a doctor until well into my twenties," said Trumbo. "But I never had an absolute faith in Christian Science because, never having been ill, I had no reason to doubt it."

His sister Catherine, on the other hand, remembered the family's adherence to Christian Science chiefly as a social embarrassment: "If you were a good Christian Scientist you had to get an excuse slip whenever the doctor came to school. That was humiliating as a child—not

to be able to stand in line and get vaccinated with the rest of the kids in your class."

Neither Dalton, nor Catherine, nor Elizabeth remained practicing Christian Scientists as adults. "But it was an excellent religion in which to be raised," he said, "because you were taught that fear was the cause of human ills. Have you noted that Haldeman and Ehrlichman are both Christian Scientists? And that John Dean is not only a Christian Scientist, but a graduate of Principia, which is the Christian Science college? Now, my point is that these men were acting without a sense of guilt. They were pursuing a righteous cause, apparently without fear at any time. Now, one can safely say this is not a comment on Christian Science as a religion. For one can say the same thing in a comparable matter of Methodists, Baptists, and anybody. But the one thing it says is that [these men] had fearlessness. It's really lack of a sense of fear that Christian Science gives many people. And this is a very healthy thing to have." Especially for a boy growing up with a world of prospects before him.

However, his parents must have felt some fear *for* him, because much was forbidden him. Growing up in Colorado, he never went horseback riding once—as other boys did. He was not allowed to swim in the Gunnison River, which ran through Grand Junction, and for a long while he was not even permitted to splash in the shallow waters of the irrigation ditches outside town. His father tried to interest him in baseball. Orus Trumbo loved the game so much that he would often be late home for lunch in the summertime because he had stopped off to play an inning or two with the boys along the way. But in spite of the equipment he bought Dalton, and the time he spent coaching him, there was no exciting the boy about baseball. Nor, in turn, about tennis, bike-racing, or track. Dalton was simply not athletically inclined.

Although not athletic, he was not what you would call sedate. In fact, an incident early in the fifth grade transformed him rather suddenly into one of the unruliest boys in the school. At the beginning of the semester, among strangers and dressed in his new fall suit, he was called a "sissy." The hateful epithet, hissed after him by boys who did not even know him, shamed him so that he couldn't even tell his parents of it. It would have been better if he had. They never lacked confidence in him: they could have bolstered his own in himself. His solution to the problem was to become such a wild prankster that he would stun

those who had jeered at him into silence, and finally, into admiration. It worked, more or less, just that way. He clogged a water fountain with sawdust, tossed books out the window, and worked out an elaborate arrangement by which cans of rocks were tied to window shades so they would spill whenever the shades were raised. Nobody else in his class thought of doing such things. Nobody else had the nerve to try them.

Unfortunately, this set a pattern in his life for years to come. His grades began to suffer, too—since he'd decided it must be sissified to study—and it wasn't until he was well into high school that he made a limited recovery. By that time, he was thinking of college and of life beyond it. But by then, he was such a confirmed hell-raiser—"son of Bacchus," he was called in his high school yearbook—that he only did well in those subjects, such as English and Public Speaking, for which he had a marked aptitude.

All this put an increasing strain on his relationship with his father, although it never seriously damaged it. They continued to be quite close. And while they never got together on baseball, nor shared any sort of athletic interest at all, the two did go camping together often out in the Colorado wilds. They would ride out in tandem on Orus's single-cylinder Excelsior motorcycle. Dalton remembered one trip up to Kannah Creek to fish. They had six spills along the way on the rough roads, and appropriately, Dalton caught six fish. The story of the lost fishrod, so painful to read in *Johnny Got His Gun,* seems to be based on an incident that took place in Dalton's life a little earlier than it did in Joe Bonham's. He lost a prized hatchet of his father's but then denied responsibility for it, not because he dreaded physical punishment but because he could not stand to see the expression of disappointment in him on his father's face.

He had no fear at all of physical punishment from his father. When Dalton was younger, his mother delivered disciplinary spanks and slaps when it was necessary. But when he was old enough to respond to reason and be made to feel guilty when he did not, Dalton found the moral force of his father far more devastating. Specific punishment, when it was meted out by his father, was most likely to come as a penance assigned, a condition of forgiveness for some moral offense.

Because he was the oldest, Dalton was granted a voice in the family councils the Trumbos held every now and then. He came to exercise it a little too freely and, by his own admission, became insolent on several

occasions. On one of these, in front of his father, he accused his mother of lying. Without a word, Orus Trumbo reached over and slapped his son across the face with the back of his hand, cutting the boy's lip in the bargain. Vindictively, Dalton sat where he was, letting the lip bleed down onto his clothes and the chair he sat on—but the point had been made. This is, in Dalton's memory, the only time that he was hit by his father.

And finally, there was the gardening done by Orus Trumbo at that little house on Gunnison Avenue. It was a pretty dismal location when they moved in—a dirt yard and a lot next door overgrown with weeds— but Dalton remembered his father plowing up the yard and planting grass seed and plots of flowers. Then Orus looked at that lot next door and decided that would be his vegetable garden. He got permission to plant it and put in a whole truck garden of table vegetables, lettuce, carrots, turnips, watermelons, peas, cucumbers. They fed the Trumbos all year long, and eventually, Dalton even took to peddling them around town. How, along with everything else, did Orus Trumbo manage to do it? As he did most things: with care, with patience, and with abundant hard work given to it. He would get up early in the morning during the growing season, and work in the garden from five-thirty until he left for his job at the shoe store, then back again to do what needed to be done in the evening after work. To make things grow in the harsh semi-arid climate of Grand Junction, where the mountains meet the desert, it was necessary to lavish just such care—and Orus Trumbo was the most avid and productive amateur farmer in town. Later, years later when he wrote *Johnny Got His Gun,* Dalton Trumbo reflected upon this and the paradox contained in it.

> It was hard to understand how his father could be such a big failure when you stopped to think about the thing. He was a good man and an honest man. He kept his children together and they ate good food fine food rich food better food than people ate in the cities. Even rich people in the cities couldn't get vegetables as fresh or as crisp. They couldn't get meat as well cured. No amount of money could buy that. Those things you had to raise for yourself. His father had managed to do it even to the honey they used on the hot biscuits his mother made. His father had

managed to produce all these things on two city lots and yet his father was a failure.

World War I had an immense, though delayed, effect on life in Grand Junction, Colorado. In the beginning, it was Europe's war, and nothing more. Dalton learned "It's a Long Way to Tipperary" at school and responded to Allied propaganda stories of crucifixions by the hated Huns in no-man's-land by donating his savings of two dollars to the Red Cross. However, his father, like most of the adults in town, wanted no part of the war. In 1916, after years of voting Republican, Orus Trumbo crossed over and voted for Woodrow Wilson for president on the strength of the scholar-statesman's promise to keep America out of it. The whole town went for Wilson that year.

But after the election, the situation changed rapidly. On February 1, 1917, the Germans announced that they would wage unrestricted submarine warfare against all shipping in the Atlantic, whether under neutral flag or not, and the next day, as a result, the United States broke diplomatic relations with Germany. None of this had the direct, immediate impact on Grand Junction that the so-called Zimmermann Telegram had. This was the diplomatic communication between Germany and Mexico which was intercepted and decoded by the British and handed over by them to the government of the United States. The message invited Mexico into an alliance against the United States and promised, with the successful completion of the war, that the neighbor to the south would be rewarded with the states of Texas, New Mexico, Arizona—as well as a strip of western Colorado that included Grand Junction.

A virulent epidemic of war fever suddenly broke out in the town. During the two months or so that preceded America's actual entry into the war, there was great agitation there in favor of it. An airplane appeared one day in the sky, not an altogether unusual occurrence in 1917, flew once around Grand Junction, then headed off. Immediately the rumor was out that it was a German plane, presumably out on an aerial survey of the territories the Kaiser would be annexing on behalf of his prospective ally.

Persecution of German-Americans began early there. Well before war was declared, boys in Dalton's school—including Dalton himself—began

baiting a boy named John Wolf because his father was German and
had, in fact, served in the German army years before in peacetime. Dal-
ton recalled that on the day that war was declared, "We gathered and
followed [John] to school and finally had a dog pile on top of him,
taunting him all the time as a pro-German. He was thrown up against
the curb and we broke his arm in the dog pile." There was a scene after-
ward with Dalton's father, and Dalton had to explain his part in the
business.

Orus Trumbo's attitude toward the war, once America was in it,
was rather ambivalent. On the one hand, he was staunchly patriotic: he
owned a flag, which he put out on all holidays; and he had taught Dal-
ton and his sisters the civilian salute (they were the only kids in town
who knew it). But on the other hand, he deplored the excesses of war
propaganda and the blind zeal they inspired. For example, when the
scurrilous propaganda film *The Kaiser, Beast of Berlin* made its appear-
ance in Grand Junction, Dalton's father absolutely refused to let him
see it. Dalton sulked, and Orus presented him with fifty cents, more
than the price of admission to the film, telling him that it was not a
question of the money but the principle involved, forbidding him still
to see the film. He believes he and his sisters were probably the only
kids in town who missed it, for he reckons his father was the only man
in town who was able to see through its crude hate-mongering.

The specter of sabotage by German-Americans was raised in official
propaganda, and the Justice Department encouraged vigilante groups
of private citizens to keep track of the German-born and other suspi-
cious characters. In Grand Junction, it was the Loyalty League, a secret
organization which Orus Trumbo was invited to join. He accepted
and was made secretary. Dalton had no idea of this, for the Loyalty
League was a semi-secret organization, until one day ("being a snoop
by nature") he came across the minutes of a meeting which his father
had recorded. Eventually, however, Orus Trumbo broke with the Loy-
alty League—resigned as secretary and quit it altogether. There were
two cases that convinced him that the organization was doing harm in
the community, and only harm. In one of them a German tailor was
suspected of disloyalty and had his shop broken into and ransacked—
presumably in a search for instructions from the Kaiser; even the cloth
from his ironing board was stripped off as they looked for letters and
documents. Another case involved a German farmer who lived outside

Grand Junction; he was tarred and feathered simply because he was German. The Loyalty League did not participate directly in this, but Orus Trumbo felt—probably quite rightly—that the organization had helped establish the climate in which such acts might be committed by the self-righteous and the super-patriotic.

Orus Trumbo's resignation from the Loyalty League did him no good whatever within that tight little community; and the League altered none of its policies or practices. Germans were still investigated and persecuted. The war continued. Boys from Grand Junction could not wait for the draft and volunteered for the chance to see Europe and have a fling at a great adventure.

Then the war ended, and one by one, the boys came back. A gradual disenchantment set in as the townspeople saw the wound scars and heard the stories. Dalton himself recalls working at Roy Chapman's bookstore in Grand Junction for the owner, a young veteran who returned blind from France. As janitor, sweeper, and part-time clerk, it was one of his tasks to call for young Chapman each morning and walk with him to the store. Together they would open it up for the day. This was the routine through one characteristically bitter Colorado winter. That whole season Dalton's companion met him every morning in dark glasses. When they arrived, Dalton would heat a pan of water and drop in the blind veteran's glass eyes; the winter cold there was so intense that if they had been put in without first being warmed, they would have frozen against the eyelids. Once the glass eyes were heated to body temperature, the young man would put them in, and he and Dalton would be ready to begin the business day. All this made a profound impression on Dalton. He suspected that the experience, repeated every morning, was the earliest from which he drew in the creation of Joe Bonham in *Johnny Got His Gun.*

Yes, by the end of the war, Dalton was working regularly at a series of part-time jobs he held to help pay his own expenses and to provide pocket money for himself. He began, as many boys do, as a newspaper delivery boy—and at that he succeeded all too well. He greedily added route after route, and soon he was delivering the Grand Junction morning and evening papers, as well as the morning and evening papers from Denver. "During that awful period," he said, "I was actually making more money than my father was at the shoe store." But in the end he worked himself sick, his father had to take over the delivery of the

papers in addition to his own job, and Dalton was finally convinced that he had taken on too much.

The one job that mattered most to him, however, was the one he held through most of high school. He became a cub reporter on the *Grand Junction Sentinel*, the going afternoon daily of the town. It was owned and edited by Walter Walker, who more than any other man except Dalton's father had a strong and lasting influence on him as a boy. Walker was a good small-town editor, the kind who was willing to crusade when a cause arose that was worth crusading for—or against. When, just after the war, he took after the Ku Klux Klan in the columns of the *Sentinel*, Klansmen trapped Walker's son one night and tarred and feathered him. Walker attacked them in the columns of his newspaper all the harder then, and eventually he saw the Klan driven out of the town.* Dalton respected Walter Walker, and Walker liked him. In the usual course of things, the boy began by reporting school activities and athletic events, which in a town the size of Grand Junction were important news. But soon, Dalton was covering the sort of beat that any cub reporter might, making a daily round of the police station, the courts, the funeral parlors, and the hospitals in search of news.

He did well at his job. You can tell that from the notes sent by Walker in response to certain stories done by him:

Dalton:
Your rotary story yesterday was excellent, well written and everything well covered. Be sure your name is over it each week.

W.W.

In another, Walker informed him that he would be getting a larger check than usual, and he went on to say: "I do this in recognition of the splendid work you did this month.... Your stories were exceptionally

*In the beginning, it seems, the Ku Klux Klan even held some fascination for Dalton Trumbo. He was attracted by the military nature of the organization and wanted to wear the uniform. He nagged his father for the nineteen dollars it would cost to join. Finally, his father said that he could have it if he wanted, but that no Ku Klux Klansman had need of an education, so he could just forget about going to college. He made his point: Dalton gave up his ambition to be a Klansman.

good. Your football stories and the murder trial stories were also excellent." Walter Walker's approval meant a great deal to Trumbo.

Look at some of those stories that appeared in the *Grand Junction Sentinel* under Dalton Trumbo's byline, and what do you find? What he was writing then was straightforward, fact-filled newspaper journalism. Of its kind, it was good, representative work, but not at all distinctive in style; it covers the ground. His work for the *Sentinel* was apprentice work for the career he had ahead of him as a writer—and that was how he looked upon it, too. It seems that even in high school, and perhaps earlier, he knew what he wanted to do. He would be a writer—and not just a writer of newspaper pieces, but a *real* writer, one who produced books, novels, stories.

The only serious challenge to that ambition came from Walter Walker, of all people. For once the editor had taken the measure of his cub reporter, he decided that the boy was cut out for big things. He took Dalton aside one day and advised him to go on to law school and come back to western Colorado to practice. He told him quite seriously that he thought Dalton had the makings of a United States senator.

What had caught Walker's attention, just as it had the attention of most of the town of Grand Junction, was the oratorical ability which Dalton Trumbo suddenly manifested in high school. Talk to his classmates, as I did, and you would find that through the period of fifty years that had elapsed, the memory most retained was that of Trumbo the fiery and eloquent orator. It was what he was best known for then. Grand Junction High School's debating team won the Western Slope Rhetorical Meet two years running, 1923 and 1924, with Dalton Trumbo as team captain. And he himself took a first place in 1924 with his original oration, "Service." Trumbo regarded this entire episode of his youth with a certain wry distaste: "You'll find no hint of the radical in the sentiments I spewed forth so solemnly then. Vomit is what it was!" he declared. "Utter vomit!"

He really was the boy most likely to succeed. In his high school annual for his senior year he was listed as the president of the Boosters' Club, the president of the J-R Club ("high school boys who have proven themselves leaders of the student body"), captain of the Rhetorical Team and the Debating Team. And so on. He was even a 130-pound substitute tackle on Grand Junction High's undefeated football team

his senior year, although at least one schoolmate remembered him as "the worst football player ever to come out of the school."

That same schoolmate, Hubert Gallagher, described Dalton Trumbo in his senior year in high school as one "who always looked like a man in a hurry, churning along with that thin trench coat he wore flapping in the breeze behind him. He was always trying to make a deadline at the *Sentinel,* or rushing because he was late for school. Always in a hurry." He was "an amazing guy," Gallagher added. "He never did much homework—he never had the time—but he got by on pure genius."

Back in Grand Junction now it was a different story. I remember spending a frustrating afternoon in a motel room, phoning around, trying to find somebody with a good word for Dalton Trumbo. What is it about your old hometown? Why are the people who stay so much less generous than those who leave?

Most of them just didn't want to talk. I sat, looking up phone numbers to match the list of names I had copied down from Trumbo's high school yearbook, dialing number after number. Wouldn't *anybody* talk? I began to feel like a reporter in a movie—the kind of story where he comes into town, asks a few questions, and suddenly finds himself frozen out, met by a conspiracy of silence. *Son of Bad Day at Black Rock* or something.

Jim Latimer, who said he hadn't seen Trumbo since 1932 when he had visited him in Los Angeles, immediately mentioned the book, *Eclipse,* Trumbo's first novel: "I think he should never have written it. I hear he admitted something to that effect in later days. He was bitter, that's what it was. They were tough times then for him and his family, but they were tough times for all of us, and...I can't talk to you too long. In fact, I don't know how much I should really talk to you at all." No, Mr. Latimer would not see me in person. No, he had nothing more to add. No, he had no other suggestions as to what other people I might talk to. No. No. No.

And that was how it went with all of them—except for Ed Whalley.

He greeted my call as an opportunity to talk about an old friend, but he said he thought the best thing for me to do was to come by early the next afternoon when his daughter, Terry, would be there. "She'll have something to contribute," he told me.

Resentment at things said by Trumbo in his first novel, *Eclipse,* had been voiced again and again by those I talked with in Grand Junction. That he treated some in the town satirically and caricatured them— Mrs. George Benge, for one—there can be no doubt. But by and large, *Eclipse* is a good, honest, and realistic novel, with some serious things to say about human nature and the quality of middle-class life in a town like Grand Junction. What was remarkable, though, was the way the air of scandal still hung over a book that had been published forty years ago—and only in England. No American edition of the novel ever appeared—which is a pity—yet nearly all those I talked with in Grand Junction, and certainly all of Trumbo's contemporaries, were intimately familiar with it. How to account for this? Before keeping my appointment with Ed Whalley and his daughter the next day, I dropped in at the Mesa County Library and asked about *Eclipse.*

Ruby Millett, behind the desk, told me that yes, they had that novel by Dalton Trumbo there, along with two others, *Johnny Got His Gun* and *The Remarkable Andrew.* "But that one, *Eclipse,*" she assured me, "is by far the most popular. In fact, we have to have several copies here just to keep pace with demand." She went to her files and showed me that there were six requests for it on hand at that very moment. About average.

"What's the attraction?" I asked. "Why such interest so long after publication?"

She looked at me as though I must be kidding or something. "That's the way people are," she said. "Why, there was one woman who made up a list of all the characters in the book and their equivalents in real life here in town. She showed it to me afterward. She had certainly gone to a lot of trouble on it, I can tell you."

George Van Camp, the Mesa County librarian, added that a lot of the requests for *Eclipse* might well be coming from Mesa County Junior College students. "One of the teachers there made it a recommended book in a sociology course. Any way you look at it, though, it's a phenomenally popular book. When I came here a few years ago there was only one copy of it left. There had been others, but they disappeared. I sent that one copy out and had a Duopage facsimile made by Bell and Howell. We've since acquired a third. We need all we can get."

Then on to Ed Whalley. His house, tucked away on a side street toward the edge of town, was a small and comfortable one, not much

more than ten years old. Ed was there—a large, easygoing man in good physical shape for all his sixty-odd years. And also present was Mary Teresa Whalley, his daughter, Terry—a good-looking girl of about twenty—who was as frank in her manner as she was enthusiastic.

Whalley told me that he had never lost contact with Dalton Trumbo, that he had seen him off and on over the years on various trips to the West Coast. The last had been in 1970, during the filming of *Johnny Got His Gun,* and Terry had been along on that one. She had written Trumbo earlier that year, when she was still a student at Grand Junction High, gathering information for a long article on him as a distinguished alumnus which she subsequently wrote for the school paper. He took time out and answered her questions at length—three pages of questions and fourteen pages of answers—in effect, a written interview.

"He said I was the first person who had written from the high school since he had left town," she told me. "He was so nice to me. Not everyone in his position would be. When we visited him there in Los Angeles, he took us down one day where they were shooting *Johnny,* and he let us watch the whole day. He escorted us to the best position to see it all, then just let us watch. It was really, well, sort of thrilling." She broke off, as though suddenly embarrassed at her own extravagance.

Ed Whalley recalled that his first recollections of Dalton dated back principally to their junior and senior years in high school. "That was when we formed the 'Ain't We Got Fun Club.' I'll tell you, they don't party like they used to. We used to party from home to home every weekend. But you want to remember that with all this, Dalton was a very brilliant student, and in practically every kind of activity they had then in high school. He was really a remarkable young guy."

"Has he changed much over the years?" I asked him.

"You know, that's the remarkable thing. Except for his appearance, he hasn't really changed very much at all."

"And he looks just great," said Terry. "Very hip or mod or something. You know, long-haired and with a big mustache, and all. I think he looks terrific."

Ed Whalley continued: "No, personality-wise he hasn't changed a bit. He always was a busy-assed guy, wound up like an eight-day clock—always noisy and talkative with that sort of outgoing personality.

Generous to a fault—that's the way he was in high school, and that's the way he is today."

"It makes me mad the way some people feel around here," said Terry. "They talk about him like he was a devil or something."

"Yeah," Ed agreed, "it's the nature of people, I guess. There was this House Un-American Activities Committee business and everything, Communism and all that. Going to prison itself is a crime to some people." Whalley paused and smiled. "He's proud of it, though, you know. He always brings up that year he spent in jail. He wants to be sure everyone knows about it. But there's a certain amount of hard feeling around here about that, I guess.

"A lot of the strong feeling about Dalton Trumbo comes right down to jealousy, though. I really believe that. He's the one of us that the whole country's heard of. Now, there's got to be a lot of jealousy because of that. But me, well, if he should show up at this fiftieth anniversary class reunion they've got planned for next year—and I don't think for a minute he will—I'm not going to treat him any different than I always have. I've always respected him."

Although neither Ed Whalley nor any of the rest back in Grand Junction had mentioned her, Dalton had a girl in high school who was generally considered a suitable match for a living legend such as he. She was a year behind him in school, the daughter of the owner of the town's ice cream factory. She was, by all reports, a beautiful girl who was immensely talented as a dancer—in fact, she was later to dance professionally and have quite a successful career on the stage—and Dalton, by his own admission, was enchanted by her. It may well have been she who inspired him to drive himself as he did through those last years in school. Sylvia, after all, was clearly marked for success. When Anna Pavlova came through Grand Junction and played the Avalon Theater there—all the great artists and entertainers did that, for it was the only town of any size between Denver and Salt Lake City—a number of local girls auditioned for the great Russian ballerina's troupe. Sylvia Longshore was invited by Pavlova to join her company. "But she decided not to go," Trumbo remembered. And he added, as though honestly baffled, "I never understood that." Eventually, however, she

did leave to begin her dancing career as "Sylvia Shore," departing for Los Angeles before she had even quite finished high school. By then, though, Trumbo was gone from the town, too—away at the University of Colorado in Boulder.

"It was the oldest fraternity on campus and certainly one of the best, if not the best. Anyway, it had the most substantial alumni around the state, and that seemed important to Dalton at the time."

That's George E. MacKinnon talking, who became a circuit judge on the U.S. Court of Appeals in the District of Columbia. He was the man most responsible for Dalton Trumbo pledging Delta Tau Delta. Graduating a year ahead of him from Grand Junction High School, MacKinnon (who was known universally as "Dizzy," in recognition of his shambling, loose-jointed walk) had gone to the university the fall before, and when Trumbo's name had come up in the spring among next semester's prospective freshmen, he had backed him all the way: "I told them he doesn't have a lot of money, but he's a good bet to have some. I said he had great writing talent, and I recommended that they pledge him."

Although MacKinnon had supported Trumbo for the fraternity, the two spent no time together at the Colorado University chapter. Mac-Kinnon returned to Minnesota, where his family was originally from, and transferred to the university there. It was as a Minnesotan that he was known in Washington: he had a successful career as a lawyer in Minneapolis which led to four terms in the Minnesota legislature, and one in the U.S. House of Representatives; his brief career as a congressman brought him an appointment as a federal judge. Then he rose to a judgeship in the second-highest court in the land.

We talked about his memories of Trumbo in Grand Junction, which were few, but then MacKinnon went on to say that he had kept contact with him after a fashion during the years that followed.

"Well, for one thing," he said, "I was a field agent for the fraternity national. Whenever I'd meet the Delta Tau Delta man from Boulder, I'd say, 'How's Trumbo coming?' Between what I heard from him and other fellows at the chapter, I gathered Trumbo had quite a successful time on campus but had a hard time financially. Then I looked him up

when I was out in Los Angeles in 1932 for the Olympics. That was the last time I saw him personally."

Trumbo had gone off to the university on a shoestring. He had saved a little; he would work there and help pay his own way; his father would supply what he could. To send a son to college on a shoe clerk's salary may have seemed to some in Grand Junction an act of hubris. If it was, then the fall suffered by Orus Trumbo for his presumption was as swift and awful as any wished by the gods on some Greek hero, and it was certainly tragic in its consequences.

Hubert Gallagher, a year Trumbo's junior, worked at Benge's Shoe Store as a sweeper and stock boy alongside Orus Trumbo: "Dalton's father was sort of my mentor at Benge's. He was always helpful and considerate toward me, and others there weren't—although in general Benge's was a happy place to work." However, the store fell on hard times in 1924, during one of the economic tremors that foreshadowed the earthquake of 1929. Harry Benge announced that he would have to retrench. He looked around at his staff, and...

"In many ways, Mr. Trumbo seemed like a loser, a real loser," Hubert Gallagher remembered. "His health failed that last year—I thought he had TB. But still, he didn't take much from people. He wasn't the type to put up with fools. Some women would come into that shop and spend half an hour just trying on one pair of shoes after another. But not with O.B.—that's what he was called. They'd try that on him and he'd get up and say, 'Well, that's it. Take it or leave it.'"

Perhaps he did that once too often in George Benge's presence. Or perhaps it was, as Benge would later insist, a case where somebody had to go and preference was given to another clerk, Fred Gilbert, because he was a World War I veteran. Whatever the justification, or rationalization, the results were the same for Orus Trumbo. He was notified on Thanksgiving eve, 1924, that he would no longer be needed after the first of the year.

Dalton Trumbo heard about it while he was at the university in Boulder, without quite realizing what it would mean to him—though that was made clear soon enough. It wasn't until much, much later that he realized what losing that job meant to his father: "Actually this loss was the thing which killed him. It uprooted him and completely upset the rest of his life's plans."

There was no other job for Orus Trumbo in Grand Junction. He took his wife, and his two daughters, Catherine and Elizabeth, and with Dalton still at the University of Colorado, moved to Los Angeles early that spring on nothing more than the promise of a job.

Dalton's freshman year at the University of Colorado was a successful one and would have been exactly the sort of good beginning he had hoped to make—had there only been other years to follow. As it was, except for odd credits picked up in fits and starts over the next few years at the University of Southern California, that year (1924–25) at Colorado proved to be roughly the extent of his college education. His time was taken up with the ordinary things of college life in the twenties. He was anxious to get to know people on campus, and to be known by them. He went to classes and studied for them more seriously than he had back in Grand Junction. He began writing for the school paper. Even misadventures, when they occurred, were of the ordinary rah-rah sort: one day a group of upperclassmen came upon him when he was not wearing the green beanie, which was mandatory for freshmen, whereupon they picked him up and tossed him in a nearby lake.

His best friend at the university was his roommate at the Delta Tau Delta house. Llewellyn Thompson, also a freshman, from Colorado. The two kept in contact through the years and once, years later, had occasion to work together again. Llewellyn Thompson, now deceased; he was, of course, ambassador to Russia from 1966 to 1969, when he retired from the Foreign Service.

Trumbo apparently loved fraternity life. The only conflict that arose between him and the chapter—and it was sharp and bitter while it lasted—had to do with exclusions of which he had apparently not even been aware. When a young man named Mike Loeffler came to Boulder to look over the campus, Trumbo had him out to the fraternity house for dinner. Loeffler was the son of one of the two Jewish merchants back in Grand Junction; he had been a friend in high school, and Trumbo invited him, thinking nothing more of it. Well, when Loeffler left that night, the fraternity's policy on Jews was made clear to Dalton. He was surprised and angry, and he moved out of the house that very night, telling them he didn't think he wanted to be a member of an organization that had such rules. In the end, however, they persuaded him to come back.

It was a busy year for him. He became involved in a number of extra-curricular activities, all of which had to do with writing in one way or another. In addition to the University of Colorado's newspaper, *Silver and Gold,* he helped edit the college yearbook, and he was invited to submit pieces to do with college life to the *Colorado Dodo,* the campus humor magazine, so as to be eligible for appointment to its staff. He was also chosen to be a member of Sigma Delta Chi, the national journalism honorary fraternity. All this may seem quite a lot of work for a young man in his freshman year of college—and it certainly was—but few came to the university with the wealth of practical experience that Trumbo had gained as a cub reporter on the *Grand Junction Sentinel.* He was already a journalist when he arrived. When money became a particular problem to him, in the second semester of his freshman year, he was even able to get a job with the local paper, the *Boulder Daily Camera.*

Most of the letters he wrote home were appeals for funds: "I never had any idea how tough things really were and was very demanding." As best they could, the Trumbos met those demands. Money was sent from time to time, but it was never enough. In their new situation, there never would be enough to keep him at college; by the end of his freshman year there, he had grasped that and had made his plans to withdraw and join his family in Los Angeles. When the time came, he signed up to ferry a Ford over the Rockies to Grand Junction. The trip, made on Colorado roads in 1925, put plenty of wear and tear on the cars, but once at their destination, they were sold as new. That was how he arrived back home. Once there, he borrowed money to continue on to Los Angeles. He took a train from Grand Junction sometime in July of 1925. Dalton Trumbo never returned there.

He left the town; but, as we shall see, he went back again and again in his writing. So much of what he would write in the years that followed—practically anything that mattered more to him than a routine screen assignment—represented an effort to come to terms through art with the events and feelings of the first eighteen years of his life. Three of his four novels and his only play are set, at least in part, in Shale City, Colorado, the putative Grand Junction. More important, though, his best work has dealt with such themes as his father's apparent failure and his own sense of exile, of dispossession.

Colorado, his memories of his years there and the fantasies they may have inspired, seems to have contributed something to some of his movie work, too. He had a tendency to sentimentalize his feelings for the land and for the rural childhood that he really never had. He may well have drawn upon them when he did one of his scripts for M-G-M, *Our Vines Have Tender Grapes.* Just because these feelings were sentimental and based, to some extent, on fantasy doesn't mean they were lightly held: that screenplay, and all the other work he did for M-G-M, was written up on a remote ranch in the wilds of Ventura County that he had been moved to buy for just about the same sentimental reasons. Family tales of Grandpa Tillery, the frontier lawman, may have helped a little in the writing of the half a dozen or so westerns Trumbo turned out while on the blacklist, although as a character his grandfather seems to appear only in *Lonely Are the Brave,* as the relentless but sympathetic sheriff, played in the film by Walter Matthau.

From this point forward, and for many years to come, it would be Trumbo's intention to show them back there in Grand Junction that he could amount to something. To take his revenge upon them for what the town had done to his father, to have the success his father had been denied. How else to account for the furious energy with which Trumbo attacked life in the next few years? What more could he have felt, to touch a specific point, but a kind of Gatsby-like yearning in the years to come, for Sylvia Shore, the girl whom he was sure was meant just for him? He had to show her. He had to show them all.

CHAPTER THREE

THE DAVIS PERFECTION BAKERY

It was the sort of odd couple you used to see fairly often in cities not so long ago—a man and his daughter. (Less so today; why is that?) The two of them would go out walking every day along the bright, palm-lined side streets of southwest Los Angeles. And each day the route varied just a little. The two of them, obviously not well acquainted with the neighborhood, were out exploring, finding out all they could about their part of it—identifying the trees, pointing out the birds to one another, even spying a lizard every now and then, dead-still in somebody's garden. Each day the route varied, but somehow there was one point the father and the daughter always seemed to pass in their stroll through the neighborhood. You couldn't call it a park exactly—just a lot on a corner among some others along their way, though this was one claimed by the city. There were a few extra trees here, a little grass, a couple of benches, and a peanut man. They regularly stopped there at the peanut man's cart—one of the old-fashioned kind with glass sides and a steam whistle poking up through the top—and every day the man bought a bag of peanuts for his daughter. The game was that they shared them, only of course they didn't really share them at all. All that "sharing" really meant was that he cracked them open for her as they walked along and popped a couple in his mouth at the start just to get her going. That was usually all the encouragement she needed; she would eat them as fast as he could shell them. But, of course, whenever she said, "Daddy, you have some, too," he would break the next peanut

and toss its contents into his own mouth. He didn't have to do that very often, though, for the girl was just eleven, and she loved peanuts.

The two of them would take such a walk every day toward the latter part of the afternoon, talking back and forth and laughing, too. But it was odd—every day they seemed to laugh a little less. And something peculiar: each time they took that walk, it seemed to take a little longer. The little girl adjusted her pace to his. Unconsciously, she used her energy in little side trips along the way, kicking at things in the gutter, peeking inside cars parked along the curb, running ahead to look at flowers in the next garden, giving her father time to catch up. Each day he moved a little more slowly. Each day he seemed less well, until each day he began to seem more sick.

Finally, they stopped one afternoon and bought peanuts from the peanut man, and the father said the things he usually said to him, observing that it was certainly a bright, sunshiny day, and asking if the peanuts were fresh. And the peanut man—swarthy, mustached, collar buttoned up without a tie—said, as he always did, "Oh, nice and hot, nice and hot." It was never really clear whether he meant the weather or the peanuts, but that seemed to satisfy them both. The price was paid. The big bag—you did get more for your money in those days—then changed hands, and the little girl looked at it expectantly.

But this day something was terribly wrong. The man moved especially slowly. He seemed in great pain. He carefully opened up the bag of peanuts and looked inside. The little girl stopped and watched him.

"What is it, Daddy?"

"Here, Catherine," he said, handing the bag of peanuts over to her, "you'll have to crack them. I just don't have the strength to do it."

"Sure, Daddy," she said, frowning. "I'll do it for both of us."

That was Orus Trumbo's condition only weeks after Dalton left the University of Colorado and joined the family in Los Angeles. By then he had lost the only job he held there—driving a motorcycle truck for a downtown Harley-Davidson agency—and he was reduced to looking after the girls while Maud Trumbo went out and earned what she could for them working in the office of a Pierce-Arrow auto agency.

Things were very much worse than Dalton had realized. It was clear to him he would have to find work somewhere, in spite of his

announced intention to live at home and continue his studies at the University of Southern California. And so, in July 1925, he went out and got a job at the Davis Perfection Bakery at 2nd and Beaudry Streets in downtown Los Angeles. "But it was temporary, always temporary. I kept saying that for three or four or five years until it began to sound foolish even to me."

He started there as a wrapper, which meant, in this commercial bakery's conveyor-belt, assembly-line operation, that he was simply the operator of an automatic wrapping machine. It wasn't long, however, before he had been promoted to checker—a kind of glorified shipping clerk. From the main plant where he worked a fleet of trucks went out each morning to cover two hundred separate retail and wholesale routes. Working through the night as bread and other baked goods came out of the ovens, the checkers would make the rounds of the bins in one of which the order for each truck route was filled. And then at five o'clock in the morning, the trucks would arrive. They would check the morning's load, get it on the truck, and go home.

Trumbo later referred to this period at the bakery as "eight rather unbelievable years. Kind of a period of horror." He grew to hate the job, going off each night to work as a condemned man, with a sense of almost physical loathing for what he knew was waiting for him. "Yet the quality of play is always there." Shaking his head, baffled, remembering. "We hated the management of the bakery. But the checkers, the group I worked with, would organize races to fill order sheets just to see how quickly it could be done. Kids making a game of it, just racing up and down those aisles, tossing bread in the bins. What did this do? Well, it helped the bosses. But somehow that was secondary to the play of it all."

As this indicates, a fundamental change was worked in his thinking during those years in the bakery, and it was evident to him after he had been there barely a few months. He began to split the world in two: them and us. On the other side were "the bosses," whom he soon grew to hate; and on his side were the boys at the bakery, with whom he competed in that crazy bread-race game. So imbued had he been with the principles of rugged individualism that a year or two before, orating at Grand Junction High, or arguing in fraternity bull sessions at the University of Colorado, he would have automatically identified his own interests (had he thought about it at all) with those of the bosses.

This change in him, bubbling quite near the surface, was due partly to the example provided him by his father: look what love of the bosses had gotten him. Orus Trumbo was fifty-one, practically penniless, and lying on his deathbed. The family had by then moved to a place on 55th Street in Los Angeles—or just off it, really, for the Trumbos were in a little apartment above a garage that faced onto an alley. There Orus Trumbo lay all day long, unable to take walks with Catherine, as he had done before, only rising occasionally to sit with the family at supper—and this he did less often as he grew weaker. His condition deteriorated. Weakness and increasing pain soon made it impossible for him to get out of bed at all.

The pain would sometimes become altogether unbearable for Orus Trumbo. Elizabeth Baskerville, Dalton's sister, who was then just a little girl, recalled the terror she felt at her father's suffering: "When my father was sick in bed I can remember times when he was in such great pain that he would pound on the wall and groan. It put me in an utter panic." It is easy to imagine. Suppertime. Maud Trumbo, Dalton, Catherine, and Elizabeth seated around the table. The groaning begins and reaches a climax at something near a shout, accompanied by thumps punctuating his agony like so many exclamation marks. Maud would get up, telling the children to continue eating, and then go over to the sickbed. The place was so small that they ate in the same room where their father lay, and they could hear Maud's voice in soothing tones, trying to comfort him, as the groaning started again. They couldn't eat. The three children would just sit, silently exchanging looks, and wait for him to stop. "Afterwards," Elizabeth remembered, "when the pain had subsided a little, we'd look in on him and Papa would say, 'I'm sorry for having made all that noise and frightened you.'"

During the long period of Orus Trumbo's illness there was, of course, no doctor called in. Maud Trumbo was a practicing Christian Scientist and would remain so the rest of her life; she attended church every Sunday and believed profoundly that prayer would cure every ill. Did her husband believe, as well? Dalton said no—that Orus merely accompanied her to church. According to Elizabeth, though, he may have believed, after a fashion, in Christian Science, but only "because she wanted him to, and if Mother had wanted him with two heads, he would have grown another."

And since no physician had been in to see Orus Trumbo, the family

was ignorant of the cause of his suffering. At the very end, however, when it was clear that his father couldn't last much longer, Dalton prevailed upon his mother to allow him at least to bring a doctor in. This was only to fix in advance the cause of death (otherwise an autopsy would have been ordered), so she consented. The doctor's diagnosis was pernicious anemia; Orus Trumbo's mother had died of it at the age of fifty, and an aunt had died of it, too. The prognosis was as they had guessed: he was terminally ill. It was only a matter of time—and a very short time, at that, for Orus Trumbo died the day after the doctor's visit. "It was nice to know," Dalton said almost wistfully, "that there was nothing we could do for him in any event. This was a couple of years before the liver extract cure for pernicious anemia had become known."

Nice to know perhaps, but still the episode left scars on the three Trumbo children. Catherine, then fourteen, recalled: "It disturbed me for years when Daddy died. I think it really hurt my relationship with Mother because she had kept saying he would get well. Well, he didn't get well. He died. Obviously somebody was lying."

What did Dalton Trumbo feel at the time? Relief? Shock? Grief? Did he feel intimidated as he looked to the future and saw himself as the chief support of his mother and two sisters? Did he feel an impulse to run away from such overwhelming responsibility? Since no record of his immediate response exists—he kept no diary—the best evidence is perhaps provided by a passage from *Johnny Got His Gun*. Here, Joe Bonham, Trumbo's spiritual alter ego, had been called from his job at the bakery with news that his father had just died:

He looked down at a tired face that was only fifty-one years old. He looked down and thought dad I feel lots older than you. I was sorry for you dad. Things weren't going well and they never would have gone well for you and it's just as good you're dead. People've got to be quicker and harder these days than you were dad. Goodnight and gooddreams. I won't forget you and I'm not as sorry for you today as I was yesterday. I loved you dad goodnight.

His father's death left him in the role that he had unofficially assumed eleven months before: he was more or less head of the family

now. His mother worked when, and as much as, she could. She continued in her job as bookkeeper in the Pierce-Arrow agency; later, she would give that up but continue to work at home as a seamstress. The money Dalton brought home from the bakery was what the family depended on during the years that followed. Brought up, as he had been, on the work ethic, he had always placed immense value on money as a measure of material success: a wealthy man was a successful man. Well, the years of deprivation that followed—years during which the Trumbos would sink very close to real poverty—did nothing to convince him that there was some other, better and truer, measure of success. Years without money did nothing to diminish it in his esteem. On the contrary, it must have seemed to him by the time things got their worst—they climaxed at the bank holiday in 1933—that there was no problem that money couldn't solve.

He did well enough at the bakery, while he continued to assure everyone who asked that he was there only temporarily and would be going back to college soon. Eventually, they made him an estimator, a break for him because the hours were shorter, and this eventually made it possible for him to pick up odd credits at the University of Southern California. The bakery produced over a hundred different kinds of goods. When the drivers came in at the end of the day, they would check in with the estimator to let him know what they had sold. On the basis of this, he had to estimate production orders for the night shift which had just come on and the day shift for the coming day. Other factors, as well, had to be taken into account in estimating orders: the weather, the day of the week, whether or not a holiday would fall on that particular day, and so on. Obviously, it was a position of considerable responsibility, and it shows that no matter what Dalton Trumbo may have thought of them, the bosses put a good deal of trust in him when they made him an estimator. It was the sort of job where danger and even potential disaster threatened with the slip of his pencil.

One day the pencil did slip. The item in question was vanilla cream pies. Trumbo put in a routine order for two hundred of them, only to return the next day to find the place unexpectedly piled high with vanilla cream pies. He protested that he had only asked for two hundred of them. But then they took him aside and showed him his order from the day before: the base of his "2" followed the line on the order form so exactly that anyone who looked at the number as he had written

it would say that he had written a "7." The situation was further complicated by the fact that it was summer, and the vanilla cream pies would literally turn poisonous in just fifteen hours.

Trumbo: "Well, I figured it was my job. But we had an interesting salesman there at the bakery, a man who used to hawk at the drivers as they left on their routes, getting them to take on this item or that. I reported to him that I had made a mistake and we had an extra five hundred pies. And this guy, who was a genius as a pitchman, got the orders from the drivers for over four hundred extra pies so that we only had to consign about seventy-five pies. Well, I figured I was the heavy until the next day the manager of the bakery came up to the salesman and myself and said, 'What the hell have you people been doing? There's obviously a market for between six hundred and fifty and seven hundred vanilla cream pies and you bastards have been selling only two hundred! Now get on it!'"

He began at the University of Southern California as a full-time day school student and took sixteen hours that first semester. In order to do it, though, he had to take on a second job. He went to work for his uncle at the Harley-Davidson agency—the same uncle his father had worked for there in Los Angeles as long as he had been able to work. The purpose of it all was to learn to be a writer. He emphasized, he was *learning* the craft: "I was bright as a kid and a young man, tolerably bright, but I don't think that I had any real talent for writing, because talent should develop faster. It took me years to learn to write. There is a kind of talent that can't be denied. You see it and you recognize it. But I had to learn."

The learning process had begun back in Grand Junction, when he had written his first short stories. The single surviving example, "The Return," which must have been written sometime in 1924, is remarkably good work for a boy of about high school age. There is a sure use of language in it that shows the benefit to him of his experience on the *Sentinel*. It is worth mentioning that the story tells of the return of Jim Norton to the town of Plainville as he approaches middle age. Jim had left for Chicago twenty years before with high hopes, but there found himself just "one among many human ants." But now he is back in his hometown, deeply ashamed that he had not achieved the success that he had hoped to: "Yes, that was the heartbreaking part of his vacation trip to his home city. They had all expected so much—predicted

so freely, and here he was. Probably poorer than the majority of his friends, without family or success in any tangible form." His best friend had prospered, his high school sweetheart had married happily. Jim, in an agony of chagrin, buys a can of gasoline, walks to the outskirts of town, and immolates himself, a burnt offering to the bitch goddess success. Remarkable, this fear of failure, even when Dalton Trumbo had barely begun.

Ever since those days back in Grand Junction, then, he had been teaching himself to write. Going to the University of Southern California was just part of the process. During that year he attended the university full-time, he took as many writing courses as he could, received encouragement from instructors, and kept right on writing, writing, writing. Besides short stories, sketches, and papers done for courses at USC, Trumbo wrote just about six unpublished novels during those years at the bakery. If "just about" seems imprecise, it is because although he completed six separate manuscripts, material from one can be found, somewhat revised, in another. Basically, there are only two stories that he is telling in them: that of the events in Grand Junction, his father's troubles, and his own high hopes in growing up there; and that much grimmer story of the life in the bakery which he was living as he was writing it. Nothing illustrates the extent of his desperation during this time quite so well as a note found scribbled on the last manuscript page of "Bleak Street, or, American Sonata," a last attempt at a bakery novel:

Completed, Wed-8-28-29 at 2:12 AM

If this is published, I make a promise to myself
that 1/10 of the net proceeds accruing to me will
be expended for the education of youth.
—James Dalton Trumbo

It wasn't published, of course, and so he was never put to the test. But it is clear from this high-minded vow that he sorely missed the opportunity for the college education he had been denied, and that he now saw success as a writer as the only practical way out of his situation. He was right, but his escape was four years off.

Why did he feel trapped? Why was he so desperate? There was, first

of all, Sylvia Longshore—or Sylvia Shore, as she was then known professionally. The two still saw one another and wrote back and forth faithfully whenever she was on tour. She was doing quite well. Trumbo's high school friend Hubert Gallagher remembered that while he was an undergraduate at Stanford he saw her in the San Francisco company of *Sunny*. She was still seeing Trumbo then. Imagine Trumbo as Gatsby without the fortune. How much more impossible his yearnings for Daisy would have seemed to him had he been no more than an estimator at a commercial bakery in Queens. He must have wondered if he would ever be able to marry Sylvia Shore. Would he ever reach that green light across the water?

And there were Trumbo's responsibilities at home. His position was ambiguous: although he was the family's chief breadwinner, he was also Maud Trumbo's son. The two fought, if not constantly, at least regularly. Dalton's drinking was usually the issue. Money was always a worry, too. They were never totally without food at home, but often the four of them would dine on nothing more than beans and day-old bread and some fancy cake that Dalton had lifted from the bakery. His sister, Catherine Baldwin, remembered: "Those were rough, rough days. But we had a lot of fun on 55th Street. We were really a crazy family. We laughed a lot, even with all the trouble we had."

The fundamental source of their conflict was probably that Maud and Dalton Trumbo were very much alike. The two shared a quick wit and were both fierce opponents. He may have lacked his father's grace and gentlemanly style, but at the same time his was not in the least a submissive nature: he was a fighter.

What was Maud Trumbo like? Dalton's sister, Elizabeth: "I think of her as something like Helen Hayes in age and size and general appearance. She was very short and very feminine and pretty. Oh, but strong—she could certainly be ornery and was no saint. Mother was a remarkable woman—intelligent and very capable. Much of Dalton's strength, I think, comes from her."

She was thirty-nine when her husband died, and she lived forty-four more years.

Driving the freeways in Los Angeles, you seem to travel over the city rather than through it. The houses on either side have no identifiable

shape or order as they flash by, and the people, if visible, lack real identity. The blocks the freeway intersects have about the same sort of reality as those green and brown patches of Ohio farmland that reel by beneath the wing of a jet. What was Los Angeles like before the freeways? There is no telling now, of course. Streetcars clanged through the streets, hauling their passengers through one neighborhood after another. Before the freeways were built, there were neighborhoods there to travel through.

It is only when you take the exit ramp and merge with the local traffic that the streets surrounding the freeway take on some degree of reality. Trumbo's old neighborhood has become a black area. It is not the faces of the pedestrians that tell you this—how many pedestrians are there likely to be on any street in Los Angeles?—but the faces on the models in the billboard photographs, selling American dreams. Glamour? Afro-Sheen products. Happy families? Contemporary African-American families enjoy a breakfast of Kellogg's Corn Flakes together.

So it's black now. The area where Trumbo lived those eight years of his life when he worked at the bakery has, in the parlance of northern cities, "changed over." Here we are on the sprawling south side of Los Angeles. It is placid enough now, however, as you turn up West 55th Street from Budlong. There is something of the small-town neighborhood about the street. It is a sleepy, palm-lined drive that looks much the same as it must have in 1933 when the Trumbos lived there last. There is a little gabled house over the garage in back, almost in the Swiss style, with its red-brick chimney and single gable overhanging the garage door. That's where the Trumbos lived, in three rooms—mother and daughters in the big bedroom and Dalton in the small one, with one room left in which to cook, eat, sew, and sit. It seemed tight to them then, just as it probably does to the people who live there now. Poverty in Los Angeles is masked by sunlight, hidden behind palm trees and blooming blossoms. And though it is not nearly as evident as it is on, say, the south side of Chicago, it is there all the same. The Trumbos were well acquainted with poverty when they lived here on 55th Street. The present residents probably know it even more intimately.

I had seen the inside of the place in Trumbo's movie, *Johnny Got His Gun.* He took the company on location and filmed right here where he and the family had lived all those years. No, there was nothing more to be seen here, and there were no questions to be asked. I started the car

and headed back for the Harbor Freeway which would take me toward downtown Los Angeles. Emerging from the underpass, with the sound of cars blowing by above me, I come upon the site which my street map tells me is an important one to this narrative. But it doesn't look quite as it should. Pulling up to the curb at the northwest corner, I get out and check the street sign. Yes, 2nd and Beaudry. This is where the Davis Perfection Bakery was located during the years when Dalton Trumbo worked there. But there is no bakery here. A chain-link fence surrounds the entire area, and a sign affixed to it says that the complex is a facility of the Los Angeles Water and Power Company. The large factory-like building closest to the corner is the one in which the bakery was located. It seems to be used today as an equipment warehouse.

Satisfied, I climb back into the car and head toward Hollywood, deciding to drive through town rather than resort to the freeway. The neighborhood surrounding 2nd and Beaudry is desolate today and utterly crummy. In the years when Trumbo was here, it was a lot worse.

"The atmosphere at the bakery was remarkable. This was during Prohibition, and there was a very corrupt police force. Cops used to constantly come in there, and we'd give them bread and cakes to keep them happy and they gave us whiskey. And it was quite customary for cops to have girls. The girl would be on probation, and as a matter of fact a cop would set her up and trap her, and would put her in a hotel room to do business for him. That way the cops—a lot of them—had strings of girls, and there was no way to get away. If a girl tried, *bang!* the cop has her for prostitution—and she would be back in for another one hundred and eighty days, plus ninety on probation—and back again at the mercy of the cop who had arrested her. One of the policemen used to pass out cards, entitling the bearer to a complimentary lay with one of his girls. He would offer this around, you know, as you would treat somebody to a drink.

"The despair of that particular area—honky-tonks, whorehouses, everyone scrounging, scrambling—well, it was just beyond belief. There was *real* Depression there. We would give away our hard, two-day-old bread. Two or three men would stand on the ramp, handing the stuff out, and there would be a line three wide—for a block and a half. Kind of a hopeless state."

It was quite an education for Trumbo. If we remember the young man who had won the Western Slope Rhetorical Meet only a few years earlier with a high-minded oration entitled "Service," and imagine him thrust into the sort of environment he has just described, it is not surprising that what emerged from it all was a radical. The first overt indication he gave of the direction he was headed in came when he led a successful strike of key employees in the shipping department for better pay. As he sized the situation up, there was no way an ordinary strike would work. If they began negotiations and gave notice beforehand of their intention to strike, they would all simply be fired and replaced—so they would have to arrange it so they couldn't be replaced. They chose their night, and at fifteen-minute intervals, one of four of them went into the office and quit—walked out, leaving word that they would be over at a nearby coffee shop if the night manager wished to discuss the matter further. Well, they had him where they wanted him: he was simply not going to get out those perishable baked goods without their help, and they knew it. So he came over to the coffee shop and agreed to hire the four back at a substantial increase in pay. It was an "elite strike," Trumbo admitted, one that really only benefited the four key employees in the shipping department. But, as it turned out, it was a beginning.

Years after he had left it, he used to go back to the bakery—partly to renew old acquaintances, and partly, too, to bring friends there (as he would do five, six, and seven years after he had left) and show them what he had come from. The bakery was his bona fides, the only credentials he need show to prove who he was and why he was.

"There was a fellow named Red who worked there, who was primarily evil—but imaginative. I don't know where he came from. And we had a young man who came in to work, and the first mistake he made was to brag about how beautiful his wife was. Naturally, for a night shift worker, that's a stupid thing, because ultimately somebody tested him out about his wife. He didn't know that, though. Then his mother-in-law got arrested for vag-lewd [lewd-vagrant—soliciting], and that required fifty dollars' bail. This was a hell of a problem for him, and we were all interested in that problem. And Red, the fellow I mentioned, finally said, 'Well, we might be able to raise ten bucks of it.' The idea was, he had a little game for the young man, if he were foolish

enough to play—that he could masturbate and come in three minutes or something of the sort. They got a pot of money together. They got two cops to act as judges, and they went up into the locker room—and he made it. His name was Larry, and after that he was called Larrupin' Larry. Well, he was still short of money to get his poor mother-in-law out of the vag-lewd charge, and Red came up with another idea that Blackie, an ex-lumberjack who worked at the bakery, would cornhole him. They could get thirty bucks for that. That would do the job. Well, Larry said it was all right with him, so Red went to Blackie and offered to pay him out of the pot, but Blackie said, 'Hell, I'll do it for nothing. Certainly.' They went to the cops, and the cops themselves were putting up money by this time. Word got upstairs, and before that contest was held, Larrupin' Larry was fired. Hence, the whole enterprise fell through.

"This, you see, was the time, the place, the period, the thing. Amazing. How can I account for it? At least this was something interesting to get us through the day—like the bread races we used to have. And then, of course, there was the drinking, which was really heavy drinking—wild, sodden, mad drinking on a night off. There wasn't an excuse for that. It was just... the way it was then."

It was all this that he sought to escape through his writing. The act of writing itself gave him an outlet for the very real pressures of resentment and frustration that welled up inside him. And it was only by achieving some degree of success with his writing that he thought it possible to escape this trap that had closed around him: "Sometimes I would walk to the bakery full of sheer horror, feeling, 'Well, here I am. This is the way it will always be.' By this time, you see, I was approaching thirty. And I was full of just a frantic determination to get out."

His sense of desperation, fed by the atmosphere of wild lawlessness inside the bakery and in the squalid area around it, led him to try things, crazy things, he would not otherwise have done. There was the heavy drinking, of course—but that was the least of it: "Almost everything you did was criminal one way or another. I was part of the crime. Not only were you yourself stealing bread and cakes, but you were also passing them out to the cops because it was the bakery's policy. The company had two hundred trucks on the streets, and they didn't want to have to put up with tickets, so they wanted to keep the cops happy,

no matter what it took. So we were all involved with crime in one way or another. And that brings me to what I think was the most horrifying part of my life."

He began kiting checks. It all started, as such episodes do, in a modest enough way. He had an immediate need one day for about fifty dollars, and so, even though he knew he didn't have sufficient funds to cover it in his Bank of America account, he wrote a check for that amount and cashed it at the cashier's window of the bakery. At that time it would take from three to four days for a check to clear, and he must have felt that he would have money enough from some source or other in the interim to cover the check. But at the end of three days no money had come in, and so he was forced to cash another check for fifty dollars at the bakery and deposit the money from that one in the bank in order to cover the first check. And then he continued to do it again and again, week after week, keeping the same fictitious fifty dollars floating between the bakery and the bank. It wasn't easy. The bakery cashier, who did all his business with drivers checking in at the end of the day, didn't open his window until two o'clock in the afternoon, and the bank, located near Trumbo's home on 55th Street, closed at three. On days when he had to cover a check—two or three times a week—he would have to take the streetcar in to the bakery, cash a check as soon as the cashier opened for business, and take the streetcar back to the bank to make his deposit within the hour. Then he would return to the bakery to start work as an estimator. Of course on such a schedule as this, there was always the lurking terror: What if the streetcar broke down? What if he failed to make it from the bakery to the bank within the hour? But somehow such threats failed to deter him. Not only that, but human nature being what it is, and a man's reach inevitably exceeding his grasp, that floating fifty dollars was soon eighty dollars, and up and up, and before he quite knew what had happened, it was two hundred fifty dollars he was keeping in the air. Quite a sum in the Depression.

It went on that way for about three years. The episode began sometime in 1930, and it ended, with a bang, in 1933. The bang was provided quite unexpectedly by President Franklin D. Roosevelt when he declared the bank holiday on March 6, 1933, and stopped the machinery of banking. That meant, as Trumbo well knew, "that every check would come home to rest at its final destination." He was certain to be discovered and was desperate.

There was, as he saw it, only one hope. The parents of one of his high school friends, Jim Latimer,* from whom he had borrowed money in the past, happened to be vacationing in the Los Angeles area. They were quite well-to-do, and, he felt, might take pity on him. As long as the bank holiday held, he knew he would be all right. The trouble would begin when the checks had returned—and he knew that if they caught up with him, it would be very bad for the cashier at the bakery, too. And so, since there was only one chance, he took it: on March 10 he traveled on the Inter-Urban streetcar line out to where the Latimers were staying. He talked to the two of them, telling the whole story. Mr. Latimer really didn't believe it; he thought Trumbo might have made the whole story up. But Mrs. Latimer did believe him and loaned him the money.

Trumbo remembered boarding the Inter-Urban Railway and starting back to the city in kind of a daze: he wouldn't go to jail; it was as simple as that. He remembered looking out the window, as the streetcar pulled past a tall building on the outskirts of Los Angeles, and as he watched it, the building began to disintegrate before his eyes. It was only moments after that that he felt the first shocks of the Long Beach earthquake of March 10, 1933.

"First the banks closed," he remembered, "and then there was the earthquake. And people said, 'Well, the banks are open at last,' because the windows were all broken. It was interesting the way the people took the bank closing. There was a feeling almost of relief: 'Now *nobody* has any money!' You see, if you have a hundred thousand dollars and I haven't got anything, then I'm not comfortable about you; I need some of that. But if nobody has anything, then there is that feeling of relief, of equality. Well, nobody had any money. I know Studs Terkel and that was a fine book of interviews on the Depression he did, *Hard Times*. But there was one aspect of the Depression experience that none of the people in his book commented on, which was that you were no longer ashamed of not having any money. It was a very nice thing. You know, we lived on the alley on 55th, and in front of us lived a man with his wife and two or three children, and they were on the government support. They got salt pork, and some ham, and a lot of beans. Well,

*The same Jim Latimer who was so reluctant to talk to me in Grand Junction.

I would bring home bread and rolls, cakes and pies from the bakery. We would exchange without the slightest feeling of embarrassment. And I would swipe these goods from the bakery without the slightest feeling of being a thief. I always honored the biblical injunction that he who labored in the vineyard was entitled to the fruits thereof, or some proportion."

The check-kiting episode, though it may have caused him the greatest terror, was not his only venture on the wrong side of the law, nor was it probably the most dangerous to him. He became a bootlegger, as well. Whiskey was sold then from five-gallon cans and doled out from them. Going on the rounds, one speakeasy might be a two-gallon stop and the next a three-gallon stop. Trumbo's bootlegging kit included, in addition to the whiskey, a hydrometer, for testing the whiskey, and a fifty-dollar bail bond if worse should come to worst. He worked for "a man at the drugstore" who worked, indirectly, for one of the big guys.

Trumbo would go to a speakeasy and order whiskey, sample it, and say loudly, "This stuff is no good." He would then pull out his own bottle, and, with a lot of people around, he would say even louder, "Taste this." The owner would taste it, and would admit it was better—because what he was offering *was* better stuff. Trumbo would take out the hydrometer, which he always carried with him as an important part of his sales kit, and on the spot he would make a comparison test on alcoholic content, his brand versus the house brand. That would make quite an impression on the customers. In this way, in certain places, he could get them to switch to what he was selling because the customers who were present and had watched his pitch would demand that the owner give Trumbo's booze a try. It wasn't often he was able to effect this because, as he said, "there were other, more lethal ways of preventing a switch." But he could occasionally pull it off, and when he did he was able to get five dollars per week per can on what he sold. At one time he was making up to sixty dollars per week on his bootlegging efforts alone.

He was doing well for himself. Things were looking up. It began to seem for a while as though bootlegging might provide a way out of the bakery—that is, it seemed so until one night when he visited the drugstore that kept him supplied and paid him off, and he found out what had happened that day on Aliso Street, just four blocks from the bakery. There was a unique setup there. Cars would line up at a

grilled manhole cover. Pulling up beside it, the driver would open the door, put two dollars down through the grill opening, and in return have a pint of whiskey pushed up at him. That morning, however, a car door had swung open, and instead of two dollars, six bullets had been pumped through the manhole cover. "Louie and the other guy," the two who ran the operation, were both dead. Competition had suddenly gotten very tough, and the druggist was scared. He opted out of the business—and that ended Trumbo's career as a bootlegger.

It proved to be the beginning of his career as a writer. He used his experience as a bootlegger as the basis for an article that he did for *Vanity Fair*. The piece, which appeared in June 1932, while he was still working at the bakery, is not by any means the sort of raw, slice-of-life account you might expect from someone writing from firsthand experience of the racket. That, for one thing, was not the style or tone *Vanity Fair* had established as its own—which was as sophisticated and above-it-all as it was possible for a magazine to be in that bottom year of the Depression. And Trumbo's article—"Bootlegging for Junior," as it was called—conformed perfectly to the magazine's established style. It is in the nature of a travesty, a learned discourse on the economics and techniques of bootlegging written in prose so ornate, highfalutin, and grandiloquent that it satirizes not just the subject at hand, but in the end, itself as well. The keenest touch of irony in it, however, was not the disproportion of style to subject, but rather the fact that it was written by Trumbo in so decorous a manner between squalorous stretches in the bakery, and under the daily threat of disclosure for his check-kiting activities.

Vanity Fair was delighted with the piece. After it had been accepted, Trumbo received a letter from Frank Crowninshield, the editor, telling him that an associate editor, Clare Boothe Brokaw, would be coming to Los Angeles soon, and if he would supply his phone number, she would contact him when she arrived. Crowninshield said Mrs. Brokaw would then have an opportunity to discuss other article possibilities with him. That, of course, Trumbo did, but then promptly forgot about it, probably supposing she would never really call. But she did. One morning not long afterward, a call came when he was sound asleep, having just come off the night shift at the bakery. He was called to the telephone

by his mother, and the woman at the other end of the line, identifying herself as Clare Boothe Brokaw, invited him to lunch at a downtown hotel. He groggily accepted.

Clare Boothe Brokaw, of course, was to become Clare Boothe Luce. She would eventually blossom forth as syndicated columnist, Broadway playwright, the queen of a media empire, congresswoman and politician, and finally an ambassador. At that time, although only a hard-driving and relentlessly climbing editor on *Vanity Fair,* she was already beginning to make her mark. By all accounts, she was a remarkable woman—clever, quick, beautiful, and with an aura of charm about her that men found simply irresistible. Trumbo responded to that charm and beauty. To him, she seemed the very epitome of glamour. "She was," he recalled, "the most beautiful girl I had ever seen."

He in turn looked to her like the sort of contributor they needed out in Los Angeles, one who could write about Hollywood from the inside: "They assumed I knew something about movies, and I had never been inside a studio. I knew nothing about motion pictures. To fake it for an hour and a half, as I did, with Clare Boothe Brokaw was not easy. It was an appalling task. But somehow I pulled it off, or I tried, because it meant to me that I might do more articles for them."

As it happened, though, he did no other pieces for *Vanity Fair.* What that meeting did for him, however, was to bring home to him the possibilities inherent in motion pictures as a field of immense potential for a writer. When he had thought of himself in that way before, it had always been as a writer of books, of novels, of stories. But here was a whole field that needed writing about, that needed writing pure and simple. His interest in movies before had been only as a member of the audience. Now he began thinking otherwise.

BEGINNING AS A WRITER

Originally, Dalton Trumbo had come to the attention of *Vanity Fair* editor Frank Crowninshield as the author of an article that was at least ostensibly about the movies, which was why Clare Boothe Brokaw quite reasonably assumed some knowledge on his part. George Jean Nathan had earlier published a piece in the magazine that was really no more than his standard highbrow jeer at the movies and the garish culture they had spawned in Hollywood ("rhinestone-studded swimming pools," etc.). Trumbo had bravely taken him on and had written a rebuttal which he submitted to a little magazine published in Los Angeles, *The Film Spectator*. It was accepted. Except for newspaper articles in Colorado, "An Appeal to George Jean," as it was titled when it appeared in January 1931, was Trumbo's first published work. It is a bit of fluff, bantering and facetious in tone, no more a serious defense of the movies than Nathan's attack was to be taken seriously. What it demonstrated most convincingly was that James Dalton Trumbo, as he signed the article, was a young man who had great resources of wit and a way with language. Frank Crowninshield of *Vanity Fair* took notice when Trumbo sent a copy of the article to him. So, too, certainly, did Welford Beaton, editor of *The Film Spectator*. Trumbo looked to him like a good prospect as a steady contributor.

Beaton, a bouncy, enthusiastic movie critic of considerable erudition, ran what was then the only film journal on the West Coast. He took an immediate liking to Trumbo and made it clear he wanted him to do as much writing for the magazine as his work at the bakery would

permit. In subsequent issues under the byline of James Dalton Trumbo appeared an appreciation of Charlie Chaplin and reviews of a number of films. Having caught the drift from Clare Booth Brokaw—this was what they were interested in—Trumbo resolved to learn as much as he could as quickly as he could about the movies. Welford Beaton, an intelligent and enthusiastic critic, proved an apt schoolmaster.

Beaton came to count on him as a reviewer more and more and soon had his young protégé doing the sort of odd-job editorial work that he himself never seemed to have time for. Finally, in 1933, right after the successful solution of his check-kiting problems, Trumbo was asked by Beaton if he would like to come on full-time at the *Spectator.* "I'll carry you on the books at fifty dollars a week," Beaton told him. "How does that sound to you?"

How did it sound? It sounded like something he had waited eight years to hear. It meant he would be able to leave the bakery at last. He would be making enough to contribute the major share to the support of the family, as he had been doing right along while working at the bakery. And best of all, he would be earning that money as a *writer.*

And so Dalton Trumbo at last quit the bakery and took the job as associate editor of the *Hollywood Spectator.** It was only then that he found out just what shaky financial condition the magazine was in. "The first week passed," he remembered, "and I got my first paycheck— but it was only for thirty-five dollars. I went to Beaton and said, 'Look, you said you'd pay me fifty dollars—what about this?' And I waved the check at him.

" 'Now wait a minute,' Beaton replied just as cheerfully as you please, 'I said I'd put you on the books for fifty. All I've got for you this week is thirty-five.' "

And it was true! He sat down with Trumbo, showed him the figures, and had no difficulty convincing him that that amount was all that was available for his paycheck. Perhaps next week—maybe it would go better then. Or the week after that.

Sometimes there was enough left over from the magazine's absolutely necessary expenses for Trumbo to be paid his full salary, and sometimes there wasn't. It was as simple as that. However, this did not

*The *Film Spectator* became the *Hollywood Spectator* in 1932.

keep Welford Beaton from thinking big. He decided his associate editor should have a car in order to get around to screenings and interviews and make trips to the printer. And so once when he hit a good week, Beaton scraped together one hundred dollars for a down payment and put it on a car for Trumbo. The young associate editor used it for a while, came to depend on it, then walked out of the house one morning to find the car gone from where he had parked it the night before. It had been repossessed.

"I came to him about the auto, and he shrugged it off. He said, 'Well, you see, you didn't have an automobile, and then you had one for several months—and that was good.' He said, 'The man who sold the auto had one he wanted to sell, and he did—and that was good. And the magazine needed it and got the use of it—and that was good. And now,' he said, 'we won't have to pay any more on it—and that is good for me. So you see? Only good came out of the entire affair.' He was a *marvelous* man."

Ultimately, of course, the magazine folded. But by that time, Trumbo was long gone. Welford Beaton had advanced him in title to managing editor but, needless to say, at no increase in salary. Trumbo worked for him for just about a year. In fact, it was because Beaton could no longer even pay him as meagerly and irregularly as he had been that he was forced to let him go.

The problem then, of course—for Trumbo was still supporting his mother and two sisters—was how he might earn money enough by writing so that he need not return to the bakery or to some other dead-end job. It seemed it might be possible. He was just beginning to sell fiction. His first published story, "The Wolcott Case," came out in *International Detective Magazine* late in 1933. It was nothing special, the story of a kidnaping with heavy vigilante overtones. He would afterward shrug it off as a piece of "Fascist crap." Nevertheless, he was concentrating on fiction, still sure that this was the kind of writing he wanted to do—that he was really meant to be a novelist. He now also had an outline for a new novel, one in which he might make use of his Grand Junction material. This would be less personal—not really autobiographical at all—but it would provide a focus on the town as a social entity, an approach that interested him more and more. And so he felt it was important to him to keep writing, to continue to think of himself as a writer, and not give in and once more become a slavey at the bakery.

The immediate solution to his problem came from an unexpected source. He came in contact with an Austrian nobleman living in Hollywood, one Baron Friedrich von Reichenberg, who was much in need of "editorial assistance" in the preparation of a biography of Metternich. Trumbo became the Baron's ghost writer. There was no doubt the man was an authority on the leading statesman of the Hapsburg dynasty; von Reichenberg simply could not organize the mountain of material he had collected and present it in comprehensible English prose; that, it turned out, was to be the job of his young editorial assistant.

"I didn't know it then" said Trumbo, "but I had found my way into a real nest of Nazis. One or two of the Baron's friends, who used to visit him at his apartment on Fountain Avenue just below Sunset Boulevard, were indicted later on. Hitler had just come into power. The Baron himself didn't like Hitler too much—there was a certain aristocratic squeamishness involved there and also the fact that he was an Austrian. But his friends *loved* Hitler—anti-Semites all. I stayed in contact with the Baron for quite some time after the book was finished. As anti-German sentiment grew, he became *de* Reichenberg instead of *von*. And during the war, as I recall, he was interned up in Canada. That was actually the last I ever heard of him."

Trumbo finished the book in six weeks' time. Eventually, it was published in England as *Metternich in Love and War*. In his preface, Friedrich von Reichenberg thanked his young friend James Dalton Trumbo for "editorial assistance," a formula which should be familiar to anyone who has done any ghost writing. Trumbo was paid in full by the Baron and that was the end of that. By the middle of 1934, he badly needed another job.

It was the Depression, after all. The economic pressures on the Trumbo family, as on everyone else in those grim days, were real, brutal, and relentless. And for him, especially, having now had a glimpse of that world of "rhinestone-studded swimming pools" that George Jean Nathan had satirized so scathingly, the thought of joining the breadlines must have seemed a most bitter prospect. Through his work on the *Hollywood Spectator* and the contacts he had made in the film world, he knew there was money to be made there—money, in fact, was being made by young men far less talented and less prepossessing than he. The better he came to know the ins and outs of Hollywood (a surprising number of his early pieces for the *Spectator* deal specifically

with the economics of the movie industry), the more his taste for luxury must have grown, and the more keenly aware he must have become that a comparative fortune awaited him. There were riches in the midst of overwhelming poverty; he had now seen both at first hand. And he must have been torn somewhat between indignation at this state of affairs and an eager desire to dip in for his share.

Things were still hard at home for the Trumbo family. They had by then moved from the alley house off 55th Street to a duplex on Cahuenga, a step up of sorts. But ever since Dalton had left the bakery, money had been coming in less regularly than before, while at the same time family expenses were spiraling up and up. Elizabeth was in high school, and Catherine was in junior college. Maud Trumbo continued as a seamstress, working for various Hollywood dressmakers and doing special jobs (ruffles were her specialty) for movie actresses, Norma Talmadge and Constance Bennett among them. But again, the major financial burden fell on Dalton. When they needed money, it was up to him to get it any way he could—and somehow he always came through, though at times the means he used were rather irregular. His sister Catherine remembered a time, for instance, when she badly needed ten dollars to buy a new dress for a dance. She went to him, and he said he would get it for her. He went out and came back a little over an hour later with that amount and a bit more. She asked rather fearfully how he had come by it, and he assured her it was all right: he had found a crap game, come in lucky, and got out quickly.

Perhaps Tolstoy was only half-right. Not only are happy families all alike, but members of one unhappy family also seem to strain and rub against one another in just about the same way as do those in the next. Dalton and Maud Trumbo, his mother, had often fought across the generations over politics. Just as Maud had crossed over and become a Republican when Orus Trumbo went for Woodrow Wilson and became a Democrat (in order—she made no secret of it—to cancel out her husband's vote), so Dalton had followed his father's lead and voted Democrat in the first presidential election after reaching his majority. As it happened, that ballot went for Al Smith in 1928, the "happy warrior," the first Catholic ever to run for president. And didn't their Christian Scientist household rock during that campaign! Trumbo admitted

it took quite an act of will for him to cast that ballot, for he had, he says, held on to his "populist anti-Catholicism many years too long." (For that matter, Maud Trumbo eventually came around: she voted for John F. Kennedy in 1960, unable to bring herself to vote for a man who sat on the congressional committee that had sent her son to prison.) Theirs was an intensely political household. The Trumbos not only exercised their franchise in every election—national, state, county, and municipal—but all of them argued the issues and were called upon to defend their choices. Things reached a pitch with the coming of Franklin D. Roosevelt and the advent of the New Deal. Families all over America split along generational lines and took opposing positions. As the Depression deepened, so did the rifts between parents and children over "that man in the White House." The Trumbos were no different from others in this.

They all remembered the fights. I talked to Dalton's two sisters on the same summer evening and found them both regretful that the rancor and contentiousness were what they recalled from that time. Everybody, after all, wants to believe his was a happy home. Elizabeth Baskerville and Catherine Baldwin lived within a few miles of one another on the same long hill, in Altadena and Pasadena, respectively. I visited them separately in their homes and found them quite different, each more like Dalton than like one another. But because they lived so close, the two sisters saw a good deal of each other and got along quite well. They saw Dalton less often but stayed in close communication by telephone, calling back and forth at least once a week, more often should the occasion arise. They were still very much a family. The mutual claim they shared existed between them, almost unnoticed and never referred to. All the same, you sensed it was there.

Elizabeth resembles Dalton physically, both of them favoring their mother. She is a small, pretty woman in her late fifties—the baby of the family, as the rest reckon it. Coming back to California, as she did, at the age of eight, her memories of Grand Junction are rather dim. She grew up in Los Angeles and considers it home: "We have two grown daughters living out of the state, up in Oregon and Washington," she tells me. "And criminy, I don't know, it's beautiful up there, but I'd hate to leave California. It's so interesting politically and socially. I wouldn't like being where everyone who lived around me was alike, the way they are up there."

Settled in the comfortable living room of the hilltop house where she lives with her husband in Altadena, I ask Elizabeth about Dalton's position in the family following the death of their father.

"Well, it was hard on him, of course," she replies. "It was hard on all of us. But there was no doubt when I was growing up that he was the dominant force in the family—not by giving orders or giving us advice or any of that—but just because it was always assumed he was going to be somebody important. We were quiet during the day because it was understood Dalton had to get his sleep while he was working in the bakery. And when he got up, we would clean his room for him."

"This must have come from your mother, somehow," I suggest.

"Yes, she knew she had a special child in him, and I suppose she communicated that to us. Catherine and I were there to be educated and cared for. Dalton was different, though—he had a special talent. He had to do his thing. That was what Mother got across to us, though we recognized it, too."

"Still, your mother didn't exactly bow to his will, did she? There were fights, weren't there?"

"Oh, there were fights between them, all right. Believe me, there were. It seemed for a while as though there would never be an end to them. I think Mother thought he was drinking—and he was. And she didn't like the girls he ran around with, either.

"I don't know. When you look back, you ask yourself what the cause of all of it was, and there were so many things involved. Things were hard then for all of us. Money was *such* a problem for a long, long while. We were dependent on him and must have been an awful burden. But he did take care of us all. He took his responsibilities very seriously back then—and still does. He sent me to UCLA a couple of years, but then I got impatient and cut out and went to business school at Woodbury, here in Los Angeles. I went out and got a job then, and so I was off his back. I continued to live with Mother, but I wasn't dependent on him any longer. Then of course I got married when I was twenty-four."

It is funny. As I sit listening to her, watching her, that youngest Trumbo daughter, the kid sister, is somehow there before me in the living room—more real, more tangible than the woman, nearly sixty, who is telling me about her. So often we are frozen in the roles in which our families cast us. Elizabeth Baskerville is a kid sister still, quiet, retiring, like Dalton physically yet much less assertive than he. It is remarkable.

Her brother must have seemed an almost overwhelming personality to her then.

"You said Dalton was the dominant force in the family," I begin.

"That's right," she agrees.

"Well, did he wield any direct influence on you? What did he talk about? Did he give orders?"

"He certainly never ordered us around, Catherine and me. He would never have done that, never even have tried. But I think, especially with me, he tried to open up our minds. Dalton talked ideas at home. For instance, now they talk about women's lib, but that was old stuff to us. I was *not* raised in a household where I felt discriminated against because I was a girl. We talked all that through. He was for equality. No, we knew discrimination of any sort was wrong—so wrong that we didn't even know who was discriminated against, how they were different. Why, I was fairly old before I even knew what a Jew was.

"I'd say these feelings and this atmosphere came from Mother, too. She was always fair. She really believed in justice. That was why that Hollywood Ten business was so hard on her. We sort of drew together as a family. I think if you talk to Catherine about all this she'll tell you just about the same thing. She's got her own viewpoint, though."

"What's she like?" I ask.

"Catherine? She's a feistier person than I am. She made waves, too, when she was young, just like Dalton did. She was going out with boys Mother didn't approve of. And of course she was much closer to Dalton's age and would talk back to both of them."

"Feisty" was Elizabeth's word for her sister, and I must say it seemed appropriate, for you don't talk to Catherine Baldwin for very long before you perceive in her a certain tough, scrappy quality. Physically she is quite unlike her brother. There is an angular quality to her appearance, just as there is to her personality. In this—a certain undercurrent of contentiousness in her conversation, a certain tartness in her expression—she resembles Dalton most. Seven years his junior, she was nevertheless old enough to come into conflict with him sharply and often over the years they were growing up together. Things never settled down completely between them. There was always that tension, the slight charge to their relationship that is so often there between the first and second child in any family. Until fairly recently, their tempers had occasionally flared at one another. I caught hints of prolonged

trouble between Dalton and Catherine back sometime in the early sixties. But they are on good terms when we meet.

Her house, down the hill from her younger sister's, on a quiet Pasadena side street, is furnished with a certain bold flair. Catherine seems to be a woman who knows her own mind. Elizabeth had offered me a soft drink; Catherine gives me a tall, dangerously brimming glass of Scotch.

"...You've got to remember that drinking, smoking, anything like that was a terribly immoral thing at our house because of the Christian Science thing. This conflict between Dalton and Mother went way back to Grand Junction. I can remember when we lived back there, Mother came in and found crumbs of tobacco in the pockets of his pants. Then she and Dad had a long, very concerned conversation about it. A kid came up to me there one day and said that Dalton smoked. I said that that was a lie, then one day I saw him out on the street with a cigarette in his mouth, and I was horrified."

Catherine is puffing all the while on a cigarette herself and sipping at a drink as she continues on Dalton's conflicts with his mother: "Their battles about his drinking continued until Dalton moved out. I remember when we were living in the house on 55th Street. One night Dalton came weaving and stumbling up the stairs, and I ran out to him to keep Mother away from him. I got him into his room, but Mother was in hot pursuit, and she was there before I could shut the door. 'There's nothing wrong with him,' I told her. And just to prove it was so, Dalton stood up to pull off a sock and fell flat on his face."

That was how it went between Dalton and his mother. The two of them never resolved that particular issue; they simply managed, after years had gone by and events separated them, to ignore it. In her personal conduct, Maud Trumbo was quite conservative, the very picture of a lady. Catherine can remember only one friend of her mother's there in Los Angeles who ever called her by her first name, a woman named Hattie Bell. The two were Daughters of the Confederacy together. (Remember that the Tillerys were from Missouri; Maud Trumbo herself had been born in St. Joseph and her grandfather had ridden with Morgan.)

"I guess you could say that Dalton and Mother maintained a sort of love-hate relationship for years and years," Catherine comments. "She was so proud of him because actually all the things he was

doing—the writing and all—she had wanted to do herself. All of us believed he would write and write successfully, and of course that's just what happened.

"All this will give you some idea why we were so furious at what happened in 1947—the hearings and the blacklist and all. It was an awful shock for us, those damned trials back in Washington—we listened to them on the radio. We were so infuriated at how it was handled. You know, I lost one job because of it. I was at Republic, a dialogue director and a script girl, but when the blacklist started, just being Dalton Trumbo's sister was enough to lose me my job. The name itself was poison around town for a long time. Frankly, I'm glad to be out of the studios, though I loved working in movies while I was at it. I loved working on the set."

I ask her about her relationship with Dalton as she was growing up. "Back on 55th Street, you mean? Oh, up and down, you know. Something I never forgave Dalton for, though, was that he was a terrible tease. Whenever he thought I was getting too carried away with my romances, he'd sit down at the piano and he'd play 'King for a Day' very soulfully. Real soap opera music. And in particular situations he'd hum the tune just to needle me. Oh, I *hated* it. I remember once I had a date with a lieutenant or a captain in the army. I can't even remember much about him now, but I was terribly impressed then. We were sitting down in his car beneath Dalton's bedroom, and we were necking. Dalton made as if to call Mother, then he leaned out the window with this fake gun we had around the house—it was a prop for a play or something, I forget. Anyway, Dalton leaned out the window with it and said, 'If you don't come in this minute, Catherine, I'll shoot!' Well, the captain wasted no time getting away then, and I never saw him again. He *believed* Dalton!"

I laugh. She laughs. It is funny. But she ends with a sigh and a shake of her head. "I guess I did my share of teasing, too," she concedes. "The first time I realized how difficult it was to write and how hard it was to take criticism was once when I came upon him when he was typing up a story to send out to a magazine. I grabbed it up and started reading it, and I didn't like the beginning of it at all. I began acting it out, making fun of it, burlesquing it, and I told him what I thought was wrong with it. It made him just livid. He rushed out of the house in a rage. Next day I happened to check his typewriter, and I found there was a note to me

on it. 'For your information,' he wrote, 'your criticism of the story was right, and I have rewritten accordingly. Now please go to hell.' "

Catherine sighs and again wearily shakes her head, remembering. "I think back on that now, and I ask myself how I could have been so brutal?"

Trumbo knew his share of frustrations. At that point in his life, at the age of twenty-eight and in the midst of the Depression, he was once more casting about for a job. It must have seemed to him then that he really had very little to show for the ambitions that had kept him going so long. After all those years of writing—six novels finished, unpublished, lying in the bureau drawer!—the only substantial piece of work of his which was to see print was the biography of Metternich he had just finished for the Baron. And that, of course, would appear under von Reichenberg's name. Trumbo was by then positively starving for recognition.

And he had begun to suspect, more than just hope, that it might finally be coming his way. He was at that time finishing up what would be his first published novel, *Eclipse*. He believed in it as he had not in the others he had written before. He had been working steadily at the manuscript, watching it grow, since just after he had left the bakery. For the first time in writing fiction he felt completely in control of his material. This was to be a long novel, one that would focus on a single key figure in the town of Grand Junction, a character through whom it would be possible to view the entire town, examining its social structure at a number of different levels. He had to get a job so he could finish the book.

Help came from a man named Frank Daugherty whom he had met while with the *Hollywood Spectator*. Daugherty had written for the magazine himself but worked in the Warner Bros. story department. During a chance meeting Trumbo mentioned to him that he was looking for work, and Daugherty, who knew and liked his writing on the *Spectator*, urged him to come up to the studio. He would, he promised, put in a word for him where he worked. Daugherty did just that. Trumbo was hired in the summer of 1934 as a reader in the story department at a good, steady thirty-five dollars a week. It wasn't much. On good weeks at the *Spectator* even Welford Beaton had paid him better. Still, it

was a way to get on with the work he considered most important. Not for a moment did he suspect—or even wish—that he was beginning a career in films.

Alice Hunter remembers him from those early days in the Warners story department. Then Alice Goldberg, she is now Mrs. Ian McLellan Hunter, the wife of a close friend of Trumbo's, herself a friend and the one person in the industry who has known him longest: "He was the kind of person you noticed immediately. The first day Trumbo came in it turned out he didn't even have money for lunch. He had been working at the bakery, I remember. He talked about that then, talked about it a lot. Even in the story department he was different from everybody else. There was a quickness and a drive to him, and he had such an original turn of mind. He was the most industrious person I ever knew. He was a writer—he talked about that, too—and he knew he would be successful."

A reader in the story department of a major studio may only have had his foot on the bottom rung of the ladder, but he was nevertheless in an important position. The job took some writing ability, but still more literary judgment. Novels, plays, literary properties of all kinds were submitted to the motion picture company's story department to be considered for purchase as the basis of film adaptation. The reader in the story department went through the material, judging it for literary quality and its movie potential, and then he wrote his report, a synopsis, and a comment. If he liked the material and recommended that it be considered further, his report might go three or four pages—otherwise, only a page was needed. One of the first books Trumbo remembers reading and reporting on there in Warner Bros. story department was F. Scott Fitzgerald's *Tender Is the Night.* "I wrote a glowing recommendation for it," he says, "but of course they didn't buy it."

It was in the early fall of 1934, while he was working in the Warners story department, writing early mornings and the evenings, that he completed *Eclipse.* He sent it out once on his own to Dodd, Mead, and had it rejected; then, thinking he might do better with help, he wrote to O. O. McIntyre, a syndicated newspaper columnist with the *New York Evening Mail,* who was a remote cousin of his. Trumbo pointed out the relationship and quickly made it clear he was only writing for advice. He asked if McIntyre could suggest an agent who might be suitable to handle a novel he had just completed. McIntyre wrote back

promptly suggesting Curtis Brown, Ltd. Trumbo wrote to George Bye of that agency, who declined but in turn recommended that he try Elsie McKeogh. She had recently formed her own agency, Bye explained, and might be on the lookout for clients. It turned out that she would be pleased to take a look at *Eclipse,* and subsequently, that she would be delighted to take him on as a client. Thus began a very congenial author-agent relationship that lasted twenty-one years and ended only with the death of Mrs. McKeogh in 1955.

She offered the novel to a couple of American publishers, then heard that Lovat Dickson in England was beginning operations as a book publisher and was looking for manuscripts there. Dickson, born Australian and raised Canadian, had emigrated to London and had made quite a splash there as the editor of the *Fortnightly Review.* She sent him the manuscript, reasoning (erroneously) that it would be easier to sell *Eclipse* to an American publisher if it had already been accepted by an English one. Since Dickson was more or less a Canadian, it seemed likely to her that he would be receptive to young American authors. And so he was.

In a letter dated December 12, 1934, Elsie McKeogh communicated Lovat Dickson's offer to publish *Eclipse* to Trumbo, suggesting that if he accepted she thought she could swing a sale to Macmillan in the United States. Dalton Trumbo never thought twice about it. He wired his acceptance, then followed that up with this letter to her on Warner Bros. stationery, dated December 15, 1934:

> *My Dear Miss McKeogh:*
>
> *I am, of course, awfully pleased that Mr. Dickson is such a coura-geous gambler; and needless to say I hope his example will inspire Macmillans to similar daring. As I stated in my wire, I am willing to abide by any decision you make in marketing* Eclipse, *and you may govern yourself accordingly....*
>
> *Because my grandfather took a vigorous part in the building of the portion of Colorado which the story deals with, I should like to add a dedication to the book. He is a grand old man who cleared the land, fought in the cattle-sheep wars, put in twelve years as a sheriff when fast shooting and hard riding were essential, and is still hale enough to enjoy any slight triumph his grandson might render him. Hence I should like the dedication to read:*

To
My Pioneer Grandparents
Millard and Hulda Tillery
 Will you please notify Mr. Dickson of this alteration, and also any
subsequent publisher?...

<div align="right">

Cordially,
Dalton Trumbo

</div>

Eclipse is a first novel any writer could take pride in. It tells the story of John Abbott, who is, when we meet him in 1926, the most successful businessman in the town of Shale City, Colorado. His department store, the Emporium, the largest between Denver and Salt Lake City, is doing a thriving business. His bank is prospering. He is the most respected and admired man in town. However, Abbott is not without problems: he wants desperately to be free of his wife so that he may marry Donna Long, an intelligent, hardworking woman who is his second in command at the Emporium. The two have carried on an affair for years, and his wife has just discovered the fact; she makes it clear to them she will not step aside. Donna Long dies suddenly, mysteriously. Although the cause of death is given as "acute indigestion," the implication is clear that she may have committed suicide.

 At first Abbott seems to rebound admirably. He comes back from a trip east, which he has taken to get over the shock of Donna Long's death, bursting with ambition and ideas, plans to make the town better. Among them is the new public swimming pool, which he donates when a town boy drowns in the river. The pool is dedicated on the eve of the 1929 stock market crash, and at just about that same time Abbott receives word that his wife, who has now left him, has died.

 He faces the Depression alone. One by one, those who had admired him and sought his favor reject him as his enterprise declines. His bank fails. His department store goes into receivership, and he is kept on as an employee. Physically disabled by a stroke, Abbott has sustained even greater damage to his psyche. Disoriented, bewildered, he is partly to blame for the fire that sweeps the Emporium, the one in which he himself perishes.

 Thus *Eclipse* is a kind of *Babbitt*-in-reverse. Where George Babbitt loses his identity and is all but swallowed up by his own success, John Abbott is made unique by his failure. Among Sinclair Lewis's cast of

Zenith businessmen, Abbott is personally much more like Sam Dods-
worth. He is a personable, honest, intelligent man, one who has good
impulses. In fact, Abbott is the very model of the enlightened capitalist:
a philanthropist, a man who accepts the responsibilities of his wealth.
And it is in this that Trumbo succeeds most impressively in *Eclipse*: he
successfully attacks the business ethos at its strongest point, presenting
Abbott as simultaneously the champion and the victim of small-town
capitalism. John Abbott is no caricature. He is a man of dimension and
depth, a man worthy of admiration, yet even he is crushed by the sys-
tem he serves and the town in which he believes.

This makes *Eclipse* sound more tendentious than it really is. It is no
tract, after all, but a novel and a rather good one: one of Trumbo's pur-
poses in writing it was to present a picture of life in Grand Junction—
the ebb and flow of events, the frustrations and choked passions—and
he does this well. But if anyone should doubt that his primary purpose
was something more than offering a slice of small-city life, he need only
consider a few of Abbott's conversations with Hermann Vogel. Vogel
is something of an amateur scholar and philosopher; he is inclined to
take a coldly intellectual view of things. Of his friend, John Abbott, for
instance: "I think you're going to die of pedestalization, old friend, just
as your archetype did." And his archetype, Vogel tells him, is Napo-
leon, who made the condition clear when he declared, " 'Your legitimate
kings can be beaten twenty times and still return to their thrones. But
I am a soldier parvenu... and my throne rests upon my successes in the
battlefields.' " And so we are invited to see John Abbott as a businessman
parvenu, one whom society and the system say must continually earn
and re-earn his place on the pedestal with new triumphs in the field of
business, ever grander gestures of philanthropy. Let him falter, let him
fail to produce, and he will be tumbled down, never to be granted even
the grace of the hundred days that fate extended to Napoleon.

The great law of what-have-you-done-for-me-lately prevails, and
when Abbott fails to satisfy the insatiable Shale City Moloch, few show
him much pity. Not even his friend Vogel, the immigrant intellectual:

> "I love America," murmured Hermann Vogel. "And I'm not going
> back [to Europe]. Not now, at least. I wouldn't miss the glory of
> these times for anything on earth. It's like—taking a clean bath.
> It's like seeing a dog deloused, with millions of filthy little insects

dropping dead after having made him miserable for God knows how long. That's what is happening to America, my friend. The lice are being driven from the body politic. If an occasional ant like you, or a spider such as I, is killed in the process—well, it's a regrettable affair, but a sacrifice we can cheerfully make. I, for one, am almost exhilarated at the thought."

An old revolutionary image—parasites dropping from the body politic, leaving it healthy at least. In hints and suggestions such as this, and in one overtly radical scene in which a young Red harangues a street-corner crowd and sings the "Internationale" as he is hauled off by the cops, *Eclipse* turns out to be a far more radical novel than we might have expected Dalton Trumbo to write at this time in his life. We see that in 1934, at the age of twenty-nine, he was well on his way leftward.

The protagonist of *Eclipse* was drawn directly from life. W. J. Moyer was a Grand Junction businessman, a merchant who, in nearly all particulars, resembled precisely Trumbo's John Abbott. Moyer's department store, The Fair, closed during the Depression, and his bank failed to open following the 1933 bank holiday. His character, too, was very much like Abbott's—open-handed and generous, he was also given to philanthropy. In fact, he donated a swimming pool to the city of Grand Junction, which was called the Moyer Natatorium, and at the dedication none other than Elizabeth Trumbo, then six years of age, was the first to jump in. In other details, too—Moyer's rocky marriage, rumors of an affair of long duration between him and one of his employees—there are marked similarities. Those in Grand Junction who knew him well maintained that, item for item, detail for detail, John Abbott quite simply *was* W. J. Moyer. And many resented this, for after all, in one important particular Moyer differed from Abbott: he was still alive when the novel was published (he died in 1943 at the age of eighty-three). He could still be hurt.

So some there in Grand Junction counted Trumbo's portrayal of John Abbott as an unkindness to W. J. Moyer. Among them, as it turned out, was his old boss at the *Grand Junction Sentinel*, Walter Walker. Trumbo sent the editor an inscribed copy of *Eclipse* shortly after its publication in England. In the letter which he enclosed, he remarked of the novel:

As for "Eclipse," I hope you will not be angry if you find characters whom you recognize in it. I am convinced that all novels are based in fact, and distorted for fiction purposes to suit the author's particular talent. I do not pretend that any of the portraits in "Eclipse" are real, yet you will, I am sure, see at least some characteristics of their counterparts in real life. I have no apologies although I do confess to some qualms. But the job is done, and it took a long time in the doing, and since I understand that one or two copies have already hit Grand Junction, there is no use trying to keep the book a secret. I am enclosing a copy of the review which appeared in the very snooty London *Times Literary Supplement**—a review which, as you can easily guess, made me extremely happy.

The letter, which he ended, "Sincerely, Dalton," might more frankly have been signed, "Anxiously, Dalton," for Trumbo was clearly uneasy about the reaction of some back in his hometown—and of Walter Walker, in particular.

His old editor, the man who had given him his start as a writer and at the same time encouraged him to consider a career in politics, replied to Trumbo after a month. Writing more in sorrow than in anger, he said:

My dear Dalton:
 . . . It goes without saying that "Eclipse" has caused a great deal of local comment. While in your letter you say you do not pretend that

*The unsigned review in the *Times Literary Supplement* had this to say about *Eclipse:* "In 'Eclipse' Mr. Dalton Trumbo has done more than write a well-constructed, interesting novel of modern life. He has by the implications of his story criticized the ethics, social and commercial, of the average American city. John Abbott, in his later days calls for our pity; but he received none—with a single exception—from the many people he had benefited. Once his prestige began to fail, the men and women he had so unselfishly helped turned against him. And in his treatment of that desertion lies the substance of Trumbo's attack. It is true one of his minor characters, Hermann Vogel, is used to give voice to what are presumably the author's own opinions, but his analyses are less effective than the inevitable development of the story. Mr. Trumbo is evidently an admirer of Sinclair Lewis's novels and may possibly qualify, one day, to succeed him."

any of the portraits in "Eclipse" are real, nevertheless people in a town that is used as the locale for a story or a novel are prone to accept as real any characters which they think they recognize.

Naturally, I have no feeling of anger toward you concerning the book. After all, it was your privilege to utilize your old home town in demonstrating your talents as a writer if you wanted to do so. Furthermore, I might say, in looking at it from a selfish standpoint, that I have no cause to complain because you treat me very decently in the book. Frankly, however, with the personal regard and affection I have for you and the admiration I hold for your talent, I do regret that you saw fit to release this story at this time. The only personality involved in the book that actuates me in saying this is that of W. J. Moyer. Had not misfortunes piled up on him quite so heavily and so frequently, and if he were not alive, this regret of mine would be considerably reduced in volume.

I cannot help but believe that your book was inspired by some real idea or fancied that you or your family had received a great injury from this community and perhaps from the man you call John Abbott, and in which case I certainly do not attempt to condemn your action....

<div align="right">

Sincerely,
W. W.

</div>

The feeling was widespread in Grand Junction that Trumbo wrote his book out of resentment—and in a general way, it is probably true he did. Walter Walker was correct, in other words, in assuming that *Eclipse* was inspired by a feeling that Dalton Trumbo and his family "had received a great injury from this community." But specifically from the man he called John Abbott? This interpretation—still a popular one in Grand Junction—does not hold up. It urges that Trumbo's portrait of Moyer as John Abbott is unsympathetic, which it certainly is not. Trumbo presents him as the most decent man in the town, one blessedly free of the hypocrisy that rules there. *Eclipse* is an honest effort to understand one man and his relationship to the town he lived in.

Why then were the people of Grand Junction so angry at the book and at Dalton Trumbo for writing it? "Really, what they hate about the book is that it's an attack on them," said Trumbo, "on a faithless town.

They could take so much from a man, kiss his ass so soundly, and then just turn their backs on him. And that's what they don't like."

But how did Trumbo settle on W. J. Moyer? Why did he choose to tell his story, and what did he hope to say through it? "Mr. Moyer, I think, served to a degree in the novel as a substitute for my father and the treatment he received in Grand Junction. Being fired, as he was, from Benge's Shoe Store after working there for so many years, well, it came to him like a bolt out of the blue—this was the end! Now I perhaps reacted to this more unfairly than I should have. But as I pondered the fate that befell Mr. Moyer after the Depression—I kept up with it all in the Grand Junction paper—I could realize it was in essence the same thing, a man destroyed. And that possibly accounted for some of my passion against the town itself, which actually had been quite good to me."

Although Elsie McKeogh tried, as any good agent would, to find an American publisher for *Eclipse* right up to, and even after, the date of its English publication, she found none for it. In all, the novel was shown to nineteen houses—and nineteen rejected it. But Trumbo left all of that to her and wasted no worries on it. Instead, he concentrated his attention on writing. In February 1935, he sent Mrs. McKeogh a package of five stories, asking her to handle them for him.

The longest of them (9,400 words) was a story called "Darling Bill," which Trumbo described as an "anti-New Deal satire." Was it political? No, he looked at politics then simply as material. Would it make a good story? What sort of background would it provide to the usual boy-meets-girl formula?

"Darling Bill" is an inconsequential bit of fluff told in letters, clippings, and a press release or two. But the New Deal had made Washington interesting to America, and the *Saturday Evening Post*, always sensitive to such fluctuations on the national seismograph, bought "Darling Bill" at first look. It appeared in the April 20, 1935, issue. By any standard he was doing well for himself. Another of the four stories he sent off to Elsie McKeogh eventually sold: "Orphan Child," a comic piece with a Hollywood movie background, appeared in *Liberty* in the September 7, 1935, issue (reading time thirty-three minutes, thirty-five seconds).

With the acceptance of a story by the *Saturday Evening Post* Dalton

Trumbo was launched as a successful writer of fiction. Much encouraged, he started a full-length political novel in the same vein—light, satirical, one that traded on the same developing interest in Washington politics and New Deal bureaucracies.

And in the middle of that, suddenly taken with a new idea for a story, one that seemed a natural for the *Post,* he took time out to write "Five C's for Fever the Fiver." The trick title is the tip-off: it is a horse-racing story, a saga of bettors and bookies, more or less in the style of Damon Runyon. Again, the story is of negligible worth but clever enough in its way and well executed. "Five C's for Fever the Fiver" is most notable, however, in that it marked the absolute finale to his long romance with Sylvia Longshore. The two had broken up while Trumbo was still at the bakery, but he had never gotten over her, nor over the feeling that he had been cheated by circumstance out of possessing the girl fate meant to be his. Now, suddenly flush with success as a writer, he thought he would make one last effort to reach her and renew their relationship.

"I worked out a system of names in the story," he recalled, "that was to be a message to her wherever she was. I remember that the hotel in the story was the Shore Arms—well, that was part of it, and there were other little details that would have been immediately understood by her—a code, so to speak, with the intended result that she get in touch with me. Well, the circumstances were perfect. The story sold to the *Post,* and it appeared in the November 30, 1935, issue, the week of the Army-Navy game. The Navy goat was on the cover, and my name and the title of the story. Well, I told myself that she had to see that, no matter where she was—and I believe she was on tour. I called her mother, told her what I had done, and jokingly added that if Sylvia had all her teeth and was not pregnant, I'd be delighted to see her. That was when her mother told me that Sylvia had married her dancing partner, a man named Harris, the week before the *Post* came out."

As early as February 1935, Trumbo had written to Elsie McKeogh mentioning Warner Bros.' interest in "Darling Bill" as a possible motion picture property. Nothing came of that, but he did take the occasion to ask her help in getting a good Hollywood agent. And although she made a specific recommendation, in the end he declined her advice. Trumbo defended his choice of Arthur Landau as his Hollywood agent:

"Landau is a robber"—he wrote to Elsie McKeogh—"but he is an effi-
cient and a fearless one, which is exactly what a writer needs in a town
filled with robbers." The dichotomy implied here is interesting. There
was then and evidently would always be a sharp contrast in Trumbo's
mind between his honorable literary work and the work he would do
for the movies. He saw the latter purely as a means to an end—or so
he put it to Elsie McKeogh, when he gave her his reasons for signing
his first modest movie contract: "I wanted a place in which to hiber-
nate, safe from the ballyhoo and the pressure to which the highly paid
movie writer invariably succumbs. In a word, I want the movies to sub-
sidize me for a while, until I establish myself as a legitimate writer."

The contract negotiated for him by Arthur Landau was not quite
as modest as it might have been. Warner Bros., for whom Trumbo had
been working all along as a reader, acknowledged at last—after a novel
had been accepted for publication, and perhaps more important in their
eyes, after two stories had been bought by the *Saturday Evening Post*—
that they had a writer of some ability in their employ. They offered him
what in 1935 was a standard contract for a junior writer: beginning at
fifty dollars per week he would be committed to a seven-year contract,
renewable by the studio on six-month options. Landau, however, was
able to give him something of a headstart. He took that offer, together
with a list of Trumbo's published works, to an unspecified "rival studio"
and got an offer from them. Using this as leverage, they managed to pry
a better deal out of Warner Bros. Finally, he signed for quite a raise in
pay: in moving from screen reader to screenwriter at the same studio,
he went from thirty-five dollars to one hundred dollars per week, with
future salary steps raised accordingly.

In the end, however, it was not dollars and cents but literary consid-
erations that proved stickiest in the negotiations. The usual Hollywood
writer's contract specified that the studio had full rights to *everything*
the writer produced during the terms of that contract. In negotiations
and prior to signing, it was up to the writer to declare exceptions—
works already written, under way, or under contract. Trumbo declared
them at great length and with considerable ingenuity. He called for
permission to write two novels for Lovat Dickson and another that he
specified by title. *The Washington Jitters* (his new political satire). In
addition, he appended a list of titles—two novels and forty-one short
stories—which he declared he had written before the drawing up of

this contract, but which he really had not. Trumbo's comment to Elsie McKeogh:

> This, of course, is deliberate fraud on my part, but it is a fraud which I understand is regularly being perpetrated by Hollywood writers. What I propose to do, of course, is to write stories and affix to them one of the titles I have reserved. In the event the title is not in keeping with the story, I think it would be well for you to write me stating that such and such a publisher has changed the title from the one under which I submitted the story to whatever is considered more appropriate. The letter would cover me at the studio.

And so it was, at the end of October 1935, with all exceptions noted and reservations duly made, that Dalton Trumbo signed a contract with Warner Bros. and became a screenwriter. He had, he thought, marked out his career very clearly before him. There seemed little doubt in his mind then he would someday be a full-time novelist. Writing for films was to be no more than a temporary solution to his money problems, a bargain struck with necessity. The old story, of course. Nobody, it seems, ever went into films with the intention of staying there. The studios were to serve as way stations to the ivory tower, or back to Broadway—yet passengers collected there in Hollywood, and coaches never departed; those who left usually straggled out alone and on foot. Better than most, Trumbo kept his resolve to concentrate on the writing of fiction: between 1935 and 1941 he would publish four novels—this in addition to a full career as a screenwriter (twenty-one screen credits during that same period). But for a number of good reasons, there were no books written after that. Money considerations played a part here, obviously, although it was not simple, crass love of luxury that made an immensely successful screenwriter out of a promising novelist. Those who think that sadly underestimate the very real satisfactions offered by working at the craft, of knowing you are one of the best at a kind of writing so particular in its demands that some of the finest novelists and playwrights of our century have failed dismally at it.

Screenwriting surprised him right from the start by being far more difficult than he had ever expected it to be: "When I began to write, it seemed to me I would *never* learn how. It seemed two or three years

before I had any confidence in myself. The problem of plot, as with most young writers, troubled me greatly before I got used to it and learned how to handle it moderately well, and then I began to feel at home." The *craft* of writing—whether novels, screenplays, essays, or whatever—held a special fascination for Trumbo. And his work always showed great technical proficiency. Even as flimsy a story as "Darling Bill," his first in the *Post,* is made interesting at least from the standpoint of technique because of the epistolary form in which it is cast. So with Trumbo, the early difficulties he experienced in learning the craft of screenwriting would enhance the enterprise in his eyes.

He joined the B-picture unit at Warner Bros., then under the command of Bryan Foy, a producer whose specialty of low-budget production had earned him the title "king of the B's." The idea was to keep the budget for each B picture at about one hundred thousand dollars. Such films would always be, in effect, remakes of successful A pictures. Now, these were not out-and-out thefts, because Foy always wanted the original scripts to be completely rewritten—characters added and changed, plot and situation altered, and so on. In this way, the job of screenwriter for Bryan Foy was that of adapter. Ingenuity, rather than creativity, mattered most. Trumbo remembers that the first time he talked to Foy, the producer confronted him with a problem. He asked him to imagine a man at the bottom of a pit, sixty feet deep, with smooth, vertical walls and absolutely no way to get out: "Can you imagine how you would get him into that situation?" Foy wanted to know. Trumbo thought a moment and said, yes, he believed he could get him into that pit. "Well," said Foy, "if you can get him out, too, then we're in good shape." That, he told Trumbo, was just the kind of thing they wanted on the B unit.

It was a good place to learn the craft. A screenwriter had to work within all sorts of limitations. The one that governed all the rest, of course, was budget. Because the actors and actresses available for such productions were often not much better than semiskilled labor, great emphasis was put on visual storytelling: the fewer lines there were for them to remember, the fewer retakes would be likely. But there were visual limitations, too. Tracking shots were out, as well as any other expensive camera setups. Establishing shots were kept to a minimum—none of this getting out of the car and walking into the door of the building then into the elevator, before you begin that scene on the twenty-third floor. You got

into a scene just as quickly as possible, got through it, and got out of it. As a result, there was a kind of quick, nervous energy to most B films which gave them a visual style much different from that of the A films of the same period. Looked at today, there is a "modern" quality that emerges from the way the old B's were shot and edited, a quality that was created almost wholly out of financial necessity.

Working on the B unit, a screenwriter found his selection of material somewhat limited. Theoretically, Trumbo and his colleagues could have turned down any project; but he wanted to learn, and so he turned nothing down. He did two films at Warner Bros., both of them released during 1936. The first, *Road Gang,* was based loosely on Paul Muni's fine film from 1932, *I Am a Fugitive from a Chain Gang.* This was the source of Trumbo's original screenplay, which was directed by Louis King, then already a veteran of B-picture production (eventually, as many did, he would graduate to A pictures and direct *Thunderhead, Son of Flicka, The Green Grass of Wyoming,* and *Mrs. Mike* before his death in 1962). Trumbo's second film at Warners was *Love Begins at 20.* He shares screenplay credit on this one with a Tom Reed, but in this case it was not a previous film but a play that provided the source— *Broken Dishes,* by Martin Flavin.

Visiting Trumbo's friends was not always so pleasant. Oh, they'd all talk. If they could squeeze you in while they were pressing hard to finish this movie or that, or if you happened to catch them when they had just finished an assignment, then all you had to do was ask and the answers poured forth. There was among them all a common desire to go on record, for each to do what he could to get the man's story told. It made things a lot easier.

Not all of them were doing so well, however. You realized, visiting screenwriters who have been between assignments for years, that for them the blacklist was not over, and perhaps never would be. It was much too easy for us to think of the blacklist as something unfortunate that happened years ago, an episode in the past. After all, Trumbo was working again, and so were Albert Maltz, Michael Wilson, Waldo Salt, Ring Lardner, Jr. But not everybody. If you were on your way up—or worse, on your way down—when the House Committee on Un-American Activities struck, then the odds of ever returning from exile were not

nearly so favorable. For every screenwriter, director, and actor who made it back after the blacklist there were probably four or five who never did.

One of these was John Bright. He had managed to make an honorable living on the fringes of the movie business. He had done some work in television, and he did occasional articles and reviews for some of the smaller magazines. But his career as a screenwriter is over when I meet with him, and he knows it.

He lives on a street in North Hollywood, a kind of blue-collar annex to the movie town. He is a tall, ungainly man—pleasant and polite but slightly reserved, and—how to put this? He doesn't quite connect. Or we don't. There are, anyway, awkward gaps in our talk. We jump around a lot.

"Where did I first meet him? That would have been Warner Bros.— oh, very early in the thirties. I was a writer and he was a reader."

They got along well right from the start—and that speaks well for Bright, for at that time he was just about the hottest writer at Warner Bros. He and his partner Kubec Glasmon had blown into town from Chicago, filled with racket lore, bursting with arcane anecdotes of Capone and Bugs Moran, and they had headed for the one studio in Hollywood where that knowledge and those stories were most in demand. Warner Bros.–First National had just finished *Little Caesar* with Edward G. Robinson, and it was a great hit—so great, in fact, that the studio initiated what was to become a whole cycle of gangster movies. And Bright and Glasmon wrote the biggest and best of them all, *The Public Enemy,* the movie which, as brought to the screen by William Wellman, made Jimmy Cagney a star. Bright was a master of the hardboiled; his dialogue was written to be delivered from the corner of the mouth. *Blonde Crazy, Smart Money, Taxi*—they were all big A pictures that helped set Warner Bros.' tough, strident, swaggering image during the thirties and into the forties. And although the two were about the same age, Trumbo was then professionally very much John Bright's junior.

"What was he like then?" I ask him.

"Trumbo? Oh, he was an acerbic, rasping, extravagant character. The way he is today, only more so. Only, no. There was a difference in him back then. He was unhappy. He put some of this in the novel he wrote back then. What was the name of it?"

"*Eclipse.*"

"Yes, that's it. The main thing was, I think, that he wasn't happy with what he had achieved. He thought he should be further along than he was. He was too talented to be just a reader. Anyone could tell that. Most readers played it safe and said no to everything. But not him. They had to notice him because he made these wild recommendations on movie projects—*Ulysses, Lady Chatterley, Candide,* Rabelais."

"And that was how he became a writer?"

"More or less. I mean, he was bound to catch their eye anyway. He was just too talented to ignore. They made him a writer at Warners, then he went on to RKO, and the rest is history. It was hit after hit. You look him up in the book. He's probably got the most successful set of credits of any screenwriter ever to work in the business."

He hesitates then and shrugs, coming to a full stop.

"Did he change much? I don't know quite how to put this," I say, "but when he began getting money, he got his money all at once, didn't he?"

"Oh sure. He was just like anybody else would have been. He'd been a poor boy, after all. I take it you know all about the bakery and his father dying and everything? Well, when he got some money, then all of a sudden he wanted five of everything. He just couldn't get enough of the creature comforts. I remember I visited him once up at the ranch. And he asked if I thought I might get cold. Well, just in case—and he pulls out six electric blankets. Six!"

He shakes his head, remembering, then looks up and fixes me with his eye. "You talk about whether he's changed. He is, believe me, the most unhypocritical man I have known in a town of hypocrites. A strictly no-bullshit character in a town of bullshitters. Also a compulsive man at the typewriter. I suppose you know that. I share the same syndrome with him. When he finishes something he goes on to something else immediately. It's almost impossible for him to take a vacation. That's the way I am myself. When he gets wound up in a project, well, there's just no getting him away from it. I remember when he was living in Altadena and was working on *Exodus.* He called me up and read me thirty to fifty pages of it—on the telephone! Just wanted to get my reaction. That's the way he is.

"Oh, and I think it should be noted—though without any specific names—that if the truth were known, Dalton Trumbo is one of the

softest touches in the world. If anyone's ever got any trouble, they turn to him. Right now he's probably owed thousands by people around town. He's more open-handed than anyone I've ever known. I ought to know. I myself was beneficiary of several legs up from Dalton. That's one reason he's sentimental about me, you know."

"Oh? What...?"

"I helped support his family when he was in prison. But I was just paying him back money I owed him—money he never asked me for. I'm very much in his debt. I always will be. Why, when I came up from Mexico in 1959, and the blacklist was still on, Trumbo got me my first job on the black market. I went on and did four pictures for that producer. I'm not sure he'd want me to give his name even now, though."

The Brave Bulls, a good film produced in 1951, was John Bright's last credited job as a screenwriter. That was the year he was blacklisted. When he was named in testimony by a number of "friendly" witnesses before the House Committee on Un-American Activities, his career (which was even then rather shaky) came to a sudden stop. Although, as he mentions, he did work on the black market and had kept busy since then at various writing projects of one kind or another, his career had never really gotten started again. He worked for a while in the sixties as a kind of combination reader–story editor and literary advisor for Campbell-Silver-Cosby, Bill Cosby's production company.

"That's right," Bright tells me, "one of my first acts as functionary there was to recommend *Johnny Got His Gun* as a project. That's what eventually led to the production of the movie. You know Bruce Campbell? He produced the picture, of course, and Dalton directed. I was the one who told him he ought to do that—that he was the only one who should direct that movie, who *could* direct it. Various other people wanted to do it—Luis Buñuel, for one. But Dalton was the one to do it. I told him that. I told him."

Dalton Trumbo worked less than a year of his seven-year contract with Warner Bros. His work was certainly satisfactory—two pictures in so short a space of time was a very good beginning for a writer on the B unit. What happened? The answer to that takes us back to 1933 and the founding of the Screen Writers Guild. It was formed with no defined political goals and only to establish the role of the screenwriter more

firmly and boost his prestige in Hollywood. John Howard Lawson was the first president of the Guild and was elected by acclamation.

Lawson, who had enjoyed some success in New York with avant-garde productions of his Expressionist dramas, was one of the first playwrights to come to Hollywood when the movies began to talk at the end of the twenties. When he returned in the early thirties, with productions by the Group Theatre and on Broadway behind him, he was committed to the aesthetics of social realism. He was a convinced radical when he was elected president of the Screen Writers Guild in April 1933. In November 1934, he announced in an article in the left-wing theater organ *New Theatre* that he had become a member of the Communist Party. As president of the Screen Writers Guild, Lawson appeared at a hearing of the House Patents Committee in April 1936. He called for copyright legislation that would assure screenwriters greater control over their material. He said that producers were responsible for the quality and content of motion pictures, not writers; they were to blame if movies were bad.

John Howard Lawson's testimony angered not only the movie producers and studio executives but the whole right wing of the Screen Writers Guild as well. A split of some sort had been in the offing ever since the formation of the Guild. Many members resented Lawson's outspoken radicalism and felt, probably with some reason, that he might be using the Guild as an instrument to achieve political ends. This was the occasion they had anticipated. Under a banner of "loyalty to the industry," Rupert Hughes and James K. McGuinness withdrew from the Screen Writers Guild and formed a rival group, the Screen Playwrights. It was embraced immediately by the studio executives as their approved bargaining agent, for they frankly feared the potential power of the Screen Writers Guild. In effect, the Screen Playwrights was from birth nothing but a company union.

Dalton Trumbo's own experience underlines this. He had joined the Screen Writers Guild at the first opportunity, glad to be a member. He was subsequently surprised when the same man who had recruited him for the Screen Writers Guild came by one day with a form for resignation from the Guild which had been prepared and mimeographed right there at Warner Bros. The idea was that he was to resign from the Guild and join the Screen Playwrights. Trumbo remembered: "I refused to resign from the Guild, and they said, 'You will go on your

six-weeks layoff, and then at the end of your six-weeks option period, if you haven't changed your mind, we will drop your option.' So I said, 'Well, why don't I get out now?' And they said, 'Fine.'"

So that was it. He was out of work. That seven-year contract with Warner Bros. that had seemed to assure him such a comfortable living for years to come was now terminated by mutual agreement: "I left Warner Bros., and I've never been back, a little over thirty years. They never have allowed me to darken their door, nor have I *wanted* to particularly."

This marked the beginning of Trumbo's long involvement in the leadership of the Screen Writers Guild. He held on to his membership, though writers all around Hollywood dropped out and joined the new Screen Playwrights, as they had more or less been ordered to do by their studios. The Guild's roster of members dropped in a few months' time from several hundred to about fifty. Because they suddenly felt themselves in need of official support of some sort, the remaining members voted to affiliate with the Authors Guild of America. They went underground. In order to survive, it became necessary to meet in secret and to keep confidential the names of those who stayed on.

This brought charges from the Screen Playwrights and from studio executives that the Screen Writers Guild constituted a conspiracy—and a Communist conspiracy, at that, for such was John Howard Lawson's reputation even then. Were there any grounds to such charges? "It *was* secret," Trumbo conceded, "as secret as we could keep it, because if it were known, you would lose your job. It was that simple. Communists participated in it. Though I wasn't a Communist at the time, I knew people who were. Still, it was not a Communist activity per se—it was a union activity."

This was how it remained for a little over one year, during which time the Screen Playwrights did virtually nothing for the benefit of its membership but rather gave away the few benefits the Guild had gained for writers in Hollywood. However, in 1937 the National Labor Relations Board was founded to deal with just such situations as this. Trumbo was one of those to testify before the NLRB when the Guild moved to challenge the Screen Playwrights—which it did successfully in an open election in 1937. And although they were now no more than a minority group of right-wing activists, the Screen Playwrights managed to hang on to their contract with the studios until 1940, when the

Guild took over rightfully and completely from them. By then, Dalton Trumbo was on the board of directors of the Screen Writers Guild. In this jurisdictional dispute with its political overtones are to be found the seeds of conflict from which the blacklist grew. For in 1944, James K. McGuinness and Rupert Hughes, who had led the Screen Playwrights, banded with other like-minded members of the Hollywood establishment to found the Motion Picture Alliance for the Preservation of American Ideals. This was the vigilante organization that provided the House Committee on Un-American Activities with most of its "friendly" witnesses and went on to maintain and police the blacklist that emerged from the HUAC hearings.

Although fired from Warner Bros., Dalton Trumbo may have felt he had reason to be optimistic, for he was expecting great things of *Washington Jitters,* his satirical novel of New Deal politics. He had completed it in November 1935 and sent the last ten thousand words of it off to Elsie McKeogh then. He had hoped to see it serialized in a magazine, probably the *Post,* but Mrs. McKeogh had another idea. Without informing him of her intention, she simply followed her hunch and sent it out. And so he was quite unprepared when, on January 30, 1936, he received a wire from her that informed him tersely:

MOSS HART WILL DRAMATIZE WASHINGTON JITTERS STOP CONTRACT WILL FOLLOW STOP THIRTY DAYS SECRECY INSOFAR AS HOLLYWOOD CONCERNED AND PUBLICATION OF NOVEL TO FOLLOW THIRTY DAYS AFTER OPENING STOP

Trumbo could not help but be wildly elated by the news. Moss Hart was then well established as George S. Kaufman's new collaborator. The two had done *Once in a Lifetime* and *Merrily We Roll Along,* although their superhits *You Can't Take It with You* and *The Man Who Came to Dinner* were then still ahead of them. If Hart—and presumably Kaufman, too—wanted to dramatize Trumbo's new novel, it looked like money in the bank to him—and a lot of it at that.

A few days later a letter from Elsie McKeogh told him that Alfred Knopf would publish *Washington Jitters* in conjunction with the production of the play. In fact, as it turned out, Knopf reserved the option not to publish the novel at all if there were no play production—or even if it should be produced and prove a flop. The publisher also declined

to offer an advance. But neither Trumbo, nor (unfortunately) his agent, were inclined to read the fine print, for at that point both were excited by the possibility of production by Kaufman and Hart.

For reasons known apparently only to Moss Hart and George S. Kaufman, the playwrights declined finally to do a dramatic adaptation of the novel. This left Trumbo high and dry, thinking at first he might do a dramatization; but that proved impossible, for he had had no experience writing for the stage, and even if he had done an acceptable job it would have been difficult to find backing on short notice for a play by an unknown. So there would be no production whatever prior to publication, and for a brief, miserable period it looked as though Knopf might decide because of this not to issue the book at all. But it came out after all in an attractive edition in September 1936, and by the end of the month Trumbo had written to Elsie McKeogh venting his anger at Knopf for "sneaking the book out on the Coast." He told her he had taken matters into his own hands and was publicizing it himself. In fact, he had hired a local publicist to help him do the job. "Nobody knows better than I that *Jitters* has absolutely no literary merit," he wrote her. "Nor am I particularly fond of personal publicity. But the book came out of headlines, and it can be sold only through headlines. I don't know whether Knopf gives a darn whether or not he gets another book out of me (I fancy he doesn't) but I do know that this is the last time I'll undertake to write a book and sell it too." Not much could be done for it, however, for the last word on *Washington Jitters* from Knopf indicated that returns exceeded sales of the novel by ninety-four copies.

Its hero, Henry Hogg, is the plain man whom everyone is sure could clean up that mess in Washington if he were only given half a chance. Fate provides that half in a rather far-fetched instance of mistaken identity: A signpainter by trade, he is sent to paint the name of the new coordinator of the ASP (Agricultural Survey Program) on an office door in Washington. It develops that there really is no new ASP coordinator, but Harvey Upp, who writes the popular newspaper column "Washington Jitters," doesn't know this. He bursts into the office, finds Henry Hogg there, and interviews him under the impression that Henry is the new coordinator. The columnist is overwhelmed by Hogg's plain speaking; he spreads his name across newspapers all over the country, boosting him as the one man in the New Deal who is talking good sense. One thing leads to another, absurdity follows absurdity,

and before he knows it, Henry Hogg really is the new coordinator of the ASP administration, and he is being hailed around the country as the man most likely to lead America out of the wilderness. In the end, Henry mourns his lost innocence: "I'm not a signpainter any more," he says. "I'm not even a man. I'm nothing but a politician."

Washington Jitters' satire may strike us today as rather obvious, its targets sitting ducks. It is not that it is a bad book, but rather that it is a slick and inconsequential one, and this is what is distressing. For Trumbo to follow a book of real quality and great promise like *Eclipse* with one such as *Washington Jitters* seems an abuse of his talent. Even in the writing of fiction he could not resolve the conflict he felt between the literary impulse on the one hand, and on the other, the desire to influence, to be part of his time—essentially, a political impulse—and to be commercially successful into the bargain. He himself was quite conscious of it. In fact, at about the time *Washington Jitters* came out, he wrote to Elsie McKeogh, telling her:

> Right now I am in somewhat of a literary quandary. I have for years projected a long, serious novel on the bakery in which I spent almost a decade. Then again I have a much shorter novel idea—shorter, perhaps than *Jitters*—satirizing the conflict between the left and the right through the problems of a Henry Hoggish sort of Liberal who eventually encompasses his complete destruction by reason of the fact that he can't decide on which side of the fence to jump. I think it can be very amusing.

There is no record of her response. And for that matter, he never wrote either novel—unless *Johnny Got His Gun,* which opens with Joe Bonham in the bakery, grew out of the "long, serious novel" he wanted to write. In any case, these problems, which are granted only to those who possess both immense writing facility and an artistic conscience, would continue to plague Trumbo for years to come.

By the time he wrote this to his agent—the letter is dated September 14, 1936—the problem was no longer quite so immediate, for he was already under contract again to another studio. His rebellion at Warners in behalf of the Screen Writers Guild actually cost him only some weeks of employment. More or less out of the blue, Harry Cohn

of Columbia called him. Arthur Landau, Trumbo's agent, had put in a good word for him and subsequently arranged a meeting between his client and the head of Columbia Pictures.

Living up to his reputation, Cohn was quite direct when they met. "You're blacklisted,"* he informed him—this was because of Trumbo's refusal to sign an application of membership to the Screen Playwrights.

Trumbo had come to suspect this and said that it was probably so.

"But," Cohn said, "I don't care about blacklists. I'm going to hire you anyway." And he did, in the grand style, raising him from the one hundred dollars per week he had made at Warner Bros. to two hundred and fifty dollars a week at Columbia.

Trumbo did only a couple of films there. The first was the extravagantly titled *Tugboat Princess,* released late in 1936, for which he did not do the screenplay but shared credit for the original story with Isador Bernstein. The second was something called *Devil's Playground,* on which he was listed as collaborator on the screenplay with the Irish writer Liam O'Flaherty and the playwright Jerome Chodorov. In most cases, a shared credit on a motion picture does not mean that active collaboration between two or three writers has actually taken place. It means, rather, that two or three writers have had a crack at a particularly troublesome script before it was judged ready for the cameras.

Occasionally, though, studio executives would place two writers in one room and hand them a single assignment, hoping that that miracle of spontaneous generation known as true collaboration would actually take place. They tried this at Columbia with Dalton Trumbo and William Saroyan. And while it did not accomplish quite what Columbia had intended—no picture was ever produced from the script that was brought forth—still, it proved a memorable experience for Trumbo.

The two of them agreed on one thing right from the start: they would not write about one another. Trumbo told Saroyan that he had noticed that sooner or later Saroyan seemed to write about just about

*The studios' blacklist in support of the Screen Playwrights lasted only about six or seven months, by Trumbo's estimate. But the company union continued to receive favored treatment: "There was no method of adjudication. A young writer would come in, write an excellent script for $200 a week, leave, having made $1,200. A distinguished Screen Playwright would then come on, polish it, fix it up, get $50,000 and total credit."

everyone he knew. And, Trumbo admitted, he had written about a few he had known himself. So he proposed a contract: he wouldn't write about Saroyan if Saroyan would agree not to write about Trumbo. That seemed fair enough, and they shook hands on it.

They sat around the next few days swapping stories and avoiding discussion of the job at hand. Finally, it was Trumbo again who took it upon himself to mention the unmentionable. "You know, Bill," he said, "why don't we decide which one of us is going to write this screenplay? Because together we're never going to get it done. Do you want to write or do you want me to write it? I don't give a goddamn." Saroyan thought it over and decided that he would really rather be out at Santa Anita watching the horses run and placing an occasional bet. That was okay with Trumbo—"a perfectly good arrangement, for he was an extraordinary man"—and he covered for his supposed collaborator and wrote the script on his own.

During the course of this alleged collaboration Saroyan showed up one night at Trumbo's home, the house on Hollycrest Drive up in the Hollywood Hills where he was living with his mother, his grandmother, and his sister Elizabeth. It seemed that somebody had sent Saroyan a baby alligator from Florida and it had arrived in rather sickly condition. Could he keep it in Trumbo's bathtub for a day or two until it got better? They put it in a few inches of water, and although the creature was still moving, it sank immediately. Trumbo decided he had better provide something more for the alligator, or it would surely drown. He put in an upturned pan and placed the alligator up on it where he could breathe. It didn't help much, though, for the next day he got up and checked the bathtub, and there was no sign of life there at all. Not only that, but the alligator smelled suspicious to Trumbo. He got on the phone to Saroyan, who said he would be right over. They looked into the bathtub, sniffed the air together, consulted, and concurred: this was one dead alligator that would have to be buried—and quickly. They wrapped it up and drove to a hill overlooking the Hollywood Freeway, and there they buried it behind are advertising billboard. Finally when they were finished and about to go, Saroyan said they just couldn't leave like that—somebody really ought to say a few words over the grave. And so William Saroyan extemporized a eulogy over that dead alligator, going on at length about the beauty of life in the best style of *My*

Heart's in the Highlands and *The Beautiful People*. It was done only half in fun and was finally, Trumbo remembers, rather moving.

Not long after that Dalton Trumbo moved on to Metro-Goldwyn-Mayer, where he met a girl who worked in the story department named Katherine Trosper. As it happened, she had known both of his sisters in high school. She had learned from them that his family came from Colorado. Well, hers hailed from Wyoming. They must have felt a sort of kinship, rugged, no-nonsense Westerners together, congratulating one another that they weren't really part and parcel of this circus called Hollywood. At any rate, she and Trumbo got on well and began going out together.

"Dalton was a very gallant young man, not sophisticated but very generous. He always did things on the grand scale—he'd take me to Musso & Frank's, the Brown Derby, all the big places. But he wasn't pompous or phony about it because actually he was a lot of fun. He's always had a good sense of humor and has been known as a good storyteller—in a town of good storytellers. There was a great sense of fun to him and to our relationship. It was no great romance. The only thing was, I think it always embarrassed him that I was taller than he."

Her name is Katherine Popper now. She lives in New York City and is married to Martin Popper, an attorney who was part of the team of lawyers who served as counsel to the Hollywood Ten in 1947 and subsequently handled their defense and appeal on the contempt of Congress citation each was handed. This is less of a coincidence than it might at first appear. The two moved in the same social circles long after she and Dalton had stopped seeing one another and he had married. Even after she had moved to New York, going there with the Orson Welles company when he had completed *Citizen Kane,* there were mutual friends, a kind of Hollywood East colony made up of theater people and writers who commuted back and forth between the two coasts. Through these associations she met her husband.

One important factor in her relationship with Dalton was that Katherine had known his sisters earlier in high school. She was in that sense a friend of the family and was welcome at the Trumbo home. The hard

years had left a mark on them all. The Trumbos had withdrawn some-
what. Maud Trumbo, especially, seemed to regard outsiders with suspi-
cion and perhaps a little hostility. But Katherine Trosper was different.
She had known the girls when times were hard. She was practically one
of them.

One of the funniest evenings she remembers with Dalton, in fact,
was not a night out on the town but one spent with the family in which
they were all busily engaged in an important enterprise: "Dalton had
one of those contracts where he was practically under bondage to the
studio. Anything he wrote belonged to them. The only exceptions
made were stories that he had written earlier, and I guess a novel that he
had begun that developed into *Johnny*. He had just written an original
screen story—there was a big market for them then—and he was sure
he could sell it if he could just pass it off as one of those stories he had
supposedly written long ago.

"That was the problem. Here was this sheaf of bond pages, about
twenty or thirty of them anyway, obviously right out of the typewriter.
How could we make it look like something old, something that had
been sitting around in a trunk for years? As I remember, the whole fam-
ily was there, and we did everything to those pages. We sat on them, we
burned holes with cigarettes into them, we applied heat with irons to
yellow them. Everything. And I want to tell you it worked—perfectly!
Not only did it look old enough to fool even Dalton's agent, but the
story actually sold. But don't ask me what it was or to who because that
was thirty-five years ago, and I just don't remember."

He was always working, as Katherine Popper recalls. "During this
period he was very much taken up with supporting his family. He really
felt the responsibility. And the way he took care of it was just to write
and write and write. He was doing screen stories and magazine sto-
ries and working on a novel, plus pulling down his regular salary as a
screenwriter. That was about three hundred and fifty dollars a week,
the way I remember. Not a grand sum, but back then, toward the end
of the Depression, that much money went a long way.

"And as I say, he liked to do things in the grand style. It wasn't just
that we went to all the best places—and we did—but he dressed to
the teeth, too, always very dapper. If he could have gotten away with
it, I think he would have carried a gold-handled cane. And then there
was that car of his. Was it a Chrysler? And he hired a chauffeur."

A *chauffeur*? I am taken somewhat aback. I guess I must have asked her if she were really certain about that.

"Oh, yes," she assures me. "I remember him very well. He used to drive us everywhere and then just be right outside to pick us up. I had reason to remember him because of what happened one night. I had been out with somebody else and got home about two A.M., and I don't know, it looked to me like there was some sort of shadowy figure disappearing around the corner of the house. My date didn't see it, and maybe I was imagining things, but I was all alone there—my father and my brother were both away, someplace, for some reason—and I was scared. My father had been a railroad cop, and he had two billy clubs around the house, all the protection I had. Well, I remember I went to bed that night with one of them in each hand, just rigid with fright. Then, of course, I woke up an hour or two later thinking I had heard a noise, and all I could think of was I just had to get out of there, so I called Dalton and told him I was surrounded. He sent his chauffeur over for me with the car, and I want to tell you I was glad to see his face at my door when he came and got me. I stayed with Dalton and his mother and sisters for a couple of weeks—until my father and brother got back."

Her brother was Guy Trosper, then a story editor at Goldwyn Studios, who would himself later become a successful screenwriter with important films to his credit such as *Birdman of Alcatraz* and *The Spy Who Came in from the Cold* before he died in 1963. "My brother," she declares, "was a *real* maverick. He wanted nothing to do with Hollywood, except to do the work and get paid. My brother and Dalton didn't really like each other, but Guy respected Dalton's craftsmanship all through his life. He used to say, 'They're not paying him all that money for his personality.' "

"What did he mean by that?" I want to know. "What sort of personality did Trumbo have?"

"You've got to keep in mind," she says at last, "that there are many people who dislike Dalton violently. He could be vicious. After all, he is well known for his sharp tongue. There was that famous encounter of his with Howard Fast where he was just so devastating."

I ask her to tell me about it.

"Well, the way I remember it, it was at a party here in New York that was given for Howard Fast right after he had come out of jail for

serving three months on a contempt charge, and maybe he was carrying on a little about the hardship of it all. Anyway, that's what Dalton, who was there at the party, seemed to think. This was during the blacklist. He began to cut him up verbally, just slice him to ribbons. 'A three-monther?' he said to him. 'You call *that* a sentence?' Oh, the scorn, the contempt! I must say it was done with class and was just devastatingly funny."

Eventually, Trumbo's newfound taste for luxury proved his undoing. The bill for that chauffeur-driven Chrysler and all those nights out on the town came due with a vengeance when he woke up one morning in the latter part of 1937 and found himself about ten thousand dollars in debt on a salary of no more than three hundred and fifty dollars per week. He was in trouble, and he knew it. He would have to sue for bankruptcy. The course he undertook, however, was one usually reserved for corporations, whereby they are permitted to stave off their creditors on a short-term basis until they can reorganize and pay off their debts. He then had his regular weekly M-G-M paychecks sent into the court. But if he had depended on them alone to settle the debt, he would have been paying on it for months and have had nothing in the meantime for himself and his family to live on. That was clearly out of the question. Instead, he did what he would do again in ten years' time when he was next threatened with economic extinction: he went to his typewriter and wrote his way out of trouble. He produced original screen stories and discharged the debt in record time. The judge who had presided over the case told him then that Trumbo's was the only instance in his jurisdiction in which this course, once undertaken, had ever been completed by an individual. Trumbo's comment on the entire affair seems characteristic: "You don't learn the value of a dollar by being poor. You learn the value of a dollar by being rich. The Rockefellers understand the value of a dollar far better than I ever will." He was without money for a very long time, and then suddenly he found himself quite dramatically with it—and he went on a spending spree. Never again was he forced into bankruptcy, although we shall see that on one later occasion, he came close. Still, his attitude toward money had not materially altered since that near-disaster. He would probably have agreed that he had not yet learned the value of money, except that

he had become profoundly convinced that it was good to have a lot of it. As much as possible, in fact.

In any case, he was in rather shaky financial shape when, toward the end of 1936, he met Cleo Fincher and began the unusual, dramatic, and nearly violent chain of events that culminated in their wedding many months later. Katherine Popper recalls very well the sudden change in him: "One time we had a date, and he called me up and said he'd like to see me and talk. It turned out that he wanted to break the date. He told me that he had met this extraordinary woman who worked in a drive-in, and he didn't think he wanted to see anyone else again. This was Cleo, of course, and as far as I know, this—his love for her—has been his one fidelity through it all."

CLEO AND JOHNNY

Enter Cleo. I don't know quite what I expected Trumbo's wife to be, but still, I was surprised when she first appeared at the gate to let me in. That time and every time afterward she was preceded by a great commotion of dogs. There were two miniature schnauzers, mother and son, I found out, always yapping; and a slower, deeper-voiced, and terribly earnest Irish setter. First would come the noise of the dogs, followed then by Cleo—smiling, quiet, contained—opening first the door and then the gate to admit me.

If, at first, she was somewhat restrained in her greeting, well, it was understandable. I was entering into their home at a time when Trumbo seemed to be in almost immediate danger of death. Following his pneumonectomy and heart attack, during the time when it was difficult for him to talk and even hard to breathe, it must have been a kind of victory for them all when he woke up each morning. And then I came with my tape recorder. I probably seemed to them during that first visit to be robbing him of the little strength he still possessed.

And so she would show me in, and down the stairs to his room below, along the way accepting my assurances that I would not stay too long, that at the first sign of his weakening, I would switch off the tape recorder and be on my way. Accepting them, perhaps with a grain of salt, for she had seen that eager look in my eye and knew the nature of writers who appear with tape recorders in their hands: they stalk as predators and attach themselves as parasites. But once, in fact, I did

leave early, and that seemed to establish my credit with her. I *am* on her side, and I want her to know it.

For a woman now living in such comfortable circumstances, Cleo Trumbo has had her share of hard times, and not all of them came to her by courtesy of the House Committee on Un-American Activities. By the time of that particular ordeal, she was used, not to say inured, to trouble. A native Californian, she was born Cleo Fincher in Fresno on July 17, 1916. The Finchers, an old family in that territory, once owned the land on which Friant Dam, outside Fresno, was built. They were prosperous, middle-class people, but her parents were divorced when she was quite young. Her mother, Elizabeth MacElliott Fincher, kept the children, and looking for some sort of independence, coached them into a kind of kid vaudeville act. Brother Dick played the violin as his sisters, Georgia and Cleo, did tap and ballet numbers, and then a song by Georgia and an acrobatic solo dance by Cleo. It went over pretty well. They played the local movie houses (in the twenties, almost all theaters ran a few vaudeville acts in before the feature), and others in small and middle-sized cities in the same general area—Madera and Tulare among them, as well as clubs and lodges, such as the Elks and the Shriners. They were going great guns, in fact, up until the child labor laws were passed in 1927, and the Fincher kids were thus put out of show business. Cleo's stage career ended then and there at the age of eleven, but her brother and sister went right back to work at it as soon as the law allowed—Georgia in a song-and-dance act that eventually won her work as a dancer in the M-G-M musicals of the thirties and forties; and Dick into music, in which he worked in and around Fresno, until his untimely death in an automobile accident in 1943.

Following the act's forced retirement, Mrs. Fincher took the children and moved from Fresno to Los Angeles in order to be near her brother, who was operating a laundry in Pasadena. Cleo went to school there, quite independent, more or less bringing herself up: her mother was working, and by the time Cleo started Polytechnic High School in Los Angeles, both her older brother and sister were out pursuing their own careers as teenagers. It was while she was in high school, at the age of sixteen, that she went swimming in the ocean off Santa Monica

Beach and nearly drowned. The undertow got her, and when at last she was pulled out, her lungs were filled with water. As a direct result, she developed empyema, an accumulation of fluid in the chest cavity which led to surgery, the collapse of her left lung, and a six-month stay in Los Angeles General Hospital. The whole experience left quite an impression on her: it wasn't just the scare she got when she came so close to drowning; it was also the painful recuperation and the long, depressing stay in the hospital. She remembered in particular how, in the open ward, they would place screens around a bed, and that would mean its occupant was dying. When they did that, a pall descended over the place as they waited for the screens to be removed and the corpse to be carried off: it was just a matter of time.

Those six months that Cleo Fincher spent in Los Angeles General Hospital were in 1932. That was Trumbo's last full year at the Davis Perfection Bakery at 2nd and Beaudry, only blocks from the hospital. She returned to high school, still in some pain and carrying drainage tubes in her back to keep her left lung clear. All in all, she lost nearly a year in the episode and graduated from high school in 1933, the year Trumbo left the bakery. And so the two came out into the world more or less at the same time, at the very bottom of the Depression: he to try to earn his living for the first time as a writer, and she as a waitress at a small drive-in out in the San Fernando Valley. The drive-in was operated by two sisters, friends of Cleo's who were not much older, Lucille and Wilma Thompson. The girls made a valiant struggle of it, but the Valley was comparatively empty in those days, and after not much more than a year the stand failed. The three of them went to work then at McDonnell's Drive-In at Cahuenga and Yucca. That was where she was working when Trumbo met her.

During my second series of visits to Trumbo, months later, I found him much improved. He was working again, doing a screenplay—an adaptation of whatever for whomever. And with that, he had gone back to the bathtub, spending long hours as he had for a long time past in a tepid soak, writing in longhand on a tablet propped on a writing stand balanced across the tub. When he wasn't working, he spent a lot of time in bed, for he was still recuperating, had a long way to go, and knew it.

Cleo was consequently more relaxed and open when she met me at

the gate, her smile a little broader, her voice a little surer. Was it that time she wore tennis clothes? It was then, or a day or two later—during that second visit anyway. When I saw that she was on her way to or from the courts down at the bottom of the hill, I knew that Trumbo was much, much better. That made it official.

He seemed so, too. I remember I talked to him in the bedroom. His voice was stronger. He seemed to be much more in control of his breathing; there were none of those distressing pauses as he would sit for a moment or two, waiting to catch his breath before resuming. The talk flowed on smoothly for an hour or two. Miscellaneous stuff, mostly—questions I had brought back with me from Grand Junction, points I wanted cleared up after further reading through his correspondence and papers which were on file at the University of Wisconsin. We covered the waterfront.

Finally, toward the end of the session, when we had already agreed we were about through for the day, he said, after a long moment's pause, "Now, there's one area that you haven't touched upon, the only area on which I would place a compulsory approval by my wife—namely, the story of our courtship and marriage. I don't think you know anything about it."

"I know a little about it," I said. I had heard sketchy details from a few of his friends, people I had interviewed already.

"Well, if you know a little," Trumbo replied, "you should know all. But since it does deal with her, I think she ought to be able to read it."

"I think that's fair," I said. We had decided between us that there would be no manuscript approval by him. Accuracy would be my responsibility. Better a few errors of fact than to write a book intended first to please its subject. This proviso on the material dealing with Cleo and their courtship was, then, the only exception he made to our original agreement. And, as I said to him then, it seemed only fair.

Irving Thalberg had told the head of his story department, Samuel Marx, to go out and get him the best writers there were, and Marx had taken him at his word. That was how it happened that during the mid-thirties, the time they refer to at Metro-Goldwyn-Mayer as the Thalberg era, some of the brightest and wittiest people in America came to work at the studio. Seated at the writers' tables in the M-G-M

commissary on any given afternoon back then, you might find the likes of Dorothy Parker, Anita Loos, S. N. Behrman, George S. Kaufman— and perhaps in one corner, a little in awe of the rest, Dalton Trumbo and his friend Earl Felton.

That, at least, was where the two were one day in the spring of 1936 when they had a conversation that changed Trumbo's life, eventually for the better—though for a while the issue was in doubt. At that time he was living in the house in the Hollywood Hills with his mother and his sister Elizabeth, who then was having her brief fling as a student at UCLA. Trumbo was ill at ease, discontent, still waiting, at thirty-two, for his life to begin. He was drinking too much, and he knew it. And as it happened, he did a good deal of that drinking with Earl Felton, a fellow B-movie writer there at Metro who was physically handicapped and possessed of a fierce wit that was as often as not turned against himself. On dismal, drunken occasions, Trumbo had poured out his discontents to Felton and had confided that what he really wanted most was to get married.

That was where they stood when, that day in the commissary, Felton asked him if he were still sure that he wanted to get married.

Trumbo said he was, and then began to hold forth once again on the many advantages in it he saw for himself.

But Felton cut him short. "Never mind that now. I think I've found the girl for you."

Involuntarily Trumbo glanced around the commissary, as though he half-expected to have her pointed out to him from where they sat. "Who is she?" he asked. "Where?"

Felton frowned. "Never mind. Trust me. We'll go out tonight— drinks and dinner—and then I'll take you to her and introduce you."

That was it then. Trumbo knew enough not to press his friend. The night proceeded just about as Earl Felton had outlined it until, after dinner, they set out to meet the young lady Felton had picked out for him. Much to Trumbo's surprise they drove to the McDonnell's Drive-In, then at the corner of Cahuenga and Yucca.

"Here?" Trumbo asked.

"Here," Felton said firmly.

In 1936, the drive-in restaurant—complete with carhops, curbside service, and short-order menu—was a fairly recent innovation. There

were not all that many of them, even in Hollywood, and the McDonnell's at Cahuenga and Yucca, part of a small but successful Los Angeles chain, was one of the few all-night stands open in town. It drew heavily from the surrounding area where there were film studios and low-rent court apartments in which extras, bit players, technical people, film people of all kinds were living. And so McDonnell's was a lively place with a lively regular clientele. It may not have been Musso & Frank's, but it drew its share of famous names and faces, especially late at night as they trailed in for the coffees and hamburgers which they hoped would sober them up. It had become a favorite last stop for Earl Felton.

He knew his way around it. He waved a greeting to a couple in another car as he pulled in. Then he flashed his lights for service. A carhop two or three cars away called over that she would be right there. Felton pointed her out to Trumbo as she walked quickly away in the direction of the service counter. "See her?" he asked. "That's the girl for you."

It was Cleo Fincher, of course. When she came over to take their order Trumbo saw that she was really a remarkable girl. Good-looking, yes, young, trim, and pretty—but something more. She knew how to handle herself. Trumbo joked with her when Felton introduced them. Cleo came back with retorts that showed she was bright enough to parry with the best of her customers, and she had been given plenty of practice. She was the favorite there at McDonnell's Drive-In. Working nights—from six to two or eight to four—she attracted the attention of the men, who usually said they might be able to give a pretty girl like her a big break in the movies. They buzzed around her like flies around the sugar bowl. A well-known cinematographer seriously offered to arrange a screen test for her. A slightly sinister movie stunt man frightened her by making a habit of trailing her home. She was propositioned almost nightly.

But not all the attention directed her way was of that sort. Cleo was—and was still when I met her—a very likable person. The late director Frank Tuttle and his wife, Tanya, for example, were frequent visitors to McDonnell's. They came to know and like this nineteen-year-old carhop well enough to invite her to dinner at their home on one of her Mondays off. Cleo had told Tanya Tuttle, who happened to be a Russian-born dancer, that she herself had done some dancing when

she was younger. The Tuttles were intrigued and invited Paul Draper, the dancer, to the same dinner, to see how the two would hit it off. In effect, they were matchmaking. But it didn't take. Cleo was much less sure of herself than she seemed at the drive-in, her turf. She was slightly intimidated by Draper and the Tuttles.

And so with all the attention she had been receiving at the drive-in Cleo Fincher was used to glib and impetuous plays for her. Even so, Trumbo surprised her, even astonished her, when he asked her to marry him at the end of that first night's visit as she came to collect the door tray from Earl Felton's car.

Marry him? What was with this guy, anyway? Nice enough looking and well dressed. He didn't *look* drunk. It didn't seem like a joke; he seemed absolutely serious about it. Cleo could only conclude that this guy who had been introduced as Dalton Trumbo was crazy. Literally that.

Trumbo did not do much during their courtship to persuade her otherwise. He began showing up every night at the drive-in in that chauffeur-driven Chrysler Imperial of his. And the more he persisted, the more certain she became that he was insane. Every night he appeared he put the question to her again.

"Why don't you at least give it some serious thought?"

"Oh, sure."

"You're not married now, are you?"

"No. I told you I wasn't."

"Then marry *me*."

"Be serious."

"I *am* being serious. Can't you tell? Look, at least let me take you out next Monday night."

"I can't. I've got a boyfriend. I told you that. I'm going out with him."

It was true enough. She did have a boyfriend. Nevertheless she had told herself in the beginning to pay no attention to Trumbo no matter how persistent he might become, no matter how he protested his love, and no matter how ardently he declared his wish to marry her. She refused to believe any of it. She was sure he was crazy.

Lucille and Wilma Thompson, her friends from that early independent effort at a drive-in in the Valley, were a good deal less certain than Cleo that Trumbo was mad. They kind of liked the guy. He was, in any case, a lot nicer than that brash bartender-restaurant manager Cleo

had been going out with. They advised her to look more favorably upon Trumbo. Maybe he really did want to marry her. Maybe he wasn't as crazy as she thought. The Thompson sisters became Cleo's advocates there at McDonnell's Drive-In. They encouraged him, passed on to him information about his rival, and kept him up to date on the progress of his own petition. And to Cleo they argued in his behalf.

Just like the cameraman who had preceded him at McDonnell's, Trumbo became convinced that Cleo had a future in motion pictures; that if she were only given a screen test and her special quality captured on film, then a studio—M-G-M, as he imagined it—would certainly see her potential and sign her to a contract. He told her this. She told him to forget it; she'd heard that one before. But he persisted, and she kept turning him down. In all, he must have brought it up to her a dozen times and just as many times she turned him down. Finally, in utter exasperation, she agreed to meet him for the proposed screen test. She was never serious about it because she was sure he wasn't serious about it. But he was! He lined up a cameraman and, on the appointed date, had him come to the home of a married couple whom they both knew, because he didn't want the test to seem to Cleo "a prelude to seduction." The big night came. Trumbo had worked up a scene for her. The cameraman was ready. They waited. She never came.

Anybody else might have been discouraged by this—but not Trumbo. He redoubled his efforts. He wanted to win her away from this "boyfriend" of hers, whoever he was, and if possible, to get her to leave the drive-in and work someplace else—practically anyplace else where she wouldn't be so completely available to others. As long as she was there at McDonnell's, anybody in Hollywood could talk to her for the price of a hamburger. What if Clark Gable should happen in and turn on the charm? What chance would Trumbo stand against him? He had to get her out of there somehow.

One night he put it up to her. "Look," he said, "have you ever thought of leaving here? Taking some other kind of job?"

"Leave the drive-in? But I like it here."

"Well, I know, but you don't expect to work here all your life, do you?"

"No, maybe not. But where else would I work? I don't know how to do anything, really, except what I'm doing here."

"I've been thinking about that," Trumbo said. "How would you like to go to secretarial school?"

Not very much at all, as it turned out. He urged it upon her, offered to pay the tuition, told her she ought to think about making some sort of future for herself. Again, she turned him down time after time. But again, too, Trumbo persisted. He kept insisting soberly that she think of her future, that she take the long view (when all the while what he was most interested in was getting her away from all those hungry wolves at the drive-in). In the end, she had to admit that it was probably practical to get job training of some sort, and secretarial seemed as good as any. So she gave in at last and agreed to go.

It was a disaster. In a way, it could hardly have been otherwise, for to work at all, it meant that Cleo had to get by on three or four hours' sleep each night—up at seven to be at the school by eight; there until twelve; perhaps a nap in the afternoon; and then, depending on her shift, in to work at McDonnell's Drive-In at four or six P.M. to work until two or four A.M. She told Trumbo she got "sleepy." Not surprising. What is surprising is that she managed to stick out the schedule for two weeks before deciding she really didn't want to be a secretary, anyway, and paying him back the money he had invested in her future.

The screen test was one bit of difficulty; the secretarial school was still another; but the biggest difficulty of all for Trumbo—and for Cleo, too—was Hal. Call him that. It is as good a name as any for her boyfriend, the front-runner, the suitor who was there long before Trumbo appeared on the scene. He had established prior rights—had staked out his claim on Cleo. Just as Trumbo did, Hal wanted to marry her. Lucille and Wilma Thompson quite frankly did not like him. They were suspicious of him from the start. He seemed to be not quite what he said he was. He had declared he wanted to marry Cleo but then delayed, saying he was waiting for his divorce to become final. Then, however, when he learned about Trumbo as a competitor, he was suddenly eager to marry her; the time was suddenly just right.

Unwittingly, Trumbo forced the issue. At this point he had been courting in his crazy fashion, receiving little or no encouragement, for better than a year. He had never even had a date with her. He kept pressing her to go out with him. Cleo, feeling she had let him down on the secretarial course and growing fonder of him as she got used to him, agreed at last. They would meet at the Pantages Theater on Hollywood Boulevard for the show and go out to dinner afterward. Given even

this much encouragement, Trumbo was suddenly certain that he could win her. But somehow Hal got wind of the upcoming date and, feeling the pressure from his rival, he told Cleo that he had just gotten word that his divorce decree had come through and the way was now clear for them to marry. He wanted to take her away immediately. This was what they had been waiting for, wasn't it? Well, yes, but now Cleo was a little less certain about wanting to marry Hal than she had been before. Still, she allowed herself to be persuaded, cajoled, and finally pushed into it—she was only nineteen, after all—and the two drove off to Reno to get married. That was the day of Trumbo's date with her at the Pantages. He waited for her for an hour and a half in front of the theater and finally went to McDonnell's to find out what had happened. Then he heard the bad news: Cleo had gone off with Hal. Trumbo later realized that if he had not made that date with her, she would probably not have been stampeded into marrying his rival.

Cleo came back, already a little less than ecstatic about her newlywed state; she feared, and had begun to suspect, that she had done the wrong thing. Perceiving this, Lucille Thompson called Trumbo aside one night at the drive-in and confided her own misgivings: "You know," she told him, "that divorce of his certainly came through at just the right time for him. I've got a suspicion that he either didn't need to wait for the divorce in the first place and was just stringing her along. Or, when he heard about you, he got scared and told her the decree was final just to get her married to him, which would mean they got married early, and it's not really legal."

"Thanks," said Trumbo. "I'll look into it."

He did. He hired a private detective who did some checking back in Michigan—Hal was from Detroit—and when the report came through, it confirmed what Trumbo had suspected: the divorce was not yet final, and so Cleo's marriage was invalid. In the meantime, Trumbo did a little detective work on his own. Although the two rivals knew something about one another, they had never met, never even seen each other. Trumbo took advantage of that, and began hanging out at the small bar and grill that Hal managed in Hollywood. Inevitably, the two fell into conversation. Soon they were having long, convivial, philosophical talks that Trumbo managed to steer in the direction of marriage and domestic life.

"You're not married?" Hal asked him one evening. "I don't know but what you're better off. I've been married twice—I'm married right now—and I'll tell you something, you just can't keep them happy." He went on in that vein, unburdening himself to this sympathetic stranger, making plain what Lucille had hinted to Trumbo: that Cleo was not happy with her marriage. In the course of their talk, Hal also let slip where the newlywed couple was then living (information Trumbo was tempted to use but never did).

From there, Trumbo would return to McDonnell's and compare notes with Lucille and Wilma on Cleo's emotional state, for she would never complain to him. Finally, knowing all that he did about her feelings and armed with the information he had received from Michigan on the divorce, he brought Cleo around to the back of the drive-in one evening and told her what he had learned. "Now look," he said, "this guy may be fine, but you are *not* legally married to him. He married you three months before he should have—and if you stay with him, you're going to be stuck with him. From what I hear, you're not so happy with him. You should be stuck with me."

He was persuasive. He was eloquent. His frank intention was to separate them, to woo her away from her supposed husband, and so he suggested to her a cooling-off period. He proposed that he would rent an apartment for her, for which she alone would have the key, and there, at least theoretically free from emotional pressures, she might coolly and wisely decide with whom she preferred to spend the rest of her life. Trumbo was betting that it would be with him. Cleo agreed to try it. She left her would-be husband without notice, quit her job, and moved secretly into the apartment Trumbo had provided.

The next day he telephoned her there repeatedly but got no answer. Finally, he went to the drive-in and asked her friends if they had any idea what had become of her. With that, Lucille took him aside and upbraided him for what he had done—or rather, for what he had not: "You fool!" she said. "You shouldn't have left her alone like that. Don't you understand anything about women? The girl was lonely, confused. She got up in the middle of the night, got dressed, and walked back home to Hal. What the hell did you expect her to do?"

"You're right, of course," he sighed. "I can see that now. But what am I going to do?"

"Well, whatever you do, don't give up. You don't think she would have agreed to that apartment idea in the first place, do you, if you weren't winning her over? Of course not! Keep after her!"

Christmas was coming—Christmas 1937—and it seemed to Trumbo that he had to win her away from Hal by then, or his cause would be lost absolutely and finally. Cleo's fault in this was her virtue: she was intensely loyal. She knew by now that she wasn't legally married to Hal; she had also come to realize that she didn't even like the guy much; but she felt that since she had made her commitment to him, it was up to her to honor it. Trumbo understood all this, and he was afraid that if she spent Christmas with Hal it would put a "sentimental seal" on their relationship. The two could then repair the marriage at their leisure and go through the ceremony again, and that would be the end of Trumbo as far as Cleo was concerned. He felt it was now or never.

And so with Cleo once more back at McDonnell's, he mounted his final campaign, choosing a day on which she reported at six P.M. to work until two in the morning. He put Lucille and Wilma Thompson on notice and asked them to let him know as soon as she showed signs of weakening. Every half an hour that day Cleo got a telegram pleading his case, accompanied by a gift—"not sumptuous or lavish but something chosen to please her." Each time a telegram came, it was brought directly to her by a kid from Western Union on a bike; business was slow at the drive-in, and as the night wore on and the telegrams piled up, Cleo found herself going broke tipping the messenger boys. In the meantime, Trumbo had gone to the house of a friend, Morton Grant, who lived in the Valley, determined to wait it out. There, about ten-thirty that night, he got a call from Lucille Thompson, telling him to come right away—not to waste a minute, for Cleo at last saw things his way. He ran out and jumped into his car (on such a personal mission as this one he was driving the Chrysler himself and had given his chauffeur the night off) and roared off into the night—in the wrong direction. He was in Burbank before he discovered his error, then had to backtrack to Cahuenga, then down to Yucca, where he arrived at the drive-in many minutes late.

Wilma was motioning him to park his car at the rear in a dark area of the lot. Then she ran into the women's rest room, and they emerged, Lucille and Wilma, one on each side, bringing a weeping

Cleo across the parking lot to his car. That was that. She had given in completely. Distraught, confused, hoping for the best, she surrendered to him.

This did not mean, however, that there were not trials to come. That very night, after driving and talking for hours in the car, Cleo and Dalton went to Wilma Thompson's for a late supper, then left for a little while to buy some things at an all-night market. They returned to Wilma's with groceries to learn that Hal had been there in their absence, brandishing a pistol, demanding to know where Cleo was. He had gone through every closet, looked under the beds, and left, promising to return. He was a very angry man—not without some cause.

Cleo had no clothes, no bags, nothing but the brief, military-cut uniform she had worn that day to work. In it, she went with Trumbo late that night, and they took rooms in a Hollywood hotel. He could hardly take her home to his mother, and he was not about to leave her alone again. She had to have something to wear, of course, and so the next morning Trumbo called his business manager, filled him in on what had happened, and had him buy and bring a couple of dresses so that she would have something, at least, to wear out of the hotel. He took her out in one of them and bought her a wedding ring, demonstrating that his intentions, at least, were honorable. Then on to a department store to buy a wardrobe for her. There—perhaps she was growing ill with flu, or more likely it was just the emotional strain of the events of the past twenty-four hours—Cleo fainted. Trumbo took her back to the hotel and nursed her back to health as best he could over the next few days, running into M-G-M from time to time to convince them he still worked there.

That was where he was one afternoon when the guard phoned him from the gate to tell him that there was a guy patrolling the area, asking for Dalton Trumbo. The guard had asked the guy—it was Hal, of course—what he wanted with Trumbo. "I'm going to kill him," Hal told the guard.

"What do you want me to do, Mr. Trumbo?" the gate guard asked. "Shall I call the cops?"

"Uh, well, no. See if you can get rid of him. Tell him I'm not here today or something."

That day it worked. Hal left. Trumbo knew that next time it might not. The only thing to do, it seemed, was to get out of town until Hal

cooled off. (He was a deputy sheriff of Los Angeles County and enti-
tled to carry that gun wherever he went.) And so they left, the three of
them: Trumbo thought, under the circumstances, it would be best if
his chauffeur, Harvey, accompanied them; Harvey thought, under the
circumstances, it would be best if he took along a gun, which he did.
Only a .22 rifle, but it rode next to him on the front seat all the way
on the drive down to La Jolla, just in case Hal should show up with
his gun. On their first night in La Jolla one of the bus boys at the hotel
where they were staying developed a sudden crush on Trumbo's Chrys-
ler and decided to take it out on a joyride. In the process, he wrecked
it. They chose not to press charges. After all, the bus boy was not much
more than a child, and besides, Cleo and Trumbo were feeling so guilty
by that time that they hadn't the heart to prosecute anyone. While they
waited for the Chrysler to be repaired, Trumbo took her to visit his
sister Catherine, who was living in San Diego with her then-husband,
William Baldwin. She was the first member of the family to meet Cleo,
and the two of them hit it off marvelously well.

About a week elapsed before the car was ready. That, they felt, was
just about right for their return. They drove back to Long Beach and
registered at a beach hotel. There they continued the long, hard process
of meeting and winning over the family, one by one. It was about that
time that they took Cleo's mother out to dinner and provided her with
her first glimpse of the man who had turned her daughter's life upside
down; Trumbo passed muster. The not-quite-newlyweds spent Christ-
mas with friends—among them, Earl Felton, the man who had started
it all—at a little apartment they had taken in Hollywood. And finally,
after Christmas, they made ready for their severest test: meeting Dal-
ton's mother.

Maud Trumbo had known, or strongly suspected, for quite some
time that there was a Cleo in her son's life. He had confided noth-
ing, but there were hints and clues that only one less acute than she
would have missed. There were, first of all, a year and a half of eve-
nings spent at McDonnell's Drive-In. She must have been aware, if
only from Dalton's desperation during the latter months, that there
was something important happening in his life. And then that sud-
den departure and the trip to San Diego—that must have made her
curious. If all this weren't enough, upon their return, Dalton had been
unwise enough to call for service from the same laundry his mother

used. Inevitably, there was a mixup, and some of Cleo's things showed up in Maud's bundle.

So when the invitation came to her from Dalton to come to his apartment for dinner "to meet someone," she was well primed to expect something. Nevertheless Cleo surprised her. Although rather straitlaced, Maud Trumbo knew quality when she saw it. The dinner went beautifully. Dalton explained their situation and made sure his mother understood the reasons behind it—Hal, the invalid marriage, all of it. She understood, all right. Toward the end of the evening, with Cleo out of earshot, Maud took her son aside and said severely, "You have disgraced this wonderful girl, and now you must marry her." Dalton assured her that nothing would suit him better, and that as soon as they could get the legalities of the matter ironed out, he would do just that.

It took a while. And in the meantime, there were further developments: circumstances conjoined to bring them even closer. First of all, Trumbo lost his job at Metro-Goldwyn-Mayer. His single-minded pursuit of Cleo during the two years he was there had played hell with his screenwriting career. Although he had worked on a number of projects, he had not a single credit to show for his time at Metro. When he had left with Cleo to escape Hal, Trumbo's friend, the producer Sam Zimbalist, had covered for him as long as he could. Finally, there was no help for it—Trumbo was fired. Zimbalist had taken the news to the couple just after Christmas. Trumbo, unemployed, had just $1,200 left to his name. He put it in a box and assured her they would get more somehow. And of course they did. Money was not their worry.

He managed to sell an original screen story, later the basis for the film *The Kid from Kokomo,* to his old studio, Warner Bros. His friend Frank Daugherty, the man who had gotten him his first movie job there in the story department, was the person Trumbo dealt with. Daugherty happened to mention to him in the course of things that he knew of an absolutely terrific buy in a ranch far up in the mountains of Ventura County. It was a 320-acre spread with a cabin and ranch buildings on it for only $7,500—and just $750 down. Trumbo told Daugherty he wanted it sight unseen; it seemed just the place he had in mind for Cleo and himself to settle down in and start their lives together. He borrowed the money for the down payment and bought the ranch. Next weekend he and Cleo drove up to look it over. It was primitive,

all right—there was no telephone (he never had one installed), the only light was provided by individual kerosene lamps, although there was indoor plumbing. But it was remote from Hollywood and isolated from the outside world, and that suited him just fine.

Cleo had filed for an annulment on grounds that Hal had not been legally free to marry when the ceremony was performed. The facts were all on her side, but because three states were involved—she and Hal were residents of California who had married in Nevada; and Hal's divorce had been filed in Michigan—it took a little time putting the case together. At last the judgment came, the marriage was annulled, and she and Trumbo were free to wed. The ceremony took place at Maud Trumbo's apartment on March 13, 1938. Presiding, appropriately enough, was Ben B. Lindsay, the controversial judge of the Los Angeles County Courts who had gained national notoriety for advocating "companionate marriage."

Cleo presented Trumbo with a dowry of sorts. Quite unknown to him, she had carefully kept all the tips he had given her after their first night at McDonnell's Drive-In. She had saved them apart from the rest. Why? Had she suspected from the start, in spite of her repeated rejections, that the two of them would wind up together? Probably. In any case, she handed Trumbo back his tips, over one hundred dollars. She called it her dowry.

Cleo had read an earlier version of the preceding account, and Trumbo told me she seemed a little uneasy about it for reasons he couldn't exactly define—though he did say she let him know the information he had given me about the affair was both inaccurate and insufficient.

And so when next I saw her, I asked her to read through the earlier version with me present. Trumbo was there, too. This way I hoped to get at what it was, besides facts and dates, that troubled her. She turned the pages, one by one, frowning and shaking her head.

I looked over at Trumbo and shrugged. "What's wrong?" he asked her.

"It doesn't make it clear here that if you were an ordinary man, things wouldn't have been nearly so difficult for you." She kept reading—and kept frowning. Finally with a sigh she finished.

"Well?"

"You don't get the feeling out of this of how glad I am I married this crazy man instead of some dull son of a bitch."

Later, I talked to her alone and asked her about that.

"Well, it's true!" she protested. "He is just *not* an ordinary man. He goes at everything like a sort of dynamo. Imagine how he seemed to a kid like me. He'd be there, night after night, maybe he would have been drinking and maybe not. It didn't matter. Either way he was so intense, so single-minded in his courting—if you want to call it that. He goes at anything this way. He'll do anything to get what he wants. That was how he was; he acted *crazy*. Eventually, of course, this crazy quality of his—and I do mean slightly nuts—which had frightened me at first actually began to attract me. He just isn't like other men. The better look I had at the rest of them, the more I thought that was really in his favor."

"And what about Hal?"

"Well, what can I say? I'd been going with the man for a year and a half. And in that time I'd discovered so many things I didn't like about him. I was in that old dilemma of being in love with a man I didn't like a lot. Basically, I didn't want to be married. But of course Hal pushed me into that when he felt me getting interested in Trumbo. He made his move the very night we were going out on our first date, you know."

I nodded. I knew.

"And then, well, Trumbo convinced me I'd made a mistake. It didn't take all that much convincing. Hal and I must have been married—together, anyway—all of two weeks."

"What was life with Trumbo like?" I asked.

"After Hal? Mostly Trumbo was different from what I expected, though I can't imagine now what that could have been. I had to get used to a few things. You may not know it, but he used to spend *days* in the bathtub, soaking, writing, talking on the telephone. The telephone was like his best friend. He'd spend hours on it, it seemed. When we got to the ranch, I was so happy because there was no telephone. I would never have guessed that he could have gotten along without it."

No episode in Dalton Trumbo's life is more revealing of the man than this story of his courtship and marriage. The way that he went after Cleo, apparently impetuously but with a sustained and almost obsessive

concentration, foreshadowed the intensity with which, in twenty years' time, he would be working to break the blacklist.

Dalton Trumbo was a romantic, and the shade of Jay Gatsby, so casually summoned up a couple of chapters back to suggest Trumbo's pining after Sylvia Shore, seems to fit him better and perhaps more specifically than I had realized. It is not just that Gatsby, too, was a romantic—the romantic hero of American literature—but that there was a fabulous quality to his life, a sense of making it up like a story as he went along, which seems to fit Trumbo perfectly. The life Trumbo wrote for himself rivals, and really surpasses, any literary work he undertook. You get the feeling, looking back over it, that nothing he did, no decision he made, should ever be taken at face value, for all of it had immense significance, mythic and moral, to him. His courtship of Cleo Fincher is such a fascinating story because in a very real sense it is a story—that is how Trumbo must have experienced it, with himself as hero and she as heroine. How else could he have seen it through as he did to its successful completion? He believed passionately and profoundly in happy endings.

All this goes a long way toward explaining his affinity for film-writing. It was his métier, perhaps the kind of work that suited his deeper nature best. And so it shouldn't be surprising, nor even too disappointing, that he returned to movie work at the earliest opportunity. The invitation came from RKO Radio Pictures in April 1938. His agent, Arthur Landau, worked out a contract for him there which contained an important proviso: it stipulated he had the right to work at home—in this case eighty-five miles away at the Lazy-T—as he called his new ranch up in Ventura County.

At RKO Trumbo was once again installed as a writer in the B-picture unit. There, as at Warners, the accent was on quantity; speed and craftsmanship were the qualities that mattered. Movie production was up all over Hollywood. In the midst of the Depression every studio in town had started cranking movies out as fast as they could make them. The reason was that at that time the studios owned nearly all of the movie theaters, vast chains of them, all around the country. They had to keep them filled, and to do that they had to keep new films flowing through them constantly. The double feature was born during the Depression as just another means of pulling audiences in. And with the double feature came the B picture, second feature, the "bottom of

the bill." As a result, the studios were forced to keep movie production very high, even though they were losing millions in the proposition. Only those who were actually involved in the making of films were doing well at all. Salaries—even salaries for writers on the B unit—were high and getting higher. Everybody in Hollywood seemed to be getting fat in the midst of the Great Depression.

His first assignment at RKO, a routine B production titled *Fugitives for a Night,* was discharged in short order. It was shot, released, and passed into extinction quite without notice—the fate of most such films. His next, however, was somewhat different. *A Man to Remember* was a remake of a 1933 film, *One Man's Journey,* and both were based on a published story (not an original for the screen) by Katharine Havilland-Taylor, "Failure." Working up at the ranch, Trumbo did the screenplay in two weeks, and Garson Kanin, in his first directorial assignment, shot the film in just fifteen days. They actually came in under budget at $108,000 and so were able to argue a musical score at $8,000 (originally unbudgeted) out of the studio.

It was a good film, one that stood head and shoulders above the usual B product. Starring Edward Ellis, Anne Shirley, and Lee Bowman, it told the story of a small-town doctor (Ellis), a supposed failure who has died in debt as the film begins. The events of his life, related in a series of flashbacks, demonstrate that no matter what the merchants who are pressing their claims against his estate may have thought, he was no failure but a man who brought life and hope to the entire town, one to remember.

Obviously, this was material with which Dalton Trumbo could identify personally. The small-town setting, the theme questioning the nature of failure and success—these he had treated at length in his novel *Eclipse,* and would give incidental treatment to again in *Johnny Got His Gun.* He put his stamp on the film. The atmosphere, the general feeling of it, is what might have come from a movie adaptation of *Eclipse,* and the small-town doctor is so much like the protagonist of Trumbo's novel that as a kind of final gesture of authorship Trumbo gave him the same name; the protagonist of *A Man to Remember* is Dr. John Abbott.

It was the first film with which Trumbo was involved to gain any sort of special attention. He was singled out for praise by, among others, the *New York Times* critic, Frank S. Nugent, who noted in passing

that it was "one of the most uncolossal pictures of the year." He cat-
egorized it as a good little movie and put it on his ten-best list that
year. It appeared on a number of others. And while the job Trumbo
did on *A Man to Remember* didn't immediately change his status as a
screenwriter—he continued on the RKO B unit—he took pride in the
film for years to come.

During that first year at RKO, a production of *Washington Jitters*
was eventually brought to Broadway. As it finally happened, though,
Kaufman and Hart had nothing to do with it. The team had had
some success the year before with their own political satire, *I'd Rather
Be Right,* and perhaps by the time John Boruff and Walter Hart got
their adaptation of *Jitters* untracked, the vein had been temporarily
exhausted. At any rate, when the Theatre Guild produced it in asso-
ciation with the Actors Repertory Company in 1938, the play ran only
twenty-four performances in spite of reviews that were, on balance,
favorable.

Trumbo, of course, had nothing to do with the adaptation of *Wash-
ington Jitters.* His only participation in the enterprise, as original author
of the work, was the receipt of a box-office statement and a modest
check during each of the few weeks it ran. But that doesn't mean he
had been doing no writing of his own. In the course of that long period
he spent in pursuit of Cleo, he had begun a novel, one as different as
could be from *Washington Jitters.* It was certainly the most serious
and—as it would turn out—also the best work of any kind he had ever
undertaken.

The move out to the ranch was undertaken partly* to give him
a chance to finish this new novel, which was to become *Johnny Got
His Gun.* He wanted to insulate himself from Hollywood, perhaps to
avoid social occasions that (with the Spanish Civil War in 1936–1939,
and the *Anschluss* of Austria in 1938 followed by the annexation of the

*But only partly. The remote and primitive quality of the Lazy-T made it especially desir-
able, for in that lay its mythic appeal to him. Living at the ranch, in circumstances not much
different from those his grandfather Tillery had known in Colorado, must have seemed to
him an act of loyalty to his western past. In fact, he brought his uncle Tom Tillery up to run
the place and turn it into a working ranch. Cleo remembers Trumbo going out and kicking
the dirt in front of the house and saying, "That's mine." And on more than one occasion he
took the day to walk the boundaries of the ranch. Nikola and Christopher Trumbo were
born during the time they were living there—in 1939 and 1940, respectively.

Sudetenland by Germany) had grown increasingly political as war seemed more imminent. He was personally convinced that America should stay out of a European war that now seemed inevitable. His reasons had their roots in his experience as a boy, seeing the young veterans he had known returning from World War I—some maimed, blind, and broken—to Grand Junction. But it was more than sentiment that swayed him. His was also certainly an intellectual position. He held to it firmly because he thought any other was then quite unreasonable.

Never one to avoid an argument, he must frequently have found himself in bitter debate at that time with people he had always felt in fundamental agreement with before. Nothing is so ruinous to the writing of a novel as to find oneself arguing the intellectual point of it night after night. It was for this reason, to avoid such occasions, that he removed himself from Hollywood to the Lazy-T during the writing of *Johnny Got His Gun.* The important thing was to get the novel written and let that stand as his statement against the war, rather than dithering it away in a hundred separate wrangles.

He had begun the project in 1937 after carrying the idea with him for a number of years. Early in the thirties he had seen an item in the newspaper telling of an incident that had occurred during an official visit to Canada by the Prince of Wales. In the course of a tour of a Canadian veterans hospital, the prince was seen by reporters to emerge weeping from a closed room. Inquiries disclosed that behind the door lay a World War I soldier who had lost not only his limbs, but all his senses except touch as well. According to the newspaper account, the only way that the prince could communicate with the soldier was to kiss him on the forehead—and that he had done.

Well, Trumbo thought, why not a novel from the point of view of such a man? The basket case, war's most extreme victim, could surely make the most eloquent and persuasive statement against it, if only a novel could actually be written under such difficult restrictions. And so very early, the composition of *Johnny Got His Gun* presented itself to Dalton Trumbo as a series of technical problems to be dealt with and solved. And perhaps that was just as well, for if he had allowed himself to become totally immersed in the dramatic reality of this emotionally loaded subject, then he might have been tempted to raw excesses of passion—to bathos or to rage—and the book that was *Johnny* might

never have been written as it was written. He managed to solve those technical problems by the intelligent use of a number of devices. Since the action of the book was to take place totally within the brain of his young soldier—"a dead man with a mind that could still think," Joe Bonham calls himself—Trumbo quite properly employed a modified stream of consciousness technique and deviated from it only toward the very end of the novel (doing some slight damage in the process to *Johnny*'s integrity of tone).

Trumbo also uses film techniques to good advantage. Flashbacks, in such a context as this one, seem so inevitable that if the technique were not then available, it would have had to be invented. The success of the flashbacks in *Johnny* is due partly to the skill with which they are handled: each of Joe Bonham's memories is sharp and incisive, introduced logically, and each is essential to the structure of the novel. But partly, too, the success here is due to its naturalness in the context of the novel's situation. You would almost expect the entire novel to be done in alternating flashbacks and soliloquies. What is perhaps more remarkable, given the fact that his protagonist has lost all senses but touch, is that Trumbo is able to extend his narrative through present time in the latter half of the book, putting Joe in contact with the outside world, and ultimately in conflict with it.

Trumbo also employs the movie technique of montage, covering space with sound brilliantly in the scene of Joe's departure for war. Bits of talk between him and his girl Kareen are jumbled with an orator's highfalutin rhetoric, shouts from the crowd, and lines from "Over There," the George M. Cohan war anthem that gave the novel its title—all of it sketching in the scene and evoking the period with a shorthand that is essentially cinematic.

And finally, though this may seem a bit vague, his treatment of time in *Johnny Got His Gun* is not novelistic in the usual sense, but more in the nature of what you experience seeing a film. There is little of the density of detail and incident that you usually get in a novel: it is actually a rather short book. Yet time passes. This in itself is surprising in a narrative that is so nearly static, the only real action coming in the second part with Joe's breakthrough to the outside world. But what is especially impressive is that although the period of time that passes is an unspecified one, Trumbo manages to create the impression that it

is of rather considerable duration, several years certainly. He uses fade-outs suggesting loss of consciousness. He fixes our attention firmly on Joe so that Joe's subjective experience of the passage of time, whether faulty or not, is totally believable to us. It is like movie time, an emotional dimension, an empathetic reality.

The first of *Johnny*'s two "Books" begins with Joe Bonham's numbed and agonized wish that the phone would stop ringing. It is an auditory hallucination, and in with it rushes the memory of his father's death: The phone rings at the bakery where Joe works, and he is summoned home by his mother, telling him that his father has just died. Joe's reaction, as he views his father's corpse (quoted earlier in Chapter Two), leads him to the realization that something is wrong, that he is sick, that there really is no telephone ringing, and that he is stone deaf. He drifts in and out of consciousness, and it is not until toward the end of the chapter that any memory or mention of the war comes, and then only fleetingly, for he is quickly back with his parents in Colorado—living, as he then must, in the past, existing only in his memories.

As Book I, entitled "The Dead," moves on, we follow the pattern established in the first chapter. Joe Bonham continues to remember, and his memories center, for the most part, on his early life in Shale City, Colorado. These individual scenes are brilliantly realized; the past is evoked with the economy and vividness of film. A paragraph, or sometimes just a sentence, will call forth the precise image, the remembered detail that makes it all real to us: the smell of a hamburger stand down on Main Street, and the warmth of the hamburgers inside his jacket as he ran them home to his family; the old men of the town sitting around the cigar store, discussing the progress of the war in Europe, with America still neutral. And the longer sections—the story of his last fishing trip with his father and the lost fishrod, and the hellish couple of days spent working out on the railroad in the Utah desert with a Mexican section gang—these, among others, tell not only what it was like growing up in Shale City, but also what it was like to be Joe Bonham. This last is, I think, quite important, for considering his condition and all he stood for in the novel, there must have been some temptation to generalize Joe's character, to make him the pacifist's Everyman, the universal victim. This, however, Trumbo wisely refused to do and instead made Joe Bonham into a person, a very specific person—himself. For clearly Joe's Shale City is Grand Junction, his parents Orus and Maud

Trumbo, his eagerness to succeed and be somebody, to be admired—
this, as we know, was certainly also Dalton Trumbo.

By contrast to the sections of Book I dealing with Colorado, some of
those set in Los Angeles seem a bit weak. Could it be that the alterations
Trumbo made in chronology offered some fundamental difficulty? The
problem was this: because he wished to combine the bakery material
with his Colorado boyhood, he was obliged to shift the locale. But he
did so in the most arbitrary sort of way: "Then his father decided to
leave Shale City. They moved to Los Angeles." Only that. It is one of
the few instances when the bones of the book show through its flesh.
Why was this necessary? It may be that Trumbo's sense of identification
with Joe was so keen that he felt he had to share whatever he could of
his own life with him, even though it meant bending years to fit.

In the course of Book I, Joe Bonham has learned, little by little
and sense by sense, that he is not only deaf but also blind and dumb,
and that all four of his limbs have been amputated or blown off. Each
separate discovery stirs a memory within him that makes the loss just
that much more painful to him. The only sense left him is the sense
of touch; at one point he has a tactile hallucination and believes that a
rat has come to nibble at him, just as the rats chewed at the corpses in
the trenches. But later he realizes that real as it was to him at the time,
"the rat was a dream." He knows then that he must regain control of his
mind, or these hallucinations will continue and he might go mad. He
must learn to keep track of time passing. He does so, finally, through
the warmth of the rising sun in the morning and the nurse's hands on
his body beginning him on what he comes to recognize as his daily
routine. And once he has mastered that: "He had a mind left by god
and that was all. It was the only thing he could use so he must use it
every minute he was awake. He must think till he was tired tireder than
he had ever been before. He must think all the time and then he must
sleep."

And if thought is to provide his salvation—as, in a sense, it does—
Book II of *Johnny*, entitled "The Living," details the working of that
salvation. Put briefly, it is brought about through Morse code. Joe had
learned it as a kid. It occurs to him that since he does have control of his
neck muscles, he can use them to beat his head against his pillow. And
so he begins, hoping he can get through to someone, sending out the
SOS signal over and over again. It is remarkable, but Trumbo manages

to pump a great deal of excitement, even suspense, into these efforts by Joe Bonham to get through to the nurse, or to a doctor, or to anyone out there he can communicate with. Finally, he does, and the reply to his SOS comes back to him from the outside world, tapped by a finger on his forehead: "What do you want?"

Then follows a very moving chapter in which Joe must deal with that staggering question. His mind races. He remembers that once he saw an exhibition of a man turning to stone: "You could tap a coin against his arm and it sounded as if you were tapping it against marble it would ring so." If that was bad, thinks Joe, then he is worse. They could put him out on exhibit in the same way:

> He would be doing good in a roundabout way. He would be an educational exhibit. People wouldn't learn much about anatomy from him but they would learn all there was to know about war. That would be a great thing to concentrate war in one stump of a body and to show it to people so they could see the difference between a war that's in the newspaper headlines and liberty loan drives and a war that is fought out lonesomely in the mud somewhere between a man and a high explosive shell. Suddenly he took fire with the idea he got so excited over it he forgot about his longing for air and people this new idea was so wonderful. He would make an exhibit of himself to show to the little guys and to their mothers and fathers and brothers and sisters and wives and sweethearts and grandmothers and grandfathers and he would have a sign over himself and the sign would say here is war and he would concentrate the whole war into such a small piece of meat and bone and hair that they would never forget as long as they lived.

And so he taps out his request, asking that he be let out, that he be put on exhibit at beaches, county fairs, church bazaars, circuses, and traveling carnivals. The answer: "What you ask is against regulations." His response—and we are now in the last chapter, so it is meant as Trumbo's final statement—seems uncharacteristic of Joe, perhaps even a false note here. Denied his request, he suddenly has "a vision of himself as a new kind of Christ" and begins preaching a new kind of gospel, one of threat and what-will-happen-if: "If you make a war if there are guns to

be aimed if there are bullets to be fired if there are men to be killed they will not be us." Who then?

> It will be you—you who urge us on to battle you who incite us against ourselves you who would have one cobbler kill another cobbler you who would have one man who works kill another man who works you who would have one human being who wants only to live kill another human being who wants only to live. Remember this. Remember this well you people who plan for war. Remember this you patriots you fierce ones you spawners of hate you inventors of slogans. Remember this as you have never remembered anything in your lives.

By rhetoric—and certainly it is impressive rhetoric—Trumbo tries to elevate Joe from a figure of pathos to one of heroic dimensions. It does not really work. Joe Bonham cannot but be a victim, a living reproach to the world that makes war and leaves its surviving victims tucked away neatly behind locked doors in hospitals.

To say this is simply to concede that *Johnny Got His Gun* has its faults. What is remarkable is that it hasn't many more of them, considering that Trumbo's overriding purpose in writing it was to get his antiwar message across to a world hurtling toward war. That he did, certainly, but in so doing he also created a profoundly moving novel.

Few have found it less than that. When, at the end of August 1938, he sent the first half of *Johnny* off to Elsie McKeogh, she responded immediately and enthusiastically: "I am tremendously interested in your new book and I am very curious to see what you are going to do with the other half of it. It is an amazingly vivid and touching job, and I haven't been able to get Joe out of my head since I read it." She believed in the book and was sure that any publisher she showed it to would feel just as she did.

That, however, was something of a problem. Trumbo had resented the treatment given *Washington Jitters* by Alfred Knopf and was not especially anxious to turn over the new novel to him. Mrs. McKeogh urged him to reconsider: "If you were in my position you would realize that every publisher has certain authors who are dissatisfied with his labors in their behalf, and even the ones that you are particularly eager for are not exceptions." The question of the publisher hung fire. When

he had completed *Johnny Got His Gun,* he wrote to her on February 20, 1939:

> One of the things that disturbs me is the fact that there is grow-ing up in this country among liberals and intellectuals a strong pro-war sentiment. They appear to view war as the only salvation for democracy, whereas I see it as a sure destruction for the kind of democracy we know at present. These perfectly sincere war mon-gers are becoming louder, more influential and even more danger-ous. If Knopf were in sympathy with them—and I suspect that he might be—he would certainly be out of sympathy with "Johnny Got His Gun." In such an event he might deliberately delay a deci-sion, and if he decided to publish it he might further delay its ulti-mate appearance. If the book is any good at all it is good as an argument against war; and it will be utterly valueless if the coun-try is either in war or in favor of war by the time it is published.

Note the press of time felt by Trumbo, the need to get the book out before the world—and America with it—was plunged into war. The immediate problem of the publisher was dealt with directly and, as it turned out, was solved easily when Mrs. McKeogh went to Alfred Knopf himself and explained that her client was dead-set against pub-lishing his new novel with Knopf. Nothing could be simpler. Trumbo was released from his contract. *Johnny Got His Gun* was offered to J. B. Lippincott and was snapped up immediately.

He was right, of course, to feel a certain sense of urgency in getting *Johnny* out. Although Lippincott wasted no time in seeing it published and out into the bookstores, Trumbo and his novel were ultimately overtaken by events: Germany invaded Poland a week before the book came out. World War II was several days under way when the reviews began to appear. All were respectful, and Ben Ray Redman, in the *Sat-urday Review of Literature,* was quite bowled over. "This is one of the most horrifying books ever written," he began, but manfully continued with a full and accurate synopsis of the novel, concluding his review with this paragraph:

> To say that this book is a terrific indictment of war is to employ a phrase that has been robbed of its proper weight of meaning

by careless and promiscuous use. Yet the phrase must serve. To insist that this book should be required reading for all men big and little, for those who are capable of making wars and for those likely to be herded into them, is to betray an innocent and mistaken faith in the power of the printed word. Yet one must insist, even though one knows that there are some indictments that simply will not stick, and that war has survived them, and doubtless will survive them, beyond numbering. It is possible to insist conscientiously, too, on more grounds than one for "Johnny Got His Gun" is not merely a powerful anti-war document; it is also a powerful and brilliant work of the imagination. In giving voice to a human experience that has hitherto been voiceless, Mr. Trumbo has written a book that can never be forgotten by anyone who ever reads it.

There has grown up a tradition among Trumbo's liberal and right-wing detractors that *Johnny Got His Gun* was purely a product of the rather ignominious von Ribbentrop Pact period, during which world communism did an abrupt about-face the moment the Soviet Union signed its nonaggression treaty with Nazi Germany, suddenly beginning to talk pacifism and nonintervention, leaving Hitler free to range across Europe. None of that, however, had anything to do with how or why *Johnny* was written. Trumbo was not a member of the Communist Party during the time the book was in preparation, nor for years after it was published. When it was being written, its antiwar message was very much contrary to the Party line. It was simply an accident of history that the book was published when the Party line itself had been altered so that it suddenly and quite surprisingly conformed with what Trumbo had freely expressed in his novel. As a result of this accident of history and at J. B. Lippincott's suggestion, *Johnny Got His Gun* was serialized in the Party organ, the *Daily Worker,* soon after publication—giving rise, I suppose, to the myth that it was written to order, a hack job.

None of this concerned Trumbo much at the time, nor would it even bother him greatly in retrospect. Once he had written *Johnny,* and publication was assured, the matter was out of his hands. Now he would spend correspondingly less time up at the ranch in Ventura County and more with the new friends he had made about the time he began pursuing Cleo. There were three of them—Ring Lardner, Jr., the son of the

short-story writer; Ian McLellan Hunter; and Hugo Butler—all junior writers at Metro-Goldwyn-Mayer when Trumbo got to know them, all around Cleo's age, about ten years younger than he. They remained good friends for life (Butler died in 1968). All four were blacklisted.

Ring Lardner, Jr., and Ian McLellan Hunter live within a few blocks of one another on the Upper West Side of Manhattan. It suits them. Having met these two New Yorkers in their native habitat, it is hard even to imagine them elsewhere. They started out as reporters together at the *New York Daily Mirror* and were on their way west to become screenwriters by the time they were twenty-one. Not much more than a decade later, however, they were back in New York, blacklisted, pariahs of the movie industry. During that period they eked out a living writing for television under pseudonyms (a lot of it for the old Robin Hood series which was filmed in England). With the blacklist ended, both resumed their rightful identities and continued to write for films and television. Lardner's post-blacklist credits include *The Cincinnati Kid* and *M*A*S*H*. And although Ian McLellan Hunter (he used his middle name to distinguish himself from the English actor Ian Hunter) did some work on theatrical features after emerging into the sunlight, most of his writing was on television for such distinguished shows as *Hallmark Hall of Fame* and the PBS production of *The Adams Chronicles*. Neither Lardner nor Hunter felt it necessary or especially desirable to move back to Hollywood, and though they were at a continent's remove from Trumbo, the three kept in close touch. They visited when trips took them to the other coast. They called at all hours of the day and night. After more than twenty years apart, they still spoke of one another as "best friends."

I met with them in the apartment of Ring Lardner, Jr. Also present were Frances Lardner and Ian's wife, Alice Goldberg Hunter, who has known Trumbo longest of them all—since the days the two worked together in the Warner Bros. story department. With all of them— the two men especially—I sensed a certain reticence born of propriety, as though it bothered them a little to speak of something as personal as their friendship with Trumbo. But they did speak freely and quite personally, almost out of a sense of duty. More than from anyone else I talked to (with the exception of Trumbo himself), I got the feeling

from Ring Lardner, Jr., and from Ian McLellan Hunter that they were consciously and carefully speaking for the record.

"We were all writers at M-G-M," Lardner remembered. "It must have been about 1937." He looked to Hunter for confirmation and then nodded. "Yes, 1937. We looked up to him because he was very much our senior, the old pro. Remember by this time he'd published a couple of novels and many stories and had a number of movie credits, too."

"My first memory of Trumbo?" Hunter echoed my question. "Well, that would have to be him in his big black Chrysler. I saw him in it before I actually knew him. He was in a hut down the road from where I worked, which was in a location hut near Metro's Tarzan jungle. But as for when we actually met, I guess that was at a party. He came up to me and congratulated me for a script I didn't write, an *Andy Hardy,* as I recall. He was embarrassed by his mistake but then we got that sorted out and became friends."

Alice Hunter remembered the Chrysler, too: "I recall going out with him once before Cleo sort of exploded into his life. He invited me to the Philharmonic Hall for some event, and in the course of getting there, I did something terrible to the Chrysler. As I recall I must have opened up the car door extra wide and chipped paint off his car. Anyway, he was just princely in the way he handled it—so gallant. He neither cut me off his list for all time or said one word of reproach. We simply went off and saw the concert."

I asked her what he was like then. "Physically? You mean what did he look like? Well, he was sandy-haired and had a mustache off and on. He was slight but strong, kind of wiry."

"We've got a picture of him someplace on a yachting trip," Ring Lardner put in.

Alice Hunter nodded and remembered, "And we have a picture of the three of you wrestling."

"That wrestling got to be a big thing with us," Lardner mused. "I don't know why exactly. We'd all gang up on one—say, Trumbo, Ian, and me against Hugo—then suddenly switch sides and start in on another. We called it the treachery system."

"The way Trumbo was," said Alice Hunter, "he challenged all comers. This was how his son, Chris, grew up, arm wrestling his father practically every day. Meanwhile the kid was getting stronger and stronger, and finally, when he was in high school, he took Trumbo and

took him with a vengeance. Trumbo put all he had into it, but Chris forced him down. Finally, Trumbo strained so that he tore the muscle in his arm, just detached the bicep completely. Couldn't use that arm for weeks. And that ended the Indian wrestling."

They talked about Cleo and how right she was for him. During Trumbo's relentless courtship, his friends had gradually become aware of her and finally had gone to the drive-in to see for themselves, "Who is this girl everyone's raving about?" Hunter summed up: "With us, she was from another world, you might say. But she immediately sized us up and her assessment of us and our relationship with Trumbo was always correct."

(Sometime before, I had talked with Jean Butler,* Hugo Butler's widow, in Hollywood, and the subject of Cleo had come up with her, too. "I remember Trumbo bringing her to dinner for the first time," Jean Butler had told me. "She was coltish, lovely—a shy, awkward girl. I don't think she said a word all night long, just gave us that big grin of hers and charmed us all.")

"It was funny with him," said Lardner. "When I first got to know him he was going through bankruptcy, chauffeur-driven Chrysler and all. And he no sooner got through that crisis than he was into another. It seemed that little time ever elapsed between one set of money problems and another. He would get out and then overextend himself again. Buying the ranch was part of that routine—or not so much just buying it as what he did to it afterward. When we first went up there to visit them, it was just a little shack, way the hell and gone up into Ventura County. But that shack grew and grew. Before you knew it the shack itself had become the kitchen and there were two additional rooms."

"And then the landscaping," prompted Alice Hunter. "He put in a big lake and all."

"What a place that was!" exclaimed Ian Hunter. "When they were finished adding onto it, it had a marble floor and a bar, a formal bar in an elaborate room. And off that was an enormous dining room done in some high-class Philippine wood, the kind of paneling job that would be just prohibitive today.

*Jean Butler also goes by Jean Rouverol.

"But it was always a working ranch. There were farm animals, and at its height there were a lot of horses. Cleo wasn't a bad rider but Trumbo himself could hardly stay in the saddle. I remember once in the winter a couple visiting them had headed down in a car to the little crossroads general store when it started to snow, a real blizzard, very suddenly. We were quite rightly worried and headed out on foot to look for them. Dalton disappeared. We went out and found the car stalled in the snow some distance away. There was a kid in the car, I remember, and I was carrying the kid back with the house already in sight through the heavy snow when Trumbo suddenly came galloping out of the barn and up to us on a horse to join the search party. He had taken all that time just trying to get the horse saddled. He was no cowboy."

Ring Lardner, Jr., nodded. "The place was so remote and inaccessible that you were really at the mercy of the weather. No Hollywood producer could conceive of a place so inaccessible. The telephone process was just horrendous—to get a call through they had to get hold of the store at the crossroads and convince somebody there that the call was important enough for them to drive twenty miles to get Trumbo, which wasn't easy, and then have Trumbo drive twenty miles back to the store to take the call. In most cases, the producer would be reduced to driving up to the ranch. And producers didn't really like to do that. You'd take 101 north along what they called the ridge route—it had a fearsome reputation, that stretch of road. Trucks' brakes would give out all the time. In fact, Cleo's brother and his family were killed by a truck that went out of control along there. At the crest of the ridge was this little crossroads town of Lebec. You turned due west there and went up this crappy little road twenty miles to his ranch. If all this was a barrier between Trumbo and the producers, as he intended, it also made difficulties for him.

"We used to drive up there on the weekends. I remember one Friday we left about ten-thirty at night. And on an impulse we turned off to visit Hugo Butler in the valley. We got there and found the house dark but the door unlocked. The Butlers were asleep. We tiptoed inside and had a couple of drinks at the bar and got to thinking what a great joke it would be on Hugo and Jean if we were to rearrange their furniture and then leave. So that's what we were doing, and in the course of it making some pretty big bumps and scrapes, when we heard this very tough,

'Don't move!' We looked around to find Hugo standing in the door-way with a shotgun. We dropped down behind the bar and called out that we were friends. So we all had a big laugh and more drinks, and Trumbo and I slept on the living room floor and left the next morning."

(Jean Butler had remarked earlier to me of that time in their lives, "That was early, 1939, when the Katzenjammer period began. All this wrestling and the pranks they'd play—it was *crazy*. I don't know how the other wives felt, but to me we seemed superfluous—the husbands were absolutely self-winding. They had a life of their own. In that movie of his, *Husbands,* John Cassavetes touches on it a little. It was like that.")

"With all these elaborate jokes and with the expeditions we used to go on," said Alice Hunter, "Trumbo was sort of an instigator, a regular Clausewitz. He got a lot of enjoyment out of planning strategy, putting together moves, like a general."

(Jean Butler: "It was a little like having Dickens or Twain as your buddy. Even in this foursome, Trumbo was very much in the lead. It was the impact of his personality on all of us, the speed of his wit. He had the theatrical qualities of a Twain or a Dickens, too. It was just the way the room sorted itself out. You listened to him. Everybody else tended to take second place in the relationship.")

"Occasionally, however," said Ring Lardner, Jr., "we were serious. About writing, for instance."

"That's right," said Hunter, "but the general philosophy was, don't bother your friends with your work problems if everything's going basically okay. To this day Ring will only know in general what I'm working on without the nitty-gritty details. The idea was always that we consult each other when we have soluble problems with alterna-tives and are past the blockage. There was never any shoptalk as such, however."

"But," said Lardner, "about specific story problems, yes, we might ask for help and you'd read perhaps half the script and have a confer-ence of several hours in which you'd get everybody's best ideas. It was truly a free interchange. That happened."

"Then there was his idea book," said Ian McLellan Hunter. "Like most writers Trumbo had more ideas than he could execute, so he would put them down for future use. If he wrote it and sold it, he would

check it off in his book. But if one of us was in trouble—'between assignments,' as the euphemism goes—he would be invited to ransack the idea book. My screenplay *The Day It Rained Money* was sort of a collaboration of this kind."

"Look," said Alice Hunter, summing up, "in many ways it was an enormously meaningful relationship for all four of them, Hugo included. The blacklist brought tremendous closeness to them. When Ring and Trumbo got out of prison, Hugo split what he had in the bank with them. Anybody who got a check would share it with the other guys. The type of banter they engaged in could only come out of a deep and close relationship. In no way could any of the kidding they did—and they did a lot of it—be taken as a threat, an attack, or an insult. Even today, if we were in serious trouble, we would turn to each other, which may be why we still keep in close touch."

Silence hung over them for a moment. Ring Lardner, Jr., started to speak, then hesitated. He was a pensive, careful man, as laconic as his famous father. He chose his words well and thought out his statements before he made them. He was the first of the Hollywood Ten (with the exception of Edward Dmytryk, whose motive was self-serving) to reveal that in fact he had at one time been a member of the Communist Party and was one when called before the House Committee on Un-American Activities in 1947. He wrote about his membership in the Party in the *Saturday Evening Post* in 1961, when he surely might still have been considered blacklisted. He spoke plainly and directly on this point that would certainly have troubled the readers of the *Post*. With that same spirit of directness, of putting his cards on the table, he brought up what we had all carefully avoided to that point.

"You'll want to know about the political part of it," he said.

I agreed that I certainly would.

"Well, this is more or less how it went. I was the first of this group to declare myself a Communist. I kind of involved Ian not long afterward. But Dalton, because of his pacifism, was reluctant to take this sort of position. This was during the period when American Communists were supporting the front against Hitler. During the Pact period when Communists were against the war, our points of view were very much in agreement, of course, and we worked together on the American Peace Mobilization. In June 1941, when the Nazis attacked Russia,

he found it very difficult to support the war. But Hugo, who had been quite nonpolitical, then said he saw things our way. Gradually Dalton, too, became increasingly less pacifist in his approach, and by the time of Pearl Harbor, America's entry into the war had changed his mind. We didn't see as much of one another during the war, but I remember that he and I did happen to get together in Washington when he was in to do research for *Thirty Seconds Over Tokyo*. I remember how he put it then. He said, 'Well, I've joined the Red Cross.' I knew what he meant, of course."

I glanced around at the others seated there in Lardner's living room. There was general agreement. His statement seemed to satisfy them all.

As America's entry into World War II grew nearer and seemed more and more certain, the political atmosphere in Hollywood became warmer and more turbulent. What began with organizing activities for the various guilds and craft unions led to radical-chic benefits for Spanish Republicans and subsequently to aid for the Spanish refugees. During the Pact period pacifist sentiment was instantly mobilized, then just as quickly, with the invasion of Russia by Germany on June 22, 1941, rallies were organized urging America to make a quick entry into the war and stem the tide of fascism that was sweeping over the world. It was not the finest hour of the American left. Such sudden reversals of position were clearly dictated by the exigencies of Soviet foreign policy.

The American right had noticed and was carefully taking the measure of the "Hollywood Reds": they looked vulnerable, and they were. A chapter of the Order of the White Camelias, a Klan-like organization, had been founded in Hollywood to combat what was seen as the Red Menace there. A member of the White Camelias, director Sam Wood, invited the first House Committee on Un-American Activities, under the chairmanship of Texas congressman Martin Dies, to come out to Hollywood to investigate Communist infiltration of the movie industry. In fact, the Dies Committee did come to Hollywood in August 1940 and held what promised to be a sort of dress rehearsal for the Hollywood Ten hearings in Washington seven years later. A few of the same names were named—director Herbert Biberman and his wife, actress Gale Sondergaard, and writer Samuel Ornitz, for example— but the Committee left, Dies promising to return and see to the job of

exposing individual Reds in the movie industry. World War II intervened, however, with the consequent alliance of the United States and the Soviet Union.

Anyone could see that the day of reckoning had only been postponed. When the opportunity presented itself, the right would strike, and Hollywood—because of its prominence and because of the movie industry's vulnerable dependence on good publicity—was certain to be a prime target. A more prudent man would have avoided political activities of any kind during the years that followed, but of course prudence had never been a virtue cultivated by Dalton Trumbo.

THE WAR YEARS

Johnny Got His Gun was the first of Dalton Trumbo's books to be widely and well reviewed. It caused quite a stir, coming out as it did the week the war began. In fact, it won the American Booksellers Award for him in 1940 as the "most original novel of the year" (which it certainly must have been). He had then with *Johnny* what he had really never had before, the beginning of a literary reputation.

As an almost inevitable consequence of this, Trumbo suddenly felt an urge to be free of the movies, to end his state of contract dependency. It seemed evident that if he worked less for films he would have more time to work for himself, to write the kind of novels he was then sure he could write. Something of the sort was in his mind when he was approached by RKO to work on *Kitty Foyle,* a screen adaptation of the best-selling Christopher Morley novel. By that time, he had done eight films for the RKO B unit, including *A Man to Remember.* He had also received screen credit on five other films produced by various other studios during this same period; these were original screen stories, for the most part—everything from the popular *The Kid from Kokomo* (Warner Bros.) to the forgotten *Half a Sinner* (Universal)—all sold by the usual slightly devious means. By then, he had earned a reputation as an excellent craftsman, and so he seemed the logical man to turn to when trouble developed on *Kitty Foyle.*

Donald Ogden Stewart, who happened to be a friend of Trumbo's, had turned in a script on *Kitty Foyle* that had a lot to recommend it but was judged unshootable by studio executives. Dalton Trumbo seemed

a likely man to save the project; he could work quickly and could, if his recent work were any indication, be counted on to come up with a well-crafted, cinematically sound screenplay that would, at the very least, be ready for the cameras when he had finished it. And so RKO put it up to him: if he did *Kitty Foyle* for them, did a good job and on time, he would be through with the B unit; he could expect from then on to work on nothing but A productions.

But Trumbo wanted out. "I had some time to serve on my contract," he remembered. "So I agreed to do *Kitty Foyle* if they would cancel my contract, which they did. So I did the screenplay, which received an Academy nomination for me and won an Oscar for Ginger Rogers. They got what they wanted. So did I." He was free for the time being. Eventually he would return to Metro-Goldwyn-Mayer, but not before he had written another book—almost by accident.

Kitty Foyle was released in December 1940. By then, he was at work on a novel that had been pre-sold to the movies. Or was it merely a movie for which he agreed to write a screen treatment of novel length? *"The General Came to Stay,"* as the project was first known, was begun in spring 1940, after a deal had been made with Paramount on the strength of a brief story outline. He was to receive $20,000 on signing, $7,500 on publication of the novel by a reputable house, and $2,500 if and when it were given magazine publication. (All this was money from Paramount; he could expect something, in addition, from the book and magazine publishers.) Further, Paramount guaranteed him $1,000 a week to do the screenplay from his own novel—if he were available. On the face of it, this looked like a pretty good deal. "But," as Trumbo later commented ruefully, "I found out a novel should be written for itself alone."

He was right. *The Remarkable Andrew,* the novel written to order for Paramount Pictures, effectively ended his career as a novelist. He had misgivings from the start: "I am going to try to get some time off from the studio immediately and go to work on the book," he wrote Elsie McKeogh at the end of his tenure at RKO. "It will be the first time I have ever had a chance to work uninterruptedly on a single job and I am going to do my absolute best to try to make 'The General' as good a book in its fluffy way as 'Johnny' was. I dread any critical comparison of the two but I'll just have to make the best of the situation."

It would have been hard to follow *Johnny Got His Gun* with any

novel. In it, he had achieved something unique, real, and lasting. But to turn from that to *The Remarkable Andrew,* promising to make the latter "as good a book in its fluffy way," was to emphasize craftsmanship and professionalism out of all measure. *The Remarkable Andrew* represents an almost criminal abuse by Trumbo of his recently proven talent as a novelist. It is not merely puzzling that he should have written it when he did, but revealing and deeply unsettling as well. It indicates that he had somehow ceased to value his talent as worth something in itself. Perhaps he never really did.

The Remarkable Andrew starts promisingly in Shale City, Colorado, the thinly disguised Grand Junction in which *Eclipse* and much of *Johnny Got His Gun* are set. Young Andrew Long is a bookkeeper in the Shale City government who, upon close examination of the city's account books, discovers evidence that the mayor and a couple of his cronies have been embezzling considerable sums. When they learn of his suspicions, they manage to shift the blame from themselves to him. An investigation of young Andrew—his reading, his stated opinions, even his thoughts—is undertaken by a committee of concerned citizens with the same sort of vigilante passion that Trumbo remembered from the activities of the Loyalty League back in Grand Junction during World War I. The onus is shifted to Andrew Long: he is presumed guilty, unless (worse luck) he should manage to prove his innocence.

So far so good. Some of the details of small-town life are done well in the opening chapters. And if Trumbo draws his characters rather broadly, they are at least recognizable as small-town types. And finally, the situation in which Andrew Long finds himself, while uncomfortable for him, is one rich with plot possibilities.

Rather than treat any of them, however, Trumbo summons up the specter of President Andrew Jackson—visible, of course, only to his young namesake. Except for the last chapter or two in which Andrew successfully defends himself before the townspeople, the rest of *The Remarkable Andrew,* nearly two hundred pages of it, is a kind of extended seminar conducted by Old Hickory on true American values. These turn out to be, for the most part, populist (certainly consistent with the historical Jackson) and antiwar in his international position (can this be the Jackson we remember as the hero of the Battle of New Orleans?). It may seem remarkable that the issue of war or peace should have come up at all in their extended colloquy. But remember that

Trumbo was writing in 1940, and the burning issue of the moment was whether or not America should enter World War II as a gesture of solidarity with Great Britain in her darkest hour. Jackson, of course, was simply the mouthpiece for Trumbo. As it comes from Andrew Jackson, it sounds like old-fashioned isolationism.

There is eloquence in *The Remarkable Andrew,* but it is rhetorical eloquence, essentially political oratory. It has nothing to do with the art of fiction. And if *The Remarkable Andrew* was unsuccessful as a novel, it was not much better as a motion picture. Trumbo did the screenplay, and not even he could sustain it after the first shock of Brian Donlevy's unexpected appearance as Andrew Jackson (in full regalia, of course) and the first round of discussion had taken place with William Holden as Andrew Long. The deficiencies of a story in which very little actually happens become quite glaring when translated to the screen.

Early in the filming of *The Remarkable Andrew,* during the summer of 1941, Donlevy and Holden together came into serious disagreement with the director of the picture. Both were sure they would get along better with Trumbo, and so they came to him and asked him to direct the film; they would, they said, force the issue by threatening to quit if he were not substituted. Trumbo refused—"You just don't do that," although in fact other screenwriters have become directors under similar circumstances. "I never regretted it, since I never envied a director that much. I always felt I had a lot more freedom than directors. My occupation, the steady hours, and the fact that I worked in an office, all quite different from directing—freer."

He stayed on at Paramount because he had become involved with Preston Sturges and the French director René Clair in the adaptation of a bit of Thorne Smith nonsense titled *I Married a Witch.* Eventually, of course, it was produced with Paramount's new blonde bombshell Veronica Lake in the starring role, but without Dalton Trumbo's name among the credits. He remembered the project, for the most part, as a series of uproarious and bibulous lunches at which the three of them kept reminding one another that they really had to get down to work sometime soon. Eventually they did, and what developed there were differences between Sturges and Trumbo on the interpretation of the material. The last of these, on which Trumbo finally bowed out altogether, took place on a Sunday for some reason. Trumbo remembers coming away from it, not discouraged but hungry, wanting to eat the breakfast

he had missed. He stopped off at a place on Sunset, and while he was there eating he heard the news: the Japanese had attacked Pearl Harbor.

It was war, of course. Trumbo must have expected it, for he had thought it out beforehand. What would be his response, he must have asked himself, when the war that seemed so inevitable finally came? This is how he had put it beforehand in *The Remarkable Andrew*, speaking here in the person of Andrew Long:

> Now a lot has been said about my being a pacifist, although I haven't said a thing about it. I want to point out that this is a lie. I suppose if this country went to war, I would go to war too—even if it was a *bad* war—because once you're in it there doesn't seem anything to do but fight your way out of it. But I also think it is my right, if I want to, to oppose this country going to war, even if the war is a *good* one. Because the people of a country should have something to say about whom they will fight, and when, and where, and how. I don't think it's pacifism to be against war. I think it's just being decent.

If that does not, in itself, constitute a change of position, then it certainly prepares the way for a change. Of course Trumbo was never a doctrinaire pacifist—perhaps not a *real* pacifist, at all. The radical final chapter of *Johnny Got His Gun* ("Remember this well you people who plan for war....") shows that although he was emotionally—passionately—opposed to war, he drew the line well short of unconditional surrender. At any rate, he had no real choice now: he deferred his doubts and resolved his difficulties; and he threw himself as completely as a 4-F could into the war effort.

He did one more original screenplay during this free-lance period, one that came back to haunt him at the Hollywood Ten hearings. Very early in 1942—the war had just begun—he approached RKO with a project that not only seemed right to them, but also seemed right in particular for Ginger Rogers. And the idea of pairing Trumbo and Rogers, an Oscar-winning combination in 1941, was irresistible to them: they had him proceed with *Tender Comrade*. The film that resulted from this collaboration was a prime wartime tearjerker and certainly not a good film. Released in 1943, at a time when girls all over America were saying goodbye to their men, it told of Ginger's brief affair with

soldier Robert Ryan on the eve of his departure for duty overseas. They marry and have one night together before he must leave. He is killed in action, and in the last scene she goes to their baby, holds up Ryan's picture to him, and says, "Little guy, you two aren't ever going to meet. He went and died so you could have a better break when you grow up than he ever had. Don't ever let anybody say he died for nothing, Chris boy."

Now, there are plenty of reasons to object to a movie like that, but it is hard to see how anyone could find fault with it on ideological grounds. However, during the 1947 hearings of the House Committee on Un-American Activities before Trumbo or any of the other "unfriendly" witnesses were called, Lela Rogers, the mother of Ginger Rogers, appeared, and in her testimony cited *Tender Comrade* as a specific example of a movie in which her daughter had been given lines that contained Communist propaganda. And it was, of course, Dalton Trumbo she blamed. What annoyed her most, it turned out, was the fact that in the movie, after Robert Ryan ships out, Ginger persuades three female coworkers to pool their resources and move into a big apartment together where they can live "just like a democracy." Of just such flimsy stuff was the case against the "infiltrators of the motion picture industry" made.

By the time *Tender Comrade* was released, Trumbo was safe under contract to Metro-Goldwyn-Mayer. He had gone back to the studio which he had left in 1938 to marry Cleo. And in the latter part of 1942 he returned to Culver City, happy to renew his friendship with Sam Zimbalist and others there. What was the attraction that M-G-M held for Trumbo? "It was immensely the best studio," he declared, "in all respects. If you were going to work for a studio, that was the one you wanted to work for." And that was it, of course. Trumbo, who wanted to be the best at all cost, could only see himself working at the best studio in town. He had—no more than temporarily, he would have said then—stopped thinking of himself as a novelist. So there was no reason not to work at M-G-M.

They knew how to use him there. The first full-blown project they put him to work on was *A Guy Named Joe*. By the time Trumbo got hold of it, it had been through a couple of versions, the latest by the old western writer Frederick Hazlitt Brennan. The production was scheduled. Spencer Tracy and Irene Dunne were set for it. All Trumbo had to do was come up with a shootable script.

It was to be a big picture. Not only were Tracy and Dunne set for it, but so also were Van Johnson and Ward Bond. The project brought him together with one of the studio's top directors, Victor Fleming (*Captains Courageous, The Wizard of Oz,* and *Gone with the Wind*), a macho right-winger with whom Trumbo might not have been expected to get along. Yet he found Fleming tough, direct, and honest in his personal dealings, and the two grew to like one another quite well. This is worth mentioning because it underlines the fact that in the pre-blacklist days, film people of very different political persuasions usually got along on the professional level. Their business was making movies. Too bad, in this case, the movie they made was not a better one. *A Guy Named Joe* is a far-fetched, at times almost fatuous, story of an Air Corps pilot who is killed in combat but comes back as a benign ghost to look after the woman he loves, who is also a pilot. Enough said. Still, as a star vehicle for Spencer Tracy and Irene Dunne it was quite successful. When it was released in 1943, audiences flocked to it and laughed, thrilled, and applauded at all the right places. Dalton Trumbo's future at Metro-Goldwyn-Mayer seemed assured.

Late in December 1943 he joined the Communist Party. Why? How? Remember that it was wartime. The United States and the Soviet Union were allies. Under the leadership of Earl Browder, the Party line at that time was in strong support of America and the war effort. Browder, Kansas-born with a Russian wife, softened the Party's customary stand on such bread-and-butter issues as race and trade-union militancy in order to flow with mainstream opinion and to make Marxism more widely acceptable. In a way, Browder was successful; for in May of 1944, approximately six months after Trumbo joined, the membership increased to its all-time high of eighty thousand. And the following year, 1945, Communists registered some success in local elections—principally in New York City, where two candidates running openly as Communists were elected to the city council. Browder even changed the name of the Party slightly, to the Communist Political Association.

That's the background—not the excuse. Trumbo made no excuses for having joined the Communist Party. He may have gone to jail once rather than discuss it, but on this day in his study, he is more than willing to talk. I had probably been a little too discreet to suit him earlier. In my questions over the past few days I had skirted the question of

his membership a couple of times, as though it were an embarrassment between us. Pussyfooting, you might call it. But the embarrassment was all on my side. He brought the matter up himself:

"Now," he says, "there is one area we haven't gone into yet that I think we must."

I clear my throat. "What's that?" I ask.

"That's my membership in the Communist Party."

"Yes. You joined during the war, didn't you?"

"It was in 1943."

"Did that have a lot to do with it? The war and all?"

"No, not much. You see, I had worked with Communists, friends who said they were Communists, from the time the Screen Writers Guild began to reform itself in 1936. In the organization of Hollywood labor—the talent guilds, and in particular the Readers Guild—I had been very active, and working along with me were men who were Communists and men who were not Communists. The Readers Guild came above ground—of course it had to be secret during the period it was organizing—at my house on Hollyridge Drive, where I was living with my mother just before I was married. And the principal speaker to greet them was Dashiell Hammett. I was delighted because I had been a reader myself and had helped out at the beginning of the Readers Guild. You see, I had been a part of every such movement, and some of my very best friends were Communists. And no one had pressed me to join. There was really no reason to. I came to trust them, to admire them, to like them. And when the war came, I worked with Communists during the war—Communists and others—until it seemed to me that I was traveling under false colors.

"I hope this doesn't sound as some might interpret it, but the growing reaction against Communism—and in Hollywood the formation of the Motion Picture Alliance for the Preservation of American Ideals—convinced me that there was going to be trouble. And I thought I wanted to be a part of it if there were. I didn't want to have the advantage of those years of friendship and then to escape the penalties. Now that may sound odd. I don't think it's odd at all. That was part of my motive. If they hadn't been my friends, I wouldn't have joined. Someone asked me to an open meeting, and I went, knowing full well what that meant. And then someone said, 'Would you like to join?' And I said, 'Well, look, I wouldn't have come to the meeting if I hadn't

decided to join.' And I was a member. To me it was not a matter of great consequence. It represented no significant change in my thought or in my life. As a matter of fact, I had a Party card that I put in my shirt pocket, and I left my shirt at my mother's house for laundry because we were at the ranch part of the time, and I used to leave my laundry there. So that was where I left my Party card, and that was the last I saw of the Party card. So that it was just casual. It wasn't a traumatic moment in my life. I would not remember the year or the exact time, as I would remember the year of my marriage. It was literally no change. I might as well have been a Communist ten years earlier. But I've never regretted it. As a matter of fact it's possible to say I would have regretted not having done it because, I don't know, but to me it was an essential part of being alive and part of the time at a very significant period in history, probably the most significant period of this century, certainly the most catastrophic."

There is nothing, as he talks, of the bantering manner of the raconteur that he sometimes adopts. He is talking directly, and (I'm convinced) frankly, setting the record straight. "What kind of people did you find in the Party?" I ask him.

"Well," says Trumbo, "you must remember that about a million people passed through the Communist Party in the period between 1935 and 1945. Very few intellectuals were not influenced in one way or another by the Communist Party. And, you know, there were some pretty nice people among them. With all the damnation we've heard directed against the Communists since the forties, I've never seen it set forth just what kind of people we had in the Party. There were self-seekers, self-servers, there were neurotics, et cetera, as there are in any group, anywhere. But the people who joined the Communist Party didn't join it in order to become popular. They didn't join it because they thought it would make them rich. As a matter of fact, they knew that if their membership was known, they would probably lose their jobs. There are very few selfish reasons why anyone would join the Communist Party. They didn't join it because they expected a revolution to reward their efforts because as far as I know there was no expectation in the Communist Party of a revolution in the United States, except in some remote future. So that reward was not there. They knew that they would be watched by the FBI. They knew that at the first

moment of trouble, in the pattern that had already been established by the old Palmer raids, they would be the first to go to jail."

"All right," I say, "why did they join then?"

"Well, they joined for very good, humane reasons, in my view, most of them. In a time that began with the Depression and the total collapse of the American economy, with fourteen million unemployed, and soon spread throughout the world. In a world that had fascism in Germany, and Spain, and Italy, and an era that culminated in the forties in a war that killed fifty or one hundred million people—and saw the fires, not only of Hiroshima and Nagasaki, but the fires of Auschwitz and Treblinka—in such a world and such a time, it was not madness to hope for the possibility of making a better sort of world. And that, I think, is what most of those who joined wanted to do."

Trumbo learned firsthand of the FBI's interest in members of the Communist Party shortly before he joined up. ("You must remember that at this time the secretary of the Communist Party of Los Angeles was secretly working for the FBI.") The incident, which he described at length in his introduction to the Ace paperback edition of *Johnny Got His Gun,* had to do with some odd correspondence he had been receiving from certain readers of the book. He found that because of the antiwar message of the book, it had suddenly become useful as propaganda to the far right in America as Axis fortunes began to fail. Anti-Semitic and native fascist groups put on a big push for an early peace, demanding that Hitler be offered a conditional peace. Trumbo was understandably distressed that he and his book had been embraced by such as these—so distressed that he did something imprudent: he invited the FBI to come and take a look at this correspondence, some of which he was sure bordered on the treasonous. They came, all right, "a beautifully matched pair of investigators," but it turned out that they were far more interested in Dalton Trumbo, his left-wing opinions and activities, than in his right-wing fans. He realized then that he must have been the object of their scrutiny for quite some time. In the letter he wrote them following the incident (actually only a draft written but never sent), he objected to the interrogation he had been put through and set out to account, point by point, for his shift from the antiwar

attitude of *Johnny Got His Gun* to his then militant support of the war effort, which included a recent pamphlet urging the establishment of a second land front in Europe in relief of Russia.

That pamphlet was not the only war writing he did. He became deeply involved, as did most of the movie writers who stayed behind, in the production of the apparently never-ending stream of war propaganda that issued from Hollywood for all official sources. He was a member, as were most active members of the Screen Writers Guild, of the Hollywood Writers Mobilization, a sort of clearinghouse to provide writers for every war-related project and purpose for which they might be needed.

Trumbo did more than his share of work of all kinds for the Hollywood Writers Mobilization, but eventually he found his calling as a speechwriter, the old Western Slope Rhetorical Champion coming to the fore once again. And it was this talent that led him into one of the most unusual episodes of his wartime years: his service for the American delegation to the United Nations Founding Conference in San Francisco in 1945. It all came about rather suddenly when Trumbo was waiting to hear from the Army Air Force whether or not he had been accepted as one of a group of writers who were to be taken into the war zone for a firsthand look at combat. When a long-distance call came through to him one night then, he expected that it was the Department of the Army at the other end, telephoning the permission he had been waiting for. Instead, it was Walter Wanger, the motion picture producer. He was calling from the first United Nations Conference and asking Trumbo's help. The problem was putting together a proper speech for Secretary of State Edward L. Stettinius to deliver to the Assembly. Nobody there could write, Wanger said. Could Trumbo come up at once?

He flew up the next morning. Wanger, who had arranged for the travel priority and Trumbo's accommodations with the American delegation, was anything but a radical. As a young man he had been a junior member of the American delegation to the World War I peace conference at Versailles. And although he had come out to Hollywood immediately afterward, he had always kept his hand in politically and was an official member now of the American delegation to the UN Conference. He had no idea of Trumbo's politics—or, if he did, must have felt they didn't matter.

Trumbo spent the first night at the Mark Hopkins Hotel and met members of the delegation, which included Thomas K. Finletter and, by the rarest sort of coincidence, Trumbo's old Delta Tau Delta roommate from the University of Colorado, Llewellyn Thompson. "It was a reunion after many, many years," Trumbo said. "Wally [Thompson] and I talked at great length. Obviously none of them knew anything about my political tendencies." And probably a good thing, too.

The next day he was moved into quarters with the delegation in the Hotel Fairmont. "I was given a room on the fourth or fifth floor, between [John Foster] Dulles and [Harold] Stassen. It was a rather weird sensation to get off the elevator and look down the hall and see white-gaitered MPs standing guard in front of each room, and then, walking down that hall, to hear typewriters going behind each door. I went into my room, and for some reason I looked under the blankets in the closet, and I found two copies of the *People's World* [the West Coast Communist weekly]. Now, this obviously wasn't a plant on me. The previous occupant of that room had read the *People's World* and left two copies there. But the *People's World* was the last thing in the world I wanted in the room, so I went into the bathroom, and I carefully tore both copies up and burned them and dropped them down the toilet to get rid of them.

"I worked for Tom Finletter, for example, sometimes for whole days. We corresponded later on, and afterwards he became secretary of the air force, I believe."

The problem Trumbo had been summoned to work on was the admission of Argentina. The Fascist government of Juan Perón had sympathized with Germany all through the war. The speech Trumbo was called in to work on was intended to be an appeal to be delivered by Secretary of State Stettinius over the head of Perón to the people of Argentina. As such, of course, it had to be both carefully and passionately phrased.

In a few days of intensive work there in the Fairmont, Trumbo solved the problems and finished a draft of the speech that was acceptable to everyone present in San Francisco. "I have a copy of the original speech as it came back among my papers at the university," said Trumbo. It is now probably the only copy of it in existence. "Finletter and I went to the top of the hotel where they had cable machines, mixer machines, and we received our speech, approved by the President. I have it in that

form. I kept it. Two days later, when the Argentine foreign minister had been in town for a week, he had a good idea of what was up. But it was Nelson Rockefeller who gave it the shaft. He was able to stop the speech, which was pretty tough, and we had to go back with it, and the speech was rewritten—though not by me. Rockefeller even brought his own speechwriters in to work on the new, tame version in which they practically welcomed Perón with open arms. I got out of there as quickly as I could.

"It was interesting that within two years I was on the witness stand before the Committee. Then, of course, Wally Thompson was in a much higher position indeed, and Stettinius was rector of the University of Virginia, I believe. I had worked closely with all of them. And there I was on the witness stand. If I had been willing to play it chicken-shit, I could have said, 'What do you mean I'm unpatriotic? Didn't I do this? and this? and this?' But I didn't say that, and I made no attempt to get in touch with any of them from that time forward. However, Otto Preminger and his wife were in Moscow many years later while Wally [Llewellyn Thompson] was ambassador there, and they had dinner there at the embassy. My name came up, and Wally said to Otto, 'You know, that man saved my career. If he had mentioned my name or sent me a letter, I would have been through.' "

The three from the San Francisco UN Conference were not the only names he could have used. George MacKinnon, with whom he had grown up in Grand Junction and who became a judge in the United States Court of Appeals, was serving his only term in Congress when Trumbo appeared before the House Committee on Un-American Activities. As a congressman from Minnesota—even a freshman congressman—MacKinnon would have been in a better position than almost anyone to put in a word for him at the Committee. Did he? No. "I didn't go to the hearing room that day Dalton was up," Judge Mac-Kinnon told me. "And he made no effort to contact me while he was here in Washington."

Hubert Gallagher, the boyhood friend who had even worked with Orus Trumbo in Benge's Shoe Store, was on Truman's staff in the Executive Office of the White House when Trumbo made his appearance before the Committee. Gallagher told me when I talked with him that he had been deeply ashamed ever since that he had failed to contact Trumbo when he was in Washington. He felt he had let him down: "I

talked it over with the people I worked with, and they pointed out that if I had gone out to visit him I would be tagged and watched closely from then on. I didn't want to lose my clearance, so I let it go. It's been on my conscience, I can tell you. You see, just a couple of years before that he had been through Washington on publicity for that movie of his, *Thirty Seconds Over Tokyo*. We had a great old time then. I remember he even insisted I come along partway with him on the trip to New York, so I rode with him as far as Baltimore in his drawing room on the old Congressional. Would you believe it? We downed four Scotches between Washington and Baltimore." Gallagher laughed, remembering. "They had to pour me off the train. That was just three years before all that Un-American business. I was ready enough to share his good fortune with him, but when the crunch came, I let him down. I've had to live with that ever since."

I had wondered about Thomas K. Finletter's impressions of Dalton Trumbo from the San Francisco UN Conference. The two men worked very closely and for extended periods during that time—"for whole days," as Trumbo remembered. And of course, had Finletter's memory begun to fade, it would have been refreshed rather dramatically when, in less than two years' time, Trumbo's name appeared in the headlines.

I was encouraged when I talked to Thomas Finletter on the telephone and told him why I wanted to see him.

"I'm writing a book about Dalton Trumbo," I told him. "And I understand that he worked with you at the UN Founding Conference in San Francisco in 1945. Could you talk to me about that?"

"Yes," he said, "certainly."

The name of Thomas K. Finletter is one at least familiar to anyone of my generation. He is one of those men who seemed always to have held prominent positions in successive Democratic administrations. Like most such men, he was from a socially prominent Eastern family—the Finletters are from Philadelphia. Born in 1893, he grew up there, attended the University of Pennsylvania, and married a daughter of Walter Damrosch, then the conductor of the Philadelphia Orchestra. However, he began the practice of law in New York City and eventually became a highly successful corporation laywer there. Among his posts in a long public life which began in 1941 were a number in the State

Department during the war; he attended the UN Conference at San Francisco as a special consultant. Following that, he was minister to Great Britain in charge of the Marshall Plan mission; and from 1950 to 1953, under Truman, he was secretary of the air force. With time out during the Eisenhower years, he returned to government service as the United States ambassador to NATO, under Kennedy and Johnson, from 1961 to 1965.

At the age of eighty-one, Thomas Finletter looked fifteen years younger. He was bald but what hair he had left was dark. Erect and positive in his movements, he indicated where I might sit, a secretarial table opposite him, and took a place himself at his desk. He then turned his direct, rather cold gaze upon me and indicated with a slight inclination of his head that I might begin asking questions. I inquired about his role at the United Nations Founding Conference.

"My own role?" he echoed. "It was very minor. It was advisory, I suppose, more in the nature of personal contact. I was not even a member of the American delegation to the conference."

"A consultant?" I prompted.

"Was that the title? Yes, I suppose so."

"How well do you remember Dalton Trumbo?"

He fixed me with a stare. "I do not remember him at all."

"Really? But..."

"It's all been so long ago that I've forgotten most of the details. I did stay there during the conference, yes, but as to the details, I remember very little."

Why had he let me come? If he wasn't going to talk about Trumbo, what was the point in talking to me at all? I decided to press as delicately as I was able. "Dalton Trumbo came to the San Francisco Conference to help in the writing of a speech," I said. "He came at the invitation of Walter Wanger, the motion picture producer. Do you remember Walter Wanger being there?"

"Yes," said Mr. Finletter, "I remember Walter Wanger."

"Llewellyn Thompson, too. Mr. Trumbo worked with him there, and he knew him from earlier. They were fraternity brothers in college."

"I remember him, of course. I knew all the American delegation. But I don't remember Llewellyn Thompson's role in the San Francisco Conference."

"I was also told that he—that Dalton Trumbo—worked with you," I persisted. "The speech that he helped write, did a draft on, you would say, concerned the problem of the admission of Argentina. You recall the problem?"

"Yes," he conceded, "I recall there *was* a problem."

"Wasn't that your area? Weren't you more or less responsible for that?"

He shook his head and frowned deprecatingly. "I doubt that I had such authority as that."

"Then you don't recall working with Mr. Trumbo on that?"

"I have already said, I do not remember Dalton Trumbo at all."

"Do you know who he is?"

Once more he directed that level gaze at me. "No. Who is Dalton Trumbo." I have omitted the question mark in the interest of stenographic accuracy, for there was never a question asked with less curiosity. I told him briefly of Trumbo's reputation as a novelist and screenwriter, that he was a Communist at the time of the San Francisco Conference, and of his subsequent blacklisting. He waited until I was through, then nodded curtly and rose. The interview was over.

On the way out, for want of something to say, I remarked that I knew of his books—this was true; I had read one and looked through another in preparation for the interview. "Are you doing any writing now?" I asked.

"Yes, as a matter of fact I am," he said.

"Not your memoirs, I hope." In less than a minute I was in the elevator on my way down to the street.

Why? Why had Thomas K. Finletter changed his mind about talking to me? Was he afraid that at even this late date his name would be dirtied if he were to acknowledge his association with a Communist at so crucial an occasion as the founding of the United Nations? If Finletter was a man who had played a role in the shaping of the modern world, he was certainly also a man who had been shaped by it. His attitudes were fundamentally those of the embattled Cold Warrior, the liberal in public life trying carefully to pick his way between the excesses of American isolationist conservatism on the one hand, and on the other, the very real threat offered by Stalinist communism abroad. Such men had, since the McCarthy era and well before, been judged by

the company they kept; it was not surprising that he should be reluctant to admit working with a member of the Communist Party, even though he had had no knowledge of his politics at the time.

While Trumbo was at the UN Conference in San Francisco, the word he had been awaiting from the Army Air Force on the tour of the Pacific War Zone came through. He was to report in a few days' time for transportation. A list of basic items he was to bring along on the trip yielded one surprise and very nearly caused a crisis. He had no passport. A rush priority was put on his application, and the passport was actually delivered to him from Washington in Stettinius's pouch.

Most of the civilians who were traveling in Trumbo's party were writers like himself—that is, novelists, screenwriters, and feature writers, rather than news correspondents. The reasoning behind this was that since it looked as though the war with Japan would last for many years more (the war in Europe had just ended), there would probably be plenty of time for novels and films to be written, and it would be best to have them accurate in their depiction of combat and service life. Trumbo was chosen because he had already written a film that pleased the Air Corps immensely, *Thirty Seconds Over Tokyo*. Of the writers who accompanied him, however, he recalls only one: the mystery writer George Harmon Coxe, whom he heartily disliked.

There was a good deal of war left for Trumbo to see during the six weeks he spent in the Pacific—and in fact, he saw quite a lot. He was in on one island invasion, one of the last amphibious assaults of the war, the invasion of Balikpapan. It was a combined Australian-American operation of some importance, for its purpose was to cut Japan off from one of her last sources of oil. The crude oil pumped from this South Borneo island was said to be so pure and rich that it could be used as diesel fuel just as it came from the wells. The assault was mounted July 1, 1945. For some days before the island had been under continual bombardment, but the Japanese were, as always, very well dug in. The Australian soldiers who were landed by the American amphibian teams came under very heavy artillery and mortar fire. It took them most of the day to secure the beach and begin to move inland. The party of correspondents set out for the beach only fifteen minutes after the operation had begun and hit Balikpapan between the first and second waves

of assault troops. They stayed for the duration of the brief campaign and were, of course, under fire through nearly all of it, though back far enough that none of their number was so much as wounded.

Later that month Trumbo came under fire once again during a combat mission he flew with a B-25 crew against targets in the southern islands of Japan. During the course of this episode he had his only real close call of his four weeks in the Pacific. Bad weather kept them circling the island of Kyushu, waiting for it to clear so they could make a run over their primary target, all the while under antiaircraft fire from the ground.

> Then we received orders to turn back. The crew are disappointed. It means a flight under combat conditions, but no credit for mission. They brighten at the thought of Tanega Shima. Perhaps there. But Tanega is completely overcast. Kikai Shima is the last chance. The weather begins to clear. Far below a yellow stain shows up on the sea—the dye spot from a fallen Corsair. Later we spot another. Kikai Shima is clear as a bell. We come down to 6500 feet for the bombing run, plant our whole load on Wan airstrip and scoot for home.
>
> The bombardier-navigator comes back to check figures with the pilot. The co-pilot leans toward him, and the three of them shout soundlessly to each other. The gunner and I watch, trying to make out what they're saying. Then it comes over the intercom. The hour and twenty minutes over Kyushu has consumed too much gas. Prepare to jump if the engines conk out. Calculations give us less than enough fuel to make it back to Kadena.

They did make it back, however, and discovered upon landing that there were just fifteen gallons left in each tank.

The account from which I have just quoted appears in a long article, "Notes on a Summer Vacation," which Trumbo published in the *Screen Writer** upon his return. It is a fine piece of first-person journalism, graphic and precisely detailed, brought to life with the sights, the sounds, and even the smells of war.

*Dalton Trumbo not only wrote for the *Screen Writer,* he was also its founding editor (1945).

How did Trumbo find time for such extracurricular activities? He had done war work for the Writers Mobilization; gone to San Francisco to write a speech for the secretary of state; made an extended tour of the Pacific combat zone; and had even managed to edit a magazine on the side. While all the while he was supposed to be working as a screenwriter at Metro-Goldwyn-Mayer. The truth was that he did very little work for M-G-M during the war, for the terms of his contract there were so favorable that they made it possible for him to work in almost a part-time capacity while on (very) full salary.

"The result was I really didn't do very many pictures there," said Trumbo. In a way, it is remarkable that those he did were as good as they were. But quality was what Louis B. Mayer was paying for. He knew it, and he knew he could get it from Trumbo. And if, objectively, *A Guy Named Joe* was a rather dismal beginning, from M-G-M's point of view, at least, it couldn't have been much better, for it was a solid box-office success. Trumbo's next film for the studio was probably the best of all his pre-blacklist screenplays—*Thirty Seconds Over Tokyo* (1944). It was based on the memoir by Captain Ted Lawson of the bombing raid early in the war (1942) on Tokyo, led by then Colonel James Doolittle. The raid itself had been almost in the nature of a publicity stunt and of no appreciable military value. Just to be able to tell the folks on the home front they had really bombed Tokyo, it was necessary to send out a small flight of B-25 medium bombers from the deck of the aircraft carrier *Hornet* with no expectation of returning. Their fuel range permitted them only to make their bomb run over Tokyo and continue on for crash landings on the Chinese mainland. This was officially Japanese-occupied territory but was effectively controlled by bands of Chinese guerrillas; many, though certainly not all, of the crewmen from the Tokyo raid were thus rescued by the Chinese and smuggled through Japanese lines into northern China, whence they were able to return to America.

This was the story told by *Thirty Seconds Over Tokyo*. The film dwelt upon the rigorous training of the airmen for the mission, including dangerous takeoffs from a flight deck never intended to accommodate planes so large. It built nicely to the natural climax provided by the raid on Tokyo, about two-thirds of the way through the picture. There was, unfortunately, no way to prevent the remaining third from turning into a protracted anticlimax. It was simply inherent in the

material—especially so since the protagonist Ted Lawson, played by Van Johnson, was injured in the crash landing in China and had to be carried out hundreds of miles in a litter. Robert Mitchum starred as Lieutenant Bob Gray, and Spencer Tracy received star billing for what amounted to a supporting role as Colonel Doolittle. As for Trumbo's contribution, it came chiefly in the form of exercising restraint. *Thirty Seconds Over Tokyo* is blessedly free of the phony heroics and unreal wisecracks that mar just about every other war movie made during World War II. There is a certain grit to its dialogue and a careful attention to detail that makes it believable and enjoyable today. It stands the test of time. And if Trumbo failed to solve the problem of the film's anticlimatic final third, at least he did not try to inject suspense and plot interest into it artificially with old B-movie tricks. He was true to his material. *Thirty Seconds Over Tokyo* is an authentic and in some ways an austere film. It is certainly the best that Mervyn LeRoy, who directed it, ever made.

As for the final picture Trumbo did at Metro, *Our Vines Have Tender Grapes* is, like *Thirty Seconds,* the kind of movie that can be viewed today without consternation or discomfort. Although it starred Margaret O'Brien, her lugubrious displays in the film were kept to the absolute permissible minimum. In fact, Trumbo's screenplay manages to save the film from the sort of cloying sentimentality that marked most of her other films. For good reason, he was extremely fond of *Our Vines Have Tender Grapes.* "That turned out to be a *lovely* picture, I thought. It wasn't wildly successful, but it was a very sweet, honest, decent picture of farm life, and that's because it came from a lovely novel."

This is probably another instance of Trumbo doing his better work when he found something personal in the original material with which to identify, as was the case, for instance, with *A Man to Remember.* And for him, the personal element in *Our Vines Have Tender Grapes* must have been its rural setting. He continued to think of himself as a landowner, a rancher, a man of the soil. Even though trips out to the Lazy-T were restricted because of wartime gas rationing, the ranch continued to be important to him as an expression of something in him, something in his conception of himself. The place continued to have great symbolic importance to him, even when it became necessary to buy another house in town, a rather palatial one on Beverly Drive in Beverly Hills (which was a dead ringer for the manse David O. Selznick used as

his trademark). They only held on to it through the war, and then they sold it. It was all right: Trumbo could afford it.

Shortly after *Our Vines Have Tender Grapes,* he had his contract renegotiated. The new one was at that time the best that any writer in the motion picture industry had ever held: three thousand dollars per week or seventy-five thousand dollars per picture, as he preferred; no layoffs for the period of the contract; and no morality clause. Why was he worth all this? Because he had written three hits in a row. And, as Louis B. Mayer told Trumbo, the studio had faith in him to write more. Negotiations had been prickly, but they had come to terms quite favorable to Trumbo. Mayer summoned him to his office, and Trumbo came, prepared to hear almost anything. Still, he was surprised when Mayer sat him down on the couch and came around in his sockfeet to talk in his most *haimish* manner. "Look, I know your record," he said. "And I'll tell you this. You sign this contract. You make the first picture, and if it fails, you won't hear a word from anybody. Make another picture, and it's a failure, and nobody will say anything to you. You make another picture, and it fails—not a word! Because the fourth picture will not fail, and that one will make up for the first three." Mayer knew his averages, and he knew his writers, and he knew that Trumbo was batting at the top of the league.

It was at that house on Beverly Drive that the Trumbos spent most of the war, with occasional trips to the Lazy-T, just to prove to themselves that it was still up there waiting for them. They were living in Beverly Hills when the youngest of their three children, Melissa (Mitzi), was born October 4, 1945. These were quite important years for them. For better or for worse, Trumbo was now deeply committed politically. He gave his time and energy unstintingly to what were essentially political causes, including war work of one kind or another. It was a time— as indeed most times were for him—when Trumbo was tremendously busy. Yet it was also a time of waiting, of marking time, for they could sense the crisis that lay ahead.

On the bottom of the first page of his account of his tour of the Pacific war zone, "Notes on a Summer Vacation," published in the *Screen Writer,* there is a note that in retrospect seems almost sad: "Dalton Trumbo submits notes on a recent Pacific trip. Since he is using them as the basis for a novel, he requests no re-publication or quotes without written consent." Yes, he did intend to write such a novel.

Considering the period in Trumbo's life during which he planned it, it is not surprising that this one was to be a political novel. Trumbo knew that he had had an unusual look at the top and bottom of the war in the period of a month, going from the UN Conference in San Francisco to the war in the South Pacific. Trumbo wanted to write the kind of novel that would use and encompass such experience, one perhaps necessarily with a strong political point of view. But the more he thought about it, the more the project expanded in his mind. At one point, late in 1945 or early 1946, he wrote to Elsie McKeogh that he saw it as a cycle of six novels, in which he would borrow heavily from his own experiences, beginning with his vivid memories of life in the bakery and concluding with the postwar years which he saw then only as a question mark. He took notes, drew up a list of 161 characters, and did a first chapter; but nothing more was done on it for a few years. Ironically—or perhaps inevitably—the only one of these novels on which he actually did much work was started and half-finished during the only period in the coming years that he would have any time for extended writing projects of this sort. That is, during the time he spent in jail.

CHAPTER SEVEN

THE TEN

I find Jean Butler, the widow of Hugo Butler and a writer herself, to be a likable woman. Along with her husband, she passed through the Communist Party during World War II, the Browder period: "You have to remember that at the time we joined, it was very easy to agree with the Browder interpretation and just be what you'd always been before—a good liberal.

"What was life in the Party like? Well, I can only tell you what it was like for us, and the way I remember it, there was the most rigid caste system in the formation of the Party's small groups—what people outside the Party seemed to call 'cells.' I never heard the word inside myself. And the funny thing was, the Party's caste system was based on money. The high-salaried writers were in one group—that was Dalton—and the low-salaried writers were in another—that was Hugo. Again, it was funny to discover that the wives were in separate groups entirely. I found, frankly, that the Communist Party was just as male-chauvinist in its orientation as any group, even the American Legion, I suppose. I was in this study group with all the other wives, but I'm afraid I didn't go after the first few meetings because I got bored by all the economics we had to read.

"Hugo was a little different, maybe a little more serious about it all than I was. At a certain point he found that all his friends were in the Party, but as it turned out, none of them—Trumbo or Ring or Ian—recruited him. Somebody else did that. In part, I think he joined out of

a feeling of friendship and solidarity with his friends who were in. In part, I think he felt a kind of dare to do it. And in part, too, I think, he may have joined because of his stepfather."

"His stepfather? Was he a Communist?"

She laughs. "No, nothing like that. He was just a guy who had worked most of his life at a United Cigar Store. He was making thirty-four dollars a week when the Depression hit, and his boss wanted to cut his salary to fourteen dollars a week. When Hugo's stepfather protested, he was fired. His boss told him he had a boy lined up who would do the same job for ten dollars a week. Hugo used to say there's something wrong with a system that permits that kind of abuse, that kind of cruelty."

And for her? What was her motive?

"Oh, I went along. You know. But once I was in, I found I developed a sense of fellowship with these people that was very real.... You'd go into a drawing room at a party and see people there who belonged to the Party, just as you did, and you'd have that thrill of fellowship. That was my feeling.

"All this was fairly early in the war, during the Browder period. And things *were* different then. I remember, for instance, when it came time for Hugo to go into the army, they put him on a leave of absence from the Party because they wanted no feeling of divided loyalty. This was late 1942, as I remember. Then just after the war, when he came out of the army, he went back in. I didn't. I was advised not to by him. I guess he sensed what was coming and wanted to spare me what he could. I think we all knew that it was going to be different after the war. For one thing, the openness of the Browder period was coming to an end—the honeymoon was over. And then came the Duclos letter, and the arguing began inside the Party. I remember one practically all-night session between Trumbo and Hugo. I finally went to bed, but they got so loud that I woke up to hear Trumbo saying, 'It comes down to this, if Lenin was right, then Browder was wrong—and vice versa. I prefer to believe that Lenin was right.' That was Trumbo. He knew how to argue. I thought, 'Oh, dear,' and rolled over and tried to get back to sleep, knowing we were really in for it."

The Duclos letter Jean Butler referred to was a contribution by Jacques Duclos, a French Communist Party official of international

importance, to the Party's publication in France, *Cahiers du Communisme,* which was published in April 1945. It was an attack on Browderism, and the line of patriotic cooperation during wartime. Duclos was especially bitter about the dissolution of the American Communist Party in favor of the Communist Political Association, and the renunciation of revolutionary goals which this implied. He praised the right-thinking of Browder's hard-line opponent in the Party, William Z. Foster, and in effect marked Earl Browder himself to be purged. Although it was a month before the Duclos letter appeared in the *Daily Worker,* the effect it had on the American Party leadership was immediate and devastating. While they had received no prior notice of Stalin's displeasure, it was understood by Browder, Foster, and the rest that such strong criticism from so high a source had to have been ordered by the chief himself. Browder had no appeal. Within a few months, the Communist Political Association was the Communist Party once more, Browder was ejected from it in February 1946, and the much tougher William Z. Foster was firmly in charge.

Inevitably this shakeup and the sudden change of direction it signaled had an unsettling effect on the rank-and-file membership of the Communist Party—and nowhere more than in Hollywood, where the patriotic line of Browder had attracted many members to the Party who were only a little left of liberal. If Earl Browder could be disposed of so quickly, and the philosophy he represented bumped so unceremoniously, then, they reasoned, the Communist Party was not the liberal body they had been told it was. Many wartime recruits left the Party about this time—many in Hollywood who were subsequently blacklisted; the question, after all, was, "Are you now, or *have you ever been*...?"

A few chose instead to bring the debate out into the open. One of them was Albert Maltz, who would, in a little more than a year's time, be identified as one of the Hollywood Ten. More than most Hollywood writers, Maltz had an established literary reputation at the time. He had by then written four novels but had come west from New York on the strength of the work he had done as a playwright for the Theatre Union during the thirties. He arrived in Hollywood in 1941 and worked successively at Paramount and Warner Bros. on a number of big productions. *This Gun for Hire* was his first screenwriting credit, and he subsequently worked on such important films as *Destination Tokyo,*

Pride of the Marines, Cloak and Dagger, and *The Naked City.* He was as well established as any writer in the Party when, in February 1946, he published in *New Masses* a fairly short essay, "What Shall We Ask of Writers?" in which he explored quite logically the discrepancy between the writer's obligation to himself and to the Party. The difficulty, he strongly suggested, lay not so much in the idea of art as a weapon but finally in the refusal of Party intellectuals to place on art any value except that "I have come to believe that the accepted understanding of art as a weapon is not a useful guide, but a strait-jacket," he wrote. It was now understood "that unless art is a weapon like a leaflet, serving immediate political ends, necessities and programs, it is worthless or escapist or vicious."

The storm that broke over the Maltz essay filled the pages of *New Masses* for the next couple of issues. It should be noted, by the way, that Maltz's protest against the intellectual and aesthetic restrictions imposed by the Communist Party was published in the Party organ, and that it had appeared even after William Z. Foster had assumed much tighter control. Does this mean that Foster and the new leadership were actually more liberal than supposed? Not at all. It was well known to them that independent notions such as Maltz expressed were quite popular among young Party intellectuals at the time, a legacy from the more liberal Browder era. It must have seemed to them that the best way to deal with these heresies was to get them out into the open—so that they could be denounced as heresies. That way, there could be no doubt where the Party stood on such matters, nor what was the proper line for the loyal Party member to follow. Accordingly, *New Masses* published attacks on Maltz and his views by the magazine's editor, Samuel Sillen, by novelists Howard Fast and Mike Gold, and by William Z. Foster himself, among others.

Maltz, the Browder surrogate, was, in fact, given treatment rougher than Browder himself had gotten in the magazine. But it was nothing to what he received face-to-face from his comrades in Hollywood. A meeting was called to discuss the issues Maltz had raised which became, in effect, a trial for deviationism. After that evening, as described by Murray Kempton in his book *Part of Our Time*:

The face of the Party had hardened and never again would the innocent and the uncommitted feel comfortable before it. The

recollections of that period for repentant Hollywood Communists are of repetitive plunges into a cesspool. They have forgotten the abstractions of doctrine; they remember only Alvah Bessie "morosely clawing" at Lester Cole, Dalton Trumbo "ripping at" Cole, and Cole "tearing at" Lawson. They were walking toward a common grave, hating one another.

Since there is no indication here, or anywhere else, what Trumbo was saying as he ripped at Lester Cole, his memories of the affair are the only record of his feelings at the time. "I was asked to write an article for the *New Masses,* as a number of others did, on the issue, attacking the Maltz position," said Trumbo. "I refused to do it. It was not an act of great courage, but I figured, what the hell. Though I didn't much like [the Maltz article], some of the criticisms of it were so vicious, and you found in them personal differences, or jealousies, or quarrels being translated into ideological principles, which always happens. And this made it the worst of all the episodes at the time. It wasn't the worst that he recanted. It was a measure of himself, a sign of belief, a sign of loyalty, and there is a virtue in that. However, I think he was essentially right in his original article and wrong in his recantation. But he will to this day defend his recantation and will not defend his original article."

Later, when I conveyed what Trumbo had said to Albert Maltz, Maltz looked at me severely and asked, "Did he say that? Did he indicate that he hadn't had much to say at the time?" That, I said, was correct. "Well," Maltz said, with a shake of the head that conveyed paragraphs of rebuttal, "I suppose I'll have to let that stand then."

These events—the Duclos letter and the consequent deposing of Earl Browder as head of the Communist Party, together with the Maltz affair which followed—all transpired against a background of labor unrest in Hollywood which itself had a profound and far-reaching effect on the situation that led to the blacklist. All during the war, there was a series of jurisdictional disputes and actions between the two major craft union bodies in Hollywood, the International Alliance of Theatrical Stage Employees & Motion Picture Machine Operators (IATSE), on the one hand, and the Conference of Studio Unions (CSU), on the other. Herb Sorrell, the leader of the CSU, though not a Communist himself, had been sympathetic to the Communists and had gotten to

his position of power there in Hollywood at least partly through their help. On the other side was Roy Brewer, an AFL leader who had had a job with the War Labor Board before coming out to the West Coast to take charge of the union during the war. A strike finally resulted. It was called by Sorrell on March 12, 1945.

The Communist-dominated unions and individual Communists throughout the industry all eventually threw their support to Sorrell. Roy Brewer, the head of the rival IATSE, was aghast at this. Brewer saw the whole thing as a concerted campaign by the Communists to take over the motion picture industry through the convenient agency of Sorrell's Conference of Studio Unions. He had no trouble selling this conspiracy theory to the producers and studio heads, thus making his position and his unions' even more solid with them than before. It was a nasty strike, unusually long for wartime. It climaxed on October 5, 1945, just after the war had ended, of course, in front of the gates of the Warner Bros. studios in Burbank. As newsreel cameras ground away and flashbulbs popped, police used tear gas and hoses to clear away the pickets, then waded in with their nightsticks to finish the job.

Dalton Trumbo took an active part in all this. As a member of the Independent Citizens Committee of the Arts, Sciences and Professions, he delivered a speech on October 13, 1945, at the Olympic Auditorium that was in essence an attack on the IATSE. He spoke longest and most eloquently about the union's racketeer past—there was no getting around that, after all, because Willie Bioff and George Browne had been sent to jail for shaking down the IATSE rank and file, as well as the studios. And although he never mentioned Roy Brewer's name, he certainly did what he could to sully his reputation in the speech: "After the imprisonment of Browne and Bioff, the public generally assumed that the IA had been cleaned up. But this was not necessarily true. The underlings appointed by Browne and Bioff simply moved up a notch in their absence. The same people in the IA are still doing business at the same old stand."

Whatever else could be said of Roy Brewer, he was not a crook of the Willie Bioff stripe; Brewer had, in fact, been installed as head of the IATSE to bring reform to a union whose membership had been made victim of the worst sort of labor racketeering and he had been making progress in that direction when Trumbo's attack was delivered. Naturally he was angry; the speech was intended to provoke anger. Brewer

wrote a letter to Trumbo five days later that was not so much a defense of his own reputation or that of his union as it was a counterattack on Trumbo as the spokesman for forces whose evil intentions Brewer clearly understood. We know who you are, Brewer seems to be saying, and we know what your support of the CSU in this strike *really* means. The underlying assumption is that Trumbo is a Communist (which was true) and that the Communists are, through actions such as the CSU strike, engaged in a conspiracy to take over the motion picture industry (which was not true). There was a heavy emphasis throughout Brewer's long, three-page letter on the Americanism of the IATSE, and there was a pledge to fight foreign—that is to say, un-American—influence in the motion picture industry.

During this time, Dalton Trumbo had also been making trouble in the pages of the *Screen Writer*. In the very first issue of the publication, Trumbo had written an article attacking producer-director Sam Wood and the Motion Picture Association for statements Wood had made against the Screen Writers Guild and its executive board. Wood was a violently reactionary man who was, ironically, best known for directing one of the few movies ever made in Hollywood in which Communists were treated sympathetically, *For Whom the Bell Tolls*. Although he answered Trumbo with a counter-blast in the trade papers, the matter certainly did not end there. He was Dalton Trumbo's enemy for life.

Under his editorship, the *Screen Writer* was strongly weighted to the left (for that matter, what union or guild publication did not, at least in its basic stance, face off in that direction?). But Trumbo's political sympathies were known or suspected by many. The fact that the preponderance of articles in the *Screen Writer* reflected liberal and radical views on all subjects was automatically attributed to Trumbo's influence. Yet he insisted, perhaps a little disingenuously, that his only standards were literary quality, general relevance, and respect for the Guild and its policies and objectives. Richard Macaulay, a screenwriter of conservative leanings and a vigorous anti-Communist, put him to the test with an article, "Who Censors What?" on movie content which was in rebuttal to an earlier piece by Alvah Bessie. As editor, Trumbo rejected Macaulay's article, taking the same shaky position that Herbert Marcuse would two decades later, as he argued, "It is difficult to support

your belief in the 'inalienable right' of man's mind to be exposed to any thought whatever, however intolerable that thought might be to 'anyone else.' Frequently such a right encroaches upon the right of others to their lives. It was this 'inalienable right' in Fascist countries which directly resulted in the slaughter of five million Jews." Macaulay was incensed. He wrote back accusing Trumbo of rejecting his article simply because it did not follow the editorial line that Trumbo himself had established, one that the *Screen Writer* had in common, Macaulay declared, with *PM, New Masses,* and the *Daily Worker.* Clearly, Trumbo had made another enemy.

One of the many "letterhead organizations"* operating in Los Angeles at the time was the Hollywood Independent Citizens Committee of the Arts, Sciences and Professions. Reformed and expanded from the Hollywood Democratic Committee in June 1945—an organization which Tenney also claimed to be a Communist front—HICCASP, as it was known (believe it or not), seemed designed as an umbrella big and shapeless enough so that individuals of all shades and persuasions, from Ronald Reagan to John Howard Lawson, might stand together under it in relative comfort.

If the Hollywood Independent Citizens Committee of the Arts, Sciences and Professions were a Communist front organization, then as such it would have been an utter failure, for in 1946 a strong faction within the organization began a movement to transform it into a militant anti-Communist unit. In this group were Reagan, the embryonic politician; Dore Schary, then production head of RKO; film composer Johnny Green; actress Olivia de Havilland; and screenwriter Ernest Pascal. And apparently it was none other than Dalton Trumbo who was responsible for the situation that converted them into aggressive anti-Communists. It all turned on a speech Trumbo wrote for Olivia de Havilland, as an official of HICCASP (she was listed as vice-chairman of the organization), for delivery at a function in Seattle in June 1946. In fact, she never gave the speech that he wrote for her, which he learned only some weeks later. He wrote her a testy note on June 24, 1946, citing what had happened and asking for the return of his work. She sent

*So-called by California State Senator Jack Tenney in his yearly red-bound reports, *Un-American Activities in California.*

back two speeches then, the one he had written and the one she had given, explaining that she had wanted to speak more in her own person and that a friend had helped her to prepare the remarks she had made in Seattle. That friend turned out to be screenwriter Ernest Pascal. Pascal had not merely rewritten Trumbo's fiery and very partisan radical oration, he had practically turned it inside out and provided her with a speech which contained "an attack on and a repudiation of Communism"—as Trumbo described it—"which consumed exactly one-fifth of the entire speech." Trumbo was furious at Pascal, or he must have been to use such rhetorical overkill in denouncing him in the letter he wrote: "I think I understand your motives, Ernest; and to understand is, in some degree, to forgive. But don't you occasionally wonder, alone and late at night, who butchered the women of Europe and buried their living children and burned their men?"

By 1947 it began to look as though the movie capital were divided completely between two camps: the Communist and the anti-Communist. That, anyhow, is the way the Motion Picture Alliance for the Preservation of American Ideals wanted it to look. The word was out: you're either with them or with us. What and who was the Motion Picture Alliance? It was the anti-Communist body that had been formed by the Motion Picture Association to fight those elements in the movie industry that the producers were unable to control. Roy Brewer, whom Trumbo had offended, joined the Alliance because it seemed to him a potentially effective force in fighting what he now saw as the Communist conspiracy to take over the industry. Sam Wood, of course, was a member already, one of the most outspoken and bitter opponents of communism—and of Dalton Trumbo. Richard Macaulay was soon also to be a member of the Alliance, along with most of the other young conservatives among the members of the Screen Writers Guild, as well as all Trumbo's old opponents from the Guild's battle with the Screen Playwrights—men like Morrie Ryskind, James Kevin McGuinness, and Rupert Hughes. And finally, the anti-Communist contingent from the Hollywood Independent Citizens Committee of the Arts, Sciences and Professions joined forces with arch-conservatives from the Screen Actors Guild, such as Adolphe Menjou, adding to the enterprise a sprinkle of the glitter that only movie actors and actresses can provide. In a way, Dalton Trumbo made a very special contribution to the creation of the Motion Picture Alliance for the Preservation of

American Ideals: he had made personal enemies of all its most promi-
nent members.

It is possible, even likely, that the Hollywood Communists could
have achieved a sort of peaceful coexistence with the reactionary ele-
ments in the motion picture industry had they maintained the Browder
line of cooperation and accommodation, and there would have been
no blacklist. If the Communist Party had actually worked out a design
by which to take over the movie industry by infiltration, wouldn't it
have been in the Party's best interest to proceed about the job as quietly
and inconspicuously as possible? Instead, the Hollywood Communists
organized mass rallies for various causes, mounted the podium, and
made themselves visible and audible. They took out ads in the trade
papers to which they signed their names. They contributed articles to
"dangerous" publications, such as *People's World, New Masses,* and the
Daily Worker. Was that any way to subvert the movie industry? They
did their fighting as much in the open as Party discipline permitted. Of
them all, none fought harder and more openly than Dalton Trumbo.
He plunged into the 1946 Democratic campaign of Will Rogers, Jr.,
for the United States Senate. When he was about to give a speech to
the HICCASP membership urging them to endorse Rogers, he wrote
to Carey McWilliams, the campaign manager, urging the candidate to
go on the attack. It was especially important, he declared, because of
the "developing situation"—the impending pressure from the House
Committee on Un-American Activities: "Rankin is one of the most
unpopular men in America, and an attack upon his committee by Rog-
ers can also be tied in with the Negroes, anti-Semitism, FEPC and a
whole host of liberal issues. Rogers must understand that an attack...
is not an act of political magnanimity on his part, but a political neces-
sity to destroy the effect of an investigation which is aimed to destroy
all liberal forces which support him; and which, if successful, *will result
in his own defeat.*" Trumbo was a shrewd strategist. Rogers declined
his advice, and William F. Knowland beat the Democrat handily. The
House Committee on Un-American Activities directed its attention to
Hollywood, just as Trumbo predicted it would, though not until 1947.

Carey McWilliams, the liberal California lawyer, watched it happen
just as Trumbo predicted it would: "The more I was exposed to it, the

more concerned I became." He wrote the first book on the ensuing per-
secution. *Witch Hunt* was published in 1950, just as the blacklist and
the McCarthy era were getting under way. "I must say that in retrospect
some rather silly books have been written about the period. People for-
get how desperate the situation became for thousands of people. It's all
been reduced, more or less, to a pile of yellowing clips. People would be
stunned at the suicides from the period, and just incredible things that
happened then. It wasn't merely some Walter Mitty aberration, as, for
instance, Richard Rovere wanted us to think it was."

A few months after the book was published, Carey McWilliams was
invited to New York to edit "How Free Is Free?," a special civil liberties
issue of the *Nation,* the liberal weekly for which he had often written.
They liked him so well they asked him to stay, and he was there as
editor of the magazine until he retired in September 1975. That was
where I found him the afternoon I came to call—there in the maga-
zine's offices in the West Village, just below Sheridan Square.

He greets me, sits me down, and talks to me with his chair swiveled
back and his hands clasped behind his head. It is somehow an editor's
posture, and, ex officio, Carey McWilliams talks to me first about his
editorial relations with Trumbo.

"He is an astonishing writer," says McWilliams. "A polemicist! If
that talent had really been harnessed, there's no telling what he could
have done with it. He could write other things, too, of course, but I
can't help but feel it's a great shame he couldn't have done more with it,
turned himself loose on a whole range of situations and people."

During the latter years of the blacklist, Carey McWilliams pro-
vided Dalton Trumbo with his most direct line to the embattled liberal
community in America. Trumbo did a mini-series of essays on social
topics—everything from the movie black market to the quiz show
scandals. At one time, the writer was contemplating doing enough such
pieces to collect them into a book, a personal sort of message on the
state of the union. "The fact of the matter is," says McWilliams, "I nee-
dled him to do far more than he actually did for us. If he did five I must
have asked him to do twenty-five."

He sighs and fidgets for a moment with a pile of papers on his desk.
"You touch here on a subject that is close to me and one about which I
have come to have mixed feelings."

"What's that?"

"Well, there are so many of the very talented out there who get caught up in motion picture writing to the neglect of all else. Trumbo is one of them. John Fante is another—a wonderful writer whose books were all done in a few years before he began working in motion pictures. The industry was the undoing of both of them as writers. Once they've begun making money, they *think* they'll find time to do another book, but they never quite find it. There are scores of them. It's a pattern.

"With Trumbo it's especially frustrating because he was such a keen observer of the scene—and I don't mean just his journalism. Just think what a fantastic collection of potential novels the man lived! Imagine a good novel about the Hollywood Ten with that showdown at the Guild with Dore Schary. Or imagine a novel about IATSE and the Hollywood labor battles of the thirties and forties—it would take somebody with Dalton's appreciation to capture that crook Willie Bioff as a character."

"Was that how you came to meet Trumbo?" I ask. "During the labor troubles?"

He looks away, frowning in concentration, for a moment. "I met him before the IATSE business, but we were both caught up in it, so that's how we really got to know one another. The reality is this. He and I were never close personal friends. I was in his home often for meetings and we'd get together for lunches and so on. But at the same time we were good friends. I worked well with him. It was an intellectual friendship—political and, oh, I guess *social* in its basis. I personally admired the man's style very much. I'll never forget the Christmas card he sent out one year during the blacklist. The greeting on it was, 'Fight mental health!'" Carey McWilliams breaks off and cackles in appreciation.

"When you look back at the McCarthy era," I say to him, "and remember what passed for sanity then, that slogan makes a lot of sense."

"Exactly! The man played all kinds of wonderful fandangles like that. He kept his sense of humor through it all. But he was political, too—in the best sense. Altogether, I thought he was a fine influence in Hollywood. It was a very difficult situation, and he behaved very well. The whole left political movement in Hollywood was a good thing, if you ask me. You know, they talked a lot at the time about swimming

pool Communists. But the thrust goes the other way. These people were not idiots. They knew they were taking chances, and some of the things they were doing and saying did not endear them to the moguls, even in the period when there was no overt blacklist. There was nothing silly about leftism in Hollywood. They saw the danger—real danger—to the people in the industry posed by the labor practices of the period. And they knew the Nazis were not playing make-believe. I think they deserve some credit for the stand they took."

In the beginning, it wasn't the Hollywood Ten, but the "Unfriendly Nineteen." This was the number of subpoenas issued to those designated in advance as "unfriendly witnesses," directing them to appear before the House Committee on Un-American Activities in Washington, D.C., on October 23, 1947. Only eleven of the nineteen were actually called before the Committee. The eight who were not called up to testify were screenwriters Richard Collins, Gordon Kahn, Howard Koch, and Waldo Salt, directors Lewis Milestone, Irving Pichel, and Robert Rossen, and actor Larry Parks. One called before the Committee who was not subsequently one of the Hollywood Ten was Bertolt Brecht. The German playwright double-talked the investigators so reassuringly that he managed to avoid the contempt of Congress citations that the other ten received. He then quite sensibly flew to Europe and left the fast-developing atmosphere of paranoia in America behind him, but found an even faster-developing atmosphere of paranoia when he arrived in East Germany.

Everybody in Hollywood knew the subpoenas were coming. Chairman J. Parnell Thomas, Representative John McDowell of Pennsylvania, and Committee investigators Robert Stripling and Louis Russell had been out earlier in the year interviewing "key Hollywood figures," all of whom turned out to be members of the Motion Picture Alliance for the Preservation of American Ideals. Stripling later declared that "we obtained enough preliminary testimony to make a public hearing imperative." And those from whom they obtained that preliminary testimony were the very ones called first before the House Committee on Un-American Activities as its "friendly witnesses," all of them members of the Alliance.

Alvah Bessie, one of the Ten, gives an amusing account* of a visit to the Lazy-T just after the arrival of the subpoenas. Trumbo greeted Bessie and his wife and daughter there, playing lord of the manor, exuding optimism and good cheer as he took them on a tour of his palatial frontier estate. He had tried to put them at ease by telling them earlier, "Don't worry about the subpoena—we'll lick them to a frazzle." But Bessie's wife was skeptical:

"Do you really think we'll lick them to a frazzle?" Helen Clare asked.

He took a swallow of his drink and said, "Of course not. We'll all go to jail." A realist to the end, Trumbo began the ordeal with his eyes wide open and his spirits remarkably high.

There were meetings, endless strategy meetings, between the nineteen who had been subpoenaed and their attorneys. Every alternative was explored. Nobody *wanted* to go to jail. But for both practical and political reasons, they decided to make a cause of their plight. From a practical standpoint, many of them needed money. There would be trips to Washington and what looked to them like an endless future of legal fees. Two of the nineteen were unable to contribute anything at all to their defense and had to be carried by the rest.

They also felt it was important to bring the issues before the public. What they wanted to make clear was that the essential question involved here—and ten of them went to jail on this very point—was freedom of speech. Besides themselves, the movie industry was most directly concerned. If the House Committee on Un-American Activities succeeded in intimidating Hollywood in these hearings, then it would be the beginning of motion picture censorship in America. Extreme as that may sound, it proved, in a covert and rather subtle way, to be correct.

The Committee for the First Amendment was formed in Hollywood to give support to the nineteen and to publicize their predicament. For an essentially liberal organization which sprang into existence practically overnight, this one boasted more than the usual illustrious sponsors—four U.S. senators; Thomas Mann; Robert Ardrey; a major film producer, Jerry Wald, and (as Louis B. Mayer boasted of

*In his book *Inquisition in Eden*.

M-G-M) "more stars than there are in the heavens." They contributed their names, their time, and their money in defense of the nineteen. By the time the nineteen were to leave for Washington, there was a great deal of popular support for their cause. It had become, as they hoped it would, a national issue. On the eve of their departure, the Committee for the First Amendment held a rally for them at the Shrine Auditorium. No fewer than seven thousand attended.

They left the next day, preceded by a star-studded deputation from the Committee for the First Amendment, which flew in a chartered plane direct to Washington to keep public attention focused on the case and draw sympathy to those who had been labeled "unfriendly." For their part, the nineteen flew by way of Chicago and New York, where they spoke at rallies. In New York there were further councils of war, where strategy was argued and re-argued among them. And there, too, another lawyer was added to the legal team that accompanied the witnesses to Washington.

"I remember very well how I happened to get involved in the case. I was at a World Series game with a bunch of their lawyers. It was 1947, of course—the Yanks and Brooklyn—and this was the game where Cookie Lavagetto hit his double. Well, here I was sitting beside Bob Kenny, who was the president of the National Lawyers Guild then and a former attorney general of California. Naturally I was interested in what had brought him east. He told me and said he felt I could help, particularly since I was based in Washington."

This was Martin Popper talking, the husband of Katherine Trosper Popper, who knew Trumbo since his single days at Metro. Martin, of course, did not know him nearly so long but nevertheless considered Trumbo a friend. He is a New York lawyer and has been one all his life when I interview him. "But at that time," he explains, "my firm had an office in Washington, and so for this case I was the local man, more or less."

In an interview earlier Albert Maltz had asserted that those called as witnesses knew very well that they could have pleaded the Fifth Amendment and escaped the contempt of Congress citations they received. Maltz explained that they took the First Amendment instead, reasoning that under the right to free speech was also understood the

right to keep silent. I ask Martin Popper about what Maltz had told me and if it was as sound legally as it seemed politically.

Popper nods emphatically. "Well, yes," he says, "some such thinking had gone into it, and it might have worked. Because, you see, if the Court had sustained our contention that the Committee had no right to inquire, then it would have been the end of the Committee. It was a gamble, a calculated risk."

There is nothing pedantic in his manner. He is simply trying to make it clear. "You see," he continues, "the First Amendment is the arch—no, say, the *keystone* in the arch—of the entire Bill of Rights. When these amendments were framed, the principle they followed was that Congress shall make no law abridging the freedom of speech. This was held inviolate. And from that fundamental right flowed the right to join political parties, to form organizations. Here was the Committee apparently ready to interpose itself between the individual and that right. What the Committee seemed to represent here was a point of view on the relationship of the individual to the government quite the opposite of the one represented in the Bill of Rights.

"Now, the witnesses in this case thought they were standing on strong constitutional and philosophical grounds. So they were ready to take the First, rather than the Fifth. It was only as a result of the Supreme Court refusing to hear the Hollywood Ten case that the Fifth was so widely used afterward. So what I'm saying is that it wasn't strictly a matter of the First Amendment covering the right to keep silence. I don't mean it was *not* that, but that it was something else as well."

"Do you think they would have had a chance before the Supreme Court?" I ask.

"Yes—as it was constituted when they appeared before the Committee. It was that Court they were betting on. But then Justices Rutledge and Murphy died. They had always given individual liberties a preferred position. We could have been almost optimistic. With them died our petition for cert."

It all happened more than a score of years ago, of course, but it is important to Popper still. "Yes, I know what some of these guys went through during the hearings and afterward—the blacklist and all. I was the man in Washington, of course, and I had to see them off to jail. I remember visiting Dalton after his first night in the D.C. jail. He told me that in the middle of the night the police had brought in a

guy who was supposed to be part of a gang. He was charged with some heinous offense—assault with a deadly weapon or something. This is what he told Dalton. Then this gang member asked him what he was in for and Dalton told him. This tough guy shrank back. 'Holy Jesus!' he said. 'Contempt of Congress!' He was impressed, overwhelmed, as most people are. But let's make no mistake about it. Contempt of Congress is a misdemeanor, nothing more."

The hearings of the House Committee on Un-American Activities on the "Communist Infiltration of the Motion-Picture Industry" were gaveled to order by Chairman J. Parnell Thomas on October 20, 1947, with the testimony of the "friendly" witnesses. It was quite a lineup. The parade began with Jack L. Warner, head of Warner Bros. Studios, and among the others there were actors Gary Cooper, Robert Montgomery, Ronald Reagan, Robert Taylor, George Murphy, Adolphe Menjou, and novelist (formerly screenwriter) Ayn Rand. It would be wrong to attempt to characterize the testimony of these or the other "friendlies" who appeared before the Committee with the usual cant adjectives, such as "reactionary." There were great differences in the quality and style of testimony given by them, from the reckless Red-baiting of Jack Warner and Robert Taylor, to the somewhat more responsible manner of Reagan (who was then president of the Screen Actors Guild), or to the uncomfortable reticence of Gary Cooper. Testimony varied with each witness. But the picture that emerged from the early days of the hearings, the one the Committee members themselves sought to paint, using the testimony of individual witnesses as colors on their canvas, was one of a Hollywood caught in the grip of the Communists; of studios and guilds virtually at the mercy of militant Reds who took their orders from Moscow; and of directors, and especially writers, who managed to twist the message of their movies, to coax Communist propaganda out of even the most modest material.

Richard M. Nixon was there as a freshman congressman, then sitting on the House Committee on Un-American Activities. He was to have his first big triumph the following year as he pressed the case against Alger Hiss; this would provide him with the springboard that would shoot him into the Senate, and then into the vice presidency. He owed his career, such as it was, to the Red Menace.

This is probably the only time that he and Dalton Trumbo were ever even in the same room together. When the "friendly" stars left the stage and the "unfriendly" witnesses came on, writers and directors all, Nixon vanished, suddenly finding other legislative matters more pressing. But the nineteen had their own contingent of stars on hand, the group from the Committee for the First Amendment who had made the trip to Washington to demonstrate their support. It included Humphrey Bogart and Lauren Bacall, Danny Kaye, Gene Kelly, Jane Wyatt, John Huston, and Sterling Hayden, among others. To their credit, they hung right in there during the testimony of the "friendly" witnesses, kept right on giving interviews and holding press conferences which were intended to alert America to the clear and present danger, etc. Somehow, though, the members of the Committee for the First Amendment hadn't been prepared for the testimony of the Ten. They expected them to be more polite, to remember that, bad as it was, the House Committee on Un-American Activities was nevertheless a unit of the Congress of the United States and if only for that reason deserving of respect. Well, when John Howard Lawson was called on October 27, 1947, he gave the Committee none. Although all of the "friendly" witnesses had been granted the right to read statements, Lawson (the first of the Ten to appear) was denied that, and the few minutes he spent under the lights in the caucus room were consumed, for the most part, in a shouting match with Chairman J. Parnell Thomas over the question of whether or not his statement might be read. When, at the end, he refused to answer the big question: "Are you a member of the Communist Party, or have you ever been a member of the Communist Party?" many of the group who had come to offer moral support were profoundly disturbed. Following Lawson's appearance, the support of the Committee for the First Amendment began to erode very swiftly. Those who had come across the country together, so full of high purpose, began leaving in ones and twos, feeling vaguely betrayed by the very men whose cause they had come to Washington to fight for.

Except for Lawson, Dalton Trumbo was probably the Committee's least cooperative and most "unfriendly" witness. He came to the stand on October 28, 1947, at ten-thirty A.M., just one day after Lawson had caused such an uproar in the caucus room. Trumbo was met by hostility from Chairman J. Parnell Thomas, and he gave as good as he got.

The two began with a preliminary skirmish on the question of whether or not Trumbo might be allowed to read the opening statement he had brought with him. Thomas inspected the statement, conferred with the other members present, and refused him, telling him the statement was not "pertinent to the inquiry."

The next point went, surprisingly, to Trumbo. As it turned out, it was the only one he would score. The "Mr. Stripling" who addressed him here is Robert Stripling, counsel and chief investigator for the House Committee on Un-American Activities:

> **Mr. Stripling:** Mr. Trumbo, I shall ask various questions all of which can be answered "Yes" or "No." If you want to give an explanation after you have made that answer, I feel that the committee will agree to that.
>
> However, in order to conduct this hearing in an orderly fashion, it is necessary that you be responsive to the question, without making a speech in response to each question.
>
> **Mr. Trumbo:** I understand, Mr. Stripling. However your job is to ask questions and mine is to answer them. I shall answer "Yes" or "No" if I please to answer. I shall answer in my own words. Very many questions can be answered "Yes" or "No" only by a moron or a slave.
>
> **The Chairman:** The Chair agrees with your point that you need not answer the question "Yes" or "No."
>
> **Mr. Trumbo:** Thank you, sir.

It was then that Trumbo sought to introduce into the record twenty screenplays that he had written. While this may have seemed a rather outlandish thing to do, it was really nothing of the kind. The hearings had supposedly been called by J. Parnell Thomas in order to substantiate his charges that Hollywood films—and in particular, those films on which the "unfriendly" witnesses had worked—had been packed full of Communist propaganda (a point never proved by the Committee). The work Trumbo had done in the movies was under attack; there was no defense to offer, really, except the work itself. But the chairman denied him the request: "Too many pages." He also blocked Trumbo's attempt to have read into the record various commendations

of his work by personages above suspicion (even by the Committee) such as General H. A. "Hap" Arnold, wartime head of the Army Air Corps.

The two clashed next on the question of whether Trumbo was or was not a member of the Screen Writers Guild—another simple question which, as he saw it, was not nearly so simple as it seemed. Chairman Thomas himself had announced to the press in Los Angeles on an information-gathering sortie earlier that year that the Screen Writers Guild was "lousy with Communists." Well, if Thomas believed that, then Trumbo could certainly tell in what direction they were headed:

> **Mr. Trumbo:** Mr. Chairman, this question is designed to a specific purpose. First—
> **The Chairman (pounding gavel):** Do you—
> **Mr. Trumbo:** First, to identify me with the Screen Writers Guild; secondly to seek to identify me with the Communist Party and thereby to destroy that guild—

Then, after the two had sparred a few minutes over that point, Robert Stripling hit Trumbo with the Sunday punch: "Are you now, or have you ever been, a member of the Communist Party?" Trumbo never answered that, either. Instead, discussion between them dissipated into a wrangle over whether or not Trumbo would be allowed to see an alleged "Communist Party Registration Card" made out to "Dalt T" which Committee investigators had earlier shown to the press. Of course he was not shown it, though it was entered into evidence minutes later. Not, however, before Trumbo was led away from the witness chair, shouting his anger at the Committee and its chairman:

> **Mr. Trumbo:** This is the beginning—
> **The Chairman (pounding gavel):** Just a minute—
> **Mr. Trumbo:** Of an American concentration camp.
> **The Chairman:** This is typical Communists' tactics.

For refusing to answer two questions, "Are you a member of the Screen Writers Guild?" and "Are you now, or have you ever been, a member of the Communist Party?" Trumbo was, immediately after his testimony,

voted "in contempt of the House of Representatives of the United States" by the members of the Committee then present.

So it went, with two major exceptions, through the witnesses who remained to be called before the Committee. All those who followed were somewhat more subdued than Trumbo and John Howard Lawson had been. Ring Lardner, Jr., managed to inject a bit of his own wry humor into the proceedings when he was asked repeatedly by Chairman Thomas if he were a Communist and at last responded, "I could answer it, but if I did, I would hate myself in the morning." A few were even permitted to read the statements they had prepared. But in the end, there were ten—the Hollywood Ten*—who refused to cooperate with the investigation. All were cited for contempt of Congress.

The exceptions noted earlier were Emmet Lavery and Bertolt Brecht, both of whom were apparently expected by the Committee to show the same belligerence and lack of cooperation as the rest. Both were assumed to be Communists by Thomas and his investigators. Lavery, who was president of the Screen Writers Guild, had been attacked by a number of "friendly" witnesses. One of them, Morrie Ryskind, had told the Committee that under Lavery's leadership the Guild "was under Communist domination"; another, Rupert Hughes, called him "a Communist masquerading as a Catholic." Emmet Lavery was interested purely in preserving the Screen Writers Guild and making sure that, even if it meant sacrificing a few members—or more than a few—the Guild would survive the assault of the Committee. The tactics of an Irish politician. As the lawyer he was, Lavery gave exemplary testimony before the Committee—direct, cogent, and informed. He denied being a Communist. He refused to engage in speculation, to repeat hearsay, or to blacken the names of those who had already testified to save his own neck. But he was chiefly interested not in saving himself but in preserving the integrity of the Guild: "Mr. Stripling, they do not have control of the Guild, and, if they did have control of the Guild, I would have stayed home long ago." He did not sell out the Ten before the Committee; he did that, unfortunately, later on back in Hollywood.

*They were, in alphabetical order: Alvah Bessie, Herbert Biberman, Lester Cole, Edward Dmytryk, Ring Lardner, Jr., John Howard Lawson, Albert Maltz, Samuel Ornitz, Adrian Scott, and of course, Dalton Trumbo.

The last witness to testify during that round of hearings was the German playwright Bertolt Brecht. At the time he appeared he had been in the United States over six years, had taken out his first citizenship papers, and had declared his intention to remain permanently in the country. During that period in Hollywood he had had his name on the screen only once—an original story credit for the film *Hangmen Also Die*—although he had worked on a number of other movie projects. These years were fruitful for him, however, in his career as a playwright. He wrote a number of plays, revised others, and saw one of his finest, *The Life of Galileo,* mounted in an excellent English-language production which starred Charles Laughton in the title role. Brecht did indulge in a good deal of double-talk with Stripling and Chairman Thomas, the point of which was to make him seem a good deal more cooperative and less radical than he really was. On one point, however, he gave in completely:

Mr. Stripling: Now, I will repeat the original question. Are you now or have you ever been a member of the Communist Party of any country?

Mr. Brecht: Mr. Chairman, I have heard my colleagues when they considered this question not as proper, but I am a guest in this country and do not want to enter into any legal arguments, so I will answer your question fully as well as I can. I was not a member, or am not a member, of any Communist Party.

There is, incidentally, no reason to believe that Brecht was telling anything but the absolute truth when he said this; no proof has ever been offered to the contrary, and when he subsequently returned to East Germany, Brecht certainly did not behave as a fully committed Party member might have been expected to.

That last day of the hearings, on which Bertolt Brecht appeared before the Committee, was October 30, 1947. The Ten who had refused to respond to the question put to each of them regarding their membership in the Communist Party had all been cited for contempt of Congress. All would eventually serve prison terms on the charge. But a harder punishment was being prepared for them by leaders of the motion picture industry. Major producers and studio executives met late in November at the Waldorf-Astoria Hotel in New York to discuss

the embarrassment to the industry caused by the Hollywood Ten. They conferred for two days. And while there is no record of what was said inside their meetings, the document that came out of them, the notorious Waldorf Agreement, said loud and clear that people like Dalton Trumbo and his fellow "unfriendlies" were, in effect, no longer employable in the motion picture industry.

There is some irony in the fact that Eric Johnston, head of the Motion Picture Association of America, was chosen to announce the Waldorf Agreement to the world. Irony because Johnston had given repeated assurances to the press, to the "unfriendlies," and to their counsel, that the motion picture industry and Johnston himself would stick behind them all the way. Even when J. Parnell Thomas had announced to the press that movie producers had agreed to establish a blacklist, Eric Johnston came around (as reported in Alvah Bessie's *Inquisition in Eden*) to reassure the "unfriendlies." He declared: "That report is nonsense! As long as I live, I will never be a party to anything as un-American as a blacklist, and any statement purporting to quote me as agreeing to a blacklist is a libel upon me as a good American." Evidently he meant that, at least when he said it. However, like most of the industry's leaders, he was intimidated by the Committee. All were subjected to pressure, as well, from the bankers and brokers on whom the studios and independent producers depended for their flow of production capital. The industry was told to clean house or to expect grave consequences.

On November 26, 1947, Eric Johnston read the movie industry's pledge to the press. The heart of it was this:

> We will forthwith discharge or suspend without compensation those in our employ and we will not re-employ any of the ten until such time as he is acquitted or has purged himself of contempt and declares under oath that he is not a Communist.
>
> On the broader issue of alleged subversive and disloyal elements in Hollywood, our members are likewise prepared to take positive action.
>
> We will not knowingly employ a Communist or a member of any party or group which advocates the overthrow of the Government of the United States by force or by any illegal or unconstitutional methods.

Whatever private protocols had been, or would be, put into effect, the Waldorf Agreement was the document which made the blacklist a public fact. They tried, in the wording of the document, to put the best possible face on what was to be a witch hunt. They promised not to be "swayed by hysteria or intimidation from any source"—while intimidation and hysteria were what had occasioned the meeting and the Agreement in the first place. They appealed hypocritically to "the Hollywood talent guilds to work with us to eliminate any subversives; to protect the innocent; and to safeguard free speech and a free screen wherever threatened."

When you were with Robert W. Kenny you had the feeling that you were in the presence of a historical personage. The public offices that he had held were not so high that they would have conferred any degree of grandeur on the man. He had been a state senator, the attorney general of the state of California, and he then a judge of the Superior Court of the county of Los Angeles. Still, a quality of something close to greatness clung to the man. He conveyed the feeling that even if he himself might never quite have achieved all that he might have wished, at least he had influenced those who in turn had influenced history. It was this quality that Carey McWilliams touched upon in his obituary tribute, "The Education of Earl Warren," in the *Nation,* when he credited Kenny and Pat Brown with initiating the long process of liberalization that reshaped Warren from the conservative, small-time politician who started out in California to his position of leadership in the most liberal Supreme Court in American history.

Physically, Robert Kenny is not a very prepossessing figure when I first see him. He has a lame right side and moves with a little difficulty around his courtroom on the sixth floor of the County Building in Los Angeles. But he is very much in command, and having heard both sides in the civil case that is before him and indicating to me with a nod from the bench that he is aware of our appointment, he does not hesitate to call a recess. He makes for his chambers, and I follow.

"Just let me get out of this black muumuu and into civilian clothes," he says, "then we can talk as long as you want to." That he does, again with some difficulty, for it becomes a matter of his left arm doing the work of both left and right. His resigned manner tells me that he has

been through it all thousands of times before and that help would not be welcome if it were offered.

He settles down in the sofa opposite me and we talk. "I got into it, I suppose, as attorney for the Screen Writers Guild," he tells me. "My partner, Morris Cohen, handled most of the Guild work. When we started out I was in the State Senate and then I became attorney general. As far as Trumbo was concerned, I only got to know him after the subpoenas went out in October 1947. We had less than thirty days to prepare for the hearings and a mountain of work to do beforehand. Quite reasonably, they wanted to be told what to say when they got there, and there were meetings on that. But there were a hell of a lot of other things to do. We needed the time, for one thing, to get a PR campaign of our own going, this Committee for the First Amendment thing. And there were also just details of the mundane kind, like buying transportation for us all, making reservations, deciding whether we traveled by train or plane, or what. I remember Gordon Kahn, one of the original nineteen, had the last word there. 'We're going by tumbril,' he said. I think that shows both the seriousness with which they looked at the situation and the way they kept their humor in spite of it."

"How detailed were these strategy sessions? Was it Trumbo's idea that all of them should challenge the Committee's right to question them—and in effect plead the First Amendment?"

"Not exactly." Then Judge Kenny explains: "I was playing it pretty cautiously because the Committee's technique had taken a nasty turn in the case of Dr. Edward K. Barsky and the Joint Anti-Fascist Refugee Committee. He was asked to give them his membership lists. He refused, and they tried to develop a case of conspiracy which would have meant a sentence of years, not months. Ultimately what we—I and the other attorneys involved—did was to put the options before them. We were determined that they would arrive at their own decisions of conduct before the Committee. That's really what happened, too. The decisions were their own. And it was not a collective decision, though it came after intermember deliberation.

"Nevertheless, there was a lot of animosity between the Committee and Committee staff on the one hand, and us on the other. Thomas tried to get me for conspiracy. I guess that shows pretty clearly in the

transcript. What we actually tried to do was treat the hearing as though it were a court trial—and Stripling and Thomas as though they were officers of a kangaroo court, which of course they were."

Would it be accurate to say they pleaded the First Amendment, then?

"Our position in Washington was that we're not refusing to answer. We had just not completed our reasons for providing the answers we were giving them."

At this point Judge Kenny pauses, grins, and shakes his head. "We had more angels hopping around on the heads of pins there, didn't we? What difference does it make what amendment you use for your defense as long as you keep out of jail? And we didn't even manage to do that. All we managed to do was put the lawyers' children through college with all that litigation. No, that's not all really. Because after the Ten went to jail, we had a jail-proof defense in the Fifth Amendment. People knew they had to use it then, and they used it. In effect, we bought time for hundreds of people.

"Before the Ten actually went off to the pokey, nobody believed anybody was going to jail. Even the judges who handed out the sentences thought this was nothing more than a test case. Contempt of Congress—it's just a high-grade misdemeanor, anyway—a year and a thousand maximum. Nobody had served time on the charge since the 1920s. That was when Harry Sinclair of Sinclair Oil did thirty days for his behavior during the congressional investigation of the Teapot Dome affair."

Since, in a way, the Ten did just about what they set out to do before the Committee, when was it that things started to go wrong?

"Well, I'd say we were pretty successful until the Waldorf Agreement, when the major producers got up the courage to screw the Ten and everybody else. Eric Johnston told me before the Waldorf Agreement that there would never be anything as un-American as a blacklist advocated by the producers. Well, we saw what happened then. The Ten were fired and we brought suit immediately on all the contracts. What really killed us, though, what put an end to it all, was when the Supreme Court turned down our petition of certiorari and refused to hear the case. That was 1949. That ended it. The boys went to jail. And though they were all pretty complimentary about the prisons and the lack of any sort of special treatment they received, favorable

or unfavorable—it was still jail, time out of their lives, a blot on their record, a shameful injustice."

"Well," I ask, "if the Waldorf Agreement was the beginning of the end, what about the blacklist that came out of it? Was it legal?"

"Of course not!" Judge Kenny seems irritated, not so much by the question as by the memories that it brought up of all the angry, fruitless arguments he had made decades before. This was territory he had been over again and again and again.

"Look," he explains patiently, "the blacklist was a violation of the Sherman Act. It's simple. If A hires B to do work for him, then it's no damned business of C's whether B has been hired or not. If C is allowed to influence A in hiring—or in firing—then it is a violation of the Anti-Trust Act."

He sighs, lapses into silence as though suddenly exhausted by the effort. He is not a strong man. Aged seventy-two, he looks every year of it. Along with the memories of all the old battles, he bears scars from the wounds suffered in them. Judge Robert W. Kenny seems a very tired man.

"So you see," he begins again, gathering himself to sum up, "the issues involved in all this were important. They were real issues. I was proud to be involved in it. I only wish it had turned out better for the Ten."

I ask Judge Kenny about Earl Warren: "You were on the opposite sides of most battles during your years in California politics, yet in the end were much closer philosophically than when you both started out."

He agrees: "That's right. You can never figure out the voters in this state. The same voters who elected Earl Warren attorney general elected me state senator. And the same voters that elected me attorney general elected him governor in 1942. I ran against him in 1946, and to tell you the truth, I didn't lay a glove on him. He cross-filed—you could do that here then—and got both parties' nominations." Kenny smiles ruefully, time's triumph over chagrin.

I ask, on a gamble, just how he thinks the Ten's appeal might have fared before the Warren Court.

"Oh, I don't think there's any question of it. It takes four votes to get a petition of certiorari granted, and I think there were certainly four justices in that court who would want to have the case heard. Earl would have voted for certiorari because it involved an important

constitutional question. And that was his strength as a justice—he never ducked the important ones. So we would have gotten before the Court. We would have argued it, and we would have won."

Why?

"Because we were right, dammit."

Time did not stand still for Dalton Trumbo during this period, although it may have seemed to him and to his family as though it had. When he became one of the Hollywood Ten, his life was changed profoundly. Trumbo's public life consumed his private life almost completely. The telegrams of congratulation poured in: "To Dalton Trumbo in support," "Your Washington performance and that of others was most gladdening," and so on. There were poison-pen letters, as well. And Dalton Trumbo concentrated, to the exclusion of almost all else, on the role in which he had been cast.

So much so that it is necessary to look beyond him for personal responses to the situation. Trumbo was what the record indicates. He was totally the man quoted in the *Congressional Record*. Cleo and the children had nothing to say about that moment. They remained for the most part up at the Lazy-T, where they were out of reach of the newspapers and the wire services. They just listened to the radio news in which the progress of the hearings was followed closely. They listened and waited for Trumbo to come home.

His sisters and his mother listened, too. And his mother read the *Christian Science Monitor*. True to its liberal viewpoint, the newspaper offered objective accounts of the day-to-day events: "Like Mr. Lawson, Mr. Trumbo argued that a congressional committee has no right to inquire into a man's political affiliation, thereby presenting a point that probably will go to the Supreme Court. Whatever Mr. Trumbo's own connections he appealed for protection in this instance to those rights of free expression and belief and to those civil liberties, which are noticeable by their absence in Communist countries." And in its editorial pages, too, the *Monitor* gave the "unfriendlies" its qualified support.

What conclusions did Maud Trumbo draw from what she read in her newspaper about her son and what she herself knew of him? This is how Elizabeth Baskerville, Dalton's sister, remembered it: "I think Mama was outraged because she felt her son was right. He may have

fallen in with bad companions, but she felt he was right. And really, we all supported him. The prospect of it must have been very threatening to her because as she was hearing Dalton testify she must have had the feeling that all her security—that was Dalton—was going down the drain."

And how did Trumbo view the future? As one of endless litigation, probably. He returned to the West Coast with the contempt of Congress citation over his head and with the feeling that time was running out for him. He was at that time engaged with producer Sam Zimbalist in a film project for Metro, *Angel's Flight,* that was intended to star Clark Gable. It proved to be Trumbo's last assignment at Metro-Goldwyn-Mayer; since it was never produced, nobody seemed to recall much about it. He reported to the M-G-M lot and had a couple of conferences on the script, then went off to join Cleo and the children to work on it up at the Lazy-T. He had always had a great affection for Zimbalist, whom he had known for years and with whom he had worked on the best of his M-G-M films, *Thirty Seconds Over Tokyo.* He felt he had better get this one done in a hurry for Sam.

But time ran out. On Thanksgiving Day, 1947, the producer brought him the news. It would have been impossible for Zimbalist to call. In spite of the many improvements Trumbo had made at the Lazy-T—and it was now only a little less than a palace nestled up in the Ventura Mountains—there was still no telephone; after all, the idea in moving up there in the first place had been to get away from the telephone, to make him inaccessible. But Sam Zimbalist had the kind of news he would have felt obliged to deliver in person, anyway. Trumbo recalled: "I was cooking mince pies in the kitchen and Sam came in and said, 'It's all over, batten down the hatches, it's going to happen. All of the Ten are going to be blacklisted.' " He offered his sympathy and his promise to help, personally, in any way he could. But there was very little more to be said.

This was the only real warning Trumbo received prior to the Waldorf Agreement. Not that knowing in advance would have helped much. There was only one hope for the Ten, and that was that the talent guilds might be persuaded to fight the blacklist—to stand up, as unions should, and protect their membership. A meeting of the Screen Writers Guild was called. Dore Schary, who was, ironically, one of Hollywood's most vocal liberals, came as the producers' representative and

made an appeal for the Guild's cooperation. Trumbo had been chosen by those of the Ten who were members of the SWG (which was most of them) to speak for them at the same open meeting. He did so, savagely attacking the producers and the Waldorf Agreement and predicting quite accurately what lay ahead if the Guild cooperated. He also made an appeal for the support of the Guild membership. All to no avail. The Screen Writers Guild cooperated with the producers in the implementation of the Waldorf Agreement.

Had they held out, the producers might have been forced to reconsider and alter their position. In fact, it would probably be accurate to say that the blacklist could not have been instituted, nor could it have been enforced, without the assistance of the Screen Writers Guild and the other Hollywood talent guilds.

THE BLACKLIST BEGINS

The day Trumbo returned from the hearings in Washington, he was contacted by a man named Frank King who asked him if he would like to write a movie for him. "There was no big deal to it," said King when I interviewed him. "We just had a short budget to make a picture and saw this as an opportunity to get a fine writer to work for us whom we could not otherwise afford."

The King brothers—there were three of them: Maurice, Frank, and Herman (born Kozinski)—were known to Trumbo and to the rest of Hollywood as independent producers. Very independent. They eventually found a place for themselves in film history and attained almost legendary status as among the last masters of B-movie production. And they did so very largely on films written for them by Dalton Trumbo.

Trumbo got to know them very well over the course of the next decade, and he grew to like them quite well. He found, perhaps to his surprise, that he had a lot in common with them. During the years he was struggling to become a writer, and at the same time support his mother and two sisters, the King brothers were struggling, too: "Maury, the oldest one, fought as a pug," said Trumbo. "And that enabled Frank to get through Franklin High School in Highland Park. Hymie was the youngest, and he got through high school, too. The father had died, and they were supporting their mother. The boys had to make it on their own, and they did it bootlegging and in the rackets." Trumbo, of course, had done some bootlegging, too.

With the end of Prohibition, the King brothers got into motion

picture production—first for PRC during the late thirties and subsequently for Monogram. In 1945, at Monogram, they made the very successful *Dillinger.* Budgeted at $193,000, with Lawrence Tierney, Edmund Lowe, and Anne Jeffreys, and directed by Max Nosseck, *Dillinger* brought in over $4 million worldwide. With that hit under their belt, they decided to go independent. Their first film was *The Gangster,* released in 1947; it featured Barry Sullivan and Akim Tamiroff, and while the movie had its moments, it failed to make money for them. The King brothers were in the market for a new script when the craziness in Washington caught their eye. The brothers noted the quality of talent that had been hauled before the Committee, heard with interest the talk among producers that was circulating during the hearings about a political blacklist, and drew some shrewd conclusions. Frank King put in a call to Trumbo.

"Politics didn't enter into it at all," said King, some slight annoyance evident in his voice. "What a man's politics were didn't concern us one way or the other. I guess he spoke his mind before Congress, and that was all right with us. But we never discussed that at all. We were just interested in making pictures."

For his part, Trumbo realized that he was probably as of that moment unemployable as far as the major studios were concerned, and that he would have to fight for every cent that remained to be paid to him on his lucrative M-G-M contract. He owed $40,000 in short-term debts for improvements on the ranch. He faced terrific legal expenses for the appeal of the contempt of Congress citation that he had received. And he was financially responsible not only for his wife and three children, but also for the support of his own mother. The modest deal offered him by King Brothers Productions—$3,750 to be paid over the period of a year and a half—looked good to him then. They made him an offer he couldn't refuse. They shook hands on the deal, and he started to work on *Gun Crazy* the next day.

As Trumbo told me, he wanted it understood that he did not feel he was taken advantage of by Maury, Frank, and Herman King, or by the others who employed him at cut rates on the movie black market. The King brothers paid him what they could afford. "A lot of independents never paid more than that," he said. "When I and others plummeted in value, we naturally found ourselves in this new market, and naturally these independent producers availed themselves of our services because

they felt that for this money they could get better work. So there wasn't really this brutal exploitation of black market writers that has sometimes been referred to."

Trumbo and the King brothers agreed that some other name besides his own would appear on the script and on the screen (Millard Kaufman offered the use of his), thus beginning a practice for many over the years to come. At that point, however, it was as important to Trumbo as it was to the King brothers that his name be kept out of it because he had begun legal action through his personal attorney, Martin Gang, to force Metro-Goldwyn-Mayer to reinstate him or to make settlement on his contract. Obviously he could not himself be found in violation of that contract by working for another producer, so a "front" writer offered the best solution.

Following the Waldorf Agreement he was put on suspension by the studio—and not fired. That may have been because the studio's lawyers themselves were uncertain how Trumbo's contempt of Congress trial and inevitable appeal would turn out. Or, with good reason, they may have felt on shaky ground in taking any punitive action against him within the limits of his contract because he was the only writer at the studio, perhaps the only one in Hollywood, who had managed to get the standard morals clause excluded. (His position in negotiating the contract had been, "When Louis B. Mayer signs a morals clause, I'll sign a morals clause.") So the question for the lawyers was, of course, on what grounds could Trumbo even be suspended? Barring disclosure of his little job for the King brothers, it seemed to Trumbo and Martin Gang, the only legitimate grounds M-G-M would have to take action against him would be his failure to fulfill his obligation under the contract—which was simply to do the work that had been assigned him by the studio. That being the case, Trumbo saw to it that that exit was closed to them: he took down from the shelf his half-finished first-draft screenplay of *Angel's Flight,* the project on which he had worked with Sam Zimbalist, and he completed it. On December 15, 1947, Martin Gang submitted it to Loew's Incorporated, then the parent company for M-G-M, with a letter pointing out that Trumbo was hereby fulfilling the terms of his contract by completing the assignment and was now awaiting his next from the studio. Loeb and Loeb, Loew's Incorporated's Los Angeles attorneys, returned the script in the next mail, insisting rather vaguely that "Mr. Trumbo's employment and the

payment of compensation to him have been suspended pending the occurrence of certain events." Thus the way was clear for the lawsuit that would follow.

Partly because of the situation with Metro-Goldwyn-Mayer, and also partly because he was then sincere in wanting to break out of motion picture writing, Trumbo decided that it was time for him to try his hand at writing a play. Sometime in late December 1947, he wrote Elsie McKeogh of his intention, and she got busy on his behalf. In the first week of 1948, she wired him that producer Lee Sabinson was willing to pay Trumbo an advance on any play he was working on, topic unspecified and sight unseen. As it turned out, the offer was a fairly substantial one under the circumstances: one thousand dollars down and one thousand dollars upon agreement to make whatever revisions were deemed necessary. Trumbo wrote his acceptance to Elsie McKeogh and asked her to pass on to Sabinson a little information about the play, which he expected to have in first draft by the middle of March of that year. The title, he told her, was *Aching Rivers* (in production it subsequently became *The Emerald Staircase* and finally *The Biggest Thief in Town*); it had three acts, one set, and eleven characters (twelve in its produced version). He went on then to add a note of reassurance for Sabinson: "In the sense that no thoughtful work can escape having social point, it will have a certain import in line with my convictions. But it will contain no exhortations, no social declamations, no obvious political demands. . . . I see nothing in the theme and its treatment which would place the play outside the main stream of general serious drama and into the specifically radical category."

The idea for the play had its genesis in Trumbo's experiences as a cub reporter on the *Grand Junction Sentinel,* when he had been assigned to the "mortuary run." It proved quite an education for him: "I saw many prominent citizens without their clothes on, as well as other alarming things." He never quite got over his experiences in Grand Junction's funeral parlors, and he became convinced that a play could be written set solely in a mortuary. Eventually that play was written, and it was *The Biggest Thief in Town*. It turns on the theft of the body of the richest man in town, a Citizen Kane-like character who lives in a castle overlooking Shale City. Bert Hutchins, the town's philosophical undertaker, learns of the death and claims the body, thinking to turn a handsome profit on the funeral before the cadaver can be shipped off for far

more expensive burial in Denver. As it turns out, however, John Troy-balt, the tycoon, is not even dead. In the play's funniest scene—and it has a number that are very funny indeed—Troybalt is prayed back to life by supposed mourners whose intention is to send him off in the opposite direction.

Trumbo has commented that the essential difficulty with this play is that it was really two plays in one—a serious piece and a comedy. In rewriting before production and while out on the road prior to its Broadway opening, the serious play within it was somehow irretrievably lost. Only the comedy survived. In the final text—that is, the one that was performed on Broadway—you can see vestiges of the original play in undertaker Bert Hutchins's ruminations on his responsibilities as a parent. He has a daughter, Laurie, who is a dancer (remember Trumbo's old flame, Sylvia Longshore?), and he is trying to arrange her future.

As for the moral of all this, if indeed the play that survived does have a moral, it would seem to be contained in Bert's justification for one last bit of wheeling-and-dealing that stops a good deal short of the body-snatching with which the night's enterprise began. In the last lines before the final curtain he declares, "I'm just like anybody else. I only steal what I absolutely *have* to have—and then I work for the rest."

A complication developed with regard to Trumbo's situation on the Metro contract. It seemed that the terms of the contract stipulated that he was able to write plays while on a leave of absence but not while on suspension. This meant that when it came time to submit the play to Sabinson, at the end of March 1948, the secrecy he had stipulated earlier had to be maintained more vigilantly than before. It was not until August 1948 that this difficulty was ironed out and he was able to sign with Lee Sabinson. By that time, however, plans were well under way for production. Herman Shumlin had been engaged as director, and discussions had been begun on casting.

By that time, too, Dalton Trumbo had gone to Washington to stand trial for contempt of Congress. He had been convicted and sentenced to a year in jail. The process of appeal had begun.

"I remember that trip to Washington" says Lester Cole when I inter-view him. "He and I went back together to stand trial for contempt. All the way across the country by train, the way it used to be done. We

shared a compartment, and we drank a *lot* of whiskey. We managed just to float across the country in a state of euphoria and fine spirits."

The look on Cole's face as he remembers is interesting to see. A rueful smile. Or call it amused indulgence toward that younger self who could carry on in such circumstances.

"He and I are alike in some ways," he continues. "We're both raucous and boisterous guys, especially with a couple of drinks in us. We're about the same age, too. Actually, I'm a year older than he is."

This comes as a surprise, for Lester Cole looks nearly ten years younger than Dalton Trumbo. He is balding, but the hair he has left is close-cropped, giving him an almost military appearance. A man of medium height, he is stocky and deep-chested and appears physically strong. Both Cole and Alvah Bessie, who left Hollywood for San Francisco, seemed younger than their years when I met them. Trumbo, who had worked continuously in the movie industry since 1933, looked every year of his age and then some.

"It's true, really," Cole assures me. "I think one of the things that's kept me young is getting out of that rat race in Hollywood. There has always been this carnivorous attitude there. I found that to some extent it was restrained among us—among people who had common political goals. We were under the same pressures, of course, but there was the feeling we had that there was something beyond the next big payday. Let's say it alleviated the competitiveness and envy among us a little. It wielded a kind of humanizing influence."

Lester Cole and Dalton Trumbo were thrown together frequently during the period between the hearings and their imprisonment. There was that trip to Washington, and there was also the civil case against Loew's Incorporated, their suit on their contracts. They were the only two of the Ten who worked for Metro-Goldwyn-Mayer at the time the Waldorf Agreement was announced and the blacklist begun. Cole had started in films in 1932 and had actually tallied more screen credits than Trumbo at the time of the hearings, though most were done for the B units at various studios. He had begun working at Metro just after the war and was there from late 1945 to 1947. While there, he did three films—*The Romance of Rosy Ridge,* an Esther Williams vehicle called *Fiesta,* and *High Wall.* Oddly enough, however, he worked picture to picture on a free-lance basis during this period. Not so unusual in itself, but what is curious is that Lester Cole was not offered a contract at

M-G-M until after he was under subpoena to appear before the House Committee on Un-American Activities as an "unfriendly" witness.

"You see," Cole explains, "the contract had already been drawn up and was to be offered when the subpoena came. When it did, they didn't dare not go through with it until they knew which way the wind would blow. They may have struck a pose at the Waldorf, but they were anything but hard-liners. Listen, the last thing I worked on at Metro was a film biography of Zapata, the Mexican revolutionary. Eddie Mannix, who was Mayer's right-hand man, was skeptical about the project at first. But then he was shocked to find out that the Mexican government was so anxious to have the film made that they were offering one and a half million dollars in services and cooperation to M-G-M and wanted to make it the first Mexican-American coproduction under their big producer Gabriel Figueroa. When Mannix heard about the deal, all his doubts were resolved. He said, 'What the hell, Jesus Christ was a revolutionary, too.' For a couple of million he was willing to compare Zapata with Christ! And he was a Catholic!" It was about this time that they shoved the contract under Lester Cole's nose and he signed on the dotted line. The Zapata picture was never produced by M-G-M. The studio sold the entire project to Twentieth Century-Fox, where it became *Viva Zapata!*

To give you the homely details of this conversation between us, Lester Cole and I are having lunch at a restaurant on the fringe of Chinatown. A nice restaurant. Secretaries from the financial district have strayed over. He glances appreciatively at them once or twice as they file past us. It is easy to imagine him in Hollywood and hard, in a way, to imagine him away from it.

It took some time for him to cut the cord. He had put in his years on the black market, too—had even begun, as Trumbo did, by working for the King brothers. Although he has no idea whether or not Trumbo recommended him to them, he was made to feel welcome by them. He sold a story under an assumed name to them sometime between 1947 and 1950.

"Then I worked for a major studio with another writer fronting for me. That was how I was involved until I went to jail. To Warner Bros. I sold a couple of story ideas under a pseudonym—*Every Man for Himself* and *Chain Lightning,* that Bogart picture. When I came out of jail I went to New York and remained associated with the radical movement.

I put on shows, wrote TV shows under another name, and even worked for a while as a cook in a restaurant. Then in 1956 I left New York for Hollywood, where I continued to do some television work, a little on the film black market, and saw Trumbo, of course, from time to time. Then, in 1960, that was the year he broke the blacklist—it was kind of a mania all those years with him—I went to London and worked there for five years. What did I do there? Let's see. Well, I wrote the screenplay to *Born Free* under an assumed name. Other things. But when I came back from there, the idea of returning to Hollywood just wasn't attractive to me, so I came here, to San Francisco."

I ask Lester Cole if he continued to think of himself as a radical, if his political attitudes had remained fundamentally the same.

He nods. "Oh yes. I've never taken a political position that would have eased my personal position in any way. Some did, of course. Some informed and others altered their stand in more subtle ways to make themselves acceptable. I never did. The Ten was a pretty disparate group before they became the Ten, you know. They stuck together in the crisis. Conflicts and differences were submerged. But when that need was gone, the men followed their original feelings and related to world events as they had before they restrained themselves and their feelings and became the Ten.

"But no. No, I don't think my own position has altered at all. I've always written from what I believed in, too. I got into a debate once with the original author of *The Romance of Rosy Ridge.** He claimed I had destroyed the film by politicizing it when I adapted it. Well, it's true I altered it. The original had the soldier just sort of wandering through after the Civil War. I gave him some purpose to come back. I don't think I destroyed it, but I do think it gave the story a more distinct viewpoint.

"Sure, I suppose we did seek to bring our own convictions into the films we wrote. But were they subversive, as the Committee claimed they were? There was nothing subversive about *The Romance of Rosy Ridge*. For myself, if I had it to do over again, I would do just the same. Some who testified claimed to have been betrayed by their political beliefs, by the times, by who knows what else. I don't feel I was

*The novelist MacKinlay Kantor.

betrayed, or misled, or bamboozled. I knew just what I was doing, and
I don't regret any of it."

As the appeal process ground on, the Hollywood Ten and their attor-
neys became increasingly aware of just how important it was that the
public know about their case and that opinion be marshaled in their
favor. In 1948 it may have seemed just possible to win mass support for
their cause. That was the year of Henry A. Wallace's Progressive Party
campaign for the presidency. Dalton Trumbo's personal involvement
in the Wallace campaign was minimal. He made a speech or two and
wrote a letter in support of Wallace to be reprinted in advertisements
along with statements from others of the Ten. There was an effort to
identify the cause of the Hollywood Ten with that of Henry Wallace—
and vice versa. When Wallace lost so decisively, it must have discour-
aged them and their supporters.

And 1948 was also the year Trumbo left the Communist Party: "We
were living at the ranch, and it was an eighty-five-mile drive into town.
I was hopelessly engaged in the Ten's problems and so forth. And I just
drifted away. I changed no beliefs. I just quit going to meetings and
never went back—with no more feeling of separation than I had before
I started with the Communist Party."

The next year, 1949, brought further discouragements to the Ten,
for that was the year that Supreme Court justices Frank Murphy and
Wiley B. Rutledge died, in succession, thus reducing the chances of
having the contempt convictions heard on appeal before the Court
from fifty-fifty to about thirty-seventy. Something had to be done. And
so Trumbo sat down and wrote a pamphlet, "The Time of the Toad,"
which, even allowing for its strongly partisan viewpoint, is still the
most lucid discussion of the issues in the case.

He devotes the first half of "The Time of the Toad" (which derives
its odd title from a rhetorical conceit employed by Zola in his pamphle-
teering on behalf of Dreyfus) to an exposition of the events leading up
to and through the contempt citations before the House Committee on
Un-American Activities. In the second half of the pamphlet, Trumbo
deals at length with the larger issues raised by the Hollywood Ten case.
He establishes it—and he may well have been the first to do this—as a

domestic manifestation of the Cold War that was only then just developing: "We are against the Soviet Union in our foreign policy abroad, and we are against anything partaking of socialism or Communism in our internal affairs. This quality of opposition has become the keystone of our national existence." He then focuses on that species which would soon become the most avid of all the Cold Warriors—the New Liberal, the champion of the anti-Communist left. His chief target here was Arthur M. Schlesinger, Jr., who had already made statements during a panel discussion that in principle denied academic freedom to university teachers who were or had been members of the Communist Party. (Schlesinger subsequently attacked the Hollywood Ten directly in an article published in the *Saturday Review of Literature,* "The Life of the Party." He became a particular enemy; it would not be overstating to say that Trumbo despised the man.)

In "The Time of the Toad," Dalton Trumbo attempted to sound a general alarm, tying the plight of the Ten to the threats posed to free speech and intellectual freedom which were, after all, at the heart of the position he and the rest had taken before the Committee. They took the show out on the road in an attempt to stir up popular support during the final appeal period. Speaking around the country, appearing at rallies and meetings, they would sound this note again and again. They packed Carnegie Hall at a rally for the Ten at which Trumbo spoke, but the message was brought out to Middle America as well. He remembered going to Duluth, Minnesota, on a winter night and finding that thirty-five or forty people had braved the cold to hear what he had to say about the Hollywood Ten and freedom of speech down at the local union hall.

"Adrian [Scott] and I went to speak at the University of New Hampshire," he remembered. "We got off the train and found the Liberal Club, which was the sponsoring organization, had a guard on hand for us. And I suppose it was a good thing, too, because there were some rocks and eggs being thrown at us there at the depot—feelings ran high, you see. Rather than take us to a hotel where we would be available, they took us quite secretly to a rooming house, an immaculately kept place with two beds in a single room. Well, before night the university revoked our permit to speak on the campus, and so the Congregational Church threw its doors open for us, and we spoke there. But

sitting in the front row were six members of the football team wearing blazing red sweaters—the opposition, you see. They glowered at us the entire evening and did their best to intimidate us.

"I remember Ring and I met during this time in Chicago. We went to the Pump Room of the Ambassador at noon. Now, the Pump Room in those days had enormous martinis, and we began to drink martinis. We stayed, and stayed, the two of us, and we were there at dinner time, and we had dinner. And we continued drinking, until about twelve-thirty, Artie Shaw came in, having just finished an appearance with his dance band. He sat down and we drank a little bit with him. A fantastic thing—and we were able to get up and get to our hotel! We just spent the whole day drinking those God-damn martinis and talking. We were young and healthy then and could get away with it.

"What did we talk about? Well, I know it wasn't politics because, God, politics was running out of our ears by this time. Oh, we might have been critical of the job we had been sent out to do. You know it was rather embarrassing because one of the problems of the Ten was that they were known to have been very highly paid. And it *was* embarrassing to go into a union hall in Chicago and make a speech, then somebody would make a pitch and a collection would be taken. You might get thirty dollars or maybe more. There was something fundamentally wrong with this, it seemed, yet the people wanted us at the union hall and wanted to contribute. But publicly there is no way you can allow much indignation for people who are making only ten thousand dollars instead of the hundred thousand they made before. We had some personal difficulties over that, and that may have been about the closest we came to discussing politics."

Part of the time during which Dalton Trumbo was touring for the Ten was also taken up with his involvement in the production of his play. He had kept his work on the black market to a minimum then and was betting boldly on its success. But there were problems with it right from the start. Director Herman Shumlin was calling for rewrites even before rehearsals began. There were problems in casting, too: for instance, Thomas Mitchell, who was not their first choice for Bert, never completely satisfied Trumbo, Shumlin, or Lee Sabinson. But he was a name, and the play badly needed whatever prestige he could lend it. The biggest problem, however, was the very fundamental one of just what sort of play this was going to be. Rewriting furiously on the

road, Trumbo altered the play completely in Boston and Philadelphia; the name was changed a couple of times before it became *The Biggest Thief in Town;* and one character was totally eliminated in the rewriting. As Trumbo put it to Sam Zolotow of the *New York Times* in a brief interview published on March 30, 1949, the day it opened: "The play started out as a drama of frustration. Then the audience and other factors changed it into what it is today. We hope it's a comedy."

There seems little doubt he succeeded in making people laugh. William Pomerance, Trumbo's friend from the Screen Writers Guild, who by that time had moved back to New York and started a television production company, remembers the play as "one of the funniest I've ever seen. I heard they had to carry two people out from laughing in Boston." And even Brooks Atkinson's negative review in the *Times* allowed that the opening night audience had certainly enjoyed itself: "To enjoy 'The Biggest Thief in Town'...you have to do Dalton Trumbo one favor. You have to agree that an undertaker's parlor is a comic place and that body snatching is hilarious. To judge by the laughter in the theater last evening, many people have no difficulty in agreeing with Mr. Trumbo's ghoulish point of view."

Although *The Biggest Thief in Town* would eventually have a run of nearly a year in England, the play was finished in America. The project on which he had spent so much time and on which he had counted so to rescue him financially had come to nothing—or next to nothing. Immediately after it closed, there was some brave talk between Trumbo and producer Lee Sabinson about another play. Sabinson went as far as to offer him another thousand-dollar advance, which Trumbo declined. He wanted to write another play, all right, if only to put Brooks Atkinson in his place; but he knew very well now that at least for the time being, his only real salvation lay in screenwriting. He took a deep, desperate plunge into the black market.

To do it, he had first to find an agent willing to represent him, one who would do so on a completely confidential basis. His agency-of-record had been Berg-Allenberg, the high-powered outfit that had negotiated his surpassingly favorable Metro-Goldwyn-Mayer contract. Because the agency wanted primarily to stay in the good graces of the studios, it was certainly not going to do much—if anything—on Trumbo's behalf. One of the principals of the agency, Philip Berg, had angered Trumbo during an interview in April 1948, when he took it upon

himself to lecture him for "making long speeches" while he was before
the House Committee on Un-American Activities. Berg then went on
to suggest seriously to Trumbo that he and the other nine might throw
themselves on the mercy of columnist Westbrook Pegler, a friend of the
agent's, and thus gain forgiveness (along with their old jobs, presum-
ably) by cooperating fully and telling him whatever he wished to know
about their allegiances and associations. Finally, Berg refused to make
him the loan of ten thousand dollars he asked for, or even to take a ten-
thousand-dollar trust deed on the Lazy-T—and Trumbo had always
maintained that an agent's primary function was to loan his clients
money. All these and other complaints are detailed in a long letter he
wrote on December 17, 1948, to his contact there, a letter that becomes
ironically amusing when we note that it was addressed to Meta Reis
(now Meta Reis Rosenberg) at that agency. She appeared before the
House Committee on Un-American Activities on April 13, 1951, and
cooperated fully, admitting her former membership in the Communist
Party and giving the names of twenty men and women known to her to
have also been members.

Dalton Trumbo's name was not among them, but the name of George
Willner was. He was the agent, a principal of Goldstone-Willner, who
said he would be willing to take Trumbo on as a secret client and help
him find work in the black market. Trumbo had written to him first
on July 17, 1948, asking if Willner could get him some work—a polish
job or a shooting script to be written from a story already set. Nothing
developed for a while, for Trumbo was traveling for the Ten and was
involved with the play, though Willner did help him collect money that
was owed him by the King brothers for his *Gun Crazy* script. However,
when Trumbo floated back from New York, clinging to a spar from the
shipwreck of *The Biggest Thief in Town,* he sent a Mayday to Willner.
The agent responded with a job, an original story, *Fairview, U.S.A.,*
for the comedian Danny Kaye. Not long afterward (June 1949), Will-
ner lined Trumbo up with independent producer Sam Spiegel to do a
screenplay on a "fairly commercial yarn, somewhat similar in theme to
Double Indemnity." What resulted was *The Prowler,* a thriller that after
starts and stops, and many demands for payment from Trumbo, was
brought before the cameras the next year only a little before he went off
to jail (more about this one later). And then George Willner pulled off a
real coup. He sold one of a couple of original screen stories Trumbo had

written the year before, *The Beautiful Blonde from Bashful Bend*. The purchaser was Twentieth Century-Fox. It carried the name of Trumbo's friend Earl Felton, and it brought them both some money. "Whatever he got," says Trumbo, "he deserved every penny of it because if it was discovered, it could have been his career. Earl was a friend." Felton subsequently did the screenplay for Preston Sturges, who made the picture. It failed disastrously, however, and did neither of them any good.

In the midst of all this occurred an incident that was silly enough in itself but had some negative effect on the image of injured propriety that the Hollywood Ten had sought to project. It all came about when Trumbo made one of his rare trips into town from the Lazy-T. He had errands to run and shopping to do and wound up going out to dinner with Ian and Alice Hunter. He and Ian drank a little before dinner and quite a bit afterward—so much that he decided he had better spend the night. In the course of it, he felt a powerful urge to urinate, and, finding the bathroom occupied, Trumbo marched out the front door to the curb and cheerfully urinated in the gutter. Just as he was finishing, a car turned the corner and bore down upon him, illuminating him in its headlights. It was a Beverly Hills police prowl car, and Trumbo had been caught in the act. The police took him into the station, as he insisted all the while he was not drunk and demanded a sobriety test. They refused to give him one, but rather, realizing who he was, invited reporters down for the story. Once the press had been satisfied, Trumbo was allowed to pay twenty dollars bail and leave the station. He went immediately to the home of a doctor he knew, woke him up, and asked to be given the sobriety test the police had refused him. He took it and passed.

By the time the case came up, Robert Kenny had represented his client's case informally to the judge who would try it. "I called him up before things got tense," Kenny recalled. "It was all very easy. We'd been in Stanford together, and I simply told him what happened, and the judge himself said that things had come to a hell of a pass when a man hasn't got the same rights as a horse. 'That's right,' I told the judge, 'it's a constitutional question.'" It may not have been an artful argument, but considering that Trumbo had passed a sobriety test within the required time and could prove it, it was enough to persuade the police not to prosecute.

There was no need to. The newspapers had already done that job.

The story was splashed through them all. If the object had been to ridi-
cule the Hollywood Ten, that band of "swimming pool Communists,"
then they succeeded. But if the intention was to cause Trumbo himself
personal embarrassment, they failed. He took it all with equanimity.
His only real concern was the effect the publicity might have on his
mother. She had always opposed his drinking when he was a young
man; as he grew older, she tolerated it. He was afraid that she would
assume from the lurid accounts of the incident in the papers that the
pressures under which he was now operating had made a drunk of him.
And so he wrote Maud Trumbo, assuring her that reports of his deprav-
ity were greatly exaggerated. He ended the letter with two paragraphs
that illuminate the rough sort of bargain mother and son had struck
during a time that must have been hard for both of them:

> When I look back on my own convictions and rebellion, I find
> nothing remarkable in it. For I am reminded that at a younger
> age than I my mother too, rebelled, left her church, joined an
> unpopular and ridiculed faith, insisted upon the immunity of her
> children from supervision of medical authorities; and that the
> church she joined was fighting for its life before various legisla-
> tures, and that was in the newspapers, falsely and outrageously,
> and fought them off to the end. How, then, could a rebellious
> mother produce anything but a rebellious son?
>
> Disagreeing as we do and have, we have finally struck a rela-
> tionship which I am sure pleases us both—one of mutual respect.
> I love you very much, but I respect you even more, and that is
> what I hope to earn from my own children, after suitable conflicts
> and disagreements. Instead of regrets for my present plight, I have
> only renewed confidence, and a joy in writing that five years ago I
> thought would never come to me.

Time was growing short, and Trumbo knew it. When he wrote that
letter to his mother he and his nine co-defendants were sweating it out,
waiting to see whether the Supreme Court would hear their case. Their
petition of certiorari was turned down on November 14, 1949. They
knew then that delay was possible, but jail was inevitable.

He chose to spend the few months he had left to him hard at work.
If he was to be lost to his family for a year, then—he told himself—he

would have to earn enough in the time remaining to take them through that year. He managed to do just that. This was remarkable enough in itself, considering the legal expenses he had incurred, the debts and running expenses attached to the Lazy-T, and the number of people who were financially dependent upon him; but even more impressive was the quality of work he did during this time. Working under the gun, falling back on Dexedrine and Benzedrine to keep him at the typewriter and Seconal to bring him down and put him to sleep, Trumbo somehow managed to pull off some of the best work he had done in years.

The Prowler was one of the two jobs lined up for Trumbo by George Willner immediately following his return from New York. He completed rewrites called for by Sam Spiegel late in 1949, and the production, directed by Joseph Losey, was brought before the cameras the following year. Although Trumbo never set foot on the set, of course, he and Losey did work closely together on this one, and the movie that resulted from their collaboration can be presumed to be very close to his original conception. It is a "little" movie, essentially a good B picture, a sleazy morality in which an all-night disc jockey (whom we never clearly see) is cuckolded by the cop on the beat when the wife calls in a complaint about a prowler. The details of the film are sharp and accurate, and the leading roles are good, strong characterizations that are well played—by Van Heflin and Evelyn Keyes. Trumbo himself completed the triangle: since the husband is really present only in voice, Losey thought it would be a great joke for Trumbo to be heard throughout the film as the disc jockey. And so he took him to a recording studio, and Trumbo dubbed the all-night deejay's patter which he himself had written. *The Prowler* was released while he was in jail and Trumbo forgot about it completely—so completely that when, years after the blacklist, he caught it on the late-late show, he was astonished to hear his own voice suddenly issuing from the set. It was only then that he remembered that he indeed had recorded it, a ghost come back to haunt himself.

Cowboy was an anti-western, the first of that sub-genre which includes most of Sam Peckinpah's pictures, as well as such other good films as Tom Gries's *Will Penny* and Robert Altman's *McCabe & Mrs. Miller*. Trumbo adapted it from Frank Harris's *My Reminiscences as a Cowboy* for Sam Spiegel, and John Huston was originally supposed to

direct it. Production was delayed, however, and Delmer Daves finally made the picture in 1957, featuring Jack Lemmon and Glenn Ford. Hugo Butler lent his name to Trumbo for this one, as he did for the other two written just before jail. By the time *Cowboy* was released, however, the Writers Guild had entered into an agreement with the producers whereby the name of any political undesirable could be summarily removed from the credits. By that time, too, Butler himself had been blacklisted, and so Edmund North, who had done some rewriting on the script just before it went into production, was given sole credit on *Cowboy*. "North is a pleasant enough man with good feelings," said Trumbo. "He later and privately expressed to Hugo his repugnance at receiving sole screenplay credit in this fashion. . . . This credit was a good one because the reviews were good. And this is an excellent example of why no record of credits between 1947 and 1960 can be considered even remotely accurate."

He Ran All the Way was a tightly written melodrama, the quintessential John Garfield movie—and sadly enough, also Garfield's last. He played a criminal on the lam, forced to hide out with a family of strangers whom he holds hostage. Shelley Winters, the daughter, falls in love with him in spite of herself—as the song says, ladies love outlaws—and he is gunned down at movie's end with only her to mourn for him. Not a new story, certainly, but Trumbo breathes life into it with the perfect sense of fitness he achieves in writing for the Garfield persona: the part suits Garfield like a bespoke coat; the lines are his completely. John Berry directed it, the last movie he did before he himself was blacklisted, and achieves in it a feeling of sustained tension that is perfect for the material. Hugo Butler did some rewriting on *He Ran All the Way* while Trumbo was in prison and received sole credit for the picture.

Trumbo worked on so-called original screen stories during the last weeks before he was to report to serve his prison sentence. At that time there was still a market for these extended narrative treatments, and George Willner had had good luck with one of them earlier. Trumbo wrote three such stories in about three weeks, each of them ninety to one hundred pages in length. Only one of them sold, but the deal was made before Trumbo left for jail. It was *The Butcher Bird,* a thriller that was never produced but brought him and his family forty thousand dollars when they most needed it.

The family was holding up rather well. It helped, of course, that

Dalton, Cleo, Nikola, Christopher, and Mitzi were there almost isolated during the last winter together on the Lazy-T. Trumbo had bought a Jeep station wagon with which he drove the children to school through even the worst of the mountain snows. But with spring coming apace, they stayed just as close as they had during the high-country winter. They were bundling, not against the cold but against the future. What did it hold for them? The children could not help but be confused by what lay ahead, for they had been told that it wouldn't be long before their father would be going off to jail. Dalton and Cleo carefully explained why this was so and made it clear that he had done nothing that he—or they—should be ashamed of. Still, it worried the children, as Cleo found out when she overheard Christopher (then nine) ask Nikola if, when a father was sent to jail, it meant his son would have to go to reform school.

CHAPTER NINE

TEN MONTHS IN KENTUCKY

On June 7, 1950, Trumbo left Los Angeles for New York City. His ultimate destination was Washington, D.C., where he was to surrender himself to serve his sentence of one year for contempt of Congress. There was a small crowd at the airport to see him off. Cleo was there, of course, as were the children. After saying their goodbyes, Trumbo's family fell back with the group of demonstrators and, surprising him, unfurled a banner that read: "Dalton Trumbo is going to jail. Free the Hollywood Ten." When the remaining eight left some time later (John Howard Lawson had gone on ahead of Trumbo; they were to meet in New York), there was a much larger crowd at the airport to see them off. Cleo gave a speech then on Dalton's behalf to the three thousand who had assembled there, a rarity for this woman, who was a rather shy person. Trumbo was proud when he heard about this and said he wished he could have been there, but the memory he carried of the three children and Cleo standing under that crudely lettered sign was the one he took with him to jail, and that seemed to suffice.

He arrived in New York the next day and was met by Lawson, some New York friends, reporters, and photographers. There was a farewell dinner given for him by Lee Sabinson, the producer of *The Biggest Thief in Town;* and before leaving, he attended a party given in their honor by left-wing socialite Leila Hadley. And then at last to Penn Station, where they found that over a thousand people had gathered to cheer him and Lawson on their way to jail. The two were picked up and borne bodily

to the train gate on the shoulders of the crowd; afterward, Trumbo called it a "rather grotesque experience." In Washington, D.C., the next morning—June 10—they held a press conference, making a last call for support and once again explaining the issues. Then they went off to the District of Columbia Jail and surrendered themselves.

Exhausted from months of overwork as he prepared for prison and emotionally drained by the excitement of the last few days, Dalton Trumbo came as close to enjoying his first few days in jail as any man could. It provided him with a needed opportunity to sleep, to rest, to eat, and to trouble himself no more than to reassure Cleo and the children that all was well. He and John Howard Lawson knew they would be sent from the D.C. jail to one of the federal prisons. The two were hoping they would be assigned to the federal institution at Danbury, Connecticut, because of its nearness to New York. As it happened, they were not, but Lester Cole and Ring Lardner, Jr., were sent to Danbury, where, by some comic twist of fate, they found themselves in jail with the man who had put them there, J. Parnell Thomas, former congressman from New Jersey and former chairman of the House Committee on Un-American Activities. In 1948 Thomas had been indicted by the Justice Department for payroll padding; and even though he pleaded the Fifth Amendment, he was convicted the following year and was there at Danbury when Lardner and Cole arrived. "He had lost a good deal of weight," Ring Lardner, Jr., later wrote of his encounter with Thomas, in the prison yard, "and his face, round and scarlet at our last encounter, was deeply lined and sallow. I recognized him, however, and he recognized me, but we did not speak."

The prison assignments, when they were made, spread the Hollywood Ten around the entire federal prison system. In addition to Cole and Lardner, Herbert Biberman and Alvah Bessie were sent to the Texarkana, Texas, Federal Prison; Edward Dmytryk and Albert Maltz went to the Millpoint, West Virginia, Prison Camp; Samuel Ornitz, even then ill with cancer (he was the first of the Ten to die), served his entire sentence at the Springfield, Massachusetts, Federal Prison Hospital. Dalton Trumbo and John Howard Lawson were sent to the federal prison at Ashland, Kentucky, where a few weeks later they were joined by Adrian Scott.

Trumbo arrived there June 21, 1950. Once he was settled, he was able not only to write letters, as he had done faithfully from the jail in

Washington, but to receive them as well. By this time, of course, he was a man ravenous for news from home. The letters Trumbo wrote from prison are remarkable in their way. He was at other times so taken up with public concerns, so deeply involved with large issues, that it is easy to forget that he was essentially a family man—and remained so all his life. The fact that he was then in jail satisfied even him that he had done so much as he could for the cause of the Hollywood Ten; he had given all any man could for the First Amendment. There were no more speeches to be made, no more pamphlets to be written, just a period of time ahead to be gotten through. His only responsibility now, and perhaps for a good long time to come, was to Cleo and the children.

All this can be sensed in the prison letters, especially in those written early in his term. There is in them, in the beginning, a kind of feverish inquiry after the family's welfare—asking for details, giving explicit instructions. He was particularly concerned that the money keep coming in as he had arranged. There was an amount remaining to be paid to him for the screenplay he had done for John Garfield, *He Ran All the Way*. He kept urging Cleo to keep after the film's producer, Bob Roberts, who was also a friend, for this sum. And money was long overdue from Sam Spiegel for *The Prowler*; it took months more to collect even part of that. But along with this dogged desire to get what was coming to him was an apparently equally strong wish—remarkable under the circumstances—to begin paying back money he had borrowed from friends before going into prison. You come across a list of small checks which he asks to be written to Earl Felton, Edward G. Robinson, Sam Zimbalist, E. Y. Harburg, and John Garfield—*if* the big check arrives from Sam Spiegel, as promised.

It is in such scrupulous attention as this to what he owes and is owed, the old religion of debit and credit, that Trumbo seems most peculiarly and certainly that sort of nineteenth-century American they were still breeding out in Colorado during the early part of the twentieth century—rare enough qualities even now. Trumbo never lost his respect for money and its obligations, no matter what his politics may have been.

His concern for Earl Felton, a very old friend and the one who had introduced him to Cleo, went well beyond his financial obligation. Felton, who was physically deformed, had had a run of the most depressing

sort of bad luck. He had been jilted and was so deeply affected emotionally that his work as a writer began to suffer during one of Hollywood's periodic postwar slumps. He had had no work for a time and could well have used the money Trumbo owed him. Trumbo knew that, of course. He also knew that Felton needed far more the sort of personal support that he could have provided if only he had been around. He wrote urging Cleo to see him as soon as possible, and then to Bob Roberts, who was in town (as Cleo was not), asking him to do what he could for Earl. Eventually, Felton pulled himself together and returned to work as a screenwriter, although one or two of his subsequent credits were actually stories by Trumbo to which he allowed his name to be attached. Although never blacklisted, he eventually found himself again unemployable.

As for what Cleo and the children were doing during this period, they were really only waiting for Trumbo to come back. Life went on at the Lazy-T much as before, except that there was only silence from the detached study behind the ranch house where the typewriter had constantly sounded before. Hugo Butler and Jean Butler came up with their children on July 3, 1950, and stayed the summer, easing things considerably for Cleo. There was always plenty for her to do—frequent trips into Los Angeles on family and financial matters—and there were, of course, many visits to their lawyers.

Although Trumbo's participation in them was strictly limited, the legal actions in his behalf continued, even with him in prison. There were, first of all, those to do with getting him out as soon as possible. There was an odd inequality in the way the Ten were sentenced that might, it was felt, be worked to the advantage of the majority. Two of them—Herbert Biberman and Edward Dmytryk—had received disproportionately short sentences (six months each rather than the year the rest had been given) simply because they were sentenced by a different judge than the others. Robert Kenny, who was chief of the team of attorneys who had taken the Ten up before the Committee, was appealing Trumbo's sentence along with those of the rest and asking that it be reduced to conform with the lighter sentences given Biberman and Dmytryk. The appeal was ultimately denied.

That left parole. Although in such short sentences as his parole was unusual, contempt of Congress itself was a rare sort of offense (talk about your white-collar crime), and the parole board might well look

with favor on the petitions of men who had really done no more than refuse to cooperate in their own pillorying. Trumbo was eligible for parole on October 8, 1950, and for a while he was hopeful. In August 1950, in his letters to Cleo, he began to outline the steps required. He would need a parole advisor and a parole employer, as well as a number of letters from responsible citizens testifying to the high quality of his character. Would she write them? And would she try to find an advisor and an employer for him as well? Of course she would. She lined up the nuclear physicist Linus Pauling (Trumbo's suggestion: they had met at a fund-raising party given for the Ten), who enthusiastically agreed. The parole employer was a much more difficult problem. Naturally it was Trumbo's intention to return to his status as a self-employed writer. No studio would rehire him because of the blacklist and he could hardly go back to the bakery and start all over again. It seems, however, that the Los Angeles parole board made no provision for the self-employed; they wanted not only the guarantee he would provide for himself and his family that a full-time job represented, but also a number to call to keep check on him, a bit of leverage for use should he get out of line. Trumbo, seeing that he was caught in a bureaucratic web, sought to extricate himself by having Lee Sabinson (who had declared his wish to stage any new play Trumbo might write) and Bertram Lippincott (the publisher who had options on his next two novels) designated as his employers. Lippincott declined, refusing to write the parole board claiming any such relationship between himself and Trumbo. It would probably have done no good anyway, for there simply was no category in which a free-lance writer might conveniently fit for purposes of parole. Afterward, Trumbo declared it was "a flat policy of no parole for political prisoners," but it was at once much simpler and more brutal than that: he was, like many a convict before him, just a victim of the system.

The disposition of his civil suit against Loew's Incorporated, the parent company of Metro-Goldwyn-Mayer, was still unsettled when Trumbo went to jail. Ironically enough, one difficulty had to do with the fact, advantageous as it seemed at first, that his contract contained no morality clause. Clearly, the fact that it had none put him in a much stronger position than the rest of the Ten, all of whom were suing their employers. Membership in the Communist Party and/or the refusal to cooperate with the House Committee on Un-American Activities was

looked upon at the time as a moral question, nothing more or less. The fact that Trumbo's claim upon M-G-M was so much more clear-cut than that of the rest of the Ten on their respective employers became a sort of legal embarrassment to the other nine. Their lawyers felt, with good reason, that they, too, were entitled to a settlement. If Trumbo's claim had been settled first on the basis of the excluded morals clause, the rest could have been denied on the basis that their contracts contained such a clause and they had violated it. It was up to him then to throw in his lot with the rest, which he did. Negotiations on an out-of-court settlement for the Ten stretched on interminably, long after the last of them had left prison. But while Dalton Trumbo was serving his term in Ashland, he thought often and hard on the money that would be coming his way eventually. His letters to Cleo are filled with thoughts on this and instructions that she was to pass on to his attorney on the matter, Martin Gang, with an occasional exclamation such as this: "My—but I would love to take Metro for a thumping sum! Get everybody paid off, the lad* first of all, and be rich again." In the event, of course, the settlement, when at last it came, certainly did not make him or anyone else rich. Negotiating together, the studios settled with the blacklistees out of court for $259,000. While the Ten did not share equally in this, they may as well have; Trumbo's share of it, which on paper amounted to $75,000, brought him only $28,000 after legal fees had been paid and other expenses shared.

He and John Howard Lawson were together at Ashland from first to last, their cots only twenty-four inches apart in the dormitory where they slept. It wasn't long before they were joined by Adrian Scott. The three had much to discuss. The Korean War started only days after Trumbo and Lawson had surrendered themselves at the District of Columbia Jail, and with it, on the home front, began the concerted campaign of vilification, threat, and propaganda that is now referred to as the McCarthy era. Senator Joseph McCarthy, the Republican junior senator from Wisconsin, had nothing officially to do with the House Committee on Un-American Activities; unofficially, however, he admired their methods greatly, learned from them, and applied them rigorously in conducting the affairs of his own Senate Anti-Subversive

*Earl Felton.

Subcommittee. The House Committee on Un-American Activities got busy again during the period the Ten were in jail and turned their attention once more to Hollywood. From the Committee's point of view, the hearings that took place then were all they could have hoped for. With the Hollywood Ten in jail and the blacklist in force, it was apparent to all who testified in 1951 that the choice was either to admit their membership in the Communist Party and give names of others they knew to be Communists, or to get out of the movie industry. Only the writers could follow Trumbo's example and attempt to work in the black market: an actor was known by his face and voice; a director or producer worked in collaboration with others and had to work at a studio. As a matter of fact, a few days before Trumbo and Lawson were released from Ashland at the end of their term, Larry Parks, who was one of the original "unfriendly" nineteen, gave in to pressure and testified before the Committee, giving a few names to them, John Howard Lawson's among them.

But even though things were coming to a boil in Washington, D.C., and in Los Angeles; and even though the United States was engaged in a war in which the powers and ideologies were so counterposed as to make Trumbo and the rest seem renegades; nevertheless, the days in prison were quiet and without political stress. Nobody cared much what he was in for or what his politics were. It was simply a matter of getting through each day and "building time" (which was the phrase used at Ashland) which he needed to leave. In the beginning, Trumbo almost welcomed the period that stretched out before him. During the first few days there at Ashland, he wrote to Cleo:

Life here is something like life in a sanitarium. The place is airy, immaculate and most attractive, with wide expanse of lawns, and views of green country-side in every direction. The food is good, the attitude is friendly, and the restrictions are not onerous. The regularity of food, sleep—and later, I hope—work is most relaxing. Looking at myself in the mirror, I am persuaded that the wrinkles of work and tension are vanishing, and that I appear much younger than I did two weeks ago. After some twenty-five years of the most intensive work, the sudden shucking off of all responsibility gives one a sense of almost exhilarating relief— a total resignation of personal responsibility and a peaceful

acceptance of the regulations and requirements of the institution, none of which I have thus far found to be unreasonable.

But a few months later, he would begin another letter to Cleo:

Things are so dry at the FCI [Federal Correctional Institute] that I'm ashamed to put pen to paper. There is absolutely no news. Today it rained. Yesterday it didn't. My cold persists. I read. I work. I eat. Time passes more rapidly than it really should. I am not even too badly bored. But there is simply no news.

He subscribed to a good many magazines and newspapers, and even though imprisoned, he was not isolated. He kept the same keen interest in what was going on in the world, though he seldom discussed such matters in his letters to Cleo or to his other correspondents. This was partly because the letters were censored—and he knew it. But only partly, because at last his attentions and his energies were diverted from the daily alarms and threats brought in the pages of the newspaper. There was nothing he could do anyway—no article to write, no speech to make—and so he focused his attention beyond immediate events and considered history, history in the form of a novel.

In the beginning, he had half-expected to continue inside with the sort of work he had been doing just before going off to prison. He would write another original screen story or two, perhaps do a screenplay that he might try to peddle on the black market upon his release. But somehow that didn't work. He tried to get started on a number of things during his first few weeks there at Ashland. "Then I concluded," he wrote Cleo, "that precisely because of the conditions and interruptions, a serious work was the only project that could possibly engross my attention so completely that I wouldn't notice either the conditions or the interruptions." He had done a good deal of reading in those first months in jail: *Huckleberry Finn, The Decline and Fall of the Roman Empire, A Passage to India,* and *The Forsyte Saga,* among others. But the work that set him going was *War and Peace.* It persuaded him that it might be possible once again to take up the war novel he had hoped to write upon his return from the Pacific. He was especially intrigued by the idea of integrating passages of history into the book, as Tolstoy had done. As for length, he intended nothing on so grand a scale; but this

could be just one of a whole cycle of novels to deal with his time, the piece of history he knew best.

He began it in August 1950, after two months of imprisonment. At first it went very well indeed—a chapter a week for four weeks— but then, as the possible date for his parole drew nearer, his attention was diverted from the novel; he found it impossible to concentrate on it, and so he put it aside. With the parole date past and that avenue closed to him, he took the novel up again—this was at the beginning of 1951—and worked steadily at it until his release, at which time he had about 150 pages of typescript. He was optimistic about the project. He felt, while he was working in the last months of his term, that he had after all managed to do something in prison. Perhaps it hadn't all been wasted time. And with these feelings came again the recurrent yearning to be a novelist, what he still thought of as a *real* writer. He wrote to Cleo:

> More and more I realize that when I emerge from this place I must at last make the choice of whether I want to live at the rate of $25,000 a year as we always have, or whether I want truly to become a writer. I think it would be better for all of us if the latter course were taken, although it would entail certain sacrifices, including (unless we won a whopping law suit) the ranch.

The ranch *was* sacrificed, but they continued to live at the rate of twenty-five thousand dollars a year and a good deal more. What was worse, however, was that the choice was never really made. The novel was never finished.

I feel that what I have given so far is an altogether incorrect impression of Dalton Trumbo's life in prison. Was it merely an interruption? A chance to read and rest? An opportunity to try his hand again at writing fiction? No, it was time taken out of his life, months—nearly a year—that could never be reclaimed. If he was physically well treated, and he was, nevertheless there was the intense emotional pain he felt at being separated from his wife and children at a time when all of them most needed each other. There was nearly a year spent in meaningless busywork by a man who had learned to work hard and economically

at a very specialized craft, one who had developed his powers of concentration on a given project to an astonishing degree. And for what? If there had been an element of real punishment to this deprivation of time and freedom, then it might have been easier for him to take. But he felt no guilt for what he had done. In his own mind he was certain he had behaved honorably in refusing to cooperate with the House Committee on Un-American Activities. Had he shown contempt for Congress? Not for the institution; he respected it still. But yes, his attitude before the Committee had clearly reflected what he felt for those men and their attitudes that were, after all, truly contemptible. But none of this helped him in prison. All that helped him while inside were the men he got to know there:

"They had in that jail, I should say a third who were young men, or not so young, convicted on the Dyer Act, which is transporting a car across a state border. Many of them were from Washington, D.C., where all you do is leave the city and you've crossed a state line. About a third of them there were bootleggers, moonshiners. And a pretty high quality of men they were. They were largely illiterate. In the Kentucky hills, in that area, and in Appalachia, the moonshiners can't understand why they can't plant their seven acres to corn and make their corn into whiskey. To tell you the truth, I can't understand it either. But there were the distilleries, the federal licenses, and so on. But it is so much a part of their lives, and their fathers', and their forefathers', that it's useless to try to dissuade them. And they're *right*! Some of them, I'm told, make very good whiskey—if they have a chance.

"I wrote letters for a man whose first name was Cecil—from Appalachia—a moonshiner. This was his second conviction. They only gave him eighteen months and he would be out in six months, because nobody, not even the guards, felt that he was criminal. They were just somehow paying for their license with an eighteen-month sentence, and in six months they would be paroled. Now, Cecil could neither read nor write, so I wrote letters to his wife. His wife could neither read nor write, but a younger daughter could, so she wrote letters for the mother. And reading her letters to Cecil, you saw the hardship of the lives these people were living—four or five children, one of them always sick. There was the problem of getting in firewood. And always the work that went on, the planting and tending and harvesting, just nothing but hard work.

"His wife's teeth were very bad, and she'd been to the county two or three times about her teeth. And finally, there came a letter from her that said that although she didn't want them to do it and begged them not to, the county took out all her teeth. She said, 'I haven't got any teeth. All I've got is gums, and they don't know when they're going to be able to give me teeth. They've talked about a date, but my gums are too sore now. It's going to be a long time, maybe a year before I have any teeth. And all I've got is gums now, and my mouth is all scrunched up. And when you see me you're not going to love me anymore because I am so ugly.' In other words, this woman was just heartbroken. She must have been about forty-five, and she probably looked sixty-five by now. She was warning her husband.

"Well, often I would invent letters for Cecil and read them to him and if he liked them, fine, and make corrections, because he didn't know what to say, except when he had specific information to convey. So I wrote a letter in which Cecil said she wasn't to worry about her teeth, that she would be pretty without her teeth, that as a matter of fact when he first saw her and married her, he never even thought about her teeth and didn't remember whether she had any teeth or not—he didn't give a God-damn about her teeth. She would always be as beautiful as she was because it wasn't her teeth he loved anyhow. The letter came back written by the daughter for the mother. It was a love letter. I can't describe it. Just a complete, total love letter. It was very moving just to read it, to have been part of it."

What happened to Cecil? "He got out on parole before I was released. He's probably dead by now—bad health, malnutrition, the life they lead in those hills is what kills them. I never heard from him again."

But Trumbo did hear from a few. "Yes, I heard from White, the counterfeiter. He was a Marine in the war and had a 90 percent disability. I wrote letters to the parole board for a lot of people, but I would write the God-damndest things for White. He was a convinced counterfeiter, a devout one. He limped because his thighs were full of shrapnel, and he was missing two fingers on one hand. He was from Tennessee and had the wasted, emaciated face of early malnutrition. I liked him. He was first-rate. One frosty morning he went out to the loading dock and was guiding a truck in right up to the dock. The truck gave a lurch, his hand was caught, and he lost three more fingers. He came into the storeroom office then, holding what was left of his

hand, and said, 'You know, I think I ought to go to the hospital and get this God-damn thing sewed up!' He went up, and he was back again within an hour. Well, there's some quality there.

"We had a man named Brooks. Brooks was black, about six feet two and two hundred and five or two hundred ten pounds, as magnificent a man as you would hope to see. Now, military sentences are savage, but they are swiftly cut down. Brooks, however, had had an unusual experience with military justice. It happened in France where he was an MP during the war guarding a motor pool. And according to Brooks, a white soldier was trying to get away with a truck, and Brooks shot him and killed him. Well, he was court-martialed and, I think, sentenced to death. It was reviewed, and the whole thing was commuted—in other words, he was acquitted. He was transferred to Saipan. He and a friend were walking along a road, and a white sergeant in a jeep drove up beside them. There was an altercation, and Brooks killed the sergeant. Well, Christ, that was too much—he pulled seventy-five years! I'm sure there were mitigating circumstances in both instances. If he hadn't been black he probably wouldn't have gotten into much trouble, because his term had been knocked down, and by 1950 or '51, he was in Ashland, which is primarily for short-termers. Well, Brooks, for reasons that I don't know, took charge of me. While I was working unloading the trucks he wouldn't let me carry a side of beef or a hundred-pound sack of salt. He was constantly helping me. And we would sit and talk quite a bit together. Brooks said to me, 'You know, when I came into this God-damned place there was no sumbitch said hello to me. When I get out of this motherfucker, bet I ain't going to say goodbye to no sumbitch either. Fuck 'em!' He was as good as his word. The time came for his parole, and I watched him pack at the other end of the dormitory, all by himself, and when he was through, he simply left, walked out behind me, without saying goodbye to anyone. And I watched him through the window, crossing the yard, and he didn't take one look back. Not one."

Trumbo had been assigned to work in the shipping room there at Ashland Federal Correctional Institute. Everything that came into the prison came in through there. At first he worked with the gangs that unloaded the trucks that came through; but out of deference to his age and because he could type, he was soon given a physically easier job as shipping room clerk. Most of the shipments they handled were to or

from other federal institutions, usually prisons. They would get canned goods from one prison, uniforms made in another, and in exchange they would send out packages of cigarettes from tobacco grown in the fields at Ashland, cured, wrapped, rolled, and packaged there. It involved elaborate bookkeeping with profit and loss figures and was intended to make the federal prison system as nearly self-supporting as possible—on paper.

One day they got in a miscellaneous shipment from Leavenworth Federal Prison. Among the items unloaded by the shipping dock gang— with Trumbo, the clerk, looking on and more or less in charge—was a large cardboard box containing nuts, bolts, gears, machine parts, for which there was little use there at Ashland. Trumbo was checking them off as they were unpacked and carted off to the proper bins in the huge prison storeroom. Finally, when they reached the bottom of the box, what did they find there but six hacksaws.

"Well," said Trumbo, "I had a problem. What the hell were we going to do with these hacksaws? They were hot, obviously. It was my job to report them to the prison boss, who would report back to Leavenworth. There would be an investigation and somebody would catch holy hell. All the people who had been in charge of packing that box would be in some question, and somebody was going to get hurt. Now, we had no use for hacksaws because it was too easy to escape from our jail. All you had to do was get on the farm crew and run, if you wanted to, but you'd always get caught. So here we are, about six of us looking down at these hacksaws at the bottom of the box, and I finally said, 'Look, we won't say a word about these to anyone. They're not listed here on the invoice, naturally. Let's select a bin that we all know and tape the hacksaws to the bottom of it.' Well, that's what we did. In the event we needed them, we all knew where they were. Nobody else ever knew, and that was the way we solved that problem."

His boss there in the shipping room was a man named Brogan, who was the prison storekeeper. Brogan took a personal interest in him. The two worked together most of the time and filled long stretches with talk. "Brogan was a very nice man," Trumbo remembered. "He was, I should say, about sixty. He began as a storekeeper in the military and finally worked his way into the prison system."

What did they find to talk about? "Well, *never* about politics. He would tell me stories about his experiences there and in the

military—the army, I believe it was. And he would ask me about all kinds of things. He asked about Hollywood, and my work, and my children. He let me write—I could do writing on the side, which I did. But he just never asked about or wanted to discuss politics. And of course he would have known what I was in for. Everybody knew about everybody else in prison. The records were fairly accessible through convict clerks and so on. But that was just something that didn't come up between us.

"Brogan had supported his mother all his life, and lived with her, and his mother had died the year before I got there. And he had immediately gotten married. There was a personal feeling between us. He liked me, and I liked him, and he trusted me completely. He wanted to see pictures of my family, and I brought them to him, and he admired them. And he said, 'You know, I would like to meet your wife, and I would like you to meet mine.' There was a procedure, you see, whereby if you were picked up at the prison, you could get out at midnight on the date of your release. Otherwise you had to wait six or eight hours and be dressed out in the morning. Cleo was to come for me. Brogan knew this and wanted to see us off where we would be leaving on the Baltimore and Ohio train for New York. I told him I would like that very much, but I said I didn't think it was wise for him to be so very public about it, so why didn't he park his car in the railroad station parking lot, and we would sit there in the car and talk while we waited for the train to come. He said this was a good idea, so we agreed on it. The time came, and I was released. Cleo was there to meet me. We took a cab to the railroad station, and we looked for Brogan's yellow Dodge—that's what he said he had—and we found it, but there was nobody inside. Of course we walked into the station. It must have been about twelve-forty-five. And there he was with his wife, waiting for us. We met her, and we sat down and talked, and we were there together about a half hour before the train came."

It was a very human way to end that ten-month ordeal—a year's sentence, less two months for good behavior. That time out of his life was done now. He would go back, pick up the broken ends, and try to twist them together.

"ENGAGED IN SELLING"

During his term of ten months at Ashland, Trumbo learned to obey the sound of a whistle. When he or any other prisoner heard it, that meant he was to stop whatever he was doing and "stand for a count"—remain where he was, rigidly motionless at attention, while the guard came through, took his count, and made his inspection. The whistle was sounded at any time of escape, to restore order, or just to satisfy a guard's curiosity. Whenever he heard it, though, Trumbo had been taught to stay rooted where he stood.

"When I got out," he remembers, "the first New York traffic policeman who blew a whistle within earshot, well, I stopped immediately. I was conditioned."

It took him years to unlearn prison. In some unexpected ways he was changed permanently. He had, for instance, always been a night worker before—a legacy of his years at the bakery. Prison changed that. He came out a confirmed daylight worker and remained so. But the time stayed with him in more important ways: "What I have *never* regretted is the experience of it. It's one a hell of a lot of people don't have, a very valuable one. And as you see, I remember it, and I don't remember it as I remember the bakery, with a sense of horror. No, not that at all."

What prison did not do was subdue or intimidate him. After visiting for a few days with friends in New York City, he and Cleo returned to Los Angeles. On the trip back they had a long time to talk things over and to think about what might be done. It was the same old problem, really, and that was money. They could cut their expenses, but there

was only one source of income open to him, and that was the movie black market. Consequently, upon arriving in Los Angeles and before returning to the Lazy-T, he got in touch with the King brothers and declared himself ready to work. And again, Frank, Maury, and Hymie came through. On April 28, 1951, they sent him three original stories which they felt had movie potential, as well as a novel they thought was right. He did quite a lot of work on one of the projects, an original called *The Syndicate,* which he rewrote extensively and so successfully that the King brothers later turned down an offer for one hundred thousand dollars on the script, still intending to do it themselves. Only one of the originals was produced, *Carnival Story,* which the King brothers produced in Germany and released in 1954. Trumbo did the screenplay for the picture, Steve Cochran and Anne Baxter were featured in it, and Kurt Neumann directed. The King brothers, whose genius was getting a lot of movie out of a little money, worked their magic again on this one. It is quite a respectable B picture, not least because of the literate script Trumbo provided.

As for cutting expenses, Dalton and Cleo knew that the Lazy-T represented the biggest and most constant drain on their resources. The ranch was also clearly their most negotiable piece of property. And so they decided to sell it. This wasn't quite the heartrending decision it might have been, for their daughter Nikola was ready in the fall to go to high school, and the nearest was so far away that commuting was out of the question; they did not want to send her to a boarding school because it seemed especially important to them to keep the family together. After making private inquiries and the necessary arrangements, they put the house and surrounding property—the entire Lazy-T—up for sale in July 1951.

As Trumbo was making plans to sell the Lazy-T, he received a pointed letter from Herbert Biberman regarding a subject the two had discussed earlier in Los Angeles. Since his release from prison, Biberman had been working hard to put together an independent motion picture production company in which the key personnel would be blacklistees like himself. Biberman, who was one of the leaders of the Hollywood Ten's defense, had a flair for organization and was eventually able not only to bring together such a group, but also (and far more difficult) to find modest financing for their first production. That turned out to be *Salt of the Earth,* and it was the only film Independent

Productions Company ever made.* Right from the start, Biberman had declared his intention to make socially conscious, politically engaging motion pictures, the kind that could no longer be made in Hollywood.

In his letter, Herbert Biberman appealed to Dalton Trumbo for help. He was soliciting Trumbo's services as a screenwriter for a small payment to be deferred against possible profits. Trumbo, who had initially indicated his willingness, was forced to decline; his reply to Biberman is worth quoting because in it he set forth the principles that would guide him in his dealings during the next nine years—or until the blacklist was broken:

> I sired these kids of mine, and I've got to support them, and even the noblest intention to write a screenplay with social content cannot excuse me for not having present the money to buy their badly needed clothes for the new school term. That is a primary obligation, and, in accepting the assignment for reasons which were perfectly decent, I made it secondary. That was wrong. Since the problem is exclusively mine, I am the only one I know of who can solve it, and the first step to solution is clear.
>
> I am, from today on and for some time in the future, not interested in pamphlets, speeches, or progressive motion pictures. I have got to earn money—a considerable sum of it—very quickly. I cannot and will not hypothecate two or three months, or even a month, for any project that doesn't contain the possibility of an immediate and substantial sum. Once I have earned the money, once I have sold the ranch, once I am in a position where the slightest mishap no longer places me in peril, I shall again function as I should like to. But this is well in the future.

No screenplay with social content, no pamphlets, and no speeches. He was adamant—because no matter where his political sympathies might lie, his obligations to his family lay that much deeper. This was surely the gospel according to George Horace Lorimer, a frontier conception

*Biberman tells the fascinating story of the harassment and hostility experienced in the making of it in *Salt of the Earth: The Story of a Film*. The book also includes Michael Wilson's original screenplay for the picture.

of masculine responsibility. But as we shall see, Trumbo was as good as his word: he provided.

Money came to him at last when he most needed it, for an original that was one of his best and certainly his most charming: *Roman Holiday,* the Paramount picture released in 1953 that shot Audrey Hepburn to stardom and gave the Lincolnesque Gregory Peck his only successful light role. The original deal on this was to have been made for Trumbo by George Willner, just before Willner himself was named in testimony before the Committee and barred from the studios. But Ian McLellan Hunter agreed to front for his friend on this one. Lending his name and dealing through his own agent, Hunter got his established price of forty thousand dollars from Paramount on it for Trumbo. Frank Capra was originally to have been the director of *Roman Holiday,* but he and Paramount had a falling out. Trumbo recalls that in the meantime Hunter had done considerable rewriting on it for the studio: "At Paramount he greatly improved the script, but ran into many subsidiary difficulties, the principal one being that he himself had fallen under the shadow of the blacklist. The end of his employment with Paramount was also the end of his employment in Hollywood."

In the midst of all this scrambling after money came some unexpected good news that unfortunately had little effect on the Trumbos' financial situation. Elsie McKeogh, his literary agent, wrote him from New York of English producer Peter Cotes's desire to stage *The Biggest Thief in Town* in London. The plan was to do the play in a small theater production later that year. If it went over well, the production would be moved, as was the custom, to a big West End theater. And that was just what happened. When the production moved to the Duchess Theatre in the West End on August 14, 1951, Trumbo received an advance in anticipation of a long run there. The play had gone over well and would have had that long run had it not been for the sad death of J. Edward Bromberg in the leading role in January 1952. Trumbo had recommended the American character actor, who was himself blacklisted, and Bromberg had had a great success in London—always gratifying for an American actor. But then he died, and with him died the production.

By that time, Trumbo, Cleo, and the children were down in Mexico. Quite a colony had been established there. John Bright, Trumbo's friend from the old days at Warners, remembered this gathering of fugitives:

"I was the first person to land in Mexico City. At the time I got there only Gordon Kahn was around, and he was in Cuernavaca. I registered in the Imperial Hotel down there, and one by one, they all came, and everybody on the blacklist, I swear, passed through the Imperial Hotel. Why, at one time, fourteen of the sixteen apartments in the place were occupied by blacklistees. I remember the English-language paper down there, the *Mexico City News,* got wind that we were there and ran a story on us, who we were, and so on. So when the news broke, the clerk at the Imperial found out all his tenants, who he thought were Hollywood big shots, were just lepers in disguise. He was one disappointed hotel clerk, let me tell you. Let's see, John Wexley was there, Maltz—until he moved to Cuernavaca—Ring Lardner, Trumbo—until he moved to something grand—Ian Hunter, later, and, well, just all of them. You can imagine the bull sessions we had down there as they arrived one by one."

As it happened, the Trumbos didn't arrive alone, however, but in caravan with the Butlers. Hugo Butler and his family had been down in Ensenada in Baja California for most of 1951. He was there, literally hiding out from a subpoena by the House Committee on Un-American Activities. Shortly after his release from prison, Trumbo had taken the family down for a visit and had heard Hugo talk in glowing terms of the prospects for blacklisted writers in Mexico; there was work for them all in the Mexican film industry, Hugo told him. He himself had done a job for a Mexican producer who had assured him there would be more. The Butlers proposed that the Trumbos move with them down to Mexico City, where expenses would be only a fraction of what they were in California. It was an attractive proposal. Not long afterward, it looked as though they had a buyer for the Lazy-T: a rancher who owned property next to theirs wanted to annex the Trumbo spread and make his home in their luxurious ranch house. When the deal was apparently clinched, they decided to move south and began making preparations. And when as suddenly it fell through—the prospective buyer was unable to raise sufficient cash to swing the purchase—they decided to go anyway. The Lazy-T could and would be sold without them present to show the property. Any doubts they had were resolved when word came from the attorneys handling the civil suit of the Hollywood Ten against the studios that had terminated their contracts—this included

Trumbo's action against Metro-Goldwyn-Mayer. They said settlement was in sight, the studios were negotiating seriously, and there would soon be money coming to all. That settled it. The Trumbos sent word to the Butlers that they were ready to go. They left for Mexico in November 1951.

The Hollywood apartment just off Franklin where Jean Butler lives with her two youngest children is a bit crowded with furniture when I visit her there. There are some well-worn, handsome pieces that look as though they may have traveled with the Butler family from California to Mexico, where they sat out the blacklist, to Italy, where the family lived in the sixties, and then back with them to California. One whole wall of the rather small apartment is filled with books from floor to ceiling. I admire the handsome Oxford University Press set of Dickens, all with the original illustrations, and Jean Butler tells me they were bought in Mexico and went with them everywhere—"practically in our suitcases." There seem to be mementoes and reminders of their former life everywhere. Not just the furniture and books but articles and keepsakes as well. And photographs: in many, or most of them, her late husband smiles out almost shyly next to Trumbo, Ring Lardner, Jr., or Ian McLellan Hunter. And photos of the children in all manner of exotic settings. It's a family with some mileage on it.

"I guess you know we had already refugeed out of Los Angeles to Ensenada about the time Trumbo got out of jail," she begins. "There was a subpoena out for Hugo so that made it fairly urgent we stay out of sight. And so there we sat, two hours below Tijuana, just trying to wait the Committee out. Well, we didn't have too many illusions about *that*—they were running things, and we knew it, so we just wanted to stay out of their way.

"Anyway, eventually we decided to go down to Mexico City and managed to convince the Trumbos this was the thing to do. But we stayed down in Ensenada, making plans to go, until November 1 that year. We set out together—or actually, we had some kind of rendezvous point worked out with the Trumbos, and that was San Diego, as I remember. Then we traveled in three cars and had seven kids between us—our four and their three—and the adults of course, and lots and

lots of luggage. All this we had distributed between three cars—our ten-year-old Cadillac limousine, the Trumbos' new Packard, and their jeep pulling a trailer, which had most of the luggage."

"Were you worried coming back into the United States with the subpoena out for Hugo?" I ask.

"Certainly! When we crossed the border into California to meet the Trumbos we were filled with fear and trembling, expecting to have the paper served on us right there on the spot or something. We were all kind of paranoid about it by that time, you see."

They proceeded by stages across Arizona and New Mexico, traveling in caravan, and then crossed the border at Juárez into Mexico. Besides the children, the Trumbos and Butlers had an English sheepdog and a Siamese cat between them, and the pets managed to complicate their journey considerably. Still, they continued to see something of the country, pretending—if only for the children—that it was really an awful lot of fun. And part of the time it was.

"But every stop we made one of the kids came down with strep throat. The first was in Gila Bend, Arizona—Nikola—next was Christopher, who came down with it in Lordsburg, New Mexico, and then Michael, our son, got it in El Paso. Each time we lost a few days. The last one was finally in Guadalajara. The mothers and the kids stayed there. It just didn't seem practical to push on because all the young ones got sick there. So we just waited in a hotel while Trumbo and Hugo went on ahead by plane to Mexico City to rent houses for us. Which they did. Ours was big, but Trumbo's was a small marble mansion, hideously inconvenient, with a yard and a patio in it the size of a small park. And a full staff of servants, of course."

Their status in the country was a matter of some concern to them. They had come to stay, not knowing how hot the political climate in America would become: the Korean War was in its second year, and Senator Joseph McCarthy was just then getting up a full head of steam, so it didn't look good. Ironically, Trumbo had earlier explored the possibility of transferring the necessary cash to Mexican banks and entering the country officially in the "capitalist" category (he was willing to go to any lengths, apparently). This would evidently have made it easier to secure "immigrant" status in Mexico, should that have proven necessary. In the end, both Trumbo and Hugo Butler settled for "tourist" status, even though it indicated only temporary residence in the

country. This could be extended more or less indefinitely, however, by making trips up to the border every six months and re-declaring themselves as tourists. They were able to do this without bringing up their families because George Pepper had found a man at the border who would give out renewals of the tourist status for the usual *mordito* (the customary bribe they called the "little bite").

George Pepper was a Los Angeles businessman who had been executive secretary of the Hollywood Council of Arts, Sciences and Professions and was named as a Communist Party member in testimony before the House Committee on Un-American Activities. Pepper came down to Mexico City and in no time at all was a real presence on the scene, an entrepreneur for all the Un-Americans. For example, Hugo Butler had spent the long days of unemployment in Ensenada at work on a screenplay adaptation of *Robinson Crusoe*. He had brought it with him down to Mexico City, of course. George Pepper took a look at it, and told him that he had friends he thought might want to invest in such a production. It wasn't just talk. Pepper found the money, and eventually the Butler screenplay was realized in a production by the great Spanish director Luis Buñuel, which featured the Irish actor Dan O'Herlihy in the title role.

If Trumbo was willing to enter Mexico as a "capitalist," then he was more than willing to play whatever games were necessary in order to maintain his status there. That was one of the reasons he rented that huge house and hired all those servants. It was important, he supposed, to keep up a good front—and if that was what it took, then the "marble mansion" should certainly do the job. He had to have a "coyote," too. That was the Mexican colloquialism (and how apt it was!) for an ambulance chaser, a lawyer who could fix anything for you. Trumbo, characteristically, had hired the best, the most high-powered operator available. He advised Trumbo to have a party in that big *palacio* of a house and to invite all the *politicos*.

"I remember that party very well," says Jean Butler, "and it was *wild*! Trumbo hired a mariachi band, and there was lots of music and dancing. The Mexican women were so peppy that they were dancing at two or three A.M. As it turned out, all the American men present brought their wives and the Mexican men brought their mistresses. That was why the party was so lively. The lights failed once, and the toilet blocked once. It was one of *those* parties. Jeepers, I found myself

dancing with a fellow named Iturbide, or something like that, who said he was a descendant of the first emperor of Mexico. He was irritated that I didn't know who he was. Well, of course I explained that we had just arrived and none of us spoke Spanish. Which was, unfortunately, true enough."

Their politicking in Mexico was limited to just such practical ventures as that party. They were guests; it was important for them to stay on good terms with their hosts. As for what was happening north of the border, all Trumbo and the rest could do was shake their heads in dismay and reassure one another they were lucky to be where they were. "Trumbo enjoyed himself down there," says Jean Butler, "but only as long as it seemed an adventure to him. Politically neutralized the way he was, and without the immediate pressure of work, he became almost uncomfortable. He's the sort who has to have an adversary, or be behind the eight-ball in some way. He just has to have those windmills to tilt."

But there were no windmills to tilt in Mexico City—nor, contrary to their expectations, was there very much movie work to be had there. Trumbo was given long stretches of time with nothing to do. Others worked on novels: Albert Maltz wrote *A Long Day in a Short Life* in Mexico; and Ring Lardner, Jr., began his satirical novel, *The Ecstasy of Owen Muir,* down there. Trumbo left prison with a 150-page start on his war novel, yet he did nothing more on that one in Mexico. Why? Were money worries so troublesome that he could think of nothing else? A few months after he arrived in Mexico City, the settlement on his M-G-M contract came through, and though it was not nearly as much as he had expected, it might have held him long enough to finish his own novel if he had budgeted it a little more carefully—or budgeted it at all. No, Trumbo was as profligate with his cash as he was with his time; he squandered a good deal of both down there. For some writers, once it is endured and bested, pressure becomes addictive, a kind of necessary elixir that must be drunk if one is to have the power to produce. Trumbo, I think, was one of these. He was evidently as unable to work without the constant, nagging demands of time and money on him as are many newspapermen who can write only to deadline. Whatever the explanation, he wrote no further on the novel in Mexico City. He looked only for some chance to do movie work. And the longer he looked, the more certain it seemed to him that his only real hope was to

do an original of some sort. But what sort of story was there in Mexico for him to tell?

Jean Butler remembers: "Hugo was very interested in bullfighting and got Trumbo interested in it, too, more or less by stages. There was a great but modest little restaurant near the bullring that he would take Trumbo to during the day sometimes, then persuade him to come over and watch them working out in the ring during the week. That was how he got Trumbo into it. Hugo told him that he couldn't defend it on moral grounds but that he still thought it was something beautiful. And Trumbo had to admit there was something to that all right, although when they started actually going to fights on Sunday afternoons, he and Cleo were very pro-bull. The first time they went, I think, they saw a bad kill and that almost sent them away for good; but Hugo—and I guess I was along, too—got them to come back a couple more times, and then it was fairly soon they got to see the *indulto*, which is pretty rare. We had read about it but hadn't seen one ourselves. And that, of course, made quite an impression on Trumbo."

Those visits to the bullfights, and in particular the one at which he witnessed an *indulto,* were what gave Trumbo the idea for an original screenplay, on which he soon began taking notes. The *indulto* (literally, a "pardon") is a verdict of clemency pronounced by the crowd at the bullfight upon a bull that has fought with a particular show of bravery. The members of the crowd signal to the matador that the bull's life is to be spared by taking out their handkerchiefs and waving them vigorously. It is quite a sight, and Trumbo knew when he saw it and found out what was going on that it would make a marvelous climactic scene for a motion picture. He began researching the project with the sort of thoroughness he usually showed, reading whatever books he could find in English on the subject, and asking questions and more questions of those who knew something about bullfighting and the raising of fighting bulls.

Before long he was ready to talk about the project. He went—where else could he go with it?—to the King brothers, flying from Mexico City to Los Angeles on May 10, 1952. He was there for a week, attending to various matters that had to do mostly with payments due the Internal Revenue Service and the hoped-for sale of the Lazy-T. While he was there, he visited the King brothers' offices, sat down with Maury and Frank, and outlined the story he had in mind of the bull that

comports himself so well in the ring that he is granted a reprieve from the usual death sentence in the form of an *indulto.* The bull is almost a pet of a young Mexican boy on the ranch where the animal was raised—hence the title under which it was offered to the King brothers, "The Boy and the Bull."

Maury, Frank, and Hymie knew a good thing when they heard it. Frank King, then head of the company, said, "Sure, he wrote the story while he was living in Mexico City. He came up and outlined it to us, and the story he told us had his forte of heart to it, so we told him to go ahead. He was calling it 'The Boy and the Bull' then. What he did was to give his particular and very special feelings to the script. We gave him some money to go ahead with it and kept telling him we needed this one pretty fast because it looked like a sure thing." It was a sure thing, of course. When it was produced as *The Brave One,* the film did very well financially for the King brothers. And it eventually won Trumbo an Academy Award.

The period in Mexico City was the last in which Trumbo, Ring Lardner, Jr., Ian McLellan Hunter, and Hugo Butler lived and worked close to one another. They never planned it that way, but after Mexico they all simply drifted in different directions, Lardner and Hunter moving up to New York to work there on the television black market, Trumbo returning to Hollywood, and Hugo Butler hanging on a bit longer than the rest in Mexico and then heading for Europe. All four left for fundamentally the same reason: there simply wasn't work for them there in Mexico City, nor was there likelihood of getting much from the States as long as they stayed there. And living in Mexico—at least at the level they wished—proved far more costly than they had expected.

"When we all went down there," Ian McLellan Hunter remembered, "we discovered that rents were not *that* cheap. We rented a little house in San Angel for a hundred and twenty-five dollars a month. Hugo got a bigger house because he had more kids. I guess we all had live-in maids—well, because all the houses had provisions for them, a room and whatnot. You just had to pay her a hundred pesos and give her every other Sunday off, though with our turn of mind we all offered a little more money. And then, before you knew it, you had added a cook

and a laundress, and a gardener because from the Mexican point of view you represented some kind of rich character."

"That's right," his wife, Alice Hunter, agreed. "You doubled the salaries and it was still embarrassing because it was so little, and pretty soon you were supporting the whole native population. You had attracted a crowd of beggars outside of your house just like it was one of the rich places. Which, believe me, ours wasn't. But that's how we got into that situation—at least partly out of concern for the people there. Trumbo attracted the biggest crowd of all of us—not surprising because his was the biggest house."

"Yes, that's an important thing in understanding Trumbo," said Ian Hunter. "He always did things on a bigger scale than anybody else. In an odd way, he always seemed to be in competition with everybody on practically everything."

Alice Hunter: "For instance, the way he competed with George Pepper on this whole thing of pre-Columbian art. Now, George was a collector in every sense of the term, and he had taken an interest in pre-Columbian art, mainly through his wife, Jeanette, who convinced him there really was something in those little clay figures. The workmen were pulling them out, one after another, from a brick quarry. They would turn up the stuff and sell it for a few cents to George or Jeanette Pepper right on the spot. For a while Trumbo was disdainful of this. He came, he looked, and at first he simply wasn't interested. Then finally, he got hooked on it through Cleo's friendship for Jeanette Pepper. Anything that interested Cleo was of vital interest to Trumbo—and she got interested in George and Jeanette's collection of the stuff. And when Trumbo got interested, then everything—the whole market, if you want to call it that—changed immediately.

"You see, the men who dug in this brick quarry lived right out there by the site. You went out there and looked around, and it was pretty bad, just hovels around you and kids running around naked with starvation bellies on them. The man who ran everything there was the one they called the Butcher. Why, I don't know. Well, when Trumbo got interested in buying pre-Columbian figures, he and the Butcher soon developed their own relationship. They would sit down and deal in this stuff, and it would be pretty heavy. Soon the prices went up, and the Butcher's standard of living was noticeably better. He made

improvements on his house, painted it—all thanks to Trumbo. I swear, when Trumbo left Mexico the whole economy must have collapsed."

"Anyway," Ian Hunter summed up, "that was Trumbo, the collector. He began in the clay pits with the rest of us who were buying these pieces just because we liked them as funny knickknacks. But pretty soon he was making deals with other collectors, making arrangements and deals with the Mexican government for taking the stuff out of the country and everything. He was out of our league and dealing on a different level entirely. Now, of course, he has a very good and valuable collection to show for it. That's how he goes at things."

For the rest of the Trumbos, life went on somehow—though Mexico City was, in a way, as hard for Cleo and the children as it was for Dalton. They had lived up at the Lazy-T ever since his name had first appeared in headlines. There the children had experienced no change in attitude from the neighbors or from other children in school; things were as they had always been for them. "In Mexico City it was different," Cleo remembered. "We were more ostracized there because we were not part of the regular community."

The children went to the American School in Mexico City. "Basically," said Christopher Trumbo, "it was a place for sons and daughters of the resident imperialists, some of whom had been there through the second and third generation—these and a few Mexicans whose parents wanted them to be like us. It was a curious mix." Once the *Mexico City News* ran its story on the blacklist colony there, suddenly it was all over the school who the Trumbo children were. "We had a pretty distinctive last name, so we weren't able to hide behind something like Smith or Jones. We were the only Trumbos in the school. The effect was pretty immediate. We didn't make many friends there.

"In a way, we were a lot better prepared than some of the other kids of parents who were blacklisted. In 1947, my parents took us aside and very clearly explained what the whole situation was, whether they were or were not Communists, why they said and did the things they did. Some kids' parents didn't level with the children along that line, and it had a bad effect on them. It made it seem like it was coming out of the blue, like there was no sense to it at all. And that's a bad feeling to have."

Christopher Trumbo learned to play baseball down there in Mexico City, taught by his mother in the big yard of the house on Llomas de Chapultepec. "I believe in exercise and Trumbo doesn't. Chris wanted

to learn, and I was the logical one to do the teaching." Even with the big house, the servants and all, the children still missed home, and for Cleo, Mexico City was just "not all that great for living. After a while we all wanted to come back."

Trumbo, of course, was well aware of this. But his chief problem was, and continued to be, finding work and getting money. They had gone rather quickly through the settlement on the M-G-M contract. The sale of the Lazy-T had fallen through once, and a new buyer had not yet been found. The Internal Revenue Service was demanding quarterly payments on his back income taxes—payments Trumbo was finding it harder and harder to meet. The longer they stayed in Mexico, the deeper they were stuck in their dilemma. It seemed certain that he would have to resettle himself and his family in the Los Angeles area if he was to find regular work in the movie black market. Yet as they stayed on, it came to seem less and less possible to put together the kind of sum it would take to get them moved up to Los Angeles and into a house there. In December 1952, they moved to less grand and less expensive quarters in Mexico City. In January 1953, the Trumbos were in such straits that when the Mexican import duties were due on the Packard automobile in which the family had driven to Mexico, they simply didn't have the money to pay them, and so Trumbo drove the car up to Brownsville, Texas, and put it in storage there.

He crossed the border January 10, 1953, and flew on from there to Los Angeles. His mission was twofold: first of all, he hoped to clear up matters with the King brothers on "The Boy and the Bull." He badly needed the money that was owed to him on the script. They, however, were in bad financial shape at the time and prevailed upon him to take a loan to alleviate his immediate financial problems. This he agreed to do, and they arranged it for him with a business associate of theirs, thus making it possible to have an IRS lien lifted on the deed of the Lazy-T.

He also went to Los Angeles to see his friend and "collaborator," Ray Murphy. This meeting of theirs in Los Angeles was an important chapter in a long and bizarre story that had begun years before, during Trumbo's tour of the Pacific theater of operations during the summer of 1945. He met Murphy there then, one of the group of correspondents on the war junket. His first impression of him, written in a letter to Cleo, was not at all favorable: "Murphy is an impossible young ass who thinks Huxley and Beerbohm the greatest writers of this century.

He is completely tactless and behaves exactly like a young Noel Coward, minus only the wit and brains which Coward must certainly have had at such an age." But if Trumbo thought ill of him, the others in the group thought far worse. The writers, most of whom fancied themselves tough-guy writers, loathed Murphy's prep school accent, his manners and assurance, because of the wealth and social position they implied. He was young—only twenty-two—and a bit pompous, and he had clearly been included in the group through political connections of some sort, because he was the only one of them all who was not an established writer; for these reasons, he became a figure of derision and the butt of every sarcastic remark and cruel joke that passed among them.

That was enough for Trumbo. He took Ray Murphy under his wing. The two saw action and were under fire together on Balikpapan, and they grew fairly close after that. Close enough, at any rate, that when the tour of the Pacific had ended, young Murphy broke off from the group which was returning to New York and went with Trumbo to spend two weeks with him and his family in Beverly Hills. He mystified Nikola and Christopher Trumbo (Cleo was pregnant with Mitzi at the time). They had never seen—or heard—anything quite like him. Trumbo remembered: "He spoke—whatever the accent is—so eloquently that my kids couldn't understand him at all. It was just hopeless. They would just stare at him." The two were friends, as close as the years, miles, and social differences between them permitted. Murphy returned to the East, to Yale, from which he had graduated. He became curator of rare books at the Yale Library, and wrote and published a biography of Lord Mountbatten, *The Last Viceroy,* though he never tried his hand at fiction, as he had told Trumbo he would. They kept in contact by letter during the next few years, and Murphy expressed outrage and shock at Trumbo's treatment by the House Committee on Un-American Activities and at his subsequent imprisonment for contempt. They differed politically, but Murphy—young, fair-minded, even idealistic—was totally opposed to the blacklist and found it impossible to reconcile the treatment Trumbo had received from the Committee with his notion of a democratic society.

The two did not actually meet again until the summer of 1951, when Murphy visited Los Angeles. Trumbo had him up to the Lazy-T. And Murphy, giving way to curiosity, asked how he managed to survive

financially. Trumbo told him about his work on the black market and
that, for the most part, he had managed to survive because other writ-
ers had been brave enough to lend him their names—but that they had
also been rewarded for this. Murphy declared that Trumbo could use
his name anytime and that he need not pay him a cent for the privilege.
Trumbo, who was not likely to turn a deaf ear to an offer of this kind,
told him to go home and reconsider and that if Murphy really meant it,
they might indeed get together on a project. Trumbo, however, insisted
that he must pay for the use of the young man's name; there was, after
all, some risk to him.

Ray Murphy wrote to Trumbo after he had returned to the East,
assuring him that he was quite serious about the offer he had made and
asking when they might get together on something. By this time per-
haps Murphy had come to look upon such a "collaboration" as a possible
entry into film writing for himself. Trumbo delayed. The move to Mex-
ico intervened. Finally, after he had finished "The Boy and the Bull,"
he came up with an idea that he thought might be done as an original
screen story and submitted to the studios under Murphy's name. He
finished it and mailed it to him on October 4, 1952—ninety-five pages
of typescript, bearing the title, "The Fair Young Maiden." The William
Morris Agency agreed to handle it. This and other details were com-
municated to him through an elaborate medical code in which Trumbo
was to be addressed as "Dr. John Abbott."* By January, a few changes
had been made in the story, but the Morris agent was asking for more.
Ray Murphy had traveled to Los Angeles. Trumbo went there to find
out, through Murphy, what the difficulty was.

They met on a couple of occasions during that January 1953 trip of
Trumbo's to Hollywood, discussing this story and others in the plan-
ning stage and the problem of the agent. The latter problem was cleared
up when Jules Goldstone, the Hollywood representative of Murphy's
New York literary agent (and also, incidentally, George Willner's old
partner), agreed to take on the original screen story, which in its revised
form bore the title "The Love Maniac." Trumbo left it at that and
returned to Mexico City on January 27, 1953, Murphy remaining on in

*A name Trumbo was fond of. He used it for the protagonist of *Eclipse* and again in *A Man
to Remember*.

Hollywood to be accessible as the author of the story, should it be sold immediately.

And then...nothing. Trumbo waited for a month and a half without word from young Murphy. But then in the middle of March, a friend brought by a stack of the Hollywood trades from the past few weeks, and browsing through them, Trumbo came across an item headlined "20th Buys 'Love Maniac.'" Evidently it was true, and the paper—it was the *Hollywood Reporter*—was almost three weeks old. Trumbo wrote Ray Murphy, got no reply, and saw an item a few days later in Louella Parsons's column, which was carried irregularly in the *Mexico City News:* "I am sorry if my item about 'The Love Maniac' gave the impression that Ray Murphy, a fine young man, is still alive. He did write the story, but he died about a month ago." Trumbo was shocked. Had he missed the earlier item, or had that column simply been dropped by the *News*? He ran to a library to search through the *New York Times* obituaries, reasoning accurately that the curator of rare books at Yale would rate a notice there. It was there, all right—a report that Ray Murphy had died on January 29, 1953. With the sparse information he gathered from the short item, he wired Elsie McKeogh up in New York, where Murphy's mother lived, and said it was urgent he be put in touch with her. Wires flew back and forth during the next few days. Finally Trumbo heard from Ray Murphy's brother, Dr. James Murphy, who, writing on his own initiative and addressing him as Dr. John Abbott, informed him that Ray had died "following an attack of the flu." Dr. Murphy was executor of young Murphy's will, which left his entire estate to the Yale Library. However, he understood that the screenplay had been a collaboration of some sort and was willing and anxious to make the right sort of settlement.

Trumbo wrote him back a very long letter, revealing himself as Dr. John Abbott and explaining the one-sided nature of his collaboration with Ray Murphy. He enclosed documentation to prove his claim and appealed to Dr. Murphy for an immediate payment of three thousand dollars in advance of settlement so that he might make that quarterly payment on his income tax; once again, the Internal Revenue Service had put a lien against his deed on the Lazy-T. Toward the end of the twenty-five-page letter, Trumbo had this to say about his own situation and the help Ray Murphy had extended him:

In writing this letter to you, I do not feel that I have in any way dishonored Ray's memory. On the contrary, I have revealed to you that his last professional act was a profoundly generous and noble one. To help a friend and fellow-writer who had been rendered mute by circumstances, he placed his name, his reputation and his career in jeopardy. If the facts of my authorship of the story had ever been disclosed he would have been blacklisted throughout the motion picture industry. Ever since my unhappy profession first was practiced, writers have been at loggerheads with constituted authority, any efforts to suppress them or stave them off are as old as the history of government itself. There are many examples in past literature of one writer lending his name in order that another, temporarily out of favor, might continue to write. This is what Ray did. He did not consider it dishonorable, nor did I: it was, on the contrary, an act involving the essence of honor, and the moral courage it required in these troubled times is very considerable.

Dr. Murphy offered not the slightest resistance to Trumbo's claim; in fact, he rushed him the three thousand dollars needed to pay off the tax lien. It arrived just in the nick of time: the Lazy-T was saved once more.

And a good thing, too, for not long after that the ranch was finally sold. Had it gone in auction for taxes, the Trumbos would not even have had the money they needed to make their return to Los Angeles. And by the fall of 1953, they were making plans to do just that.

Before they left, however, they received money that was unexpected—though not unhoped-for, of course. It came from *McCall's* magazine. Trumbo had written a short story based on something that had happened to friends there in Mexico City. Their three-year-old daughter had misbehaved, and so the father had given the child a smart whack at the usual place. But the child put her hand behind her to protect herself, and somehow he had caught her little finger with his hand and had broken it. As Trumbo told it: "He and his wife felt like animals, and they rushed her off to the doctor to get that poor little finger taken care of, which was crooked. And of course the child was well aware of her power. They got to the doctor, and the doctor asked how it happened. And the parents didn't say anything, and the child said she fell on it."

Published as "The Child Beater," it was a charming story that captured perfectly the father's feelings of embarrassment and shame before the doctor, his wife, and his child. Trumbo had written it and submitted it under the name Cleo Fincher. Betty Parsons Ragsdale, fiction editor of *McCall's,* had picked it out of the slush pile—what are the odds against *that?*—and written her acceptance to Cleo along with a check for $850, asking for a little information about the author. Trumbo wrote back as Cleo Fincher, telling her when Cleo was born, the number of children she had, and so on. He added: "My husband is engaged in selling," and later commented, "A truer line was never written."

BREAKING THE BLACKLIST

Others managed to stick out the blacklist in Mexico and a few even thrived there. Why not Trumbo? Because, as he explained in a letter to Michael Wilson, "We are living out an old truism: 'The first time you see Mexico you are struck by the horrible poverty; within a year you discover it's infectious.' I am broke as a bankrupt's bastard." He had caught the disease of poverty down there, and to hear him tell it, he was wasting away fast. He had to get himself and his family out before it proved financially fatal. And it looked as though Hollywood, which for the sake of economy they had forsaken a little more than two years before, was the only place that a cure might be effected.

But understand, they were *relatively* poor. The mere taste of poverty he had had in Mexico City was nothing like the stomach full of it he got as a young man working at the bakery and living on 55th Street in Los Angeles. Trumbo and his family were certainly not surviving in the style to which they had been earlier accustomed. He could—and did in that letter to Wilson—recite a long list of items of value they had been forced to dispose of in the pawnshop with the grand name, run by the Mexican government, *Monte de Piedad* (Mount of Pity). Nevertheless, when the time came at last, in January 1954, for the family to depart, they left in reasonably good style. Cleo flew ahead with their youngest, Mitzi, who was judged not up to the journey, and Trumbo took the other two in the Jeep wagon which they had kept in storage. His biggest problem on the trip back was getting the valuable collection of

pre-Columbian art he had acquired while in Mexico through Mexican customs at Matamoros (he never did; in the end he went through the motions of returning the ceramics to Mexico City, where Hugo Butler got them to him in Los Angeles by trans-shipping through a friend in Ensenada). Upon their arrival, the Trumbos borrowed enough to get their furniture out of storage and got a second car, a Nash Rambler. They installed themselves in an ancient old Spanish fortress of a house—literally that: it had been used in the days of old California as an outpost against the coast Indians—which they rented for two hundred dollars a month. There Trumbo set up shop; he had resolved to write his way back to financial health.

His immediate problem was finding an agent; George Willner, who had represented him in the early years of the blacklist, was now blacklisted himself. Trumbo wrote letters to a number of independent Hollywood agents explaining his situation and asking if they would care to discuss the matter further. Some of them did, and in the next few years (until he settled on an unusual arrangement with Eugene Frenke) he used more than one at a time—among them, Arthur Landau, his first Hollywood agent. It seemed ethical enough, and occasionally an outright necessity, to be represented by more than one agent, for using all the pseudonyms that he did and working with a number of different writers who would "front" for him, Trumbo was himself some several different writers all at the same time.

As he later explained his situation and strategy in a letter to Hugo Butler, "I started from scratch, without any contacts, and operated on the theory that every satisfied customer was a future customer for steady work at rising rates.... The black market is like the old one on a much smaller scale: that is, you enter it virgin and new and unknown (I haven't had a screen credit for ten years—styles change—writers fade). Therefore I decided I had to prove myself as a newcomer."

He started somewhere near the bottom. He had worked for the King brothers, and now he would work for their competitors. With the control of the major studios over the movie industry rapidly weakening under the pressure of television, there was increasing activity in independent production. Quite naturally, in the beginning, most of it was of the low-budget, B-picture sort. It was here that Trumbo concentrated most of his efforts during the next few years, working for producers such as Walter Seltzer. The first bona fide job given him following his

return from Mexico came from Seltzer, who approached Trumbo with a sheaf of clippings and other research material on a gangland murder in Kansas City and asked him if he thought he could do an original screenplay from it. It was worth $7,500, not a bad price in that market. And Trumbo gave him his money's worth and more. The movie made from his script (screenwriter Ben Perry allowed his name to be put on it) was a tough, fast-moving little genre picture, called *The Boss,* released in 1956. It featured John Payne and was directed by Byron Haskin, a B-picture veteran.

As Trumbo intended, Walter Seltzer returned, a satisfied customer. Trumbo did another script for him, *Bullwhip,* which was never produced. And a few years later, 1957, he did an unscheduled rewrite of the screenplay for another Seltzer film, *Terror in a Texas Town.* How Trumbo came to do it tells a good deal about the way he operated on the Hollywood black market and why he came to be so successful at it. He had long made it a practice to guarantee his own work: rewrites were included in the price agreed upon. He would keep making changes— not always happily and not without argument—as long as the producer or director kept asking for them. He also made it a practice to do all he could to see that work he couldn't take on himself was passed on to other blacklisted writers. That was how he happened to get involved in *Terror in a Texas Town.* He had been offered the job by Seltzer but because he was too busy with other projects to take it on, he had recommended John Howard Lawson, one of the original Hollywood Ten, and Mitch Lindemann, also blacklisted, for the job. Trumbo went as far as to offer his personal guarantee that their work would be satisfactory. Well, ten days before *Terror* was to begin shooting, Seltzer was notified by the film's backers that they were unhappy with the script; if they were, of course, then he was, too. And so he went to Trumbo with their objections, and Trumbo, having offered his guarantee, sat down and rewrote the script in four days. Walter Seltzer came up with one thousand dollars for the job.

Most of the jobs that producers came to him with were rewrites of one kind or another. This was hard work, usually done under pressure, which offered Trumbo the dubious pleasure of knowing he had been sought out as the last resort. But it kept him busy. He remarked of his script-doctoring—again in a letter to Hugo Butler: "Of course I always come in on the tail end, generally following four complete drafts by

writers whose names would surprise you, all drafts desperately bad. It is really an eye-opener, and makes, for anyone who can rescue one of these dreadful wrecks, a continuing market in the future." Trumbo's reputation as a doctor specializing in such "last aid" was one he retained.

When jobs were not immediately forthcoming he managed not to pine away but to get to work on some original screenplay or screen story. This was how he came to write *Furia,* bought by Hal Wallis for Anna Magnani, which was made as *Wild Is the Wind* in 1957. There were others. Trumbo wrote a science fiction original which he sold to Benedict Bogeaus, who produced it in 1958 under the title *From the Earth to the Moon.* Then there was a *sort* of original, one at least that he initiated and completed on his own with no buyer in sight—and that was his adaptation of the Herman Melville novel *Typee* (in public domain, of course). Ben Bogeaus bought that one, too, though he never produced it. Trumbo began early on to acquire an underground reputation in Hollywood, not only for his abilities as a script doctor but also as one who could work with producers and write originals to given specifications.

It was the latter which brought Gladys Sylvio, one of the most formidable of all movie mothers, around to Trumbo one day. If that name doesn't exactly ring a bell, her first husband was named O'Brien, and she was the mother of Margaret. She telephoned and told Trumbo she had been trying to get in touch with him for years. She wanted him to write a movie for Margaret O'Brien. A director named David Butler was interested in doing a film with the former child star, who was now eighteen. She was sure that Trumbo was the man to do the script because he had written her daughter's last successful film, *Our Vines Have Tender Grapes.* It turned out that there was another reason she thought Trumbo was the man for the job: she wanted him to write another *Roman Holiday* for her.

"That might be difficult," he told her.

"It shouldn't be difficult at all. You wrote *Roman Holiday,* didn't you? That's the kind of script she needs."

"Well, these rumors do get around about a lot of pictures. Most of them are untrue, but I make it a point never to deny them. Why don't you go to the guy whose name is on it?" Meaning Ian McLellan Hunter, who fronted for Trumbo on the picture and did some rewriting

on it as well. He was in New York by that time, blacklisted, and writing under cover for TV. Trumbo wasn't sure he wanted this job.

"No, no," said Margaret's mother, "I want *you!*"

In the end, although she waged quite a campaign, she never got him; nor, though she also waged quite a campaign, did Margaret O'Brien ever make that successful comeback her mother had planned for her.

Of course Trumbo continued to work for the King brothers, as well. Exasperating as they often were, and hard as it had been to get from them the money he was owed for "The Boy and the Bull" (*The Brave One*), he nevertheless liked all three of them and knew they were trustworthy enough—just spread a little thin in their enterprise. Following his return from Mexico he did two scripts for them: another gangster movie, *The Syndicate,* which turned out rather well but was never made; and *Mr. Adam,* an adaptation of the Pat Frank novel about the last fertile man left on earth, which at the time was considered too hot to handle. One of the between-job originals that he wrote, *Heaven with a Gun,* was also sold to the Kings with the name of Robert Presnell, Jr., on it. They held on to it for years, and in the meantime Trumbo had broken the blacklist and had once more become an eminent screenwriter and not the *éminence grise* he was when he wrote the thing. In 1966 they announced production plans for *Heaven with a Gun* and, without checking with Trumbo first, announced that it was actually an original screenplay by Robert Presnell, Jr., and Dalton Trumbo. Presnell promptly set the record straight on that count, leaving Trumbo as sole author. But Trumbo was reluctant to have his own name appear on the film, reasoning they had bought it for production under a pseudonym and that was the way it ought to be produced.*

But that was business. Maury, Hymie, and Frank wanted Trumbo to know that he was their friend—he could count on them. And it was true enough: he could. They had even made it possible, through Lionel Sternberger, a stockholder in King Brothers Productions, for Trumbo

*The problem came up another time when an original screenplay Trumbo had written during the blacklist period, *The Cavern,* finally went into production in 1965. The director of the picture, Edgar Ulmer, let it out during shooting that Dalton Trumbo was the author of the script. Acting on the same principle, Trumbo had advised Ulmer that his name was not to be associated with the picture.

to buy a house within six months of his arrival from Mexico with no cash at all in hand. Sternberger was a well-to-do restaurant owner in Highland Park, who was putting his house up for sale. It was a big place, built in 1905, surrounded by six separate lots so that it had the look of an estate. There was a swimming pool. And the house itself had been beautifully remodeled so that it was like new inside and out. It was actually much too grand a place for the neighborhood, which was lower middle class, but Sternberger had lived there for years and loved it, and now he wanted to make sure it got the right sort of owner. For a number of reasons he was convinced Dalton Trumbo was just the man.

"Lon Sternberger was a crazy, charming man," Trumbo remembered. "He was a health nut, though he was very fat. He had gotten in trouble with the law for prescribing to people—foods, diets, even drugs—and they had his phone tapped in the process. He wasn't trying to take anyone, just a fanatic believer in these health foods and so on. But he had gotten into this difficulty with the law, and as a result he hated cops and people who listened in on telephones. When he heard that I had been in trouble with the law, and he met me and took a liking to me, why, he offered me the house for what was *very* little money even then. But we didn't put *any* money down, and Lon even lent me $2,400 to get the rest of the furniture out of storage. We just literally got the house for nothing."

That house on Annan Trail in Highland Park came to mean something special to those who continued to see the Trumbos through the blacklist. There weren't so many of them, and most were blacklisted themselves. A lot of people in the industry, even those who did business with him, were afraid to be seen with Trumbo in town. "They were bad days in Hollywood," said his attorney, Aubrey Finn, "for him and for the whole town." But in a way that seemed to bring the outsiders closer together. They went to Trumbo's as to a manor house, a kind of castle where they were all safe from that crazy society outside that had hounded them out of their jobs.

Trumbo seemed to think of it that way, too—or perhaps, remembering the old Spanish house in La Cañada, as a kind of redoubt. "Look at this location," he told Al Leavitt, "up on the hill with all this territory

around me. I bought this house so they couldn't outflank me. We're in a true command position here."

Al Leavitt, blacklisted in 1951, had known him since 1941, during that brief period when Trumbo worked on *The Remarkable Andrew* at Paramount. Much his junior and much in awe of him, Leavitt told me that he practically learned the craft of screenwriting by taking to heart the advice and criticism handed him by Dalton Trumbo and Michael Wilson. "My wife and I are the only blacklisted writers who never left this community," he said. He became a commercial photographer and moonlighted on the side in the television black market, and he kept in contact with most of the rest going to those parties at Trumbo's.

"They were marvelous parties there. I remember a Sunday afternoon around the pool. There were a great many writers and directors—he was cracking through at this time and had become somewhat more acceptable to those not on the blacklist. And who should be there but Linus Pauling, his wife, and his daughter. I recognized him from his pictures, but of course Trumbo actually *knew* the man. People there were kind of intimidated by Pauling—understandably—and he was sitting alone a great deal of the time. That was how my kid found him. My son, then fourteen, went up and engaged him in conversation. Afterward, as soon as we got him in the car, we said to my son, 'Let's have it—that conversation you had with Linus Pauling—what was it all about?' 'You mean that was Linus Pauling?' my son said. 'I thought he was a high school chemistry teacher, and so that was what we talked about, my high school chemistry.' But that was it, you see, that was the kind of gathering we had there at the time. Trumbo kept us together but helped us remember there was a world outside by bringing people like Linus Pauling around."

Aubrey Finn remembered the house and the Trumbos' situation there much less amiably: "Well, it was a very unusual area to have motion picture people living in it," he said. "Here it was a working-class neighborhood, and he's got the biggest house in the neighborhood and a swimming pool to boot. His children were shunned in school. It was a bad place and a bad time for them. The neighbors used to throw stuff in his pool, garbage, dead things, anything. And there was once—but I suppose you know about this—when Dalton was beaten up there in front of his house."

I did know. Over the years, of course, Dalton Trumbo took his share

and more of abuse in print. Through the mail, he received a trickle of hate letters that had not stopped even in the last few years before I first interviewed him.* But only once was he attacked physically because of his politics, and that took place, as Aubrey Finn said, right in front of Trumbo's home in Highland Park. It happened during the latter part of the blacklist period, after the Robert Rich Affair, when he was being interviewed often on television and radio, and his politics became widely known in the neighborhood.

Trumbo remembered: "We came home late in Highland Park. In front of our house was our own parking lot, paved and with a stone fence around it. It was about twelve-thirty or one o'clock, and there were two boys and a girl standing in front of the house as we drove in and parked. They were singing something about 'get rid of the Commie bastard' or something of the sort. So I went over to them and told them to get the hell out. Well, I was knocked down, jumped on, and I could see the girl's heel smashing my glasses on the pavement. They were kicking me, but finally I caught one of them by the feet, and then there was total panic because they were trying to get me loose of him. And I was hanging on through a portion of the fence where I couldn't be moved, and I had him—though I don't know what I was going to do with him. Finally, of course, they broke away and ran down the hill. We let them go. The last thing we needed was to have the police chase them. I didn't go out for two weeks until the black eyes went away."

So there was no love lost between Trumbo and the community he lived in. But it was characteristic of him that he refused to be intimidated by his neighbors—not when they sent a deputation to him demanding he move out, and even less when they sent their delinquent children on that dark night to enforce their demands. He had made up his mind: by God, the Trumbos were there in Highland Park to stay. If they did move, it would be when he decided they should and not a minute before. (And that, for the record, is the way it was.)

He had a friend, an artist who had come from Chicago by way of Paris, named Charles White. White had not been in Los Angeles long when he happened to mention to Trumbo at one of those Sunday afternoon gatherings on Annan Trail that he and his wife were looking

*His favorite, because it says a lot about the kind of people who write such letters, was one he received while in jail. It was anonymous, signed only with the sender's feces.

for someplace to build a house. Now, this was more of a problem for Charles White than it might have been for another man, for he was a black man married to a white woman, and this was 1957. Finding a lot for sale in a good location mattered less than finding a man who would sell it to him. Trumbo knew this, of course. That was why, when White told him, Trumbo gestured casually toward a corner of the hilltop just below the house and said, "How about over there?"

"You mean there? On your land?"

"It wouldn't be mine," Trumbo explained. "I'd sell it to you, of course. There are six separate lots here besides the one the house is on. I could sell you one of them."

"Are you sure you want to do that?"

"Certainly I'm sure. The reason I wanted all this property in the first place was so I could decide who would live beside me. And I can tell you, Charlie, I'd sooner have you beside me than anyone I've seen in Highland Park."

So that was that, more or less. Of course Trumbo explained what kind of neighborhood it was and warned that Mr. and Mrs. Charles White might find life difficult there,* but then in a few days' time the papers were drawn up (Trumbo sold the lot for precisely what he paid for it and on easy terms) and the transfer was made. Charles White and Dalton Trumbo were neighbors. They came to know one another very well.

When I think of Charles White I find myself continually reminded of photographer–writer–movie director Gordon Parks. Except for the deep mahogany color of their skins and the fact that both men wore mustaches, there was little in the way of physical resemblance between them—or perhaps one other thing: both had a quality of encompassing directness in their eyes which came from having trained themselves, photographer and painter, to see more than other men. But beyond the physical impressions, there was a sense of presence, an emanation of authority, that was, in a way, the most prominent thing about them.

*As it happened, the Whites had no trouble in Highland Park during the years they lived there.

White was a quicker, lighter, less reserved man, but that quality of personal strength was just as surely there in him.

Charles White was a painter. His love of his art and the sense of identity it gave him is apparent in the quality of light and the strong colors of his canvases; his is a very positive style. Through his teaching at the school of the Los Angeles County Museum of Art he managed to make a very comfortable living indirectly from his painting, one that gave him time and opportunity to keep at it directly. He was at the school the day I met him. I found him in his office, and together we walked over to a Mexican restaurant directly behind the Museum building. I could tell from the way he was greeted at the door that he was a regular there. I could also tell by the time we were through the gazpacho that this was a talk I was going to enjoy.

"Well, I've known him for years," he began, "just as soon as I got here, I think. Europe ruined New York for me, so when I came back it seemed natural to head out here—and just as natural to get to know Trumbo. We had many mutual friends, writers, film people, theater people. It was easy to get to know him. And once I did, well, I just took to him. For one thing, his humor—very attractive. Sometimes it is sardonic and biting and at other times light. He has a way of using it as a weapon that can be quite devastating.

"How? Well, let's just say that he knows his own weaknesses and strengths and is very intolerant of stupidity. He doesn't use sarcasm in a malicious way, understand. It's just there as a weapon to be used, so don't cross him."

I cleared my throat and must have frowned a little, for White gave me a little smile of sympathy. "What's the matter?" he asked. "Nobody talk much about that?"

"Well..."

"He is very much king of his household. There is a point he doesn't allow anyone to infringe upon, a line nobody can cross. I remember there was a large gathering of people at his house. Some of the Hollywood Ten were there and some old friends—people like that. There was, I recall, a discussion of some book, and he was challenged on the use of a word. It was done humorously and jovially, of course, but Dalton defended his use of it, and this led to a general discussion of words and how to use them. Which should have ended it gracefully. But the people there persisted, brought him back to a discussion of his use of

that *particular* word, and they began to gang up on him and insist that he was wrong. He became angry and began sticking the needle in them in return. They were putting him down, and he was furious. Finally, he took it as long as he could until he reminded them that they were guests in his house, then he pointed at somebody present—I can't remember who—and he said, 'Okay, I'm appointing you the host. I'm leaving.' He walked out on them, and that was that. Everyone left."

"And you?" I asked. "Have you ever found yourself on the wrong side of him?"

"A couple of times, yes, I guess I stepped out of line—but it was out of affection for him. I really love the man, you see."

There was such directness and earnestness in Charles White's manner just then that I had the feeling I was hearing some of the same things he must have said on an occasion or two to Trumbo. (His was the old attitude of one who enjoys the immunity of friendship: This may hurt, but...)

"If you disagree openly with Dalton, he will respect you more than if you bow to him. If you do that, he loses a little respect for you. I like to argue, and I like to do it vehemently. We've had our little run-ins, but with me, the real difficulty I have in the relationship is that I'm in awe of him. Oh yes. And people I'm in awe of I have difficulty talking to. So much of the time during the last years I've spent observing him—his response to people he comes in contact with and their response to him. And there is one thing that has become clear to me from this."

He paused portentously, his fork in the air, and a frown on his face. (It may well have been then that I first noted the likeness to Gordon Parks. It was there somehow in the way he leaned forward and fixed me with his look. That intensity.)

"What's that?" I asked. "What's become clear?"

"There are only two ways to relate to Dalton. You either love him or you hate him. Picasso is like that. Chaplin is, too. There are people in Hollywood, a lot of them, who hate Dalton."

We lapsed into less charged discussion. It was then he told me the story of how he happened to become Trumbo's next-door neighbor. And he also told me a little about his own background—growing up in Chicago, the years before the war when he was struggling to get an education of some sort in art, and of his own friendship then and there with Richard Wright—"I've always seemed to have more writers

than painters as friends." Finally, he approached rather gingerly a sub-
ject that until then both of us had skirted. It came up just about the
time the waiter came by with our coffee. It had to do somehow with
Trumbo's work on behalf of the Angela Davis defense: "...a party
in that mansion he lives in now," Charles White was saying. "Some
were fearful to commit themselves for her defense...." He trailed off,
then added almost as an afterthought, "His relationship with blacks
has been mostly with intellectual blacks—artists like myself, or with
Carlton Moss, the director. At times I have felt he never had an astute
knowledge of black life. It seemed reasonable to me once to demand
that whites have as much knowledge and intimacy of my people as I
have of theirs. But they never have had the entree to black life that I
have had to white. Anyway, they should have more knowledge than
what I can tell them. If you use me to pick my brains, then your knowl-
edge will be limited. That's simply all there is to it. I don't know what
the answer is, though. Whites cannot automatically establish contact
with poor blacks and ghetto street life. But Trumbo had his humanism.
He relied on that for his knowledge of black life, and maybe that was
enough most of the time. It's just too bad there aren't greater opportu-
nities for real acquaintance, real knowledge."

Trumbo kept hard at work. The jobs he did on the black market—
twelve scripts in his first eighteen months back from Mexico—had
restored some sort of financial equilibrium to his life. But as long as he
was forced to work for independent producers of low-budget B pictures,
he would have to continue working at just such a furious pace or pitch
dangerously down into destitution. As it was, he was sufficiently well
off by the middle of 1956 that he could repay money to those he had
borrowed from in Mexico. Albert Maltz, for one, had loaned him three
thousand dollars, which Trumbo had begun paying back to the tune
of fifty dollars a month until the sum was entirely repaid. At Trumbo's
instigation, Maltz began to do movie work by mail for the King broth-
ers and other independents.

Trumbo was in close communication with blacklistees who had
remained in the Los Angeles area or, like him, had returned. By the
time he moved to Highland Park, he had become a kind of one-man
clearinghouse for information and writing jobs, passing on to others

work he couldn't handle, keeping everyone in contact. One job came to him through this network he had set up. Early in 1956, Adrian Scott, one of the original Hollywood Ten, brought to Trumbo a young lady named Sally Stubblefield who wanted to be a producer. She was working as an editor in the Warner Bros. story department and had been in the business long enough to know that her best shot at producing—perhaps her only one—was to approach her studio as the owner of a filmable script. To get one she had borrowed three thousand dollars from the bank and gone out with Adrian Scott to talk to Trumbo. She herself had an idea for the film: it seemed that a few years ago she had worked at a home for delinquent girls in the Los Angeles area, and she was sure they would find a good story among the many at such a place. Why not go out there and talk to the girls? Sally Stubblefield was right; they went to the home for delinquent girls where she had worked, and after a couple of trips Trumbo had his story. The movie from his script was made by Warner Bros. in 1957 as *The Green-Eyed Blonde*. As they had agreed, Sally took credit for the screenplay and in that way got that associate-producer credit she was really after. It did not, however, lead to the career in production that she had hoped for. "She was someone," said Trumbo, "who, if she had been a man, would have had no difficulty in doing whatever she wanted to do in film production."

Before being blacklisted, Adrian Scott had been a producer himself, and before that a screenwriter. Now, on the black market, he was working as a writer again, but only eking out a living in television. Scott had worked out a permanent partnership with a young woman whose name went on all his scripts. One of the television shows Scott did in this way was developed from incidents during World War II that had to do with a group of Italian nuns who smuggled Jewish children out of Germany and Italy and on to Israel. He was sure there was enough there for a full-length film, and so he went to Trumbo about it. Trumbo thought so, too, and wrote the screenplay on speculation. Robert Presnell, Jr., offered the use of his name, and the script was sold for English production. Both Dalton Trumbo and Adrian Scott made some money from the deal, and that might have been the happy ending to this short story—except that there was a slight twist. The movie made from Dalton Trumbo's screenplay, *Conspiracy of Hearts*, was released in 1960 and did very well with critics and audiences alike. Catholics were especially keen on it; the picture even got an award of merit from the Legion of

Decency. Yet just down the street from *Conspiracy of Hearts* in many cities that year the Catholic War Veterans were picketing *Exodus* and *Spartacus* because Trumbo's name was on them.

The most constant and perplexing problem for any writer on the black market was not so much getting work as it was getting paid for it. Producers would often hold the blacklisted writer at arm's length while they settled with other creditors. A few of the more unscrupulous burned their writers for all or part of the script fee (this didn't happen often, and never to Trumbo); in such cases the writer had no appeal. And sometimes even the mechanics of payment became horrendously complex. Pseudonyms were necessary not just to get a name up on the screen, but also to get checks past prying bank officials. The Motion Picture Alliance for the Preservation of American Ideals, the vigilante group that enforced the blacklist within the movie community, had a network of spies and informers that even went into the major banks in and around Hollywood. If a company drew a check to a name that had appeared on the blacklist, then the word would be passed to the Alliance and pressure would be brought upon the offending company. Independent production companies were not really independent at all, for they relied upon the major studios for the use of facilities, for film distribution, and at that time often for talent as well. Threatened with the loss of any or all of these, the producer would have no choice but to promise to sin no more. As a result of all this, a writer working on the black market would have to maintain at least one bank account under a fictitious name—Trumbo had several: John Abbott, Sam Jackson, C. F. Demaine, and Peter Finch, to mention just a few he used over the years. Now, any lawyer will tell you that it is very tricky to try to do business under a name not your own, for even if channels for payment are worked out, the Internal Revenue Service is sure to assume that your motive for using another name is not just ulterior but illegal. Add to this the special interest taken by the Los Angeles office of the IRS in the tax returns of anyone who had been mentioned in testimony before the House Committee on Un-American Activities, and you will have some idea of the dangers that lurked each year after April 15 for every black marketeer. Because he was determined not to let the IRS do to him what the Committee had done, Trumbo kept meticulous financial records, ready at a moment's notice to go before the examiner. This was

quite uncharacteristic of a man with an attitude toward money such as his; he was simply being realistic.

One way to avoid the bank trap without resorting to a pseudonym was to ask for payment in cash, but in that there were also obvious pitfalls awaiting the unwary and the unlucky. Early in the blacklist period, for instance, even before Trumbo went to jail, George Willner had sold a story for him, the one that eventually was made by Preston Sturges as *The Beautiful Blonde from Bashful Bend.* Earl Felton had let Trumbo use his name on the story and had offered to deliver the money up to him at the Lazy-T. Trumbo had asked for the money—all twenty-six thousand dollars of it—in cash, and Willner got it for him, put it in an envelope, and handed it over to his son, asking him to deliver it to Earl Felton without telling him what was inside. Willner's son drove over to Earl Felton's house late on a Friday afternoon with instructions to hand it over to him. But unknown to them all, Felton had left for the weekend. Not finding him at home, and thinking no more about it, the young man simply left it there in the space between the front door and the screen door. There it stayed until eleven o'clock Monday morning, when Earl Felton returned, opened up the envelope, and found the twenty-six thousand dollars that had been lying out in the open all the time he was gone.

On another similar occasion, Christopher Trumbo, then in high school, was sent to Ben Bogeaus to pick up payment from him. In this case, Bogeaus opened up the envelope and showed the ten thousand dollars in big bills inside to Chris, who had come prepared. A friend had come along to "ride shotgun" on the trip back. Chris drove home very slowly, determined not to have an accident while carrying that kind of money.

Television proved a salvation for many blacklisted writers. It was a new medium, ravenous for material but unable then to pay enough to attract top Hollywood writing talent. It was a field left comparatively open; all a talented blacklisted writer needed to work the black market in television was another writer willing to front for him, or a producer eager enough for material to play along in the complicated arrangements necessary for payoff. In West Coast television, the blacklist pressure was not quite so severe as in the East. The organizations that enforced the television blacklist—Aware, Inc., and the newsletter *Red*

Channels—were located in New York City, where they put the squeeze directly on the networks through advertising agencies and corporations.

Even with all this, Dalton Trumbo did little in television himself, and that little proved to be almost too much. An independent producer he knew named Dink Templeton was interested in getting started in the medium and asked Trumbo to write a pilot for him. Trumbo agreed and signed to do it before he had a firm idea of just what the proposed series, *Citizen Soldier,* was to deal with. He discovered then, too late to back out, that the subject was military intelligence in the Cold War and its hero was an intrepid 007 stationed in Germany. He was appalled at that, then downright frightened to find out that Templeton had been given classified documents by the army and the Department of State to use as background material for the series. "I read the necessary documents in a state of shuddering panic," Trumbo remembered, "gave them back to Mr. Templeton and insisted that he never bring them under my roof again, did the assignment as quickly as possible, and, happily, have heard nothing of it since. One slip and I dare say I'd have been arrested as a spy."

Amazingly enough, he even managed to do some writing intended for the theater during this period. It continued to interest him. *The Biggest Thief in Town* may not have been a success, but on the other hand, it had not been a total failure. The English production had rescued the enterprise and restored his confidence in himself as a playwright. Moreover, there was life in the old show yet. It turned out that Peter Cotes, his English producer, was a half-brother of John and Roy Boulting, the English film producers. The Boultings took an interest in the play and optioned it for movie production in 1955. In fact no film adaptation was ever done, but it did give Trumbo a little money and reason to take heart.

Writing for the theater would have tempted him in any case, for it was the only medium during that entire bleak period that resisted the pressure of the Committee. The blacklist remained relatively ineffective there: even actors unable to work in films and television found employment on the stage—though not always on Broadway. He had made it once to Broadway and believed he would again with something called *Morgana,* a kind of farce treatment of the *Strange Interlude* theme that just never came right for him. He was eventually offered a

production on the play in 1962 but declined because he himself was dissatisfied with it. And as he tinkered with *Morgana,* he corresponded fitfully with his friend E. Y. Harburg, back in New York, over a plan to do *Orpheus* as a musical, an idea that seemed a natural but never really worked as a project. All in all, Trumbo's playwriting activities during this period were less remarkable in themselves than in the fact that they were undertaken at all. Perhaps, perversely, he could only have tried at all when under extreme financial pressures and while at work on as many as eight movie jobs at once.

As any writer will, he assured himself for quite some time that he had deserted none of these projects, simply postponed them. In a way, the death of his literary agent, Elsie McKeogh, on October 29, 1955, must have made it terribly difficult for him to continue with the work he considered his "serious writing." Through the years he had come to depend on her as his artistic conscience (an unusual role for an agent), the voice of the New York literary world, who from time to time urged him ever so gently to get back to work on his novel. He welcomed her urgings, and came to depend on them, so much that he eventually accepted the invitation of another agent, Jacques Chambrun, to repre- sent him in New York, even though he had little prospect of completing the war novel, which he was then calling *Babylon Descendant;* he must have half-hoped Chambrun would nag him into finishing the job. But Jacques Chambrun was not Elsie McKeogh; eventually, the association inevitably withered.

During this period, against all apparent reason, Trumbo once more became politically involved. A more careful man would have main- tained a low profile; Trumbo became so incensed at the conviction of fourteen officials of the California Communist Party under the Smith Act (the Alien Registration Act of 1940) that he threw himself head- long into their defense and wrote a pamphlet, "The Devil in the Book," attacking the decision. A more cautious man would have avoided his old associations at all cost; Trumbo rejoined the Communist Party briefly as a protest against its persecution and as a gesture of solidarity with his old comrades. "I could see no hope for the Communists," he said, "no hope at all, no future. But I ... just felt that I wanted to join and get back in, in a sense, to clean up the mess and help me find a way to put a period to that part of my life."

* * *

Dorothy Healy had been a Communist most of her life when I met with her. She had recently felt the curb of Party discipline when remarks of hers made over the Los Angeles Pacifica station, KPFK, having to do with the harshness of Soviet policy in Czechoslovakia, brought her up before the Party leadership. Whatever her personal position, she had now made a break with the Party over the question of censorship and discipline. She was in that sense, then, still a Communist, though one without a Party.

She lived her religion. There was nothing of the near-bourgeois Party functionary about her and even less of the drawing room Communist. She owned a house, a small one in which she and her college-age son lived, the only whites in a black neighborhood not far from the area around 55th Street where Trumbo lived first in Los Angeles. Physically, she was a small, attractive woman, more conventionally pretty than I would have expected. She had been a Communist since she was fourteen and joined the Young Communist League. She stayed in, too, working in the labor movement through the CIO. And that was in the thirties. "That's where my background is," she says. "It was an enormously important period. No one who lived through it was unmoved by it. The toughness of it, the sharpness of the struggle, the clarity of the issues—this was what shaped my whole generation."

It was not yet two months since her very public departure from the Communist Party of Los Angeles County, of which she was once chairman. Newspaper articles had been written, television commentaries made, and by now she had had it up to here with interviewers. That was why she was reluctant when I called and asked to talk to her. I explained that it was specifically about Dalton Trumbo I wanted to speak and she said that in that case she'd think it over. Afterward, when I had called back and we had made our appointment, she explained that her son had insisted she see me since it was about Trumbo. "Trumbo is typical of those who are able to be responsive to the new and can communicate with the young. My own son is critical of me because he feels I haven't done things quite as I should. In a way, Trumbo belongs to my son's generation. He is theirs. When my son heard what this was about, he said, 'This is one interview you must do!'"

So here we are. I have just settled in, and the subject is Dalton

Trumbo. "I don't know," says Dorothy Healy, "when I think about him, well, he and the period [when] we worked so closely together are so intertwined that just mentioning him brings it all back together again. He is a very special person in my memory because of the fifties. They were hard times for me, for us all. Others weren't there, but he was. He was always available to help. There was nothing he wouldn't do in a public fight. Which included his writing, of course, which was just unique. That pamphlet he did really helped materially in what was the first defeat of the Smith Act. And all this was done by him at a point of such enormous pressure in his own life."

"When did you first meet him?" I ask.

"Oh, that would have been 1946. I first remember him from then. As a matter of fact, I remember the first time I was at his home in Beverly Hills. A bunch of us rode out there on the bus, and we had a walk of about a block. We were looking at these houses and trying to imagine what they were like inside and what Trumbo's would be like. And we were jesting among ourselves about how ineffective as fighters against the status quo any of these people who lived out here would be.

"That's a lesson I've learned, you see. If there is integrity and an informed consciousness, then the superficial trappings a person surrounds himself with don't matter. You don't have to sacrifice the trappings to live the kind of life that matters. You know, there was an important lesson for us to learn from the way that those attacks came first on the cultural figures on the left—on the *Hollywood Ten* and all the rest who were blacklisted. The question we had to ask ourselves was Why? Why did the reactionaries go after these people first? Actually, I think they showed more perspicacity than we in the Party did about the importance of culture in the struggle. I am not a devotee of the conspiracy theory of history, but I do think that some planning went into this—the idea was to get the cultural leaders first and then the rest could be whipped into line. In their own way, in a significant way, the writers and artists represented a threat to those who were then setting about to enforce Nixonian standards on the rest of the country. Now, twenty-odd years later, we see the result of that campaign in Watergate. What we had said in the forties was going to happen, actually happened in the seventies. We tried to tell them, 'It's not us Communists or radicals that they're after—it's you.' And it was. It was you, the rest of the country.

"The way they talk, the way they act, the reactionaries try to convey that they represent the American tradition. Well, they don't—not all of it by a long shot. Actually there are two American traditions that have existed side by side for as long as this country has been here. There has been the democratic tradition and the Tory or reactionary tradition right from the beginning. I think it's terribly important not to allow them the ownership of the American tradition. The young people see this, and they have such disdain for the way the American tradition has been used that they say, 'The hell with it.' They shouldn't. The American tradition belongs to us, to them, too. But always those in the democratic tradition seem to be on the defensive. The abolitionists had to keep their identities secret, too—just as we sometimes have had to."

"Has such secrecy really been necessary?" I ask her. "A lot of people have been put off by it. I'm sure you know the argument. They take silence as an admission of some sort of guilt."

"Well, there's been a lot of pressure on everybody for a long time—the Un-American Activities Committee, the Smith Act, the McCarran Act. And all through this period I have been publicly known as a Communist, made no attempt to hide it whatever. And there's no doubt in my mind that my life has been easier for this because they couldn't do anything to me. They couldn't take anything away from me. And I think those who had a great deal to lose—their jobs, of course—were quite justified in keeping their associations secret. Besides, many wanted to say, 'Yeah, I am a this, a that, or a whatever,' but there was always the concern that they would be forced to talk about others. Once they had opened the door to that one question, they had validated the right of the investigators to ask any question on anything or anybody. And in fact, the government has no right to ask these questions—about you or anyone else. It was kind of a ridiculous exercise, anyway, because when they started asking you questions, you knew that the FBI knew who everybody was and what they belonged to, anyway. That was simply the way it was.

"I don't know, though. I do think in retrospect that it would have been better for—what? morale or solidarity, I guess—if individuals who had been put on the spot had identified themselves politically. Maybe they should have. Trumbo, of course, did identify himself at a very crucial time when he dove into that Smith Act fight. That marked

him. With that he said publicly what his politics were. And I couldn't help but admire him for it then, and I still do now."

Oscar night, 1957. Deborah Kerr takes the card from the opened envelope and announces in a loud, clear voice that the winner "for the Best Motion Picture Story is...Robert Rich!"

The sacred moment. Applause! Jesse Lasky, Jr., Cecil B. DeMille's favorite screenwriter and then the vice president of the Screen Writers Guild, jumps up and bustles down the aisle to the stage. He accepts the award on behalf of Rich, whom he refers to as "my good friend," because Rich was at his wife's bedside, and she was about to give birth to their first baby. More applause, and he strides off the stage, statuette in hand.

Lasky later admitted in his account of the episode in his book *Whatever Happened to Hollywood?* that he really had no idea who Robert Rich was. But the name sounded familiar, and it seemed to him that an officer of the Guild really ought to know the members, so...Lasky's good friend he was. And as far as Rich being at his wife's bedside, that was what Lasky had been told. It all seemed quite routine to him at the time.

The next day, however, when they had had the chance to check the Guild files, it was found that there was no Robert Rich listed in them. He was not a member and never had been. Nobody really had any idea who he was or how he could be reached, not even the King brothers, who had produced *The Brave One,* the film for which Robert Rich had just won the Academy Award. Had he really been at a hospital waiting for his wife to give birth? Somebody had called the afternoon of the ceremony and had said so. Just on the outside chance they might locate him that way, they put a team to work telephoning the obstetrics wards of every hospital in Los Angeles County to inquire if there was a Mrs. Robert Rich registered. No luck.

It wasn't long before the news magazines picked up the story and reported this rather sticky situation. Then they did a follow-up when rumors began to fly around Hollywood that Robert Rich was really just a pseudonym used by Dalton Trumbo. And Trumbo? Well, he denied nothing: "It was that Robert Rich thing that gave me the key. You see, all the press came to me, and I dealt with them in such a way

that they knew bloody well I had written it. But I would suggest that maybe it was Mike Wilson, and they would call Mike and ask him, and he would say no, it wasn't him. And they would come back to me, and I'd suggest they try somebody else—another blacklisted writer like myself who was working on the black market. I had a whole list of them because we kept in close touch. It went on and on and on. I just wanted the press to understand what an extensive thing this movie black market was. And in the midst of this, I suddenly realized that all the journalists—or most of them—were sympathetic to me, and how eager they were to have the blacklist exploded. There had been a certain change in atmosphere, and then it became possible."

By the time of the "Robert Rich Affair," as it eventually came to be known in the news magazines, the black market in screenplays was not just a thriving enterprise, it was also an open secret in the movie industry whose very existence made a joke of the House Committee on Un-American Activities and of the blacklist enforced by the Committee's Hollywood supporters. Trumbo was not the first blacklisted writer to have won the Academy Award. That honor went to Michael Wilson, who was awarded an Oscar the year that he was blacklisted (1951) for *A Place in the Sun*, written, produced, and released before he was named in testimony before the Committee. As a direct result of that, the Producers Association* ruled that no blacklisted writer was to receive screen credit—even for work done earlier. And so when Wilson's pre-blacklist script for *Friendly Persuasion* was produced a few years later, his name was simply excised from the credits; no writer's name at all appeared on the screen. Then, when the film won the Writers Guild Award and it looked as though *Friendly Persuasion* was a shoo-in for an Academy Award for Best Screenplay, credited or uncredited, the Motion Picture Academy ruled that under no circumstances could a blacklisted writer be awarded an Oscar. The Academy had, however, overlooked the possibility of a writer winning under a pseudonym; and Trumbo was the first to do that with *The Brave One*.

The Robert Rich award thus marked the beginning of the end of the blacklist. The next year the French novelist Pierre Boulle won the Academy Award for the marvelous job he had done adapting his own

*The Association of Motion Picture Producers (AMPP).

novel *The Bridge on the River Kwai* for the screen. Among insiders the award provoked knowing looks and wry smiles, for the truth was that Boulle hardly spoke, much less wrote, English (and, incidentally, did not "write" for films before or after). The script was actually the work of two blacklisted writers: Carl Foreman and, again, Michael Wilson. A year after that, the award for Best Story and Screenplay went to the team of Nathan E. Douglas and Harold Jacob Smith for *The Defiant Ones*. And while, true enough, there really was a Harold Jacob Smith— it turned out that Nathan E. Douglas was the blacklisted actor-turned-writer Nedrick Young.

In the meantime, Dalton Trumbo had begun a coordinated and deliberate personal campaign in the media against the blacklist. It was a crusade, a vendetta. It became almost an obsession with the man. As a result of that first round of statements to the press and interviews with local Los Angeles television reporters, he had not only made the public aware of the existence of the black market but had also managed to cast doubt on the authenticity of practically every screenplay produced in Hollywood. Producer-writer Jerry Wald, always outspoken, was so incensed at this tactic of Trumbo's that he himself complained to the press that "by innuendo Dalton Trumbo has been insulting the whole Screen Writers Guild. . . . In essence, he's been saying to the public, 'No matter who you vote for [for the Oscar], I'm writing the scripts.' Trumbo . . . has done a tremendous injustice to the screenwriters of Hollywood." Putting it mildly, this did not distress Trumbo greatly, for he felt that he and every other blacklisted writer in Hollywood had been betrayed by the Guild.

He continued on the attack, writing his own account of the so-called Robert Rich Affair and attendant details of the movie black market for the *Nation* ("Blacklist Black Market"). Trumbo's old friend from postwar liberal campaigns in California, Carey McWilliams, was now the editor there. McWilliams welcomed him as a contributor and kept him busy for some years more. "Mencken was his master," Carey McWilliams recalled. "He had a *fierce* style and could have been an important social critic if he had kept at it. When Trumbo broke the blacklist we lost a first-rate commentator on the American scene. Too bad, but of course I'm not complaining."

He was then invited to New York to appear on the John Wingate *Night Beat* show on September 19, 1957. Wingate, a sort of lesser

Mike Wallace, had earned a reputation for himself as a mercilessly tough television interviewer whose staff researched his victims in such detail that they were utterly powerless before him. Well, Trumbo took the trouble to research Wingate and, in a modest sort of way, turned the tables on him. It should not be surprising, after all, that he was able to hold his own in an exercise as fundamentally like formal debate as adversary interview. He had had a lot of experience in that line, and unlike most of those who appeared on the show, Trumbo had long before thought out his position on every point Wingate questioned. It gave him an advantage that few enjoyed, and *Variety,* the only major publication to review the performance, declared that Trumbo had won in a walk.

He became a kind of media consultant to others who had, because of the blacklist, been thrust into the public eye—to the King brothers, for instance, who later, in 1959, were forced to concede that what had been bruited was true: Dalton Trumbo was indeed Robert Rich, the author of *The Brave One.* Because they had, for far too long, remained resolutely vague on the identity of Rich, they had been hit by a number of lawsuits which alleged that this yahoo or that was the *real* Robert Rich. To answer them, Frank King appeared on KABC television, interviewed by reporter Lou Irwin, while at the same time Trumbo was confirming the story elsewhere. King, who had been coached in his responses by Dalton Trumbo, acquitted himself admirably, disposing of the facts of the case in short order. He was then brought up short by the question—fair enough in context—"Did you ever ask Trumbo whether he was a Communist?" Frank King replied:

> Of course not. I'm not interested in his politics or his religion or his color. I was interested in his work. It was good work. It was the story of a little Catholic boy and his pet. Is there anything Communistic in that? I'll show you reviews from practically every country in the world that proves exactly the opposite. What this business needs is better writers and fewer politicians.

King excused his earlier statements regarding Robert Rich as "what Wendell Willkie said of his campaign speeches that weren't exactly accurate. He said that was just 'campaign oratory.'" And the producer concluded the television interview by affirming, "I'll continue to buy

the best material I can get regardless of a man's politics. I'm not hiring their politics, I'm hiring their writing talent."

So there it was, a year before the blacklist was actually broken, a declaration of defiance from an independent Hollywood producer in good standing in the industry. Cracks were thus appearing in the rampart with routine regularity. But Trumbo kept pounding away at it, determined to breach it at any price. He sent word out to his contacts among producers who were dealing on the black market that he would be willing to do a screenplay without any sort of financial payment at all—literally for nothing—*if* they would publicly announce him as their writer and put his name up on the screen. In simple dollars and cents, this was quite an offer he was making, for he promised his best work, and by that time—1958—he was getting up to seventy-five thousand dollars a picture, even on the black market. As it happened, he had no takers, but the offer stood until he had later accomplished just what he had intended without resorting to measures so drastic and so alien to his nature.

And finally, early in 1959, he kept the kettle bubbling with his announcement, complete with television interviews, of the founding of Robert Rich Productions, Inc. Adrian Scott was president of the new company, and Anne Revere, the blacklisted actress, was named as secretary-treasurer. Trumbo, who named himself as vice president, was chief spokesman. Although the name, Robert Rich Productions, was undoubtedly chosen as a kind of red flag to the Committee and to the entire motion picture industry, the founding of the company was certainly not just a publicity stunt to show blacklistees fighting back. By this time, after all, the climate was changing. They had every expectation of taking the two story projects they had initiated right through into production. And so they incorporated and made ready to do business. However, though they might not have intended it so, the end of the blacklist brought an end to Robert Rich Productions as well. Scott went off to England to work, and Trumbo found himself even more in demand than when on the black market. Anne Revere, one of the finest actresses in American films during the forties, never made a comeback in the sixties.

But these episodes I have been recounting were merely the more spectacular moments in a sustained, one-man media blitz which demonstrated a kind of natural genius on Trumbo's part for handling the

press. If he had not been a screenwriter he could have made a fortune as a public relations man, or might have made his mark in history as a presidential press secretary. He made himself available always to members of the press. Even to newspaper articles and television features in which he did not figure directly he contributed information tips, sometimes the news pegs on which the pieces were hung: he worked behind the scenes as well as in front of the cameras. And he was responsive to the problems of reporters; he did not simply work them for what he could get out of them. The two Los Angeles television newsmen with whom he worked most often and most closely were Bill Stout of KNXT and Lou Irwin of KABC. He realized the two were in competition, but he also knew that he owed a debt to them both for the coverage they had given his cause. When Trumbo himself conceded that he was Robert Rich in a filmed interview with Stout in January 1959, he knew that this would put Irwin at an awful disadvantage. And so, having explained the situation to Stout, he arranged for the same story to be given to Irwin on KABC by Frank King, producer of *The Brave One* (this was the context of the King interview quoted earlier).

All in all, as a media manipulator, he proved more than a match for the Producers Association and the Motion Picture Academy, against whose members he was most often pitted. He wisely avoided direct confrontation with them, trying to make retreat as attractive as possible from the pro-blacklist position they had held for years. At the time of the Robert Rich revelations, when *The Defiant Ones* debacle was bubbling on the back burner ready to come to full boil at Oscar time, director George Stevens, who was then president of the Motion Picture Academy, issued a statement directed against Trumbo personally, and beyond him at other writers who were working on the black market. At Trumbo's urging, producer George Seaton prevailed upon Stevens and persuaded him to withdraw the statement, which appeared only in the early edition of the *Los Angeles Times*. Trumbo recognized in Seaton a reasonable man, and so he wrote to him then asking that Stevens be persuaded not to make any more such statements in print or on the air, for if he did, Trumbo would be forced to answer him directly, and "there must be no showdown in the press between George Stevens and me." He went on to explain in this letter, the tone of which is quite conciliatory, "[Stevens] should also be made to understand that I am no longer in a position where men can throw mud at me with

impunity—particularly men toward whom I feel no ill will and whom I have never injured in any way. The working press are on my side, not only the wire services, but local and New York staffs, and TV commentators as well."

He was dealing from a position of strength, and he knew it.

When a television camera crew unpacked and began to set up in a neighborhood like the one the Trumbos were living in on Annan Trail in Highland Park, it drew attention of the wrong sort from blocks around. And in places like that, when your name appeared in the newspaper identified (however tenuously) with the Communist Party, then you could expect trouble. Well, the whole family found trouble, all right, though not all of it of the sharp, violent sort that left Trumbo bleeding with blackened eyes and broken glasses in his driveway. There was really only one such incident. But the other members of the family— Cleo, Mitzi, Chris, and Nikola—were systematically snubbed and subjected to petty indignities through most of the years they lived there.

For a while, when Cleo went to PTA meetings, she sat by herself. Nobody would sit down beside her, and people would move away when she took a place too close. At the height of their difficulties, the principal of the grade school her daughter Mitzi attended refused even to speak to Cleo. All this was during and following a rather grim episode that centered on Trumbo but directly involved both Cleo and Mitzi as well. "Mitzi had such a hard time as a kid in that school," said Cleo, "because she didn't know, really, what was wrong. She assumed, as kids will, that if there was trouble, then she must have been to blame. We didn't know how much trouble she was having, though, until the PTA business."

That all began with trouble in the school-sponsored Campfire Girls troop. Mitzi had been a member of the younger Bluebirds, and Cleo had performed the usual chores of chauffeuring girls around and playing hostess for her daughter at meetings—all this before her husband became suddenly prominent in the news. About the time he did, Mitzi was up to join the Campfire Girls. Some of the mothers questioned whether Cleo, because of her husband's political background, was fit to play the same role with the Campfire Girls that she had been playing with the Bluebirds: perhaps she would defend the purge trials or extol

the new Five Year Plan as she baked brownies with the girls. An angry letter from Trumbo over Cleo's signature, in which he threatened legal action, put an end to the overt opposition. However, much hostility remained, and it was made suddenly and unmistakably manifest during the rehearsal of a Campfire Girls program for presentation at a PTA meeting. Cleo was flagrantly snubbed by all, including the principal, in front of her ten-year-old daughter. Afterward, it developed in conversations with Mitzi that the girl had been receiving just such treatment herself at school and at the Campfire Girls meetings. For three months the child had been given the silent treatment by her classmates, only yelled at occasionally in ridicule. None of her friends had stuck by her during this ordeal, and she was called a "traitor" by the rest. Upon hearing this, the Trumbos realized that Mitzi had been "sick" a great deal of the time lately, just not quite up to going to school one or two days each week; suddenly they understood why. Now Mitzi declared miserably that she never wanted to go back to Highland Park School again. Well, with the aid of the sympathetic school nurse and Trumbo's friend and former attorney, Robert Kenny, it was arranged that she would not have to. The nurse recommended that Mitzi stay home during the two weeks remaining in the school term, and Kenny quietly arranged a transfer to nearby Eagle Rock School. She had little trouble of any sort there.

Christopher Trumbo was a bit wary right from the start. His experiences in Mexico City had taught him to be careful in choosing his friends there at Franklin High School in Highland Park. "I was an outsider," he remembered. "They knew what my father did, though not really who he was in the beginning, so I tended not to make friends where that might be a problem. I had only two close friends in high school. Not that I had such an abnormal time there. What I did mostly in high school was play trumpet at dances and stuff."

He was college-bound, if his father had any say in the matter—and Trumbo did, eloquently and at great length in a letter to the director of admissions for Williams College, which was Chris's first choice. In the end, however, Chris chose Columbia because when taken to lunch by a Los Angeles businessman who was an alumnus of Williams, he had been assured that he would like Williams since there weren't a lot of Jews there. Unwittingly, the man had touched upon the one issue that moved the boy profoundly in high school. Chris's two friends were Jews. Through them and because of them, he had even managed to

join AZA, B'nai B'rith's boys' organization. Once, with his friends from AZA, Chris had gone to hear a lecture by Gerald K. Smith, to protest his appearance at Hollywood High. It gave him his first opportunity to hear how a real anti-Semite sounded. He came back visibly shaken, almost unable to believe he had heard what he had heard—and from the stage of Hollywood High School's auditorium!

Columbia (which he entered in 1958) was, in many ways, a relief to him. Even though he did not distinguish himself as a student, he got on well there. "I remember about 1961 there," says Chris, "people would come up to me and say, 'Are you related to Dalton Trumbo?' Only it was different than it was at Highland Park High. They meant good things by that, instead of, 'Are you related to that Commie rat?' I don't know, though, growing up the way I did does give you a different perspective on life. If you're on the outside instead of the inside, then that's the way you stay, basically, your whole life. That's not necessarily bad, though. If there were no blacklist I might have grown up a perfect Hollywood brat."

Nikola, the oldest of the Trumbo children, had troubles of one kind or another on the way to the University of Colorado. She finished high school in Highland Park a couple of years before her father was thrust into the limelight. She wasn't likely, however, to have permitted herself to be intimidated by her classmates. As early as 1955, Nikola's senior year in high school, she was so deeply involved in causes that her grades suffered. Trumbo wrote of her to Ian and Alice Hunter, "She is so far left that she terrifies me and occasionally reprimands me for backward habits." Between high school and college she put in a year in Europe, most of it with the Michael Wilsons. After a couple of years at Los Angeles City College, during which she buckled down admirably, Nikola transferred to Colorado. Trumbo's only visits back to the state came during her time at Boulder.

Cleo: "We're a tight-knit family, all right. Yes, I guess you could say we're very close. He's always worked at home and he's always wanted to know what was going on—more, I think, than most fathers, even when he was younger.

"Have we triumphed over the blacklist? We, as a family? Not completely. The reticence, socially—that stays with us. We keep to ourselves a great deal. Nikki seems to be reaching out more—but she's defensive, so I doubt that she ever got over it. The whole period made a

mark on us, I'm sure of that. I remember that Chris's wife, Sherry, had no idea what we were really like as a family until after they were married. Then she saw. She couldn't understand why he wasn't out more, why he wasn't more social, and so on. And of course Chris talked to her about the blacklist period, and how it had affected us as a family, and so she began to understand why we were the way we were—or rather, are."

A sure sign that the end of the blacklist was near could be seen in the increasing size of Trumbo's checks. He was dealing more openly with producers and directors and had become involved in some big-budget pictures. Still, there were difficulties, evasions, and silly games to be played—and he was obliged to play them as long as there was a blacklist. Occasionally, even he had to laugh at the results. There was, for example, the work he did on an adaptation of a novel by Richard Powell, entitled *The Philadelphian*. It was eventually produced as *The Young Philadelphians* and starred Paul Newman—though not before it had gone through a number of rewrites. That was how Trumbo got involved in the project. Producer Alec March came to him with a version of the script that he was not really happy with and asked if he would be available to do a rewrite. Trumbo was not likely to turn this one down, for it was a major studio production and would be one of the biggest films he had been involved in since his days at M-G-M. There remained, however, the sticky problem of a front man—not just a matter of borrowing a name, in this case, because March needed someone to bring into story conferences with him, nod understandingly, and take notes. They persuaded screenwriter Ben Perry to fill in for Trumbo. He went onto the Warner Bros. payroll at a salary of one thousand dollars a week, showed up each morning for work, and attended every conference with March. What Perry did in his studio office was his own business, for Trumbo was at home writing the script. The arrangement worked quite satisfactorily for all concerned for about twelve weeks, when Alec March was suddenly fired from the picture, and Perry/Trumbo naturally had to go, too. The kicker to the story came, however, a few months later. Because Trumbo had so successfully covered up his tracks on *The Philadelphian,* he was visited by Paul Newman and the director of the film, which was then just about to go into production. They were unhappy with the script they had and, not knowing he was the one who had

written it, told Trumbo they were sure he was the only one who could repair it. He managed to keep a straight face in declining their offer. He told them he had other work to do—which was, by then, true enough.

Eugene Frenke played a major role in the greening of Dalton Trumbo's bank account. This independent producer took the place for Trumbo of the agent that the writer so badly needed to legitimately offer his illegitimate services, sub rosa, on the movie black market. Frenke simply made Trumbo an employee of his own Springfield Productions; he went out and got work for him, made the deals, and maintained him on a minimum salary in slack times. It was, of course, a very profitable arrangement for Frenke, for some of the original screenplays Trumbo wrote on speculation during those slack times eventually sold for very fancy figures. Two of his best were never produced. *Montezuma,** which posed the Aztec king against his captor, Cortés, and explored their curious friendship, was sold to Bryna Productions and Universal Pictures for $150,000. Another, *Will Adams,* based on the adventures of the sixteenth-century seafarer who was the first Englishman to set foot in Japan, was optioned, reoptioned, sold, and sold again, so that through a succession of deals over a period of a dozen years or more, the screenplay brought $300,000 to Springfield Productions. Trumbo himself considered *Montezuma* and *Will Adams* to be among the best he had done.

Bryna Productions, which bought *Montezuma* with Universal's backing, was Kirk Douglas's production company. Toward the end of the blacklist period, Trumbo worked for Bryna on one project after another, a fruitful association for both, which led to the production of *Spartacus* and reached its artistic culmination in *Lonely Are the Brave.* Along the way, Trumbo wrote, or at least worked on, a number of other scripts for Bryna pictures which were, both commercially and artistically, less successful than those two, such as *The Last Sunset* and *Town Without Pity.* There were a couple of others (besides *Montezuma*) that were written for Douglas but, for one reason or another, never produced.

*John Huston, who was set to direct the film, once told me in an interview unrelated to this book that of all the movies he had *almost* made (and in any major director's career there are a score of them), *Montezuma* was the one he most regretted having fallen through. "It was a beautiful script," Huston said. "It would have made a beautiful picture."

The man responsible for Trumbo's association with the company was not Douglas, but a partner in Bryna, Edward Lewis. "I was struggling to become a producer back then," Lewis remembers, "and we bought a novel with Douglas in mind, *The Brave Cowboy*, by Edward Abbey. We just looked around then, and Trumbo was the one and only screenwriter who was right for that novel—what it said, the western background, all of it. It didn't matter that he was blacklisted. His relationship to the material was what made him right for the project."

They signed him as "Sam Jackson," a writer on loan from Frenke's Springfield Productions. (The pseudonym became a nickname: Kirk Douglas gave Trumbo a watch at the end of *Spartacus* with an inscription to Sam Jackson; and Trumbo continued to sign his letters to the actor as Sam.) He began work on the screenplay—which ultimately turned out to be one of his best—only to have Lewis ask him to put it aside. Something more urgent had come up. Lewis: "I had optioned Howard Fast's *Spartacus* and had made an arrangement with Universal that would make us producers of the picture. There was some steam on the deal because there was a competing project, Arthur Koestler's *The Gladiators*, covering the same Roman slave rebellion, which Anthony Quinn was preparing for production. We had engaged Howard Fast to do a first-draft script of his own novel. Well, he simply couldn't work quickly enough to do the job for us. We had to go to an experienced professional, and there was no more experienced professional around than Dalton Trumbo. He was and is the most skillful and the quickest writer in the business."

Lewis did have some misgivings about bringing Trumbo in on *Spartacus;* he knew he had long disliked Fast personally and had been deeply annoyed at the novelist's noisy leavetaking from the Communist Party.* When Lewis mentioned this, however, Trumbo told him he had no objections at all to working on the adaptation of the novel, for if he were to turn down material on the basis of a writer's politics,

*When asked by Carey McWilliams to review Howard Fast's personal testament, *The Naked God,* for the *Nation,* Trumbo declared that the novelist's ultimate disaffection was inevitable because of his mystical attachment to the Party: "He not only believed; he committed his last artistic resource to the service of belief." Interestingly, however, Trumbo declined to review the book since he would have been forced to deal with his own scruples regarding the Party at a time when he felt it important to maintain solidarity because "people are still in jail or threatened by it."

then he would be guilty of practice of the sort that had kept him black-listed for the past twelve years. And so in May 1959, he signed—as Sam Jackson—to do a complete rewrite of the screenplay of *Spartacus*. The wheels were grinding inexorably now. The chain of events which would lead to the end of the blacklist had begun winding tighter and shorter. It wouldn't be long now, though not even Trumbo could be sure of that at the time.

The rewrite presented no special problems; Trumbo finished it in fairly short order, altering freely and adding much of his own. The difficulties with *Spartacus* arose afterward, during production. The director hired by Douglas was Anthony Mann, a good journeyman with an impressive list of recent credits behind him. Mann knew the identity of Sam Jackson and quite reasonably wanted to discuss the script with him in order to clear up a few matters in planning the production. Trumbo had no objection, and when Mann telephoned and asked if he might also bring Peter Ustinov with him to discuss his role in the film, he told them both to come right over. Trumbo assumed that the two had come with the knowledge and permission of Kirk Douglas and Edward Lewis, though as it turned out, they had not. It was a cordial and quite routine meeting. The director and the actor finished up their business in about four hours and left. It might not have mattered at all, except that when shooting began a week later, Douglas and Mann argued violently over the first rushes, and Douglas fired Mann from the picture. Stanley Kubrick, who had similarly quarreled with Marlon Brando over *One-Eyed Jacks* and had been fired, was immediately hired by Douglas for *Spartacus*.

Mann, who was miffed at Douglas, began talking quite freely around town about just who Sam Jackson really was. Eventually, even the gossip columnists picked it up. The rest of the cast found out from Ustinov that Trumbo had written the script, and they felt that if Douglas and Ustinov had had access to the writer, then they should, too. And so, first Laurence Olivier and then Charles Laughton arranged to see him. This was the first time that Trumbo's security precautions had broken down completely. He had always managed to preserve his anonymity before, at least through the production of a picture. With Trumbo so openly discussed as the author of the *Spartacus* screenplay, there was considerable pressure on Universal either to announce the fact openly, or (as the American Legion urged) to abandon the production

altogether. Douglas had hoped from the start to give screen credit to Trumbo but considered it unlikely because of the keen sensitivity of Universal to outside pressures. The giant talent agency, Music Corporation of America, had just bought the studio, and the new management was proceeding very cautiously.

In the midst of all this, with shooting of *Spartacus* virtually completed, Trumbo was smuggled onto the Universal lot to view the assembled footage in rough cut. He didn't like what he saw and said so in an eighty-page memo to Lewis and Douglas which he wrote overnight and through the next day and sent to them by messenger the next afternoon. As far as the cast and crew were concerned, the picture was completed. They were toasting the occasion in champagne and exchanging gifts when the memo arrived from Sam Jackson. Douglas retired to his dressing room to read it and came back wearing a glum expression.

"Well," Stanley Kubrick asked brightly, "how did he like it?"

"He *didn't* like it," Douglas said, waving the sheaf of typescript, "and he's right!"

His criticisms were detailed and wide-ranging, but they centered on Kubrick's handling of the aftermath of the picture's most expensive sequence—its spectacular climax on the battlefield. That, he convinced Douglas, had to be completely reshot—and other scenes, as well. Neither Douglas, Kubrick (in particular), nor any of the rest of those involved in the production were very pleased at the prospect. But Trumbo was persuasive; he prevailed.

Meanwhile, he returned to the western he was writing for Douglas, *The Last Sunset,* which the actor was to go into after *Spartacus.* That one, which pops up now and again on the late-late show, seems uncharacteristically haphazard in conception and execution, as though it were thrown together all at once—which, in fact, it was. It didn't get the rewriting that it deserved because by that time Trumbo was involved in another important project. Or, as Kirk Douglas told the story: "It was a curious morality those guys on the blacklist developed. We were pushing him on this project [*The Last Sunset*], and Trumbo turned to me and said, 'Look, you know while I was doing *Spartacus* I was screwing Otto Preminger. Now it's your turn to get screwed.' You had to admire him and take that from him because he was so direct. There was absolutely no bullshit from him."

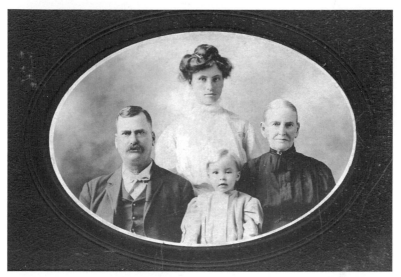

Dalton Trumbo in 1908, age three, with his grandfather Millard F. Tillery, who served two terms as Montrose County sheriff; his mother, Maud Tillery; and his grandmother Huldah Catherine Beck. (*Courtesy of the Trumbo Family*)

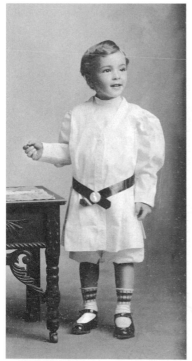

Dalton Trumbo in 1909 in Grand Junction, Colorado, where the family lived from 1907 to 1925. (*Courtesy of the Trumbo Family*)

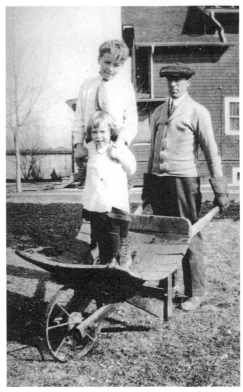

Dalton and Catherine Trumbo with their father, working in the garden of the Gunnison Avenue house about 1915. "Even rich people in the cities couldn't get vegetables as fresh or crisp." (*Courtesy of the Trumbo Family*)

Dalton Trumbo's graduation picture, Grand Junction High School Class of 1924. He was a better debater than a football player. (*Courtesy of the Trumbo Family*)

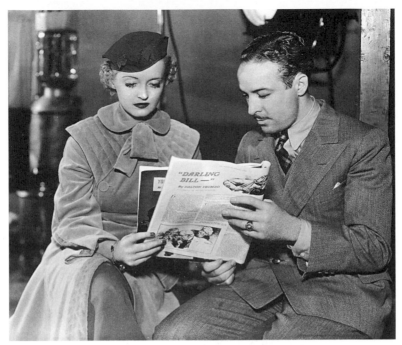

With Bette Davis, 1935, at Warner Brothers. In this studio photo for the fan magazines, the two are seen reviewing "Darling Bill," Trumbo's first sale to the *Saturday Evening Post*.

Cleo in 1943, two years out of McDonnell's Drive-In. (*Courtesy of the Trumbo Family*)

Dalton and Cleo Trumbo (with Bertolt Brecht in the background) at the House Un-American Activities Committee (HUAC) hearings, 1947.

The Trumbo Family at their ranch in the Lockwood Valley (nicknamed the Lazy-T Ranch), 1948. From left to right: Christopher, Cleo, Mitzi, Dalton, and Nikola. (*Courtesy of the Trumbo Family*)

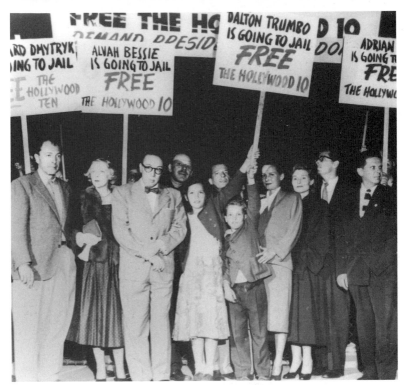

While Trumbo was preparing to serve his contempt sentence, a group of demonstrators surprised him with a banner reading: "Dalton Trumbo is going to jail. Free the Hollywood Ten." He carried this memory of his wife and children standing under that lettered sign as he went off to jail. Dalton Trumbo (third from left), Nikola, Christopher, and Cleo, surrounded by other members of the Hollywood Ten and their families, June 7, 1950.

Dalton Trumbo in his study at the Highland Park house, 1960. The African Gray parrot, who once yelled "Oh, shut up!" to Laurence Olivier who was rehearsing a line from *Spartacus*, was a gift from Kirk Douglas to "Sam Jackson." (*Photo by Cleo Trumbo*)

Dalton Trumbo and Alan Bates on location outside Budapest while making *The Fixer*, 1967.

Dalton and Cleo Trumbo arriving in Budapest for *The Fixer*, 1967. (*Courtesy of the Trumbo Family*)

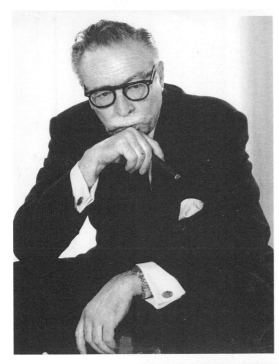

Dalton Trumbo,
with suit and
cigar, 1960.
(*Photo by Cleo
Trumbo*)

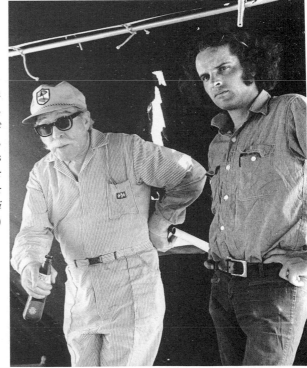

Dalton Trumbo, with
his son, Christopher,
on the set of *Johnny Got
His Gun*, Los Angeles,
1970. Christopher was
an associate producer
and assistant director for
the film. (*Photo by Mitzi
Trumbo*)

Dalton Trumbo chatting with Otto Preminger on the *Johnny Got His Gun* set, Los Angeles, 1970. (*Photo by Mitzi Trumbo*)

The actor Trumbo had chosen to play the medical director in *Johnny Got His Gun* was disqualified by the Screen Actors Guild four hours before the scene was to be shot. Trumbo got into costume and makeup and played the part himself. (*Photo by Mitzi Trumbo*)

*　　*　　*

Screwing Otto Preminger? Perhaps. But there was a legion of sadder, wiser men who would tell you that was not easily done—and Dalton Trumbo did not happen to be one of their number. The director and the writer were on very cordial terms. What these two, whose personal styles were so different, seemed to have most in common was their feeling for their work. For both, it seemed to be the driving force in their lives.

Trumbo and Preminger had earlier been involved in two projects, and as Kirk Douglas had it, it was at about the same time that Trumbo was working on *Spartacus*. They were adaptations of two novels—Pierre Boulle's *The Other Side of the Coin* and Ugo Pirro's *The Camp Followers*. And as for Trumbo giving his best to Preminger, *The Other Side of the Coin*, at least, was shelved because of the guerrilla situation in Malaysia, where it was to be shot. He thought enough of the script that he later tried to buy it back with an eye toward reselling it, or making it himself.

By that time, Preminger was living in New York. The two, who had never met during the studio years in Hollywood, were brought together by Otto's brother, Ingo Preminger, who after the blacklist became Trumbo's agent. The director thought a good deal of Trumbo's work, especially of his now-renowned ability to work quickly under pressure. And so, quite naturally, it was Trumbo to whom he turned when he found himself in a very difficult situation with regard to his upcoming production of *Exodus*. It was the beginning of December 1959. Contracts with the actors had been signed, and the film was set to begin production in April. The trouble was, of course, that Preminger simply didn't have a usable—*shootable*—script. It had been through a number of drafts by two different writers: the first was the writer of the novel, Leon Uris; the second was another blacklisted writer, Albert Maltz, who had engaged in vast historical researches of his own and had finally delivered a screenplay of some 400 pages in length (the average script then ran no more than 150 or 160 pages). This, then, was his predicament when he telephoned Trumbo from New York and told him to get a copy of the novel from his brother, Ingo, and read it that night (it is a book of over a thousand pages in length); he would be in Los Angeles the next day and Trumbo would then begin the job of adaptation.

The fundamental mistake made by the two previous writers was that they had both tried to adapt the *whole* novel to the screen, that is, to go back to Old Testament times and follow the Jews through the centuries of the Diaspora and the horror of the Holocaust, and then bring them back at last to Palestine for the climax in the creation of the modern state of Israel. In the novel, this epic approach worked, within Uris's limitations as a writer, well enough. However, to try to translate it directly to the screen would have been to show a profound misunderstanding of the uses to which the medium could be put. Trumbo realized this, and he was not about to make that mistake himself. When Otto Preminger arrived the next afternoon, Trumbo actually had read the novel. He sat him down in his study and told him that it was impossible to do the novel as it was written—there were far too many stories in it. He asked him which one he wanted to tell in the picture. And when Preminger said, as he had anticipated he would, that of course he wanted to show the birth of Israel, Trumbo said, "Fine. Let's get to it."

They worked intensively and in close cooperation on the script. Preminger would arrive each morning at Trumbo's house in Highland Park at seven o'clock. The two would go over the pages that Trumbo had completed and handed over to Preminger the night before. Then they would discuss the scenes he would write that day. Preminger would leave, and Trumbo would get to work, first rewriting last night's work according to Preminger's suggestions, then writing the new material for the director to take away with him that night. They would get together at the dinner hour, have a martini together, and Preminger would leave with that day's pages. The process was repeated day after day for more than thirty days. They worked through Christmas and New Year's Day, 1960, Trumbo taking an hour off on Christmas morning to open gifts with his family. Preminger was present and waiting, a Teutonic Scrooge. When they had finished, the two adjourned immediately to the study and continued on schedule. But the pace paid off. When Preminger left Los Angeles for New York in the middle of January he had the completed screenplay of *Exodus* under his arm.

As the script began to work into shape and the task that had once loomed so large before them now began to seem at least possible, Otto Preminger permitted himself to joke a little. He began to tell Trumbo that if the picture came out badly he would make sure Trumbo got the blame. With that between them, the call that came from New York

on January 19 was not a complete surprise. It was Preminger. "Your name is on the front page of the *New York Times* tonight," he said. "I've announced you as the writer of *Exodus*."

"How did it happen? That's easy. I went to lunch with Arthur Krim of United Artists at the St. Regis when I came back with the script, and I said it was absolutely a crime what was done to these men. They had served time, and if that was what they wanted from them, then that was what they had given. They should be permitted to earn their living in an open way. He agreed, and so I made the announcement.

"Now, I personally was never told about any blacklist. But there was, of course, a silent agreement never to use writers implicated in the Joe McCarthy witch hunt. Some exploited these men, but I always paid Dalton a decent salary. There was no discussion of him receiving a credit on this script or the others he did for me until I made the announcement to the *Times*."

Otto Preminger punctuated his pronouncements with a nod. His manner, notoriously punctilious and autocratic, made him an ideal subject for interview. He spoke directly and to the point, and when he had finished, he let you know with that little nod of his head that he was ready for the next question.

It is a Saturday morning in the fall, and I am sitting in his living room. An air of quiet hangs over the place—not so much a pall of silence as a kind of insulated stillness. A dim, subliminal awareness persists that there must be some noise out there in Manhattan, even on this quiet street in the East Sixties on which his townhouse faces, but it is clear that disturbances of any sort will not—cannot—penetrate the elegance of this large, simple room in brown. Preminger seems as much at ease sitting at his desk here as he would be anywhere, neither more nor less. A contained, direct, and forceful man, he is the sort who could defy any pressure group and simply do what he chose to do.

"There were threats of actions. Yes, of course. Threats of all kinds, but in the end, there were only a few picket lines in Boston, and a few other places. Nothing major, however. This famous opposition just wasn't there when they said it would be. It was an illusion."

"So the blacklist was maintained for years on an illusion of retaliation?" An interesting point. Preminger was in a position to know.

"Yes," he says, "and when it disappeared, it opened for Dalton a whole legitimate career. He is very successful, you know."

It was my turn to nod. Yes, I knew.

"And he deserves it all. I find him personally an enchanting man. He has a sense of humor, and just as with Ben Hecht, he is never pompous or pretentious. He is a man who loves his children. I have seen this in him. He cares very much for his family. This is dull for you, perhaps, but I have never seen bad traits in Trumbo."

"You mentioned Ben Hecht," I prompt him. "You seemed to be comparing the two."

"Yes, I always think of the two of them as very similar talents. Dalton is able to write anything. He has great facility. People might criticize him even for that, but I find it very good. There is only one other writer I have known in my long experience who had a similar facility, and this was, of course, Ben Hecht. I did seven scripts with him. But with both of them, too, I have the feeling that if pictures had not used the talent of these people, then they would have become greater writers. They got used to a higher life style, and they were spoiled for higher ambitions as writers. In pictures, you know, a writer can never be as important as he is in writing novels and plays, and so on. I'm thinking of them in this, what they could have done. On the other hand, we film people should be grateful that such talents will write for us.

"Still, with Dalton, there was his novel, *Johnny*. He came to me, you know, with the film he made from it. And I liked the film very much. I had some suggestions on editing, but I thought he directed it well. But that novel—well, he's a very talented writer, and without films and the lure of easy money, he might have written more books like *Johnny,* you know. He would have had time to go into deeper writing.

"In all this, you see, he is like Ben Hecht. Both of them could have been, *should* have been, more."

Whether or not Universal would have permitted Kirk Douglas to give screen credit to Dalton Trumbo for *Spartacus* without the impetus that Preminger provided is, of course, open to doubt. In any case, he did get acknowledgment for *Spartacus,* as well as for *Exodus*. Does Preminger deserve *all* the credit, then? Was it simply a grand personal gesture on his part that ended the blacklist for Trumbo, and eventually for others as well? Yes and no. For without detracting in the least from the moral courage he showed in the matter, it should also be pointed

out that Otto Preminger might never have made the announcement if it had not become common knowledge that Trumbo had written *Spartacus,* too. It had, after all, been so reported in the gossip columns and in the trades, and there existed the possibility, at least, that Universal would sniff the wind and decide that the time was ripe for such a revelation. If there was a risk of blame attached, there was certainly also praise; Preminger was willing to risk the former to reap the latter. He was, in spite of his authoritarian personal style, solidly liberal in his outlook. He was acting on principle—but in a most circumspect manner. Perhaps Arthur Krim and the management of United Artists deserve more credit in this than they have been given. They, after all, had more to lose and less to gain in the matter than Preminger. And they backed him up all the way.

But they, too, were businessmen, and they must also have engaged in a bit of wind-sniffing. If they did, they knew the wind was blowing in a favorable direction. All this happened, remember, during an election year. And not just any election year, but 1960, a watershed year in American politics. What may have been a calculated risk for all concerned paid off with the nomination and election of John F. Kennedy.

Kennedy himself played a part in the breaking of the blacklist. For both *Spartacus* and *Exodus* were picketed in a few cities, and among the most active in the campaign against them was a group who called themselves the Catholic War Veterans. A gesture from him in support of them could well have turned the tide against Trumbo and in effect would have reinstated the blacklist. Instead, John F. Kennedy threw his weight to the other side. The president-elect shortly after his election made a public visit to a Washington, D.C., theater with his brother, soon to be attorney general, where they crossed the picket lines and saw *Spartacus.* They asked him afterward what he thought of it, and he said simply that he had enjoyed it, that it was a good film. And if anyone doubted it, or wished to argue the point, that mild endorsement put an effective end to resistance from the Catholic War Veterans, or the American Legion, or the Motion Picture Committee for the Preservation of American Ideals, or the House Committee on Un-American Activities. The blacklist had been breached.

IN THE MATERIAL WORLD

So Trumbo, at last, was no longer a ghost. But others who had been blacklisted, bleak specters who had also been haunting the movie black market in Hollywood or who had perhaps drifted off to New York or to Europe, found the arduous process of materialization eased only somewhat for them by his success. He showed it could be done— and how. To win back their names, their identities, and their incomes, they would have to make themselves valuable to producers and directors, as Trumbo had done—so valuable that credit would be offered as a consequence of having proven their worth on the market. They would, in other words, have to work their way back. This they did, one by one, emerging from the shadows, blinking in the sunlight, suddenly, substantially there for the world to see.

Not that it was ever easy for those who struggled back. Not that the process went smoothly or predictably. For instance, the same year that Preminger announced Trumbo as the author of the *Exodus* screenplay, Frank Sinatra stepped forth boldly and declared that he had chosen Albert Maltz to write the screenplay for his forthcoming production of *The Execution of Private Slovik*. This caused an even greater furor than the one that followed Preminger's explosive report. The American Legion threatened—and in the end, Sinatra gave in. As it happened, his association with the Kennedy family may well have been the factor that put an end to these plans. He was known as a friend of the senator, who was by then the Democratic candidate for president. It was feared by those associated with the Kennedy campaign that Sinatra's action

might appear too "radical" and would reflect badly on the candidate. Therefore, a few weeks after his original announcement, Sinatra withdrew, saying: "In view of the reaction of my family, my friends and the American public, I have instructed my attorneys to make a settlement with Mr. Maltz and to inform him that he will not write the screenplay for *The Execution of Private Slovik*. I had thought that the major consideration was whether or not the resulting script would be in the best interests of the United States.... But the American public has indicated it feels the morality of hiring Albert Maltz is the more crucial matter and I will have to accept this majority opinion." There was, of course, no "majority opinion." Sinatra simply gave in to the personal pressures that were brought to bear on him. Years later, Maltz said of the episode and of Sinatra's conduct in it, "I hold him in high regard. I think he was very sincere in all this. Something just happened that he couldn't withstand. It all had the unfortunate effect of making me a hotter potato than ever." Maltz did not get his name back on the screen until 1967 with *Two Mules for Sister Sara*.

In spite of the Oscars he had won during his very active blacklist career, Michael Wilson was denied credit in North America for *Lawrence of Arabia* (playwright Robert Bolt's name was the only one that appeared on the screen) when it was released in 1962. Everywhere else in the world, however, he was acknowledged as co-author of the screenplay. Even Kirk Douglas withheld Trumbo's name from *Town Without Pity* when it was released in 1961—evidently because he felt the writer's name had been identified with too many of his films, and he didn't wish to seem dependent upon him. As late as 1966, screenwriter Lester Cole's name was deleted from the credits for *Born Free*. That was the year after Ring Lardner, Jr., made his comeback with *The Cincinnati Kid*. Writers as able and well established as Abraham Polonsky and Waldo Salt did not see their names on screen until 1967 (*Madigan*) and 1969 (*Midnight Cowboy*), respectively.

These are just a few examples—enough, I hope, to show there was neither pattern nor consistency to the lifting of the blacklist; that it became a matter between individual employer and employee, one usually with economic rather than political or moral implications. In general, the writers made it back before the directors (Jules Dassin, Joseph Losey, John Berry), and the directors made it back before the actors (Lionel Stander, Howard Da Silva, Zero Mostel, Jeff Corey). Some, as

noted earlier, never made it back at all. And still others—in many ways, these were the saddest cases of all—*almost* made it back from the blacklist without ever quite recovering from the mess it had made of their lives.

Adrian Scott was one of these. At the time he was summoned before the House Committee on Un-American Activities, he was a producer at RKO, the brightest, hottest young producer on the lot with hits like *Murder, My Sweet* and *Crossfire* to his credit. He was married to a star, actress Anne Shirley, and he had the respect of his coworkers because he had paid his dues as a writer (*The Parson of Panamint, Mr. Lucky*) before becoming a producer. He had, in short, everything going for him, every reason to cooperate with the Committee, to tell them whatever they wanted to know and get on with his career. But that he would not do. He kept faith with the rest, followed the game plan, and pleaded the First Amendment. And like the rest he went to jail.

He was one of the most decent men I have ever met. There was nothing sanctimonious about him, nothing of the professional victim. His chin was up. He talked of his plans for the future. He was still going to show them what he could do.

A young man of thirty-four at the time of the hearings, he was himself almost movie-star handsome then, resembling the French actor Jean Marais a little in some of the photographs of the Ten. But the man who presented himself when we met for lunch in Beverly Hills was an aged caricature of that younger self. He was fifty-eight, and he looked older. His face was heavily lined, his skin somewhat yellowed, and his tall, angular frame barely filled out the dungarees and chambray shirt he wore that day. He seemed, well, sort of unhealthy. He was.

Scott asked, as we sat down, if I didn't think that people were a little tired of this subject of the blacklist by now—indicating, to me at least, that he was tired of talking about it. When I told him I didn't think so, he allowed that I was probably right because I was the third person in as many months who had come around to talk. "I'm amazed," he said, "at the knowledge of the period you people show and your interest in it."

He carefully banged out the corncob pipe he had been puffing on and dug out the dottle at the bottom of the bowl—all done neatly into the ashtray. "It's me, I guess," he resumed. "I'd just as soon blot the

whole experience from my memory. It complicated my life terribly. We assumed the blacklist wouldn't last permanently, and frankly we didn't think it would last as long as it did. That it ended at all was due to the work of Dalton Trumbo. You have to give him credit—the Robert Rich episode followed by his credits for *Exodus* and *Spartacus,* well, it was just too much for them. The blacklist had been broken by one man. That showed it could be broken by all."

"When did it end for you?" I asked him.

"The blacklist? That's a little hard to say. In 1961, we went to England, and I began to do some work there, but I didn't begin functioning openly even there until 1963. You see, a little while after the hearings in 1947, I went to Europe with an eye toward doing some work there then—things were starting to open up there in pictures at the time. But I went on some kind of temporary five-month passport, which was not to be renewed without a decision by the State Department. I was in the process of setting up a picture when they refused to renew. I had friends in England and France who said I was foolish to go back then, because I knew by this time I was going back to stand trial for contempt of Congress, you see. They said they'd hide me out and then fix it up with the government. I was tempted. It could have been arranged. But nine of us couldn't go to court with the tenth on the lam. That would have made it impossible for the rest who were left.

"So by the time I could leave the country, which was 1958, I was interested in going abroad because of the possibilities I had seen in Europe right after the war. But I didn't get the opportunity to go until 1961 when I was hired as executive assistant to the head of M-G-M's English operation. I can't account for it. He just hired me. Nothing was said about my past or what I had been doing the last dozen years or so. He knew, of course, but he just hired me, and told Metro later. I was kept more or less under wraps, though, for the first two years. And so, from 1961 to 1968, I was in England, and there was no problem whatever with the blacklist. Sometime during that period, I guess, you could say that was when the blacklist ended for me."

"And what *had* you been doing before?" I asked. "During that last dozen years or so?"

"During the fifties, you mean? What saved me was TV. It was a matter of feeding the monster. I worked under the table on television from 1954 to 1961—totally as a writer. To be a producer, of course, there

has to be a body to appear at conferences and so on. And my body just wasn't acceptable."

Adrian Scott made contact with a young lady named Joan LaCour who wanted to write for television. She had no experience, but she did have ideas, energy, and a name to offer. They formed a partnership, these two. In the beginning, she merely fronted for him, proposing his ideas, delivering material he had written, and sitting in on rewrite conferences with story editors and producers. The credits and 50 percent of the money they earned went to her. But as time went on, she began to take a more active part in the enterprise, and it became something more in the nature of a true collaboration—ideas tossed back and forth, lines written and rewritten between them. The split of the take remained the same, though, for the two eventually married. Then came England and what were very good years for them. But Adrian Scott wanted to return. There were a couple of projects he wanted to mount, personal projects, things he believed in. With the new climate in Hollywood— it was 1968, after all—he thought he might be able to function once again as a writer-producer.

"I left Metro in England," he continued, "and came back here and free-lanced for a while—television again. But what I was really trying to do was get back into producing feature films. I almost pulled it off. I got up to the starting line a number of times with projects, only to see them fall apart. It happens all the time. It had nothing to do with being on the blacklist. Finally, I did get one through, and I think it turned out pretty well—*The Great Man's Whiskers*. It was a two-hour television children's feature that I did at Universal. It was from a play I had done—oh, let's *see, years* before, even before the blacklist. Did you happen to see that?"

"About Lincoln before he became president?"

Scott nodded.

"Yes, I did. I liked it. Good production and a good script."

He looked at me a moment and must have decided I really meant it, for he smiled then, and went on: "I've got another script about my prison experiences—not really autobiographical but about prison and prison reform. I was afraid that because it's basically a polemic, people would say it's not entertainment. But it's funny in a kind of Rabelaisian way and pretty human, and I've gotten a pretty good reception around town with it. I'd love to produce it, as well, and if I do a good job on it, I

have a reasonable expectation of being sought after. That's the way this town operates. If you have something they want, then that's it. You're back on top. And I really think this prison picture is going to be made."

"And in the meantime?"

He shrugged. "Television. *Ironside, The Bold Ones,* what have you."

"So much of this just happened to you," I said to him. "You couldn't choose not to be blacklisted. You couldn't choose not to be called up before the Committee. In the limited area that choice was open to you, would you have done things any differently from the way you did them?"

"I think you're asking me in a gentle, roundabout sort of way if I might give names if I had it to do over again."

"Maybe that's what I'm asking."

"Well, if that's the question, then the answer is no. I would still not cooperate—even if I were hauled before the Committee tomorrow. Because I sincerely believe that if there is an American fascism, then the House Un-American Activities Committee is an agency of it."

He paused, sighed, and then continued: "But let's see. Would I do anything differently? Well, I made a number of speeches in the heat of the moment back then that today seem oversimplistic to me in what they said. If I had it to do over again, I would write them better and make fewer of them. And also, I would take the Fifth Amendment and not the First. We knew we were taking a chance, and it seemed worth it at the time, but now I see it was just so much lost time, going to jail. It did no good. The only good thing that happened to me there was that Dalton Trumbo and I became good friends. We were in Ashland together, and that was where we really got to know one another. He's been a friend, a real one, ever since."

We talked on through that lunch. In the course of it, he revealed that his second marriage (to Anne Shirley) had broken up as a result of his refusal to cooperate with the Committee, and he also told me that on and off afterward, his health "hadn't been good." As for the blacklist, his final word on that was that there had been complications to it—"social complications, financial complications, every kind you can think of—that just couldn't be imagined, hardly even described. But why try?" he added. "It's over now, anyway, I guess."

As we finished, standing in the lobby of the place, saying our goodbyes, I felt called upon to say something to him, anything, in

commiseration. Finally, I put out my hand and said, "Mr. Scott, I don't know what to say. I think you've had more than your fair share of trouble heaped on you in your lifetime. I just want you to know I'm sorry."

He nodded. "Yes," he said, "I guess I have. I appreciate your saying so." He left then, and that was the last I saw of him. He died a year and some months later of cancer.

There were other deaths. The years following Trumbo's return from the blacklist, which were by and large happy ones for him and his family, were punctuated at intervals by incidents of death and episodes of dying. Hugo Butler, Trumbo's junior by a decade, was the first to go. It was a grim, sad story, marked by a sudden personality change which Jean Butler took at first for a nervous breakdown. He separated from his family and went for a while to live with the Trumbos while he got psychiatric help, which was really no help at all, for it was discovered at UCLA Hospital five weeks before he died in 1968 that his problem was physiological—Alzheimer's disease. "Trumbo helped pay the money to get treatment for him," Jean Butler told me. "Then, for a while, he and Ingo Preminger and Bob Aldrich were kicking in each month to support the kids and me. This went on until we could sell the big house we had with a swimming pool and all. For a while there we were living in poverty—but we had a swimming pool. Now I've been getting some writing jobs myself, and we're getting back on our feet."

One of the Hollywood Ten, director Herbert Biberman, who was not perhaps a friend but a comrade of Trumbo's and a friendly adversary, died in 1971. Cancer again. Biberman had been the driving force in the making of the all-blacklist feature, *Salt of the Earth*. After repeated attempts to get back into films as a director during the sixties, he succeeded at last in 1969 when he got a chance to direct the Theatre Guild's feature, *Slaves*. Neither critically successful, nor especially successful with the black audiences at which it was aimed, the picture put him back more or less where he had started, scrambling to put together another feature. That was where he was when he died—another, like Adrian Scott, who *almost* made it back from the blacklist.

Earl Felton, completely apolitical and one of Trumbo's oldest and best friends, committed suicide in 1972. It had been Felton, of course, who picked out Cleo for Trumbo and introduced them. And he had

also been among the first to offer to front for Trumbo on the black market. An unhappy man, crippled and physically deformed from birth, he sustained himself for years only with his wit and energy and his passion for friendship. It was only his energy that failed him, but when it did, he gave in at last and shot himself. Afterward, his friends—a disparate group that included Trumbo, Richard Fleischer, Edward Anhalt, and Stanley Kramer—gathered to scatter his ashes out on the Pacific and toast his memory at a nearby bar.

Maud Trumbo died. Dalton's mother was eighty-three. She was weak and had been in generally failing health for years. Whatever difficulties had arisen between mother and son through the years had long before been resolved. They were friends. Trumbo had a big birthday party for her on her eightieth birthday. The Trumbos, all of them, remembered it as a grand family occasion, full of fun and laughter at the old stories. A family reunion. Maud came in an ambulance, had a high old time with her children and grandchildren, and when the time came to leave, she didn't want to go home. She kept sticking her head out of the back door of the ambulance to add one more comment and poke one more bit of fun. They liked to remember that as the way she left them—and not the long period in the hospital room.

Things were quite different for Dalton Trumbo when he resumed his career as a screenwriter under his own name. There was a hiatus, a kind of enforced vacation undertaken at the orders of a doctor. Trumbo had, during the last few years, worked himself to a state of exhaustion. And so, in the spring of 1960, he and Cleo accepted Otto Preminger's invitation and, crossing the Atlantic for the first time, visited the *Exodus* location on Cyprus. Trumbo's status there was strictly defined by Preminger his first day on the set. As the crew was setting up to film a scene, Peter Lawford spied the Trumbos sitting off to one side and looking on. He came over and quietly and earnestly began to discuss possible changes in his lines. Preminger, who is absolutely locked into a script once he begins production, observed this narrowly from some distance away and marked out in that drill sergeant's voice that Lawford was not to discuss changes of any sort with Mr. Trumbo. "He is here as a guest and not as a writer," said Preminger. Lawford's reply was a meek, "Yes, Otto," and that ended it there.

The movie business itself changed drastically during the course of the sixties. The preceding decade had seen the movies at war with television, a war the industry had no real hope of winning. Movie theaters were closing down all over the country; audiences huddled in twos and threes, hidden away in their living rooms, giggling at *I Love Lucy,* thrilling to *Have Gun, Will Travel,* nodding in sober agreement at the homilies by Ronald Reagan tacked onto the end of *Death Valley Days.* This mass audience was, by and large, lost to motion pictures during the fifties. But it took the men who run the industry many years into the sixties, and many lost millions in movie extravaganzas, before this lesson was learned. (And they may not have learned it yet!) Because Trumbo had been propelled into prominence during the breaking of the blacklist, he was then the best-known screenwriter in Hollywood, probably the only one at all familiar to people outside the industry. And because the two pictures with which he did finally come out into the open—*Exodus* and *Spartacus*—were enormously successful, this modest celebrity was instantly translated into stardom, or the closest thing to it a screenwriter could claim. This made him, according to the reasoning popular at the time, the ideal writer for the sort of lavish, big-budget productions that were made in the increasingly desperate effort to attract people away from their television sets and into the theaters. When a producer could say, "I've signed Dalton Trumbo to do the script," he had a much better chance of putting together the sort of package of stars and director that he would need to attract the multimillion-dollar financing which became the rule during the period.

As a result, Trumbo wrote only a handful of films* in the years following the blacklist but made a great deal more money. His fee increased with the projected budget of the production—standard practice in the movie industry. In many ways, his situation (working much less for very much more money) was quite ideal, but there were signs that he himself was not entirely pleased with it. The clearest of them was that following a run of such projects he plunged into his own small-budget,

*As with every screenwriter, the number he wrote exceeded the number actually produced. He was involved in several projects during the sixties which, for one reason or another, were never done. Among them: *Sylva,* an adaptation of the novel by the French writer Vercors; *The Dark Angel,* on the siege of Constantinople; and *Bunny Lake Is Missing,* which Otto Preminger eventually produced though not from the Trumbo script.

independently financed production of *Johnny Got His Gun*. Except for *Lonely Are the Brave* (more of that one later), which was begun during the blacklist though finished afterward and released in 1962, things went wrong with all those big movies of his in production.

Of all the costly mistakes made by producers and studio executives during this period, the most disastrously expensive was *Cleopatra*. It very nearly left Twentieth Century-Fox bankrupt. The production became an almost legendary example of all that can go wrong with a film when its stars—in this case, of course, Elizabeth Taylor and Richard Burton—exercise near-complete control over it. As it happened, Trumbo became involved in a Taylor-Burton film just a couple of years later that failed (though less spectacularly) for the same reason. He had taken an assignment writing a screenplay for Dino De Laurentiis, *The Dark Angel*. He and Cleo lived in Rome while he was working on the script, and when he had finished, he let it out that he would be willing to take on a short assignment—a "polish"—so they could stay on there a little longer. A producer, Martin Ransohoff, who had heard the story of Trumbo's collaboration-by-mail with Michael Wilson during the blacklist, asked Trumbo if the two of them might like to try the same thing on a script for Taylor and Burton. With Wilson in Paris, and facing the happy prospect of staying on a while longer in Rome himself, Trumbo took a look at the money Ransohoff and M-G-M were offering (which was considerable) and agreed.

It was no "polish" job, though. The two of them plied their trade as professionals, following the same routine that had worked for them earlier on the blacklist westerns: Michael Wilson did the story and sent it off to Trumbo, who then did the screenplay. What they came up with was a script that pleased everyone concerned, not least the Burtons—or so they said. In production, however, improvisations of every sort altered the tone, style, and sense of what they had written. Their little picture about a beach girl who lives in a hut on Big Sur was transformed into one about a rather mysterious matronly woman (Mrs. Burton didn't feel like losing the weight that looking twenty required) who lives in a glorious beach house, changes costume twenty-two times in the course of the picture, and talks as though she were living hand-to-mouth. Richard Burton himself either couldn't remember the lines or chose not to. In any case, he ad-libbed freely, often changing the content of scenes. It was a mess. Audiences laughed when it was

previewed. Critics attacked it unmercifully. *The Sandpiper,* released in 1965, sank without a trace.

With *Hawaii,* there were other problems. This one was, at least at its inception, the biggest production with which Trumbo had ever been involved. The screen rights to the James Michener novel had been purchased for six hundred thousand dollars. One screenwriter, Daniel Taradash, had been brought in already on the project and had done what seemed to Trumbo quite a creditable job of adaptation. Still, the Mirisch brothers, who were producing the picture, wanted something different. And Fred Zinnemann, who was then set to direct it, brought in Trumbo. Fundamentally, the problem with *Hawaii* was similar to the one *Exodus* had offered earlier: that of adapting a novel which was just too big to be made into a movie. Where Trumbo and Preminger had earlier solved it by taking the climactic episode and making the picture from that story alone, this time Trumbo and Zinnemann handled it by preparing to make not one but two movies from the novel. Director and screenwriter worked fairly closely on the scripts— *Hawaii I* and *Hawaii II,* as they were designated—for about a year. But United Artists, which was financing the project, got cold feet, for the two-picture approach would have cost fifteen million dollars; they said it would have to be done in one big movie. At that point, Fred Zinnemann withdrew from the project and, after a delay, George Roy Hill came on board. When he did, he had his own 350-page script of *Hawaii* under his arm. Everyone—Hill included—knew it was far too long, and so Trumbo was brought back in to work with him on it. The two approached one another warily but ended up working closely together, ultimately in complete agreement and as very good friends. When they finished, they both knew that the script United Artists had agreed to go with was still too long, but it held together, and they were pleased with it. But after a portion of the picture had already been shot, United Artists tallied up recent losses on other films and sent word to George Roy Hill that the script simply had to be cut in half. In other words, they were going back, in mid-production, to the *Hawaii I* and *Hawaii II* concept—though doing it on the cheap. Trumbo came out to Hawaii himself; he and Hill worked feverishly during production trying to save at least one picture from such radical surgery. By and large, they succeeded in doing that. Their *Hawaii,* which starred Max von Sydow, Julie Andrews, and Richard Harris, does have style and a

certain epic sweep. But dramatically, there is a kind of sustained gray-
ness to the picture that would have been relieved if the second story
(about the Chinese in the islands) had not been ripped out so rudely
and at so late a date. A few years later another picture was made from
this material, but neither Trumbo nor George Roy Hill had anything
directly to do with it. It came out so badly that it was barely even let out
by United Artists.

Trumbo's commitment to *The Fixer* was more profound than to
the other two. Trumbo, director John Frankenheimer, and producer
Edward Lewis each deferred one-third of their salary just to get the
picture made. None of them was likely to get back that third, for it was
the kind of movie that would not turn a profit. Part of the difficulty in
making a successful film of *The Fixer* was inherent in the novel itself. It
is not, certainly, that it is inferior material; on the contrary, it is argu-
ably "too good" for the movies. But that won't do, either, for finally
the literary qualities of a book offer no direct index to its suitability for
film. Some of the trashiest books make the best films, and sometimes
(though less often) the best books make the worst films. But what the
author Bernard Malamud managed to accomplish with the density and
texture of his prose was to provide insulation—or more, a certain sense
and dignity—to the squalid, brutal story of injustice told in *The Fixer*.

Some novels (and for very different reasons) simply defy translation
to the screen. *The Fixer* may have been one of these; *Johnny Got His
Gun,* as we shall see, may have been another. To have reproduced the
overt action of the Malamud novel would have been to make a movie
that was unendurably grim and brutal: an audience tends to back off,
to withhold empathy, when things get too rough. Trumbo knew all
this and carefully constructed his screenplay so that the psychological
and physical brutality to the defenseless Yakov is relieved by episodes—
little victories—in which the fixer fashions a device for keeping time,
or fantasizes an assassination of the czar. He added a couple of others,
too, not involving Yakov directly, in which the scene is shifted from
his cell, and the audience is given at least temporary liberation from
the claustrophobic restriction of the jail setting. These sequences are
all important to the dramatic pacing of the script, and that is why they
are there—ultimately to keep a hold on the audience. They were in the
final draft of the script, and they were shot by director John Franken-
heimer. But these were precisely the bits that were edited when the film

was trimmed down to final cut. Not only that, but the beating adminis-
tered to Yakov in the film far exceeded what was called for in the script.
In fact, it was so graphically real and severe that in the filming of the
sequence Alan Bates's well-padded double sustained two broken ribs at
the hands—or rather, fists—of the guards who were, of course, doing
their best to pull their punches for the camera. In other words, John
Frankenheimer chose to emphasize precisely those elements in the film
that would alienate the audience, while cutting those that might have
attracted and held it. This had predictable results: the audience *was*
alienated, and so were the critics. *The Fixer* failed with both.

It may seem that I am doing all I can here to shift blame from Trumbo
for the relative failure of these three pictures. But all I am doing, really,
is underlining the collaborative nature of film. With all due respect to
the *auteur* theory (which asserts that the director is the "author" of the
motion picture), the very essence of filmmaking is such that it requires
the participation of a whole company of artists and craftsmen, and even
of businessmen, each of whom makes his separate contribution, and
any one of whom may tip the balance in the direction of success or
failure for any given production. This is both the strength and weak-
ness of the process. To what extent can even an auteur-director such
as Vincente Minnelli be given credit or blame for a picture like *The
Sandpiper*? Or, for that matter, just how culpable are Dalton Trumbo
and Michael Wilson? In neither case can they be said to have had much
responsibility for the final product—not when the two stars of the pic-
ture exercised the degree of control over it that Elizabeth Taylor and
Richard Burton did over that one. And wasn't the true *auteur* of *Hawaii*
the head bookkeeper at United Artists, who decided in mid-production
to eliminate an entire subplot from the script? Wasn't it he who gave
Hawaii its distinctive quality—not the director, George Roy Hill?

Trumbo would be the last to dispute the primacy of the director on
any given production, or to deny him his place as the focal figure in
any aesthetic consideration of film. "There must be an absolute suprem-
acy of the director," said Trumbo. "No one, in any way, must try to
undermine his authority. That means [the writer] must be very care-
ful in talking to an actor, because actors always want things changed."
Trumbo worked comfortably in the old studio setup in which writer

and director were usually kept quite apart, and he worked just as comfortably under the practice, which encouraged a much closer working relationship between writer and director. He was actually available and on the set during the production of four of his eleven post-blacklist films.

One of these, of course, was *Papillon,* in which he was not often on the set but was constantly available at a nearby hotel working only pages ahead of the shooting schedule. "On that one, for example," said Trumbo, "Frank Schaffner and Steve McQueen and I were talking about a knife fight that occurs in the hold of the boat at night. Well, I don't bother to describe those bloody fights in the script, or even pretend to. When you get to a fight you simply say what must happen, and then you go on. But Steve had a lot of ideas about it. He had a great deal of power in this picture—he was getting paid two million dollars, and that's all the power you need. . . . We were talking about it there in the hotel, and I said, 'What happens is up to Frank. He'll figure it out when you get there and when you're doing it.'

"And McQueen said to me, 'You be there, too, because you can call me out [tell me what to do].'

"And I just said, 'No, I won't. I'm not going to come.' Frank was sitting right there as we were talking. I said, 'I would never call an actor out. I never would talk to an actor without the director being with me and wanting me to talk to the actor.'

"And Steve just said, 'Well, I see you're being a very nice guy, and I suppose I don't know the pecking order.'

"I said, 'It's not the pecking order. It's a professional obligation.' And it truly is. A writer on the set in this way is a temptation, an open invitation to change, and unless he is highly ethical he can undermine the director, and he can harm the picture."

One factor that gave Trumbo an edge during his days writing on the black market was that he came about as close as a screenwriter can to guaranteeing his work. When he took a job, it was with the understanding that he would make all changes necessary, in order to bring the script to the point where it was ready for production. And unlike many screenwriters of the day, Trumbo wrote then—and continued to write—*shooting* scripts, with fairly detailed camera instructions together with dialogue and action. The point is, he continued to be a *participating* screenwriter, one who wrote explicitly for production and

implicitly subscribed to the dictum that there are no great scripts, there are only great films.

"In a sense," said Trumbo, "the writer is the ship's architect, and the director is the captain. It may have been a greater achievement to have designed some particular ship—still, if that ship is not sailed right, it is going to sink. So I've never felt any form of rivalry, or had any trouble with directors."

Which is, in a way, quite remarkable, for a desire for recognition grew in later years among screenwriters. Some simply envied the power of directors and wished to become directors themselves; when and if they did, their problem would be solved. For others, the matter was more complex and not so easily dealt with. Unlike Trumbo, they felt that writers were not given sufficient credit for their contribution to the finished film, and that they should be given a much stronger voice in production. What they sought was a relationship between writer and director much nearer to that of the dramatist and the director of the play. (The standard Dramatists Guild contract stipulates that no change can be made in a playwright's work without his consent; screenwriters, of course, enjoy no such control over their work.) In support of this insurrection there even developed a kind of counter-*auteur* theory of cinema, which argued that in many cases the true author of the film is not the director, but the author of the screenplay.*

One difficulty with such theorizing is that most movies are made from some previous source: a play, a novel, or a narrative of some sort. "The industry is based on adaptation," said Edward Lewis, who worked with Trumbo on a number of pictures. "Originals are written by two kinds of writers—those who are starting out and those who can take

*The author and chief promoter of this counter-*auteur* theory, a young critic named Richard Corliss, had surprisingly little good to say of Dalton Trumbo. In fact, he attacked him in his book *Talking Pictures*. In the normal course of things, this would be the proper occasion for me to defend Trumbo against Corliss and to refute whatever *charges the critic* has brought. This, however, is not so easily done—not because they are irrefutable but because they are not easily understood. That Corliss finds Trumbo unsatisfactory as a screenwriter is obvious from a casual reading of the essay, but he is maddeningly unspecific as to just why. He makes only two direct but practically unsupported statements about Trumbo's work: (1) that he wrote "predictable, simple-minded scripts"; and (2) that "Trumbo's most characteristic films are thinly disguised tracts." (I shall be just as arbitrary: both statements are false.) The rest of the essay is all innuendo and disparagement-by-tone—a put-down masquerading as criticism.

time off, who may not be in demand." Neither described Trumbo's situation. And as a result, all but one of the movies he did after coming off the blacklist were adaptations from a book source of some sort. That single exception, *Executive Action,* was an extensive rewrite of an original screenplay by Mark Lane and Donald Freed. The best of all his post-blacklist movies, in fact, was an adaptation, which according to Trumbo required very little in the way of alteration to bring it to the screen: "*Lonely Are the Brave*—now there's a picture in which I got more credit than the director, David Miller. It was unfair, in my view, and I wrote a letter to *Newsweek,* pointing out the contribution of the director, who was not even mentioned in the review. For God's sake, he did the picture! And what about the young professor, Edward Abbey, who wrote the novel? *The Brave Cowboy,* which was his title, was a very good novel, and I followed it very closely because it required very little."

It did, of course, require something. Compare the novel, *The Brave Cowboy,* with the film, *Lonely Are the Brave,* and you find in the latter a general shift of emphasis to the final part of the story, the pursuit of the "brave cowboy" by a modern sheriff's posse, complete with helicopter and airplane. The anarchist message of the novel has been muted slightly—not because it is anarchist but because it is a message. Since this is a narrative translated into a drama, the dialogue must bear a greater burden of exposition, and because it is a drama in a *visual* medium, there should be less of it. As a result, very few lines in *Lonely Are the Brave* have been taken word for word from *Brave Cowboy.* But the characters remain the same; the construction of the movie is essentially that of the novel; and it says implicitly the same thing. Everything that Trumbo did in adapting it enhanced those qualities of the novel that had made it right for film in the first place.

Could Trumbo then be put forward as the "author" of *Lonely Are the Brave*? Obviously, he doesn't think so. He could, of course, stake a much stronger claim on, say, *Spartacus* and *Exodus,* two adaptations of much inferior novels with which he took far greater liberties; both screenplays are arguably better, even as literary works, than the originals from which they are taken. But even here his contribution is something less than a piece of pure creation. That he came to do them at all was more or less the luck of the draw, as are most assignments for most screenwriters (the very term "assignment"—a job to be done—connotes this). And once he took them on, his artistic choices were

severely limited by any number of factors, the original material not least among them. Any adaptation, then, no matter how "creative," is likely to be only ambiguously the work of the writer whose name appears in big letters up on the screen.

And what about originals? He wrote a number of them during the blacklist, when he was obliged to keep busy every moment of every working day—even when he was writing on his own and between assignments. He found himself then almost in the position of a beginner, having to establish himself anew with each script he did and prove himself worthy of the cut rates at which he was being paid. He did that, again and again, more often than not in the beginning with originals. They were good, workman-like jobs, most of them genre films—thrillers like *Gun Crazy, The Prowler,* and *He Ran All the Way*—in which he proved he had not forgotten the lessons he had learned working on the B units of Warners, Columbia, and RKO. His Academy Award film, *The Brave One,* was simply a genre picture of another sort, the kind they call a Disney picture, the story of a boy and his bull, the same kind of child-and-beast story that had been done before and has been done often since. In writing all these, Trumbo was working within fairly strict limitations: the rules of genre (what has worked before becomes a "rule" all too quickly in the movie business); the exigencies of budget (working for independents like the King brothers, who made their movies on a shoestring, he was limited on the size of his cast, the number of sets, and so on); and on a couple of occasions by the story requirements of a producer (when Sam Spiegel said he wanted something on the order of *Double Indemnity* and had a story outline in hand, as he did for *The Prowler,* then that's what he got). Screenwriting of this kind, done to very specific requirements, is the equivalent of genre-writing in fiction: a mystery must begin with a murder and end with a solution. John D. MacDonald acquitted himself admirably writing paperback thrillers, yet nobody, I think, accused him of committing art.

The most truly original of all Trumbo's blacklist originals was *Roman Holiday.* One of the few comedies he did, it is certainly the most charming and distinctive of Trumbo's films, so universal in its fairy-tale appeal that it was at least as popular in Soviet Russia and Japan as in the West. Who can resist the story of the princess who plays hookey? What writer would not be proud to let his reputation ride on it? Yet he did it

in the darkest days of the blacklist, with Ian McLellan Hunter fronting for him, so that it is a film—one of the few during the period—that Trumbo is not even rumored to have written. And quite frankly, the question of authorship, in this case, is a bit fuzzy, for though Trumbo wrote it as an original screenplay, Hunter came on at Paramount and did a lot of rewriting on it before he himself was blacklisted. Then John Dighton worked on it after that, bringing it to the shape it was in when William Wyler shot it. With such a history, if *Roman Holiday* were to have been submitted to the Guild for arbitration, it would probably have come back as one of those monstrosities with three names on the screen for writing credit. To what extent is it Trumbo's? or Hunter's? or Dighton's? Weren't most of the changes in it made to satisfy the director, William Wyler?*

Trumbo was fond of saying, "Movies are an art that is a business, and a business that is an art." But Jean Cocteau once said, even more persuasively, "Films will not be art until the materials to make them are as cheap as paper and pencil." The screenwriter's materials are as cheap as paper and pencil—in fact, that's more or less what they are. However, what a screenwriter brings forth is not a film, it is a screenplay. And for that screenplay to become a movie, the writer's personal vision will, almost certainly must, be compromised. "No script can be shot as written," said Trumbo. "It cannot be done. Not necessarily major changes, but a piece of business, at least, or a scene, that may be the director's, or the producer's, or the actor's." But *something* anyway. Even to that limited extent, then, the screenwriter is denied authorship—as he will be, too, in production, on the set, where his lines are interpreted, where the shots he has called are set up, and the entire visual character of the film is established. And finally, even in the editing process, the screenplay will be further altered, sometimes in very subtle ways—perhaps a word or a line trimmed, or a reaction shot inserted, all of which may change the meaning of an entire scene. But the end result of this long and complicated process is the finished film, and unless the screenwriter controls the process, he is not the author of the film.

*On January 11, 2011, *Roman Holiday* was submitted to the Guild by Tim Hunter on behalf of Christopher Trumbo, who passed away three days before. The Guild did indeed restore the credits for *Roman Holiday* as follows: Story by Dalton Trumbo; Screenplay by Dalton Trumbo and Ian McLellan Hunter and John Dighton.

It is not for nothing that the question of authorship has been thrashed and re-thrashed by the *auteurists* and *counter-auteurists*. For only the author of the film is—or can be—its artist. All the rest of his collaborators, no matter how important their individual contributions, can be considered only craftsmen. Trumbo's success as a screenwriter may be attributed directly to his grasp of this fundamental principle. He was satisfied with his role as a collaborator. Not that he was docile or could be intimidated, or that he was unwilling to argue fiercely on points that he felt worth arguing. But finally, he was a film craftsman—not an author and not a film artist—willing to take a craftsman's pride in his work, in getting the job done. Nobody knew the rules better than he, and therefore nobody played the game as long or as successfully.

The two of them never really got along. In a way, you couldn't expect them to. Trumbo was irascible, extravagant, almost obsessive in his likes and dislikes. And Alvah Bessie was much the same: "I have a genius for alienating people like Trumbo has," he said—and he was right. But he also attracted them similarly. A tall, gaunt character, in his seventies when I interviewed him, Bessie lent the Hollywood Ten, a singularly conservative-looking and well-tailored band of rebels, a certain dash of left-wing adventurism. At the time of the hearings, he looked tough and ready, a veteran of the Abraham Lincoln Brigade who sported a Clark Gable mustache and was better known as a writer than most of the rest, except for Trumbo and Albert Maltz. He was a novelist. He had then published three books: *Men in Battle,* his Spanish Civil War story; and two proletarian novels, *Bread and a Stone* and *Dwell in the Wilderness.* However, with only two years in at Warner Bros., he was barely established as a screenwriter when his subpoena came and was in bad financial shape even then. Except for one season of success (his notorious Marilyn Monroe novel, *The Symbol,* made some money for him), the many years after that were one long scramble for survival.

"Sam Ornitz and I were the paupers of the group," says Bessie. "I had been blacklisted, in effect, a year and a half earlier, during the strike at Warners. When they threw pickets around the studio, the Writers Guild shop called a meeting to determine whether or not to go through the picket lines. I urged them to support the strike, and I guess I was pretty persuasive because it was on that basis they stayed away. But you

know how Hollywood is. When the strike was over, I was out at Warners. I hadn't worked in all that time when I got my subpoena with the rest."

We are talking in Alvah Bessie's office. It is attached to his modest suburban home in Marin County, just over the Golden Gate Bridge from San Francisco. The house is all he has to show for *The Symbol,* which ABC did as a Movie of the Week after scheduling, canceling, and equivocating nervously for a season as to just whether or not it was too "hot" for television. Bessie himself is a likable enough man, polite and fairly frank in these circumstances, though as a hard-bitten veteran of the Marxist religious wars, he must have been (as Trumbo must also have been) rather ruthless and tough in earlier days. There is some slight tension as we talk. I did not like his novel, *The Symbol,* and said so in a review of the book. He remembers, and though he makes no direct reference to it, I know he remembers, and so there is that between us.

Alvah Bessie did his year for contempt of Congress in the federal prison at Texarkana, Texas. When he was released, his prospects for employment on the movie black market were far dimmer than Trumbo's, even at the lower rates that then prevailed. There was never a lot of work to go around, and a screenwriter who was as unproven as Bessie simply hadn't much chance even with independents like the King brothers. The future looked pretty bleak when a phone call came from Harry Bridges in San Francisco. It happened Bessie had met the radical boss of the West Coast Longshoremen at a party at Trumbo's house in Beverly Hills toward the end of the war. "Bridges used to hang around Hollywood a lot back then to chase women," says Bessie. The two had seen one another on a couple of occasions afterward, but the phone call, when it came, was a complete surprise. Bridges asked him if he would like to come up to San Francisco to work for the local there. The money wasn't much, but it was a job, and Bessie was glad to get it. He worked for the Longshoremen's Union for five years, doing odd-job writing for Bridges and helping put out the local's weekly paper. "But then the International told Harry he had to contract his force, and I was the one who was elected to go," says Bessie. "Harry told me he could do my job with one finger up his ass. So I was out.

"That same week I bounced into a job at the hungry i in San Francisco. I knew guys who played there—the Gateway Singers, who became the Limelighters, and Professor Irwin Corey—and they heard I

was out of a job. So Irwin Corey took me in to Enrico Banducci, who is the hungry i, and I was hired at eighty dollars a week to run the lights. It took me five minutes to learn the job, and I stayed there twelve years. It would have been an ideal job for a writer if it had just paid enough because it gave me the whole afternoon for me to do my own work."

It was while he was there that he wrote *Inquisition in Eden,* his autobiographical account of the Hollywood Ten ordeal, and *The Symbol.* And all the while he was at the hungry i he kept after Trumbo to do what he could to get him some movie work, on or off the black market, for credit or straight cash. He would write chiding letters, sometimes almost desperate ones, asking for help in getting an assignment—rewrites, television, anything. And Trumbo kept writing back telling him that "you have to be close to the tit to get the milk"; that if Bessie were really serious about breaking back into movies, he would have to move down to Los Angeles. Although Alvah Bessie chose to remain in the San Francisco area, he did eventually manage to get some movie work. His son was then in Hollywood, working in production, and through him he got a shot at his first post-blacklist script, a thriller that was never produced. However, he did the adaptation of his novel, *The Symbol,* for ABC, and had hopes when we met for a couple of original screenplays he had done.

His relationship with Trumbo, an unequal and uneasy one, had led to bad feelings on both sides. "Well," says Bessie, "since you ask me what I think of Trumbo, I will say this: I think he has faults as great as mine but a talent much greater—or he had one. He's a poor boy who made it but never forgot where he came from. He's the only man I know of all of us who is still with the same wife he started with. All of us, including me, have had three wives. And just look at Cleo! What a woman! She looks the same today as she did in 1943 when I first met her. I told Trumbo that, and I told him, too, that he looked like something that had come out from under a rock—his eating and drinking habits are just ridiculous, and he takes absolutely no exercise."

"Well, all right," I say to Bessie, "but what's this trouble between you? This 'dead Bavarian' business?"

"Oh God, that! Really, it's a tempest in a teapot. I've always admired the man enormously. I don't see why that business should define our relationship. I *hope* it doesn't."

* * *

"What happened?" I ask. But before he can answer, his wife, Sylviane, arrives. It is late in the afternoon, and I realize I may have overstayed my leave. We have kibitzed and digressed far more than what I have written here would indicate, discussing his books, his projects, his plans for the future. His latest book, *Spain Again,* has him excited and he wants to talk about that. It's worth listening whenever Alvah Bessie wants to talk. His wife is a charming woman: colonial French, bright, frank, direct. I tell them both I think I had better be going, and Bessie walks with me out to my rented car.

"I've been thinking about this crazy disagreement," he says to me at the car. "You know, I've written apologies to him, to Cleo, to Chris. But frankly, I don't think I should apologize. I *tried* to tone down the piece. But somehow I've come out the villain, the devil of the entire business. You know, Trumbo called up Jerry Zinnamon afterward, and he wound up absolving him. He said, 'You exaggerated as all writers do. Bessie was responsible, not you. Bessie was the devil in the affair.'

"You know, his picture was a flop. Does he think it was my fault? This is the first picture he ever directed. That he should have decided that this was what ruined his picture, that *I* ruined his picture, well, that really scares me.

"The whole business, it's so sad, really."

What happened was this: After years of hoping, planning, and a little scheming, Trumbo had finally decided that the only way *Johnny Got His Gun* would ever be made into a motion picture would be for him to raise the money and do it himself. As early as 1940, an adaptation of sorts had been done. Jimmy Cagney played Joe Bonham in an hour-long radio play based on the novel. In spite of the limitations of time and those inherent in the medium, it was very effective. The first time a movie version was seriously discussed was just after the war and a little before the House Committee on Un-American Activities let the ax fall. At that time John Garfield was interested in playing Joe, and it looked as though a production might be mounted, but the hearings put an end to the project. Trumbo set it aside during the blacklist, though not out of his mind completely. In fact, it was because of the interest of Luis Buñuel, whom he had met earlier in Mexico, that he began work

in 1964 on the screenplay of *Johnny* himself. He did it all in that year, sandwiched between drafts of *Hawaii*. Once finished, he was pleased with it and so was Buñuel. Production plans were announced, but at the last moment financing fell through.

Trumbo was left with a script on his hands in which he firmly believed and of which he was sole owner. As America sunk deeper into Vietnam and each year more men were killed and wounded, it became almost a matter of urgency to him that the movie be made, that its antiwar message be communicated to a new and potentially more responsive generation. If it were ever to be produced, this was surely the time. That, too, was what Campbell-Silver-Cosby thought when Trumbo's old friend and admirer John Bright brought the screenplay to their attention. Bill Cosby, Roy Silver, and Bruce Campbell were the principals of an independent production company. Until then, they had only done a couple of the comedian's television specials, but they were interested in getting into movie feature production, and it looked to them as though *Johnny* was the right vehicle for such an entry.

This was in 1968. Campbell-Silver-Cosby undertook the project and began the complicated and chancy process of putting together a first production. In fact, the company dissolved in the course of these efforts, though this was due to other factors. However, Bruce Campbell, the youngest of the three, believed so in the production of *Johnny* that he proposed to Trumbo that they proceed on their own. Trumbo had already made it plain he would have to direct his own script; and Campbell, of course, with help from Trumbo in raising the money, would produce. On that basis, they worked at it through 1969, Campbell full-time and Trumbo giving it as much time as he could between jobs. The hardest part of all was raising the money. *Johnny Got His Gun* was simply not the kind of project that could be taken to a major studio for financing with any expectation of success, though Campbell did try it out on a couple of the more venturesome. Allied Artists actually came up with an offer which, however, didn't seem right at the time (it would have later on). In the end, of course, they did what they had expected they would have to do right from the start: they formed a private syndicate expressly for the production of the film and raised the movie's budget of six hundred thousand dollars through relatively small contributions by private investors; in other words, they financed *Johnny* the way that most Broadway plays are financed.

Casting was, in a way, less difficult. It is a measure of Trumbo's personal standing in Hollywood that once word was out on the production, there was no problem in interesting actors in the project—even though this was to be his first effort as a director. The cast that was finally assembled for the picture—which included Jason Robards, Diane Varsi, Marsha Hunt, and Donald Sutherland, all of whom have enjoyed star billing at one time or another—must have been the most illustrious ever for so small a production. Trumbo did find himself in a predicament, however, in filling the role of Joe Bonham. It was an extraordinary part: it was not just the lead; it held the entire picture together. And while a number of actors were considered for Joe (among them, Ryan O'Neal, Jon Voight, and Robert Blake), none had quite the qualities of vulnerability and innocence that Trumbo was looking for. It seemed he would have to go to an unknown to get it, but that suited him well enough. Only a few weeks before production was to begin, when the part had been tentatively cast, a young actor was brought to Trumbo who was just out of high school and had practically no professional experience. Trumbo took a look at him and was very interested indeed. He did a videotape test and knew he had his Joe Bonham. The young actor was Timothy Bottoms, and *Johnny Got His Gun* was his first picture.

They got the money for the picture together in March 1970. The thirteen-week shooting schedule began on July 2, 1970, and concluded in September. Alvah Bessie, Jerry Zinnamon, and "the dead Bavarian" figured in that schedule somewhere around the middle. Zinnamon was a writer whom Bessie had known in San Francisco. He had subsequently moved down to Los Angeles to try to break into movies as a screenwriter. He had some experience as an actor, though not much, and when *Johnny Got His Gun* was to begin production he was encouraged to try for a part in the picture by Bessie, who put in a word for him. There wasn't much of a part for Zinnamon, but since he was a friend of Alvah's, they decided he could play the dead Bavarian, that very prominent corpse who is festooned festering on the barbed wire just in front of Joe Bonham's trench. The image of the dead Bavarian recurs through the novel, and though it was naturally not a speaking part, it was at least prominent in the picture. So this was Jerry Zinnamon's role. It required three days of shooting. He came, he did his bit, and he left. Nothing at all out of the ordinary happened during

that time. Zinnamon came, went through costume and makeup, did an uncomfortable three days on the wire due to the intense August heat in which the picture was being shot—and then he went home. It was what happened afterward that made Trumbo furious, and with some justification. Zinnamon sent a long letter (seven typewritten pages) to Alvah Bessie in which he described in humorous, though not terribly accurate, detail what had happened during those three days. He embroidered, he exaggerated, he even told a few funny lies, probably without malicious intent. But when Bessie received it, he thought it was all so funny that he sent it on to *Esquire*. The magazine accepted it for publication, and it appeared in the December 1970 issue under the title "Letter from a Dead Bavarian." Trumbo did not take kindly to the joke, nor especially did he care for the untruths in the piece. He was then engaged in a life-or-death struggle to get his picture edited and in the hands of a distributor, and he was simply unwilling to laugh it all off. He wrote an angry letter to Bessie and talked to Zinnamon on the telephone, with the result that Zinnamon wrote a letter to Don Erickson admitting that many of the statements in the piece were "blatantly false," especially those about disharmony on the set. Too late, of course. The damage had been done—though Trumbo may well have overestimated the extent of it.

Bessie wrote his apologies to Trumbo and to Cleo and the younger Trumbos in two separate letters, insisting that he had not sent it to *Esquire* expecting that it would be published—or if so, that it would be published as it stood (in fact, some changes were made, though obviously not enough to prevent offense). *Esquire* had earlier that year published a humorously acrimonious exchange of letters between Trumbo and Steve Allen, which they titled "The Happy Jack Fish Hatchery Papers," and in another issue that year they published a selection of the blacklist letters which appeared in Trumbo's collection *Additional Dialogue*. Bessie declared that he had expected the magazine to honor "its friendship" with Trumbo by showing him the letter before publishing it. In any case, he was truly sorry and on a number of occasions afterward he sought to make public amends for his part in the affair.

It might all have been forgotten if things had gone a little better for *Johnny*. During post-production on the film, money began running low. With nowhere else to go for it, Trumbo dug into his own bank account and put up the twenty-five thousand dollars they needed to

finish dubbing and looping. What followed was, as he later called it, "a series of small calamities." Twentieth Century-Fox had offered the syndicate of *Johnny's* backers eight hundred thousand dollars for all distribution rights, but the company insisted on total control on the release of the film. Trumbo opposed the sale to Fox. Why? "I knew that this was not going to be an immensely popular picture. An honest truck driver is not going to take his wife and children and spend twelve to fifteen dollars to see *Johnny*. It isn't what they want to see. It did have an audience out there for it, however, and I thought that if we let it go for an eight hundred thousand advance, then that was all we would ever see from the picture. I'd seen it happen again and again. The picture would have to start out well, or there would be nothing done with it by a big major distributor." Trumbo argued persuasively that it would be wise to pass up the offer and hold out for a distributor that had experience handling pictures for special audiences. And in fact Donald Rugoff, whose Cinema 5 was doing extremely well just then with *Z*, was quite interested in *Johnny Got His Gun*.

"We took the film to Cannes," said Trumbo. "Cannes is a place where you sell." But by the time he arrived there with *Johnny Got His Gun*, he had so ruffled his investors by taking the stand he did against Fox that they withheld from him authorization to deal for the syndicate there on his own; he would have to convey offers to them and have them voted on before accepting or rejecting. (Rugoff had backed out between votes during the second or third go-round with the syndicate—that was how they lost him.) And so Trumbo was going to Cannes to show his film and attract offers that he was not free to accept. None of this would have mattered much, except that *Johnny* turned out to be a sensation of the 1971 Cannes Film Festival. It not only received the *Prix Spécial du Jury*, it also brought Trumbo the International Critics Award. He and *Johnny* were on top of the world that night.

But what good did it do them? "When you win, as we did at Cannes, you should open in Paris within two weeks. And you should sell, sell, sell right then because that is the hottest you'll ever be. [The investors] didn't get around to selling the European rights until after our American opening, which was not good."

No, the American opening was not good. The important reviews from the younger reviewers who might have saved the film all ran against it. To what extent were they reviewing the film and to what

extent were they reviewing Trumbo? A curious reaction set in against him, especially among these same younger critics who seemed so determined not to be intimidated by his reputation that they approached every picture with which his name was associated with a sort of hypercritical, show-me attitude, so much so that the gang seemed almost to be lying in wait for *Johnny,* the only picture ever to bear his *auteur* signature.* And the job they did on it was something more than criticism and something less than a mugging.

But never mind that. What about the movie itself? Trumbo had bet everything on *Johnny Got His Gun;* not just money (though he was to lose plenty on the picture), but more than that, much more. For one thing, when a man undertakes to direct his first feature at the age of sixty-five, he is putting physical demands on himself that perhaps he should not. And in insisting that he could and should direct it, Trumbo was laying his reputation as a screenwriter on the line. It was not just any film he was directing, but *his* film, an adaptation of his own novel. It added up to this: there could be no further appeal; Trumbo was asking, *demanding,* to be judged, telling everybody the buck stops here.

He was perhaps too close to the entire project to see that the fundamental difficulty with *Johnny* as a film lay with *Johnny* as a book. The action of the novel takes place inside the head of Joe Bonham. He is not only a prisoner of his hospital room, he is a prisoner of his senses, a man forced to dwell completely within his memories, fantasies, and hallucinations. In his novel, Trumbo managed to sustain this brilliantly with the strength of his prose and by using devices borrowed from screenwriting (but because they have been once borrowed does not mean, simply, that they can be returned). Since film is a *visual* medium, Trumbo had to establish two realities: the objective one, in which Joe is situated in the hospital room with the nurse coming and going; but more important and difficult, the subjective reality that tells us in images what is going on inside his head. And what is more, Trumbo had to move from one to the other without disorienting his audience and thus losing it. This was a problem, all right, and by and large Trumbo solved it by technical means. The hospital sequences are in black and white, and the rest is in color. Moving from sequence to sequence and scene to

*"Dalton Trumbo's *Johnny Got His Gun*" is how the title appeared on the screen. In this rare instance, anything less would have been false modesty.

scene, action flows rather slowly because Trumbo made much heavier use of dissolves and fade-outs than is usual today—there are no jump cuts in *Johnny*. In fact, as Trumbo pointed out to me, "there is not a swift action in the whole movie." (This is not necessarily a good thing.) He also "opened up" the action quite successfully, mixing Joe's memories and fantasies and giving a free-ranging sense of movement to the entire film.

Trumbo achieved some remarkable things in *Johnny Got His Gun*. There are moments of extreme tenderness that translate beautifully from the novel: a number between Joe and his father which Timothy Bottoms and Jason Robards realize perfectly; and scenes with Kareen (played by Kathy Fields) that work perhaps a little better than in the book. Joe's Morse code breakthrough to the outside world is, just as it should be, tremendously exciting and moving. Let me underline that: whatever its flaws, *Johnny* is an immensely moving film. And its flaws are of the kind—bizarre imagery, occasional didacticism, and an almost relentless emotional intensity—that were forced upon the film by the novel. In fact, to do the novel at all as a film was to run the risk of alienating the audience, or a large part of it, through emotional overload—simply giving more than most people can take. Trumbo ran that risk, knowing perfectly well that he would lose some of the audience in the bargain ("the honest truck driver" and his family); yet the film never had a chance to find the audience for which it was intended.

In any case, it failed commercially. The North American distributor on which at last they settled, Cinemation, was probably the wrong one for it. *Johnny* actually did better in other countries—in Japan and France, for example, where it played successfully for weeks and weeks—than it did in America. "You really can't blame anyone for it," said Trumbo, "except that the investors should have understood these things a little better when they went into the film. When you make an investment, you make a gamble."

Trumbo had gambled. He bet his time—a year and a half of it—on the film. During that period, he drew a salary of ten thousand dollars and nothing more: "The result of all those months and months of no income is worse than no income. It becomes debt. The whole thing was quite a disaster for me financially."

Trumbo leased his share in the picture at a fraction of what he

himself had invested in cash. Late in 1971, he called up George Litto, his agent, who had succeeded Ingo Preminger when the latter retired.

"You know I'm not used to calling agents, George," Trumbo said to him.

"I know that," said Litto.

"But I'll tell you, I'm really busted. All the money I've got in the world is in my art collection. Can you get me a television show to write?"

"Dalton, if you do that, you'll never live it down."

"Well, maybe you're right. How about lending me some money then? That's what agents are for."

George Litto did lend him some money. He also sent some business his way. In 1972, Trumbo wrote *Executive Action* for Edward Lewis, which David Miller directed the following year. Litto brought him *The Osterman Weekend,* which Trumbo adapted from the novel by Robert Ludlum. And then, toward the end of the year, he came to him with a deal for good money which required Trumbo to do a running rewrite of a script right on location. The movie, of course, was *Papillon.*

CHAPTER THIRTEEN

HEROES AND VILLAINS?

On March 13, 1970, at the time when Trumbo was poised to plunge into the production of *Johnny Got His Gun,* he was honored by the Writers Guild with its Laurel Award. It is conferred annually on "that member of the Guild who has advanced the literature of the motion picture through the years and who has made outstanding contributions to the profession of the screenwriter." It proved to be an almost historic occasion, which was as the Guild had intended. The circumstances were such that the Laurel Award that year was extended as a conciliatory gesture—or more, as a symbolic request by the membership for forgiveness from one of the scores of writers whom the Guild had wronged in the blacklist. The Screen Writers Guild did not originate the blacklist but it did cooperate in it willingly and completely; otherwise it could not have been made to work.

Trumbo, of course, was alive to every nuance and vibration of the moment. He came prepared, not just to receive the award, which under the circumstances would have been enough, but also to address the moral issues raised by his presence there that night. Not that he held the membership responsible—more than half there were far too young even to have the facts of the matter firmly in mind. He knew this, of course, and in his short acceptance speech, he addressed them directly:

I presume that over half of our members have no memory of that blacklist because they were children when it began, or not yet born. To them I would say only this: that the blacklist was a

time of evil, and that no one on either side who survived it came through untouched by evil. Caught in a situation that had passed beyond the control of mere individuals, each person reacted as his nature, his needs, his convictions, and his particular circumstances compelled him to. There was bad faith and good, honesty and dishonesty, courage and cowardice, selflessness and opportunism, wisdom and stupidity, good and bad on both sides; and almost every individual involved, no matter where he stood, combined some or all of these antithetical qualities in his own person, in his own acts.

When you who are in your forties or younger look back with curiosity on that dark time, as I think occasionally you should, it will do no good to search for villains or heroes or saints or devils because there were none; there were only victims. Some suffered less than others, some grew and some diminished, but in the final tally we were *all* victims because almost without exception each of us felt compelled to say things he did not want to say, to do things he did not want to do, to deliver and receive wounds he truly did not want to exchange. That is why none of us—right, left, or center—emerged from that long nightmare without sin.

It was not merely a statement appropriate to the occasion. It went well beyond that. Trumbo was eloquent, generous, forgiving. He had, in that instance, been extended the powers of a priest, and as a priest he had granted absolution.

Some, even one quite close to him, felt he had gone beyond the mark. It so happened that the Laurel Award dinner coincided with the thirty-second wedding anniversary of Dalton and Cleo Trumbo. His attorney, Aubrey Finn, and Pauline Finn, both of them longtime friends of the Trumbos, attended the dinner with them. "When he made that speech we all heard it for the first time," said Finn. "There was no prior notice as to what he was going to say. I remember that in the car afterward, Cleo didn't like it. She didn't like it at all. She felt he had been entirely too generous."

And others, including some of the original Hollywood Ten, objected to what he had said. Lester Cole, for one: "I didn't agree with that 'only victims' speech of Trumbo's. It really came as a shock. It was like Ford pardoning Nixon, if you ask me."

Alvah Bessie: "Well, *I* thought there were villains and heroes. And it seems to me he used to think so, too. There *were* villains, all right, and if there were heroes, Trumbo was one of them."

But of them all, Albert Maltz was the most intransigent and outspoken in his opposition to Trumbo's Laurel Award speech. Oddly enough, although the two lived only a few blocks from one another and were in reasonably close communication, Maltz did not express himself fully on the matter to Trumbo for well over two years—and then not until he had given a public statement criticizing the speech to Victor Navasky of the *New York Times*. Navasky was preparing an article on the blacklist which subsequently appeared in the *New York Times Magazine*. What Maltz said, in part, was this:

> There is currently a thesis pronounced first by Dalton Trumbo which declares that everyone during the years of blacklist was *equally* a victim. This is factual nonsense and represents a bewildering moral position.
>
> To put the point sharply: If an informer in the French underground who sent a friend to the torture chambers of the Gestapo was equally a victim, then there can be no right or wrong in life that I understand....
>
> [Trumbo] did not advance this doctrine in private or public during the years in which *he* was blacklisted, or at the time he wrote his magnificent pamphlet, "The Time of the Toad." How he can in the same period republish "The Time of the Toad" and present the doctrine that there were "only victims," I cannot say—but he does not speak for me or many others. Let it be noted, however, that his ethic of "equal victims" has been ecstatically embraced by all who cooperated with the Committee on Un-American Activities when there were penalties for not doing so.

Navasky, in turn, showed Maltz's statement to Trumbo and asked him to comment. Trumbo made a very mild statement, refraining even from pointing out that nowhere in his Laurel speech had he said that "everyone...was *equally* a victim." He told Navasky that he didn't want to get into a public dispute with Maltz. But that certainly didn't prevent the two from getting into a private one. Long before the article appeared in which they were actually quoted, Maltz and Trumbo had entered into a

correspondence that grew increasingly angry and more personal in tone with each letter.

Maltz taxed him bitterly for having altered his position, implying (without actually saying so) that Trumbo had sold out to the enemy, and pointing out that at the very least he had handed them a ready justification for their acts of treachery. But Trumbo stood firm: "In a country which, after a reasonable period of punishment returns murderers and rapists to society on the humane theory that it is still possible for them to become decent and valuable citizens, I have no intention of fanning hatred which burned so brightly twenty-five years ago."

Maltz reiterated angrily at length and in detail that Trumbo had given aid and comfort to the enemy. He insisted that the stand that they had taken before the Committee, as described by Trumbo himself in "The Time of the Toad," had been taken essentially on constitutional grounds—that they had gone to jail in a bid to save the First Amendment. He was arguing, in effect, that indeed there were heroes and villains during the blacklist: the Ten, who had gone to jail, were the heroes, and the informers were the villains. Trumbo, however, would have none of it:

> Our primary aim was to avoid becoming informers. To defend and justify our refusals we used the Constitution as a shield. We needed that shield so we fought for it. Our conduct was not quite as bold, noble, intrepid as it would have been had we voluntarily leaped to defense of the Constitution without regard of the blood we might lose....It is quite enough that we acquitted ourselves honorably on the right side of a good fight which deserved the admiration it then received and now receives again. But our behavior was not, by definition, heroic....
>
> If the Ten weren't heroes, what were they? They were, quite simply, ten men who chose in that particular moment and situation (although not necessarily in all other moments and situations) to behave with honor; and who, in the face of enormous opposition, have had the courage to remain honorable in that aspect of their lives to this day.

About those who did inform, Trumbo was just as emphatic and even more eloquent:

Some sixty of the persons who were commanded to take the test under pain of punishment failed it—i.e., they became informers. There is very little evidence, if any, that they *wanted* to become informers. There is an abundance of evidence that they did *not* want to inform; that they did so with great reluctance; that they acted out of fear (not at all unfounded) and under great pressure....

Motives? There were all kinds of motives: a man, to support a business venture, had hypothecated everything he possessed in anticipation of future income, without which he would have been bankrupted; a man caught in a homosexual act and given the choice of informing or facing exposure and prosecution in a time when it was more disgraceful to be a homosexual than a Communist; a woman who had worked her way from secretary to writer, now three months pregnant, the sole support of herself and a worthless husband, whose brother had a long record of crime and imprisonment; a man who had left the CP to avoid constant attempts to meddle with the ideological content of his writing; a foreign born citizen threatened with revocation of his naturalization papers; a man who left the Party because he could not stomach its insistence that the early phases of World War II offered no choice between Hitler and the West; a person whose spouse suffered from recurrent spells of melancholia which, in such a crisis as political exposure, could have resulted in suicide; a person whose disagreement with the CP had turned to forthright hostility and who, when the crunch came, saw no reason to sacrifice his career in defense of the rights of people he now hated; a resident alien threatened with deportation; a person who had been unjustly treated and testified to get even—and then, of course (since fear rarely brings out the best in any of us), the weak, the cunning, the ambitious and the greedy.

Whatever their faults, those sixty-odd unwilling witnesses were ordinarily decent people put to a test which you and I have declared to be immoral, illegal and impermissible. They failed the test and became informers. Had they not been put to the test, they would not have informed. They were like us, victims of an ordeal that should not be imposed on anybody, and of the Committee which imposed it. As for calling them villains, that cannot

be done until the history and definition of *villain* is rewritten to conform with what you believe it should mean even though it doesn't.

If they weren't villains, then what were they? They were people who chose in that particular moment and situation (although not necessarily in all other moments and situations) to abandon honor and become informers. So be it. They have lived with that terrible knowledge of themselves for over two decades, just as— even more terribly—their children have lived in such knowledge of their parents.

The letter from which I have quoted at such length here runs forty-one pages. This, however, did not end the exchange. Each wrote another letter more acrimonious than his last. Finally, Trumbo broke off the correspondence—his last letter is dated February 7, 1973—and headed for Jamaica for the major shooting that remained on *Papillon*.

I am well aware that my presentation of this exchange of letters— paraphrasing Maltz and quoting Trumbo—gives a considerable advantage to Trumbo. If this seems unfair, well, it is not entirely my fault. After all, if you have read this far, you must know that I think Trumbo was substantially right in the position he took, so there probably would, in the process of selection, have been some favor shown him even if I had been free to quote Maltz as well. But I wasn't. I asked Albert Maltz for permission to quote selectively from these letters to Trumbo, but he declined, saying that the only way he would consent to that would be for me to print the *entire* correspondence, both sides, without paraphrasing or abridgment. I told him that *might* be possible in an appendix to the text of the book. But then it turned out that by the "entire" correspondence, Maltz meant that a final letter should also be included which he had sent to Trumbo after the latter's departure for Jamaica. Cleo had returned it unopened, and Trumbo had never seen it. When her husband returned from *Papillon* to have a lung out, she wanted to make damned sure he didn't see that letter and get embroiled in that controversy with Maltz again. And so when I brought the matter up to her (Maltz insisted that the decision must be hers because he felt the material in that letter of his was so devastating that Trumbo might be

physically shaken by it), she told me to forget about it. By that time it seemed best to me, too.

Albert Maltz was a rather testy, fractious individual. After the episode between us, he began sending me letters by registered mail more or less daring me to print the *complete* correspondence. He clearly wanted to have the last word. He was the sort of man to whom it is of all-consuming importance to have the last word. But so, also, for that matter, was Dalton Trumbo.

That said, it should also be made clear that no matter what my personal experience of Albert Maltz was, I respect him as a writer. He worked on a number of good films during the war at Paramount and Warners—*This Gun for Hire, Pride of the Marines,* and *Destination Tokyo.* His last film before the blacklist, a fine one, was *The Naked City.* He sat out the blacklist in Mexico, and only toward the end of it did he even attempt any work on the movie black market. He did, in any case, make a relatively successful comeback, having picked up screen credits on *Two Mules for Sister Sara* and *Scalawag.* He would have had another on *The Beguiled,* but he was so displeased with what director Don Siegel did with his script on that one that he had his name removed from it (he was, as I said, greatly given to dispute).

He also wrote plays, short stories, and novels; in fact, he said he had a novel under way when I talked to him. His fiction is solid stuff in the old social realist mode—not flashy or terribly exciting but, like the man who wrote it, square, conventional, and obsessed with a high-minded passion to set the world right. Earlier there was a strike novel, *The Underground Stream;* an impressively imagined view of life in Nazi Germany which was published during the war, *The Cross and the Arrow;* a kind of latter-day proletarian novel, *The Journey of Simon McKeever,* which I liked quite well when I read it years ago; and *A Long Day in a Short Life,* a convincing look at people inside the D.C. jail. *A Long Day* was written while Maltz was in Mexico, during a period when Trumbo, too, had time to write fiction but could only curse his luck and wish the King brothers would come through with another job for him. Maltz was disciplined; he was precise; he seemed perfectly in control of himself.

"I met Trumbo probably the year after I first came here, in June 1941, I would say, but I knew him only very casually then. In fact, we were never then close friends. As I look back on it, though, there must

have been something sufficiently cordial in our relationship a little later on because after Trumbo came back from the Pacific and started his novel, he asked me to read some of it. He certainly wouldn't have done this to a stranger.

"And later? Well, even after we both got ticketed by the Committee, I didn't really come to know him much better. After the hearings he went to his ranch and stayed there. There were meetings of the Hollywood Nineteen and the Hollywood Ten and a two-year campaign we waged, but basically he was away during this time, up in the mountains, writing. In Mexico, well, for much of the time we lived in different cities—I was in Cuernavaca at first. During that period I was never at his home for dinner, and vice versa. But afterward, when I moved to Mexico City, we did see one another."

We are talking in Maltz's study. It is unmistakably a writer's room. Maltz sat, as I remember, behind his desk during the hour or more that I was there, fingering the typewriter, touching the keys, signaling his desire to get back to work. Although he lives only blocks from Trumbo and on the same street, the two have not seen each other for a number of years. They have, however, corresponded. It is about that correspondence that we talk most on this afternoon. He tells me about the "missing" letter, the one returned to him unopened by Cleo; but he does not offer to show it to me. And then, in general about the correspondence, he says, "The central issue in the letters is the philosophical one, in the differing fundamental positions we stated, he in his speech and I in my letter to the *New York Times*. I just wish we could have kept it at that level—or perhaps resume it there. But I suppose it's out of the question now because he's ill, and that makes a difference, of course. He's a very feisty man, you know, a regular fighting cock. It's that damned cigarette smoking of his that put him in the shape he's in today. He just couldn't stop. He used to smoke the things one after the other."

Maltz picks up a couple of sheets of paper from the desk and begins looking them over. "I started making some notes yesterday when you called, things I thought I ought to cover. Let's see. I mentioned the Pacific novel already, of course. It was quite interesting, as I recall. I read one or two chapters. I don't remember its content, but I made some suggestions. But that whole story points to an aspect of Trumbo's character that I find really disturbing. I remember we were in his study talking about this Pacific novel of his. It was around 1946, and it was in

that house on Beverly Drive. He had an enormous board up on a stand, white cardboard, and he explained to me that this Pacific novel was just one of a whole cycle he intended to write. He had a genealogical tree covering them worked out on this chart, showing where each one fitted in and what period and action it covered and all. It was a very ambitious project, but of course he never wrote them. Never wrote any of them.

"Yes, and on another occasion, too. It was in 1962 when I had come back from Mexico. He had had a piece published in the *Nation,* and it was very good, very incisive, acidly witty. I said to him, 'Dalton, why don't you so arrange your life that you write more pieces like this?' He shrugged and said nothing more about it. There is no question that Trumbo had talent for much greater literary work than the film work that he produced. The reason he never did what he could have done was this obsession of his with making money and living in a grand manner. I never knew what it was that made it necessary for him to have both a house on Beverly Drive and a ranch that he had to build a road to get to. It kept him writing, and writing, and writing, though. Why *do* writers write, after all? I know all about Balzac's desire for money, Stendhal's wish to woo women, and whatever it was that drove Victor Hugo. Flaubert didn't produce what Hugo did, but what he did write was infinitely more important. So it may be foolish for me to say this about Trumbo, perhaps. He is what he is. He must have some reason for doing what he did, for using his talent the way he did. Though it's a mystery to me."

Maltz pauses and shakes his head as though the thought disturbs him, then his eyes drop back down to the notes he had prepared. "Yes, well, let's see. In 1963 Trumbo spent a year in Rome and wrote a film script for De Laurentiis. I had been asked to read the book by De Laurentiis myself—the siege of some city. The book was actually a piece of crap, and I told this to De Laurentiis. Trumbo thought so, too, but he got two hundred and fifty thousand for doing the job. Recently I had occasion to read the script, and it was a good one. He actually used only a little from the book. But yes, I was there in Rome on work of my own and for about six weeks we had dinner together about once a week. I remember that for the first time Trumbo got interested in travel, and he did it then. It didn't take him a year to write that script. If he had had a strong bent to write a novel, he could have used it then. Instead he traveled.

"I remember—I don't know if it was then, though, it must have been earlier—but I remember he once gratuitously made a defense of his film work as compared to novel-writing. He said, 'When people see my films they will know more about what the United States was like in 1958 than they will find out from any number of histories.' That would be nice if it were true, but a great many of his pictures have a layer of crap on them."

With that, Maltz launches into an unexpected critique of Trumbo's produced films. He goes after them quite aggressively, and yet seems to find serious fault only with *Papillon, The Sandpiper,* and, surprisingly enough, *Lonely Are the Brave.* He rambles a bit then, recalling the comradeship of the period in Mexico, how they had all taken joy in each other's triumphs, how those on the blacklist had been so close. And now, says Maltz, he feels that Trumbo had just wiped out that old feeling of comradeship with his Laurel Award speech.

"I went and talked with him about it later," says Maltz. "Not from that talk or from the correspondence afterward have I ever truly been able to understand what made him present this 'only victims' thesis. I remember that Adrian Scott told me once, 'Did you know that whenever Dalton travels anywhere he takes the Bible with him?' I *didn't* know that, but I was certainly interested. And I have thought of it with regard to this. Maybe there was some idea of Christian forgiveness at work within him that led him to propound such a thesis. I'll tell you, though, what caused me to write that statement for Navasky. People feel that Trumbo is speaking for the Hollywood Ten when he says this. I wanted to make sure they didn't think he was speaking for me."

He nods, having made the point he wished to, then ducks back to his notes: "There is an aspect of his personality that is not so pleasant—this thing of his sudden outbursts. I saw it myself in 1963 in Rome. It was at a dinner with Harold Smith—he, with Ned Young, was the author of *The Defiant Ones.* In the middle of an otherwise pleasant dinner Trumbo suddenly opened up with a vitriolic personal attack on Hal Smith. I was dumbfounded. Hal was not only dumbfounded but was white as putty. Not long after that he left.

"A couple of years later I was present during a similar outburst directed against one of his *close* personal friends. The friend was just devastated, even left town because of it.

"It could be the drinking, I suppose, which at one time was fairly

constant when he was not working. But not anymore, of course, not for some time. It was at its worst during the blacklist. The pressure then must have had something to do with it, of course."

Much—all, probably—that Albert Maltz said about Trumbo was accurate and true. There was a dark side to his nature that moved him to strike out suddenly and often inexplicably at those around him, sometimes at those quite close to him. I would go so far as to say that he was so frequently and profoundly moved to vengeance that the "only victims" speech that he made before the Writers Guild took an act of will that was of, well, heroic proportions. It came, I think, as the result of a great struggle with himself and represented what he himself believed to be the most honorable and moral attitude to take toward the experience of his lifetime—a triumph over that darker side of himself.

Trumbo was a complex man, one whose impulses and attitudes were frequently, perhaps constantly, in conflict. He had a novel under way for years, begun in 1960, set aside, rewritten but never abandoned. It was a curious one for him to write, one that would have been immensely difficult for anyone to do. It is the fictional autobiography of a Nazi, an old comrade from the days of the Freikorps who rises in the Party, serves in an SS Einsatzgruppe, and finishes the war on the staff of Auschwitz. The tone of the novel is most striking, for it is a spiritual autobiography, one that perfectly captures the elevated idealism of the Hermann Hesse generation and contrasts it shockingly with the squalorous reality of their deeds, as recorded in diary entries interspersed through the text. But, reading through more than a hundred pages of it, I was struck that this is more than an impressive act of literary impersonation; it is in some private sense also a kind of spiritual autobiography of Trumbo, a mighty effort to understand not just a Nazi but part of himself as well, and thus to master his own demon.

Many people have remarked that Trumbo should have written more novels; none, I'm sure, wished it more profoundly than he did. Not that he was ashamed of the screenwriting he had done. He loved films, loved working in the medium, and he was surpassingly good at it. Yet in the end, perhaps particularly in the end, as he took stock of what he had done, Trumbo may well have wished that he had a solid pile of books that he could claim as indisputably his. Film is flimsy stuff, essentially

of the moment; that is its glory and its shame. He joked about this, always a sign with him that it was something he took seriously. When he sat down with his publisher and signed the contract for his Nazi novel (another earnest of his intention to finish it), he told the editor, "You know, I've got ideas for several books, and I'd *like* to do them all. It's just that I really feel uncomfortable selling out to you guys like this. I wouldn't do it, but I need the money so I can go back to Hollywood and write screenplays." Talking about his earlier novels, including those begun but never finished, he said something to me that may have been a rationalization but made a good deal of sense: "Except for *Johnny Got His Gun,* those other books had no need to be written. With *Johnny* there was a need, something that had to be said, and so it was written." There was, similarly, some necessity behind the Nazi book, though one of quite a different kind, and I thought it would also be written— obviously I hoped so, too.

There is no use pretending that the money Trumbo had made work-ing in motion pictures did not play an important part in the direction his life took. But his attitude toward money was as complex and appar-ently contradictory as everything else about this man. He liked it, liked what it bought him, liked the life it gave him. He also took pride in the price he commanded in a craft where achievement is both measured and rewarded in great sums. Probably because he knew real poverty in his early life, he suffered few of those pangs of guilt regarding money that are supposed to torture most of the gifted people in Hollywood. Probably because of his early life, too, he had a kind of casualness toward the stuff that bordered on contempt. He spent it, borrowed it, loaned it, even gave it away without much real regard for it. His lawyer, Aubrey Finn, told me that on more than one occasion Trumbo had torn up a contract and returned a small fortune just for the grand pleasure of telling a producer to shove it. The idea, as far as Trumbo was con-cerned, was always to earn so much money that he could do whatever he wanted with it. In our society, money is freedom—and that is what it always meant to him. If our society were different, then his attitude might also have been different.

For if the facts of Trumbo's life tell us anything at all about the man, they tell us that he was shaped, as all of us are, for better or for worse, by the conditions of his time and situation. If he was an odd sort of Communist, and he would have been the first to concede that this was

so, then he was the sort of Communist that would necessarily emerge from the childhood and youth he spent in Grand Junction and the Davis Perfection Bakery. That is, a peculiarly American sort: materialistic, professionally ambitious, and half-drunk on the romanticism he poured into his motion picture scripts.

I'm not, certainly not, suggesting that some simple social determinism has defined Trumbo precisely. No, what was most remarkable about him was not the extent to which he was shaped by his time, but rather the extraordinary way that he himself—by himself—shaped it. He proved at a time it badly needed proving that what one man does can matter. Even here, he made his point not by giving speeches, circulating petitions, or organizing demonstrations—as he had tried earlier—but by keeping his silence when it counted and working at his craft as best he could.

"Sometimes," Trumbo said to me once, "I think what a terrible state we're in when a man can be considered honorable simply because he isn't a shit." Earlier, I offered Trumbo as a kind of exemplar—one who so incarnated certain qualities worthy of emulation. But is this then all that Trumbo has to offer? That he wasn't a sheep? That he wasn't a shit? No, there is more to be said for the man than that. For even in a time like our own, one practically inured to the power of myth, a life like Trumbo's takes on something of a fabulous quality. His *was* a fabulous life—a tale told, an old-fashioned story that illustrates the virtues of hard work, of keeping faith with oneself and one's ideals, a quintessentially American story that he could, with only a few important details altered, have written himself for the *Saturday Evening Post* back in the thirties. But no: he didn't write it; he lived it—improvising it from the days and hours he was given, making it up as he went along. Let him be remembered by that story, and his place is assured.

POSTSCRIPT

Dissolve. Here we are, years earlier in Trumbo's office, my first visit to his home. Look around. It is a magnificent room. There are in it caricatures by Peter Ustinov and drawings by John Huston; photographs by Cleo; a library of about a thousand books; copies of every screenplay he is proud enough to keep; a glorious litter of memorabilia and souvenirs from a lifetime; but nowhere, look as you will, can you see any sign of that Oscar awarded to Robert Rich for *The Brave One.*

"Where is it?" I ask.

"Where is what?"

"The Oscar. The one you won with the phony name."

"I don't have it," he says. "It was never given to me."

"Well, couldn't you just claim it?" I ask. "Everybody knows it's yours."

"What everybody knows isn't good enough," he says. "You don't *claim* an Oscar. It's given to you. And so far they haven't seen fit to give that one to me."

But at last they did. In a kind of collective and symbolic act of contrition, the officers and board of governors of the Academy of Motion Picture Arts and Sciences on May 5, 1975, awarded replica number 1665 of the "copyrighted statuette, commonly known as 'Oscar,' as an Award for the Motion Picture Story—*The Brave One* (1956)."

It has Dalton Trumbo's name on it. That made it official: the blacklist, now acknowledged, was behind them all. Trumbo had done his job. He died a little over a year later on September 10, 1976.

A NOTE ON SOURCES

This book was written for the most part from primary sources—interviews, letters, private memoranda, etc. The chief source, of course, was Dalton Trumbo himself. He gave me interview time at a period in his life when he simply had no idea how much time he himself had left. He also gave me complete access to his correspondence and personal papers pertaining to his life through 1962, which are stored at the Wisconsin Centre for Theatre Research, University of Wisconsin. He allowed me to roam at will through his personal files at home in which he had those documents covering the years that followed. All this he did in an act of pure, blind faith, for with the exception of one brief section (as noted in the text), no manuscript approval was asked for and none was offered.

In addition, however, I was granted interviews by many who have known Trumbo over the years and by others who had specific or general information to impart. Not all of them who were helpful were quoted in the text. One of those quoted in the text was not helpful. Those to whom I talked were: Jacoba Atlas, Catherine Baldwin, Elizabeth Baskerville, Harry Benge, John Berry, Alvah Bessie, John Bright, Jean Butler, Lester Cole, Kirk Douglas, Jerry Fielding, Thomas K. Finletter, Aubrey Finn, Pauline Finn, Hubert Gallagher, Dorothy Healy, Alice Hunter, Ian MacLellan Hunter, Robert W. Kenny, Frank King, Frances Lardner, Ring Lardner, Jr., Al Leavitt, Edward Lewis, George Litto, George MacKinnon, Albert Maltz, Carey McWilliams, David Miller, William Pomerance, Katherine Popper, Martin Popper, Otto Preminger, Franklin Schaffner, Adrian Scott, Roy Silver, Christopher Trumbo, Cleo Trumbo, Mitzi Trumbo, Ed Whalley, Mary Teresa Whalley, Charles White, and Michael Wilson.

As any writer will, however, I made use of whatever I could lay my hands on in the way of published materials in the preparation of this book. And while my debts to certain authors are paid in passing in the text, circumstances did not always permit proper acknowledgment to be made where it was pertinent, and so I take this last opportunity to do so.

BOOKS BY DALTON TRUMBO

Eclipse (Dickson, 1935)
Washington Jitters (Knopf, 1936)
Johnny Got His Gun (Lippincott, 1939)
The Remarkable Andrew (Lippincott, 1940)
The Biggest Thief in Town (Dramatists Play Service, 1949)
Additional Dialogue: Letters of Dalton Trumbo, 1942–1962,
edited by Helen Manfull (Evans, 1970)
The Time of the Toad (Harper & Row, 1972)

This book is dedicated to the producer Kevin Brown, who met Bruce Cook at Dutton's bookstore in North Hollywood fifteen years ago, and launched what became this reprint. I am grateful to my longtime friend and attorney Chuck Hurewitz, and to my literary agent Linda Langton, for finding a new home for this book. I am also grateful to the Trumbo Family for all their help with the book and the movie.

INDEX